Medieval Art in America

Patterns of Collecting
1800-1940

Elizabeth Bradford Smith

with
Kathryn McClintock
R. Aaron Rottner
and
Sarah Andrews
Heather McCune Bruhn
Robin Dearing
Pamela Hemzik
Beth Lombardi
Marshall Price
Cheryl Snay

Palmer Museum of Art
The Pennsylvania State University
University Park, Pennsylvania

This exhibition and catalogue
are sponsored by Mellon Bank.

Additional support provided by
National Endowment for the Arts
Samuel H. Kress Foundation
College of Arts and Architecture,
Penn State

ISBN 0-911209-45-X

Lenders to the Exhibition

The Art Institute of Chicago

The Art Museum, Princeton University

Glencairn Museum, Academy of the New
Church, Bryn Athyn

Harvard University Art Museums

Library of Congress, Rare Books and Special
Collections Division

Mead Art Museum, Amherst College

The Metropolitan Museum of Art, New York
 Department of Medieval Art and The Cloisters
 Department of Prints and Drawings

Museum of Fine Arts, Boston

The Nelson-Atkins Museum of Art,
Kansas City, Missouri

The Pennsylvania State University Libraries,
Rare Books Room

Philadelphia Museum of Art

Private Collection of Stark and Michael Ward

The Walters Art Gallery, Baltimore

Designed by Catherine H. Zangrilli
Edited by Sally Atwood
Printed by Seneca Printing, Inc.

Photography credits (numbers refer to catalogue entries):

The Art Institute of Chicago, All Rights Reserved, 70;
Leland A. Cook, 62-64, 66; Diane Fehon, 42; Harvard
University Art Museums, 11, 50-52; Library of Congress,
Rare Books and Special Collections Division, 9; Mead Art
Museum, Amherst College, 4, 5; The Metropolitan Museum
of Art, New York © 1995, 6, 16, 17, 18, 20-36, 43-46, 61, 68,
69; Museum of Fine Arts, Boston, 13-15; The Nelson-Atkins
Museum of Art, Kansas City, Missouri, 71; Maggie Nimkin,
72; Penn State University Photo/Graphics, 1-3, 7, 8, 10;
Philadelphia Museum of Art, 47-49; Michael Pitcairn, 67;
Fred Schoch, 19, 59, 60, 62-64 (color), 65, 66-67 (color); The
Walters Art Gallery, Baltimore, 12, 37-41; Bruce White
Photography, 53-58; Graydon Wood, 49 (color); Fig.2, P. 24,
Garrett Collection of Medieval and Renissance Manuscripts.
Manuscripts Division. Department of Rare Books and
Special Collections. Princeton University Libraries.

PENNSTATE

College of Arts & Architecture

This publication is available in alternative media on request. U.Ed. ARC 96-129

Over the years, Mellon Bank Corporation has sponsored numerous exhibitions of art showcasing masterpieces from some of the world's greatest collections. We are especially proud to join the Palmer Museum of Art and The Frick Art Museum in presenting *Medieval Art in America: Patterns of Collecting 1800-1940*. This exhibition is a unique collection structured around how and why–rather than what–artistic treasures were collected in the late 19th and in the first half of the 20th centuries.

Medieval Art in America examines the history and evolution of taste in American collecting which reflects changes in perceptions of medieval art as well as in the social and intellectual climate of the time. The over seventy-piece exhibition includes works in ivory, stained glass, stone, and paper–several of which were included in the collections of prominent banking-industry leaders such as Henry Marquand, J. Pierpont Morgan, and John D. Rockefeller, Jr.

Mellon believes in fostering an understanding and appreciation of art and sharing those artistic works with people in the communities we serve. Our support reflects our commitment to this proud Mellon tradition, and we are honored to participate in this tribute to the enduring value of culture and the arts.

Frank V. Cahouet
Chairman, President and
Chief Executive Officer

Contents

Foreword

The connection between collectors and museums is long-standing, inextricable, and essential. While museum experiences have motivated people to collect art, the good turn is reciprocated when collectors seek permanent homes for their collections. There is something particularly American about the unending flow of art masterpieces from private collections to the public domain. Many of this country's finest museums owe their existence to the impassioned collecting habits and subsequent munificence of men and women like Henry Walters, Isabella Stewart Gardner, and Henry Clay Frick.

Major collectors of medieval art, including J. Pierpont Morgan, Henry Walters, and George Grey Barnard shepherded their extraordinary collections into public museums. Now resplendently displayed on public view, these magnificent objects capture the character of an era known for its soaring cathedrals, fortified castles, and chivalrous knights.

The Palmer Museum of Art is delighted to present an exhibition which simultaneously displays European art from the Middle Ages and the collecting impulses of nineteenth and twentieth-century Americans. That most of these works of art now reside in this country's finest museums, underscores American generosity toward its public cultural institutions.

I would like to thank the directors of the lending institutions for allowing such fine works of art to be part of this exhibition: James H. Billington, Nancy M. Cline, James Cuno, Anne d'Harnoncourt, Philippe de Montebello, Stephen H. Morley, Malcolm Rogers, Allen Rosenbaum, Martha A. Sandweiss, Gary Vikan, Michael and Stark Ward, Marc F. Wilson, and James N. Wood.

Mounting an exhibition of this magnitude is a costly endeavor that a university museum can undertake only with substantial financial assistance. Without the generous support of the National Endowment for the Arts, we would never have gotten off the ground. In addition, support for the publication of the catalogue was provided by the Samuel H. Kress Foundation, and the College of Arts and Architecture, Penn State. I would also like to thank Neil Porterfield, dean of the College of Arts and Architecture, and the Department of Art History, for their cooperation in this project.

A special word of appreciation must be extended to Mellon Bank, the sponsor of this exhibition. To Frank V. Cahouet, Martin G. McGuinn, Ralph J. Papa, and Matthew Giles go my thanks for their enthusiastic support of an exhibition which has as its focus early twentieth-century American museum benefactors of which Andrew Mellon was certainly one.

Elizabeth Bradford Smith, associate professor of art history at Penn State, served as guest curator. As the inspiration behind the exhibition, Elizabeth spent several years assembling the research, winnowing the list of objects, and convincing owners to lend their precious pieces. She has also taught several seminars the results of which form the core of this catalogue. Elizabeth's achievements as a scholar, teacher, and lobbyist on behalf of the museum are apparent on every page of this catalogue.

And finally, I would like to thank the entire museum staff for the extraordinary effort that went into mounting the exhibition. The exceptional coordination of the exhibition by Mary F. Linda, assistant director, deserves special recognition. I would also like to thank Catherine Zangrilli for the creative graphic design of the catalogue and all supplementary materials.

To Elizabeth and all of her students, and to Mary and the staff, I extend my warmest appreciation and congratulations on a job well done.

Kahren Jones Arbitman
Director

Author's Introduction

The history of the collecting of works of art is fascinating to most of us on a very basic level because it serves as a window through which we can satisfy the almost irresistible urge to peek at the "lives of the rich and famous." On another level, the history of collecting is pertinent to a variety of disciplines for a variety of reasons. To the art historian, it is essential, for example, in establishing links in the chain of provenance for a work of art no longer in its original setting. To the cultural historian, it is useful in determining the tastes of a particular milieu, which can lead to a better understanding of the culture as a whole.[1] In addition, the history of the collecting of the art of another era can reveal changing perceptions not only of the art but of the era in its entirety. As René Brimo pointed out in one of the first comprehensive studies of American taste, there are several Middle Ages—the Middle Ages of eighteenth-century England is not that of the French Romantic nor that of the twentieth-century American.[2]

Many aspects of the history of collecting have been the object of study.[3] Among these, the history of the collecting of medieval art has been treated most often within the context of the awakening of interest in the Middle Ages.[4] Although the history of American collecting of medieval art has not received as much attention as collecting in England and on the Continent, it has not been ignored. As early as 1938, Brimo's ambitious study of the evolution of taste in America through a history of American collections included several discussions of the collecting of medieval art.[5] It was Brimo's belief that Americans, at first lagging behind European collectors in the appreciation of medieval art, had, by the 1920s, leapfrogged ahead of them, especially in their admiration for Romanesque sculpture.[6] During the Second World War, C.R. Morey briefly addressed the issue of American collecting of medieval art in an article whose primary thrust was the relevance of the Middle Ages to art and life in the twentieth century.[7] More recently, a number of media-based inventories of American holdings of medieval art have traced the history of collecting within specific areas.[8] Finally, individual collectors have consistently attracted the interest of biographers and scholars.[9]

To date, however, there has been no general overview of the American collecting of medieval art, from the initial, tentative samplings of the early years of the American Federation to the serious and knowledgeable collecting of the mid-twentieth century. It is this maturation of taste, a process that took well over one hundred years, that the present exhibition is intended to explore. This exhibition is not intended to be a comprehensive survey of American collecting of medieval art. Rather, its primary aim is to broaden understanding of how and why, in the years between 1800 and 1940, Americans did (or did not) collect the art of the Middle Ages. Tracing the history of collecting by both individuals and museums from c. 1800 up to the eve of World War II, this exhibition attempts to characterize within each period both the collectors and the intellectual and cultural context within which they operated. The exhibition is restricted to works of western medieval art from A.D. 800 to 1400 (1300 in Italy). Objects have been selected on the basis of several criteria. Some illustrate the patterns of collecting which we have identified, while others are intended to reflect those forces—individual or collective—which appear to have shaped these patterns.

As a first step in the preparation of the exhibition, it was necessary to establish what was collected, when, and by whom. We began by compiling a checklist based on a survey of the major collections of medieval art in the eastern and central United States. Since virtually none of these collections has published a complete catalogue or checklist of their medieval holdings, we relied on a combination of published sources, such as museum bulletins, special exhibition catalogues, and the above-mentioned media-based inventories. In addition, we consulted museum files directly whenever possible. Using these resources, we catalogued over 1700 works of art, sufficient to provide a basis for establishing the general patterns of collecting within this time frame.

In addition to building up a file of works of art in American collections, we prepared profiles of individual collectors and curators, histories of the museums housing the collections surveyed, while also researching the artistic, intellectual, and cultural context of the time. In other words, we looked for evidences of continuity and of change in the emphasis and direction of collecting, and for the reasons behind these choices. Where possible, it was our aim to identify and examine possible hinge-points, or moments, when the direction of collecting changed course. What, for example, was the impact of a specific lecture or art exhibit? How great was the influence of a single scholar, curator, dealer, or collector? How might the acquisition of one particular work of art have affected the direction of any one collection, or of the museum community as a whole? These are some of the questions this exhibition is intended to explore.

In the course of our research, it was perhaps inevitable that

we tread upon some ground that has been covered before, often by those better equipped to do so. But we have tried to go a little farther than our predecessors and to explore new avenues wherever possible. Some of these have proven fruitful, and we hope that our modest success in these areas will encourage others to take up the task and to expand the inquiry towards the many aspects of the American collecting of medieval art which remain unexplored.

This exhibition has been made possible in large part thanks to the foresight of Kahren Arbitman, director of the Palmer Museum of Art, who, upon assuming directorship of the museum, recognized and encouraged the germ of what she must have perceived as a practicable project. Without her initial support, it would never have made the transition from theory to reality. The idea for this exhibition took embryonic shape over six years ago, in response to a suggestion by Hellmut Hager, head of the Department of Art History, that I collaborate with our graduate students to produce an exhibition which would be shown at the university's Museum of Art. The topic itself was one that had long been a personal interest, ever since student days, when I was fortunate to benefit from prolonged and intimate contact with Mildred and Russell Lynes. Under their roof, a particular blend of the history of art and the history of taste permeated the air and left a lasting impression on me. In a series of seminars, with the support and encouragement of the Department of Art History, several generations of students have worked on the successive stages of preparation for this exhibition, and each contributed to it in some way. Among former students who are not authors of the present volume, I would like to mention Jolie Elder, Valerie Grash, Mary Keating, Laura Ricketts, David Riffert, Margo Stavros, Anna Tuck-Scala and Tom Weprich. Their work has been of lasting value to the final product.

Because of the focus of this exhibition, much of the information we required was unpublished. Consequently, research was dependent on the cooperation of all of the participating museums. We are extremely grateful to their curatorial and archival staffs for generously granting us access to store rooms, departmental files, and museum archives, and for patiently answering our questions. Among them, we would like to give special thanks to the following persons: Bret Bostock, Eda Diskant, Barbara File, Melissa Ho, Lauren Jackson-Beck, William R. Johnston, Sarah Kianovsky, Virginia Krumholtz, Charles Little, Maureen Melton, Amy Meserve, Stephen H. Morley, Jonathan Munk, Betsy Rosasco, Joellen Secondo, Susan

Sinclair, Kerry Schauber, Abigail Smith, Marica Vilcek, Dean Walker, and D.W. Wright.

In addition, for further research assistance, thanks are due to the librarians of the American Philosophical Society, the Philadelphia Library Company, the Maryland Historical Society, the New-York Historical Society, the Pennsylvania Historical Society; to Glenda Meckley, Schmidt Library, York College of Pennsylvania; to George Terry, University of South Carolina; to the Interlibrary Loan Department, The Pennsylvania State University; and to Charles Mann and Sandy Stelts, Rare Books and Special Collections, The Pennsylvania State University.

For the preparation of the exhibition, I would like to thank the staff of the Palmer Museum of Art, especially assistant director Mary F. Linda, who contributed long hours and hard work to ensure its success. For preparation of the catalogue, many thanks to Sally Atwood, Peggy Willumson, and Cathy Zangrilli, to Heather Campbell and Emily Philinger, and to all of my co-authors. Finally, I owe a particular debt of gratitude to R. Aaron Rottner, without whom this project would never have set sail, and to Kathryn McClintock, who, through many a dark night, saw it safely to port.

1. See, for example, R. Lynes, *The Tastemakers: The Shaping of American Popular Taste* (New York, 1955; New York, 1980).
2. R. Brimo, *L'évolution du goût aux Etats-Unis d'après l'histoire des collections* (Paris, 1938), 7.
3. A good general study of collecting is F. H. Taylor, *The Taste of Angels* (Boston, 1948).
4. See, for example, T. Cocke, "Rediscovery of the Romanesque," *English Romanesque Art 1066–1200* (London, 1984), 360–65; T. Cocke, "The Wheel of Fortune: The Appreciation of Gothic Since the Middle Ages," *Age of Chivalry: Art in Plantagenet England 1200–1400* (London, 1987), 183–91; P. Williamson, "The Collecting of Medieval Works of Art," *The Thyssen-Bornemisza Collection: Medieval Sculpture and Works of Art* (London, 1987), 9–19; and C. Wainwright, *The Romantic Interior: The British Collector at Home 1750–1850* (New Haven, 1989).
5. Brimo, *L'évolution du goût*, 81–91; 127-28; 140–45.
6. Ibid., 149–50.
7. C. R. Morey, "Medieval Art and America," *Journal of the Warburg and Courtauld Institutes* 7 (1944): 1–6.
8. Most notably, W. Cahn and L. Seidel, *Romanesque Sculpture in American Collections*, vol. 1 (New York, 1979); and D. Gillerman, *Gothic Sculpture in America*, vol. 1 (New York, 1989). Both of these studies have been continued in *Gesta*. Also the *Corpus Vitrearum Checklist: Stained Glass Before 1700 in American Collections*, 4 vols. (Washington, D. C., 1985–91); and R. H. Randall, Jr., *The Golden Age of Ivory: Gothic Carvings in North American Collections* (New York, 1993).
9. For example, see A. Saarinen, *The Proud Possessors, the Lives, Times, and Tastes of some Adventurous American Art Collectors* (New York, 1958); and C. Bruzelius, "Introduction," *The Brummer Collection of Medieval Art* (Durham, N.C., 1991), 1–11, as well as the works cited below in the notes in Part II.

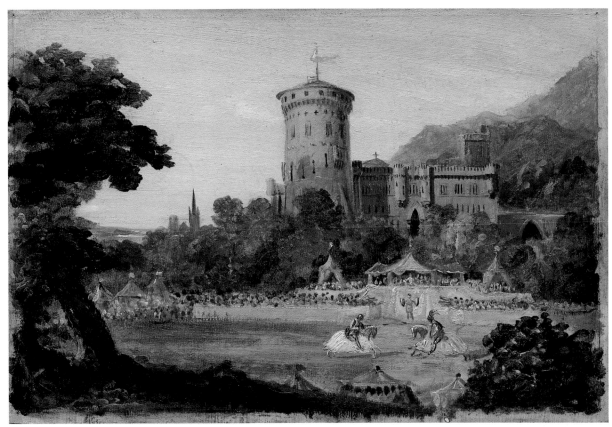

Catalogue 4 (p. 70)

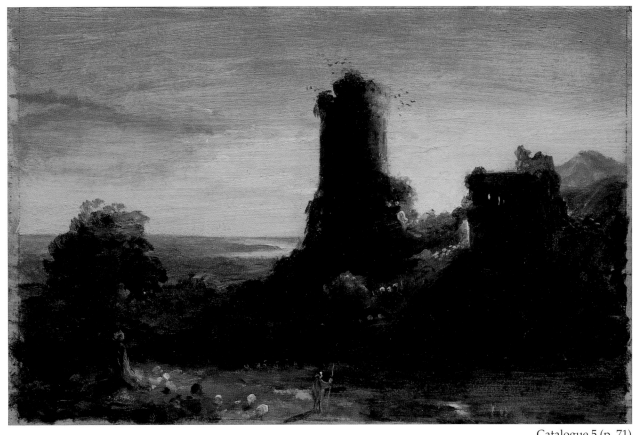

Catalogue 5 (p. 71)

Catalogue 9 (p. 80)

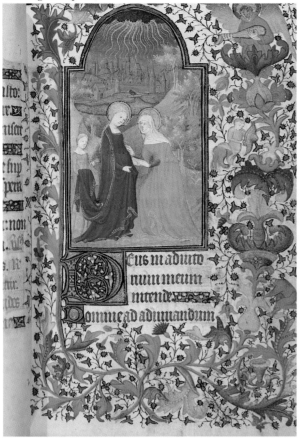

Catalogue 13 (p. 93)

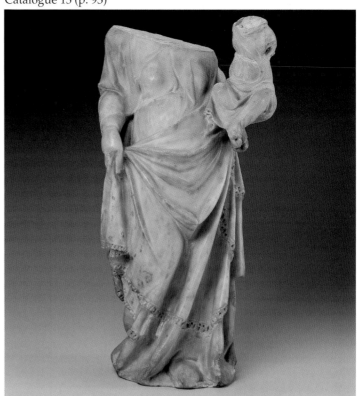

Catalogue 18 (p. 98)

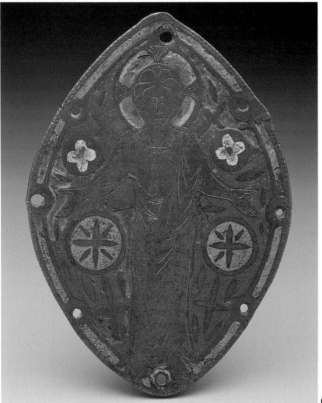

Catalogue 14 (p. 94)

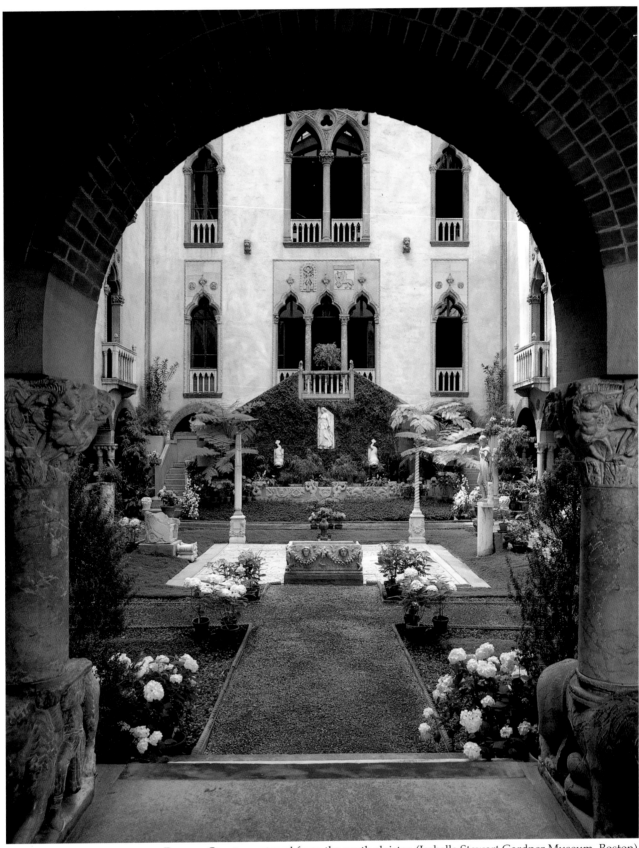

Fenway Court, courtyard from the north cloister. (Isabella Stewart Gardner Museum, Boston)

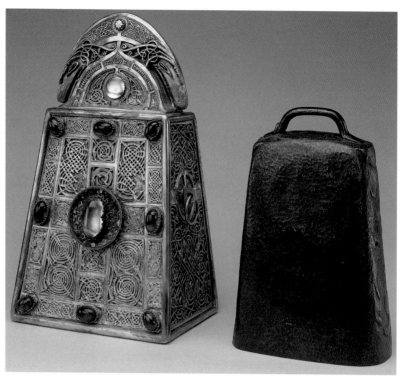

Catalogue 27 & 28 (p. 108)

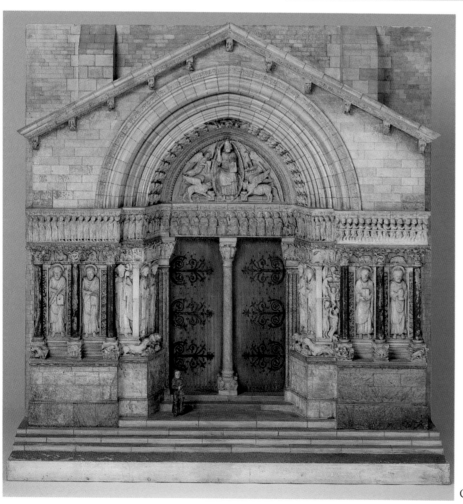

Catalogue 29 (p. 110)

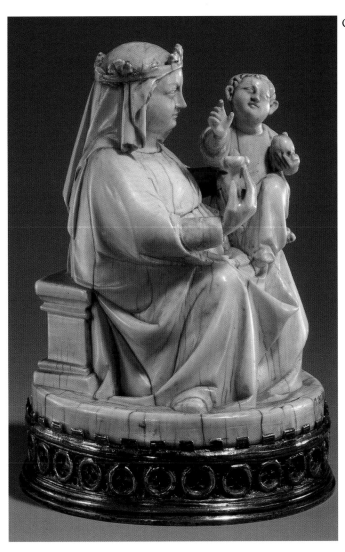

Catalogue 34 (p. 150)

Catalogue 31 (p. 145)

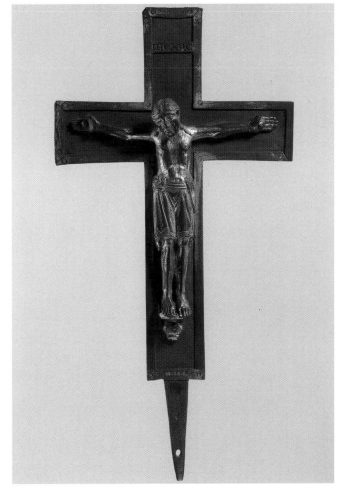

9

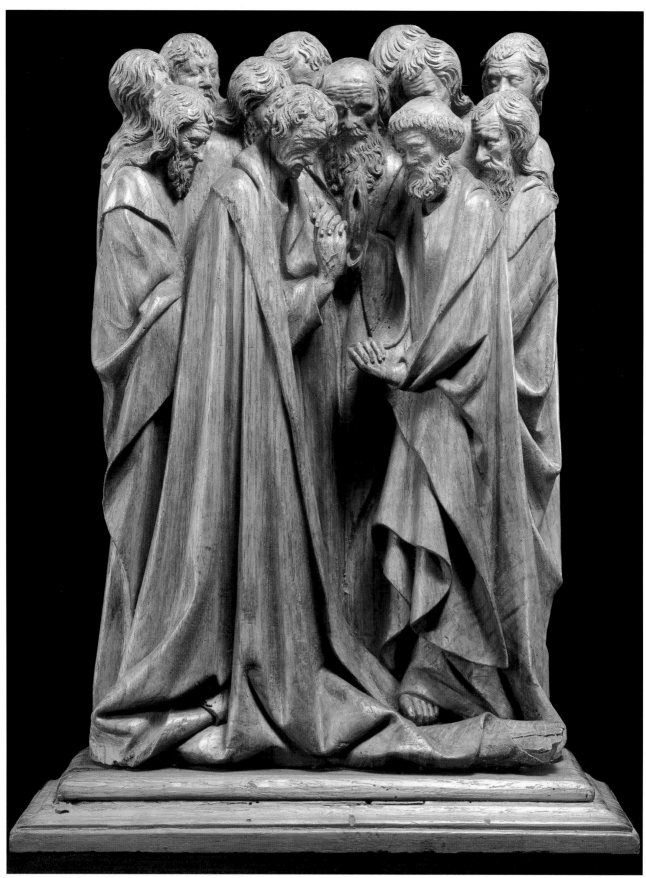

Catalogue 33 (p. 148)

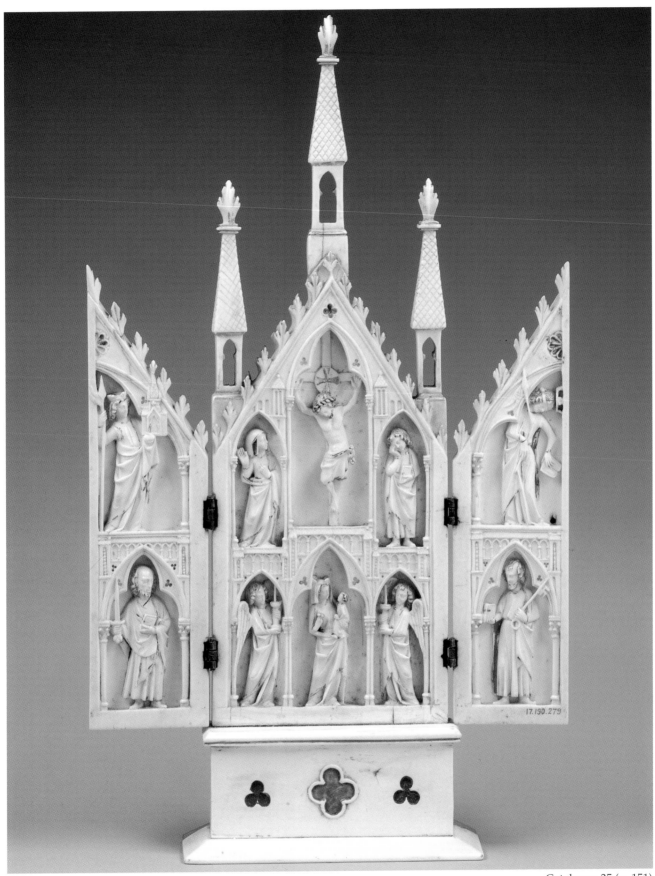

Catalogue 35 (p. 151)

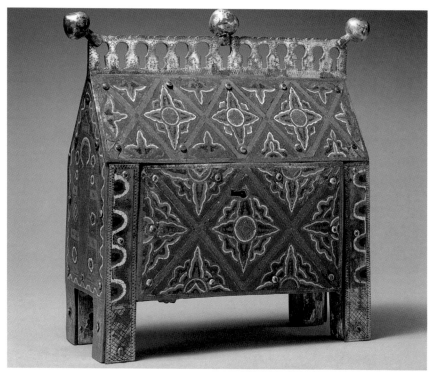

Catalogue 36 (p. 152)

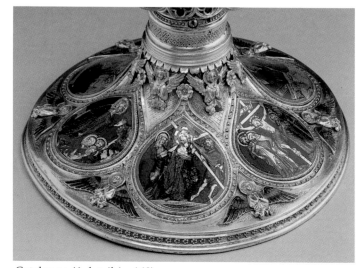

Catalogue 41 detail (p. 160)

Catalogue 41 (p. 160)

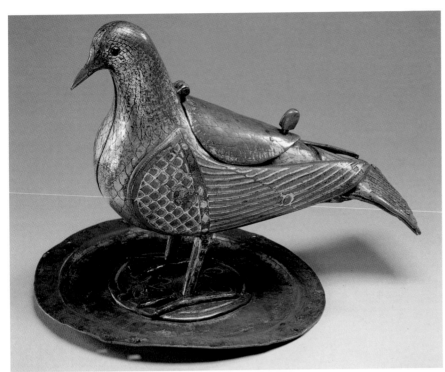

Catalogue 38 (p. 156)

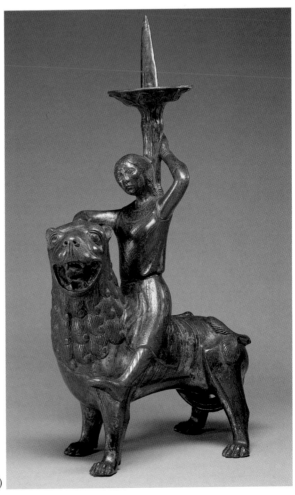

Catalogue 40 (p. 158)

Catalogue 44 (p. 164)

Catalogue 43 (p. 164)

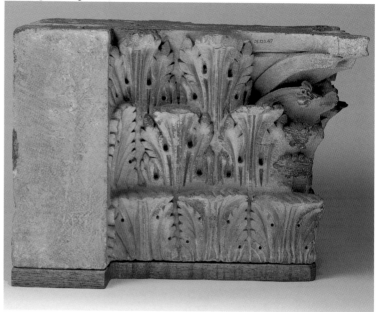

Catalogue 49 (p. 169)

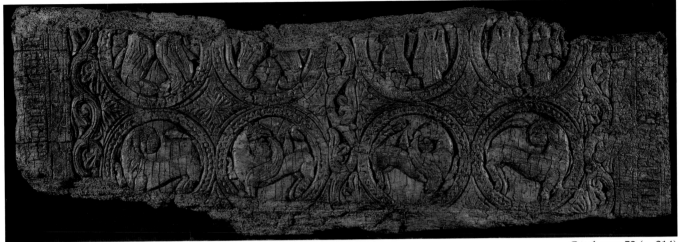

Catalogue 52 (p. 214)

Catalogue 58 (p. 223)

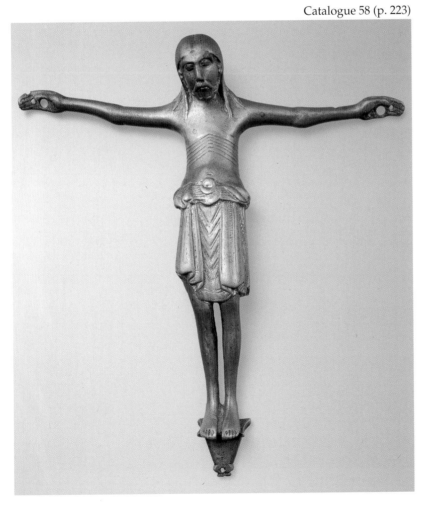

Catalogue 55 (p. 218)

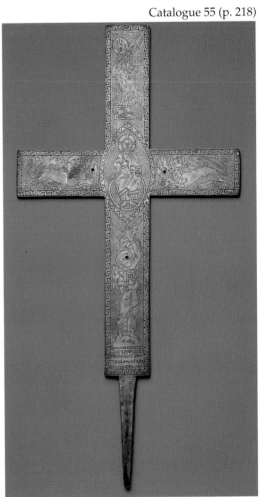

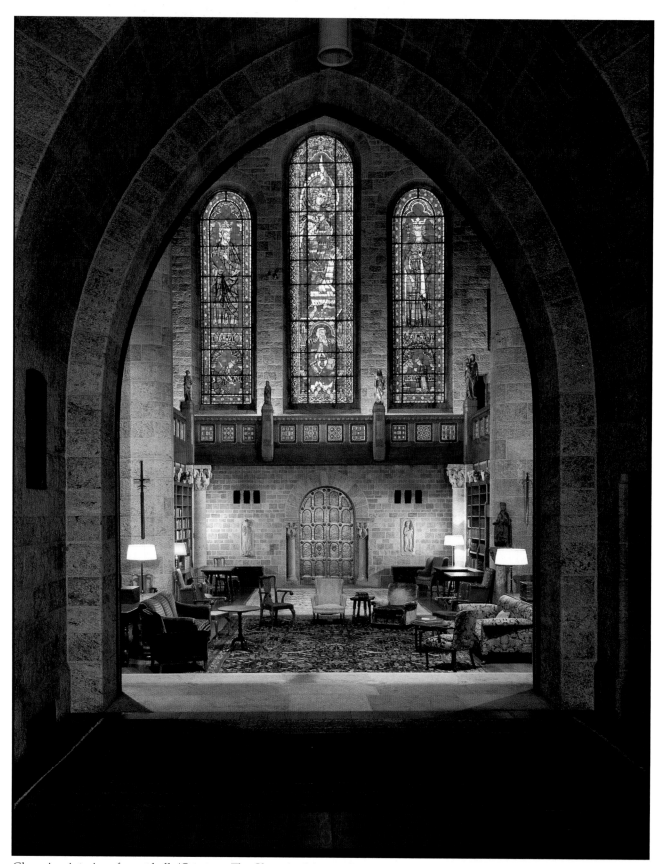

Glencairn, interior of great hall. (Courtesy, The Glencairn Museum)

Catalogue 60 (p. 226)

Catalogue 62 (p. 230)

Catalogue 61 (p. 228)

17

Catalogue 64 (p. 233)

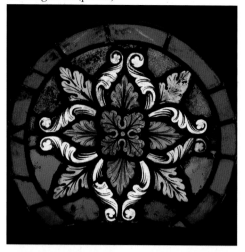

Catalogue 65 (p. 234)

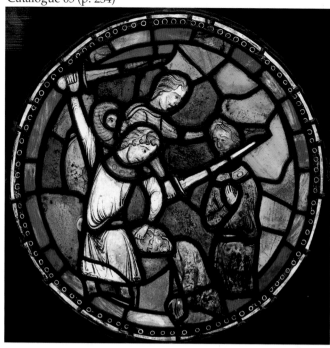

Catalogue 67 (p. 236)

Catalogue 63 (p. 231)

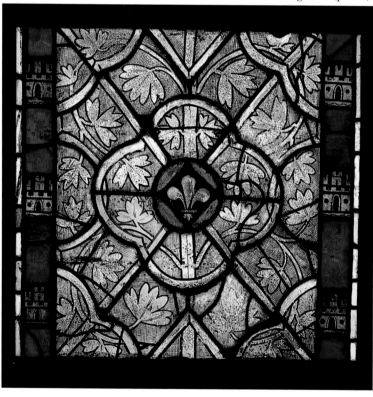

Catalogue 66 (p. 235)

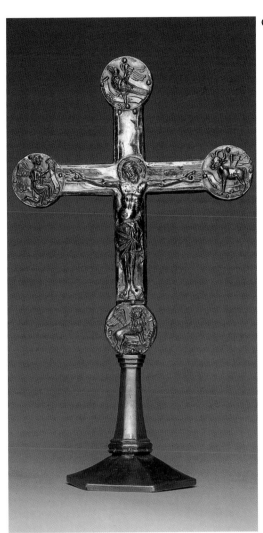

Catalogue 70 (p. 241)

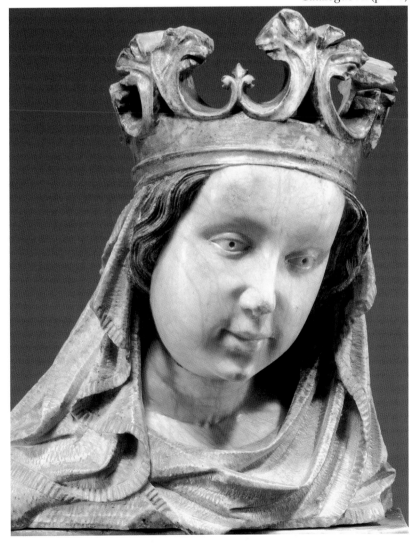

Catalogue 72 (p. 243)

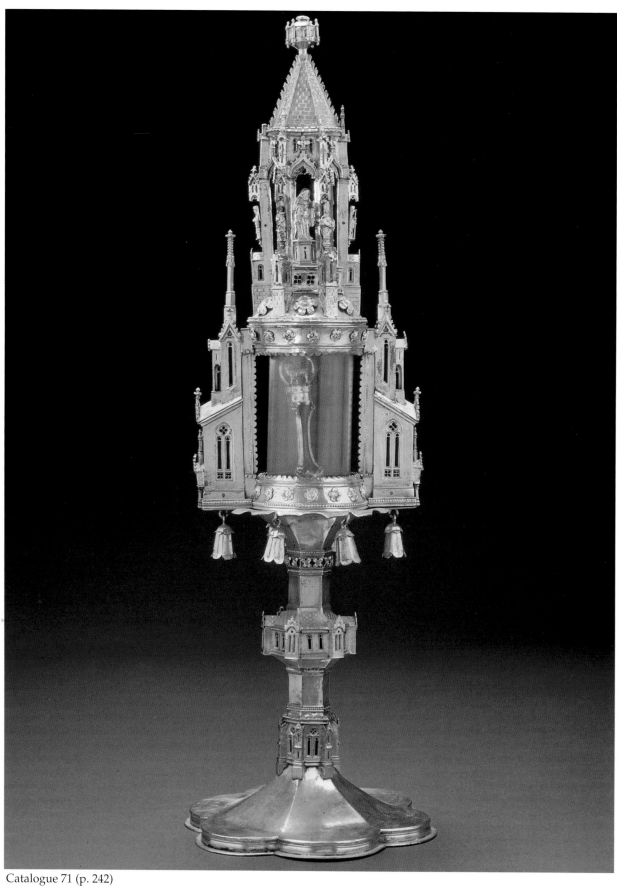

Catalogue 71 (p. 242)

1

THe Nineteenth Century

The Nineteenth Century:
Overview of the Period

Nineteenth-century collecting of medieval art was characterized by a series of false starts, or, to borrow the words of Edith Wharton, "false dawns." Beginning as early as 1803 and continuing throughout most of the century, isolated individuals acquired the occasional, sometimes very fine work of medieval art, but no major collections were formed. Several attempts were even made to provide the public with collections of Old Master paintings, which included examples of the "primitive" styles of the Middle Ages, illustrative of the early stages of the "Rise and Progress of the Art of Painting." These attempts came to naught, however, largely because the American people did not seem ready to look at medieval art.

Although Americans had embraced the Gothic novel and Gothic Revival architecture, a sampling of American travel writing from the middle years of the century shows that Americans did not approve of the Roman Catholic nature of real medieval buildings they saw in Europe nor of the religious imagery of medieval art. These were the years when the Know-Nothing party of the 1850s, characterized by a virulent antagonism toward foreigners and Catholics, enjoyed a phenomenal success in this country.

When the first major public museums were established after the Civil War, art was seen as a powerful educational tool for the masses, capable of morally uplifting the onlooker. It was also viewed as capable of having an adverse effect, if not carefully selected by those deemed knowledgeable. At this time, most Americans were still unsure of how to approach any original work of art. Even museum officials were hesitant to buy European art on the open market. They wanted but could not afford masterpieces and above all they were afraid they might be tricked by wily European dealers into buying wrongly attributed or even falsified works. As a result, reproductions of the "greatest" works were the preferred form of art for American museums in the late nineteenth century, dominating early acquisitions. Although works from the classical era took priority, medieval art was usually represented in some way.

It was in Boston that a more enlightened view of the Middle Ages, as promulgated by the English critic John Ruskin, took root in the United States. Starting at Harvard with the teaching of Charles Eliot Norton, a friend of Ruskin's, this new trend found in medieval Italy, especially in the Republic of Venice, a model of art and civilization that could be accepted by a modern democratic society. Henceforward, beginning in the relatively restricted circle of Harvard-educated Bostonians, Americans lost their ambivalence for medieval art, and it became worthy of admiration.

It was a resident of Boston, Isabella Stewart Gardner, who in the 1890s became arguably the first American to acquire a significant collection of medieval art. Mrs. Gardner had ties to Harvard and to Norton, and like Norton and Ruskin, she gravitated towards medieval Venice, choosing to erect a Venetian Gothic palace in which to house her art. While Old Master paintings were the primary focus of her collecting, she also purchased examples of the medieval minor arts and stone sculpture of both the Romanesque and Gothic periods, incorporating much of the sculpture within the fabric of her palazzo. Mrs. Gardner's collection foreshadows, on a smaller scale and with far less outlay of money, those of Morgan, Walters, and Barnard, the three great collectors of the years between 1900 and 1920. Isabella Stewart Gardner was not a "false dawn" but a major precursor, representing the real dawn of a new era.

The Earliest Private Collectors:
False Dawn Multiplied

Elizabeth Bradford Smith

During the nineteenth century, Americans, like their English cousins, embraced the medieval era through literature and in architecture: Gothic novels were widely read as early as the beginning of the century, and Gothic Revival architecture was popular from the 1840s on.[1] In a sense, therefore, for many in this country the world of the Middle Ages was a familiar presence, in both body and spirit. In spite of this fact, however, not many Americans during this period actively went in search of the art of the Middle Ages—the first large collections of medieval art were not begun until shortly before 1900. During the early and middle years of the nineteenth century, only a few works of art from medieval Europe crossed the Atlantic to enter American private collections. The sampling of early collectors considered here may help us to understand why these particular individuals acquired medieval art. In an effort to understand why these collectors were the exception rather than the rule, we will also examine public perceptions of the medieval art in these collections and of medieval art in general. This sampling of collectors includes William Poyntell, Robert Gilmor, Jr., Thomas Jefferson Bryan, and James Jackson Jarves. William Poyntell is virtually unknown today; the others are usually associated with Old Master paintings, but they all owned some works of medieval art.

William Poyntell (1756–1811)

William Poyntell is a significant figure in the history of American collecting of medieval art, because he appears to be the earliest American to make a conscious effort to collect works of art from the Middle Ages. Moreover, the works he acquired, though few in number, are of the highest quality: magnificent stained glass panels, three of which are in the Philadelphia Museum (Fig. 1).[2] These medallions (c. 1246–48) from King Louis IX's Sainte Chapelle, and therefore representative of the best thirteenth-century Parisian Gothic, came to the museum from descendants of William Poyntell.[3] Born in Oxfordshire, Poyntell immigrated to America before the Revolution, became partner in a Philadelphia stationery firm by 1779, and by 1781 was the owner of his own shop.[4] Besides stationery he sold books and wallpaper, as did many other stationers and booksellers in eighteenth-century America. By 1790 he was manufacturing wallpaper, and it is for this that William Poyntell is best known today.[5] By 1800 he was very well off. But Poyntell was more than an industrious merchant; he had artistic and intellectual interests as well.

In 1803 he founded the Classic Press, intending to publish "a complete edition of all the Greek and Latin classics most

generally in use . . . [so as to] invite an increase of that taste for the study of the best authors of antiquity, now so fondly cherished in the United States."[6] In that same year, he also engaged in scientific experiment of a sort, the results of which he presented before the American Philosophical Society in a paper entitled "Thermo-metrical Journal of a Voyage from the Downs towards the Capes of the Delaware"[7] In 1805 Poyntell's name was among the seventy-one signers of the founding charter of the Pennsylvania Academy of Fine Arts. In 1806, when the Academy met to choose its first board of directors, William Poyntell was among the twelve elected, remaining on the board until his death.[8] Many of the most notable citizens of Philadelphia marched in his funeral procession, among them the president and directors of the Academy of Fine Arts and the governor of Pennsylvania.[9] His tomb, elegant and substantial, stands in the yard of St. Peter's Church, among the graves of Chews and Biddles, Philadelphia's elite. Indeed, one might call Poyntell a prime example of the great American success story.

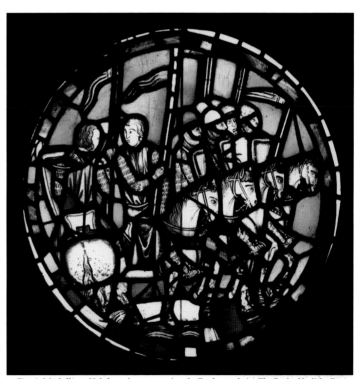

Fig. 1. Medallion, *Holofernes' army crossing the Euphrates* from *The Book of Judith,* Paris, Sainte Chapelle, 1246-1248. Stained glass. (Philadelphia Museum of Art, Given by Mrs. Clement Biddle Wood in Memory of her husband.)

Poyntell's will states, "I give and bequeath to my son in law Robert A. Caldcleugh all my stained glass which I brought from Europe excepting only two pieces thereof which my son William may make choice of"[10] Besides the three medallions in Philadelphia, only one other fragment is known today, a lancet also from the Sainte Chapelle, in a private collection, but there may have been more.[11] As for the date of purchase, it can be ascribed with some certainty to 1803. In that year a large portion of the stained glass in the Sainte Chapelle was removed by Napoleon, and in that same year Poyntell was on the Continent where, according to his obituary in the

Fig. 2. Page from a Bible, England, c. 1250. (Princeton University Library, Garrett MS, fol. 224 recto)

Gentleman's Magazine, he "collected many relicks of antiquity, and specimens of the fine Arts."[12] No matter the particulars of the purchase, thirteenth-century stained glass seems a remarkable thing for an American to have bought in 1803. What did Poyntell, classicist that he was, want with medieval stained glass? His successful career in business indicates that he was a pragmatist rather than a Romantic, and his comments on medieval art in the letters he wrote home from Europe bear this out. But he did display an interest in the medieval monuments he encountered on his travels, and he did love books, and perhaps that gives us a clue: it may be that Poyntell intended to install the glass in a "Gothic" window in his library, following the late eighteenth-century English fashion epitomized by that trendsetter of the Gothic Revival, Horace Walpole. The wording of Poyntell's will implies that the glass was loose, but as he died only a few years after its purchase, he may have had plans for the installation of his glass that he was not able to execute.

Robert Gilmor, Jr. (1774–1848)

The second collector, Robert Gilmor, Jr., was born in Baltimore, the son of a Scotch emigré who had made a great fortune in America.[13] His education included some months at a French school in Amsterdam followed by Mr. Ireland's Academy on the Susquehannah. After working for a short time in his father's firm, he went on a Grand Tour of Europe, from 1799 to 1801. Upon his return, Gilmor, by then something of a connoisseur, devoted his leisure time to the buying and selling of works of art. Although he collected for his own enjoyment, he hoped that his books and art would one day enrich a museum and library. Unfortunately, Gilmor's collection had to be dispersed at his death. In spite of this, a number of his paintings have been identified, as well as two medieval illuminated manuscripts: a Book of Hours, by an early fifteenth-century follower of the Boucicaut Master, bought in Charleston in 1807 at the time of his marriage (Cat. 9); and a Bible, now at Princeton, produced in England in the mid-thirteenth century, which Gilmor acquired in 1832 (Fig. 2).[14] It is not known from whom Gilmor bought his Book of Hours, which he described as "splendidly illuminated," nor how long it had been in America before 1807. Attempts to trace it to any antiquaries or booksellers in Charleston have thus far proven unfruitful. Gilmor spent some months in Charleston in 1807 before his marriage to Sarah Reeve Ladson, a native of the city, and may perhaps have acquired it privately from one of the social acquaintances he made there at the time.

The Princeton Bible we know more of, thanks to a now lost flyleaf on which Gilmor related the circumstances of its acquisition:

> This manuscript bible was purchased for me by Mr. O. Rich, Bookseller in London for £4.14.6 from the collection of J. & A. Arch according to their catalogue of miscellaneous books for 1830 which it is marked "no. 259. Biblia Sacra Latina, MS. upon vellum beautifully written with 70 curious illuminated capitals,". . . Baltimore 10 Feb 1832 . . .[15]

Thus, Gilmor faithfully records what he knows of the provenance of his Bible, telling us that he specifically commissioned Rich, a Bostonian diplomat who doubled as a bookseller, to buy it for him, but he does not reveal what attracted his eye in Arch's listing. Was it perhaps the "70 curious illuminated capitals?"

Gilmor's taste was varied. His art collection was of higher quality than other contemporary American collections, and he was continually upgrading it. His correspondance of the 1830s and 1840s with fellow collector Charles Graff of Philadelphia gives a good idea of Gilmor's constant alertness to what was available on the art market.[16] Although Gilmor's collection was a mixture of Old Master and American paintings, it also included a few Greek vases. We cannot identify anything as medieval other than the twelve manuscripts, but further indication of his affinity for the Middle Ages comes in a letter written by Horatio Greenough during a stay at Gilmor's house in Baltimore in 1828, which paints a good picture of the collector's cabinet:

> I work in Mr. Gilmore's [sic] library, finished in the Gothic style receiving the light through a painted window. The air of art is round me. Exquisite pictures of Italian and Flemish masters fill the compartments between the bookcases; books of prints load the side tables; little antique bronzes, heads, and medals crowd each other on the mantel-piece.[17]

Thus, like Poyntell and Walpole before him, Gilmor had a "painted window," perhaps new, perhaps medieval.

How can we explain Gilmor's appreciation of medieval art? His fifty letters written from Europe to his younger brother, William, between March 31, 1800, and March 20, 1801, show a constant interest in medieval architecture.[18] As early as Letter One, during a change of horses, Gilmor and his companion entertained themselves by walking around Canterbury Cathedral, a "venerable pile."[19] Throughout Europe, Gilmor eagerly visited medieval buildings, even climbing up the spire at Strasbourg.[20] He included medieval ruins among the landscapes he chose to draw for his brother, such as the views of the monastery at Egmont-binnen and the castle at Egmont-op-den-Hoef in northern Holland (Fig. 3). Gilmor described the scene:

A Short ride brought us to the village of Egmont-Binnen, where we stopped a short time to examine and admire the ruins of a fine old monastery, the tower of which now only remains, tottering, and decayed. This is of stone, and in the truly Gothic Style, being the only thing of the kind I have witnessed in this country. I sat down to draw it, and was soon surrounded by the peasants of a neighbouring cottage, whose curiosity led them to see what I could be about, and plagued me exceedingly with their questions and [observations?]. Near the tower is an old brick church or abbey, now in ruins, and which with the ruins of the monastery, forms an interesting picture.

This tower belongs to the Lord of the manor (who was so before the revolution) whose chateau is near the place. He has lately sold it for the enormous sum of twelve thousand florins, and it is to be pulled down to make lime, the stones being of that kind which answers the purpose, and are very valuable since the war has prevented the same kind being brought down the Rhine from Germany.

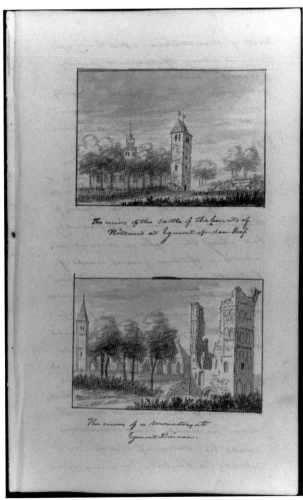

Fig. 3. Robert Gilmor, Jr., *The Ruins of the Castle of the Counts of Holland at Egmont-op-den-Hoef* and *The Ruins of a Monastery at Egmont-binnen*, July 28, 1800. Pen and ink drawings. (Robert Gilmor, Jr., Letterbook no. 2., The Maryland Historical Society, Baltimore)

The gentleman who owned it, has however reserved to himself all the inscriptions, medals, coins and in short everything of the kind, that may be found on its being pulled down. A rude figure upon the entrance, with an inscription shows it was dedicated to St. Peter. . . .[21]

Gilmor also gave a long account of his visit to the Musée des Monuments Français in Paris, with repeated praise for Alexandre Lenoir, founder of the museum.[22] Gilmor's description of Lenoir's museum is elaborate and painstaking, but it gives no indication of any personal reaction to the art itself. Although he applauds the museum as providing an excellent opportunity to study the "rise and progress of the arts," he seems more impressed by it as conducive to meditation, to a "melancholy pleasure." Similarly, Gilmor's descriptions of medieval architecture are larded with expressions—"grandeur," "solemnity," "gloomy," "dim, religious light"—drawn from the vocabulary of a Gothic novel. In sum, Gilmor's perception of the Middle Ages as revealed in his letters from Europe is that of the well-read Romantic.

Gilmor did not appreciate just any medieval work of art, however, as is apparent from the following exchange of letters with fellow collector Charles Graff, of Philadelphia:

Charles Graff to Robert Gilmor, 9 November, 1841
A gentleman stopped me in the street a few days ago to say that a Jew in Baltimore of the name of Simon Etting has a splendid Historical painting in the form of a folding Screen for which he only asked only 30 Dr & that it is worth 150 Dr. Have you seen it [?] he also said that Mr. Etting has Statuary Paintings Diamonds Mineralls & everything else that is Curious
Robert Gilmor to Charles Graff, 9 November, 1841
Mr. Eytinge [Etting] whom you speak of is a jew collector of all sorts of things, which he keeps for sale in a kind of Furniture & curiosity shop. He has one or two tolerable pictures, but not worth your notice. The one you allude to is a gothic shaped picture about 4 feet high which is covered by folding doors which are painted also. It appears to be an old German work, badly painted, & dark, & more curious than beautiful. It has been a church picture for a small altar piece. He asked I think 150 Dr. or more for it—I suspect he would not take anything like 30 Dr. & if he did, I would not myself give it . . .[23]

Thus we see that Gilmor, while obviously attracted by medieval art, remained a careful and discerning buyer.

In light of Gilmor's demonstrated appreciation of the Middle Ages, it is not surprising that Greenough's description of his library calls to mind English Romantic collectors of the late eighteenth century, such as Walpole and William Beckford. Indeed, not many Gothic libraries with stained glass windows are known to have existed in the United States in 1828 (Poyntell's being no more than an unexecuted project, if that). It was not until 1832 that Glen Ellen, considered the first truly Gothic Revival villa in America, was built by Town and Davis, commissioned, interestingly

enough, by Gilmor's nephew and heir Robert Gilmor III (Cat. 6).[24] In sum, Gilmor stood out from his contemporaries by virtue of his purchase of medieval illuminated manuscripts, his housing of them in a Gothic library, and his probable communication of his medievalist tendencies, in architecture if in nothing else, to his namesake.

In fact, Gilmor stands out generally among American art collectors and patrons of his day. It may be that he was not entirely bound by his Americanness. His close ties to the British Isles and to Europe, through his Scotch father, and his own education and extensive travel, may have combined to make Gilmor see himself more as a transplanted English gentleman than an American. Comparison of his letters written during his Grand Tour in 1800–1801 with the journal kept by his nephew during his European tour in 1829 bears this out.[25] Robert Gilmor, Jr., seems to take for granted not only that he inhabits the upper segment of society, but also that his education and connections endow him with certain responsibilities as well as with privileges; he is a serious-minded tourist. Robert Gilmor III, on the other hand, does not appear to seek out monuments of history and art but goes primarily to the most popular tourist sites—he walks across a famous glacier in Switzerland, for example. He also records going to the opera often and to a great number of parties, congratulating himself on hobnobbing with the European nobility. Another indication of the elder Gilmor's view of himself may be supplied by a pair of portraits commissioned in 1818 from the fashionable London painter Sir Thomas Lawrence.[26] Not only were these paintings among the most expensive in Gilmor's entire collection, long considered the finest Lawrence portraits in America, but also it was an unusual choice of artist for an American to make. To understand Gilmor thoroughly as a collector, we should look at influences acting on him on both sides of the Atlantic.

Thomas Jefferson Bryan (1802–1870)

Like Gilmor, Thomas Jefferson Bryan also inherited a great deal of money, and after graduating from Harvard in 1823 he went to Europe, where he lived for nearly thirty years.[27] When he returned to the United States around 1850, he brought with him a collection of some 230 paintings, which he believed illustrated "the rise and progress of each of the great schools of painting . . . in all the stages of their development."[28] These works he hung in his New York house in three large rooms, which he opened to the public in 1852 as "The Bryan Gallery of Christian Art," with a catalogue written by the journalist Richard Grant White and notations on individual paintings by Bryan. White tells us in

the preface that "Mr. Bryan has bought and cleaned his pictures himself; and of those which he thus laboriously brought to light, he has rejected six for every one which now hangs upon his walls"; and further, that it was Bryan's aim "to collect a gallery which should not only give pleasure to casual visitants, but afford efficient aid to the student of the history of Art."[29] Bryan believed that the United States should have a national museum and had formed his collection with that in mind. Upon his first return from Europe, he offered to give his collection to the city of Philadelphia, but his offer was declined.[30] He then opened his gallery in New York, hoping to "awaken a general interest in art among his countrymen."[31]

What did Bryan's gallery have that was medieval? Nothing, strictly speaking, if we disqualify trecento paintings. But he had some works that he believed to be pre-Giottesque, for example the Madonna and Child with saints that he attributed to the thirteenth-century Tuscan painter, Guido of Siena (Fig. 4).[32] He also had a smaller Madonna that he thought was by Cimabue.[33] His "Guido," a splendid panel painting over six feet high, is now considered the finest Nardo di Cione in America, while his "Cimabue" is attributed to Giovanni Bonsi, another mid-fourteenth-century Florentine.[34] The fact that Bryan's attributions do not hold today is not surprising, given the general state of expertise at the time. The attributions were not always Bryan's anyway. For his "Guido" and his "Cimabue," he was following the attributions of the man from whose collection he had acquired most of his early Italian paintings in the 1840s—a French diplomat named Artaud de Montor (1772–1849), who had bought his paintings in Italy at the very beginning of the century when the upsets of the Napoleonic wars forced Italian religious institutions to literally dump thousands of altarpieces and other works of art on the market. Artaud published his collection in 1808 in *Considérations sur l'état de la peinture en Italie*.[35] The fourth edition, complete with engravings such as the one of the "Guido" seen here, appeared in 1843 and amounted to an illustrated catalogue of his collection, with the result that it was one of the most famous of its day in Paris.[36] Not long after, Bryan bought a chunk of it, surely believing that he was obtaining the best available, happily buying some of Artaud's very earliest paintings, what were then called "primitives." Bryan's catalogue refers to Guido of Sienna and Cimabue as "the first to raise the art of painting from the depths to which it sunk in the dark ages," and describes the "Guido" panel thus: "The figures are formal and the heads tame; but there is an expression of infantine sweetness in the face of the child . . . [it is] worked in the highest style of the painter's epoch." Bryan's note appended

to the entry remarks that "The picture is in perfect condition, and is from the renowned collection of M. Artaud de Montor, in the account of which it is engraved."[37]

It would be worth while to look further into Bryan's Paris contacts, to learn how he became interested in Old Master paintings and acquired a taste for "primitives." His brief comments in the companion guide indicate that he had a discerning eye, as White is at pains to tell us, but little first-hand information has turned up. Besides his early Italian paintings, Bryan's collection included a wide selection of

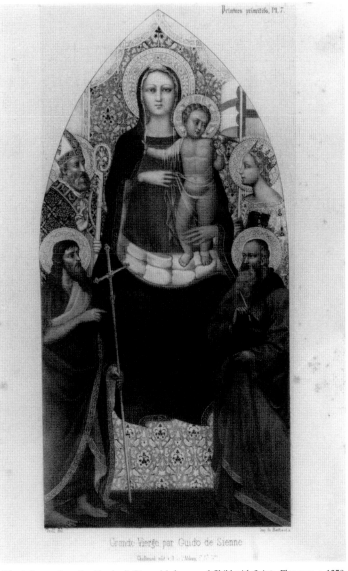

Fig. 4. Engraving after Nardo di Cione, *Madonna and Child with Saints*, Florence, c. 1350. (Artaud de Montor, *Peintres primitifs*, Paris, 1843, pl. 7)

European paintings. They are of varying quality, as he was well aware, but there is nothing embarassingly awful or posing as something far grander than it is, although there have been many changes of attribution. Although Bryan bought American paintings as well as Old Masters, we can assume that, like Gilmor's, his taste was primarily formed in Europe.

James Jackson Jarves (1818–1888)

James Jackson Jarves is well known today, due to his own numerous writings, widely read in his day, and to the fact that his collection is still intact in the Yale University Art Museum.[38] He has also been the subject of a biography.[39] Son of a prominent Boston industrialist, Jarves settled in Florence in the 1850s. There, under the influence of his friend John Ruskin and within the circle of Anglo-

American expatriate artists and writers, including Robert and Elizabeth Barrett Browning, Jarves amassed a collection of early Italian paintings.[40] In a letter to his friend Charles Eliot Norton written from Florence in 1859, Jarves tells of his motive in acquiring his collection:

> It has long been a pet scheme of mine to initiate in Boston a permanent Gallery of paintings, with particular reference to the chronology, motives and technical progress of Art, from the earliest development in Italy of the Christian idea, until its climax in the matured genius of its several illustrious schools. Masterpieces it was hopeless to expect to secure. Researches, however, . . . showed me that it was possible for me to get together a valuable collection of pictures covering the ground from the Xth to the XVI c., characteristic of the great masters and their schools.[41]

Within Jarves's collection of some 120 Italian paintings, several are now attributed to the thirteenth century. One of these, a mid-century work of the Florentine school, was

Fig. 5. "Magdalen Master," *Madonna and Child with Saints*, Florence, c. 1270. (Yale University Art Gallery, University Purchase from James Jackson Jarves)

attributed by Jarves to Margaritone d'Arezzo and described in the same letter to Norton as "perfect—naive and curious" (Fig. 5).[42] Jarves also tells Norton of his "adventures" in securing his collection, which "involved an inquisition into the intricacies of numberless villas, palaces, convents, churches and household dens all over this portion of Italy," as well as "miles upon miles of wearisome staircases, dusty explorations of dark retreats, dirt, disappointment, fraud, lies and monies often fruitlessly spent." Jarves, as mentioned earlier, was strongly influenced by Ruskin in his decision to focus on Italian Primitives. Indeed, *Art Hints*, Jarves's first book on Italian paintings, was referred to by one American critic as a "dilute adaptation" of Ruskin.[43] What is especially interesting in Jarves's case is the public's reaction to his collection when it reached the shores of America. It is to this, more specifically the public's reaction to the medieval works owned by these four collectors, that we now turn.

Public Perceptions of Medieval Art

William Poyntell's stained glass apparently was not exhibited to the public until the twentieth century. As for Gilmor, we have no record of any public reaction to his medieval manuscripts. We do know that he was esteemed by his contemporaries as a collector and patron of the arts, and that in 1834 William Dunlap listed the paintings in Gilmor's collection in his *History of the Rise and Progress of the Arts of Design in the United States*.[44] For Bryan we are fortunate in that Henry James records the reactions produced by a visit to the Gallery of Christian Art in *A Small Boy and Others*, autobiographical reminiscences of his childhood. James was greatly disappointed by the "worm-eaten diptychs and triptychs, the angular saints and seraphs, the black Madonnas and obscure Bambinos."[45] At the time of writing in 1912, James looked back on this visit as having "cast a chill," a "grey mantle" over his appreciation of primitives, which he had not yet shaken off some sixty years later. Indeed, James accuses Bryan's collection of giving an "ugly twist" to the very name of Italy. Moreover, James adds that Bryan's collection was "presently to fall under grave suspicion, was to undergo in fact fatal exposure" as consisting mainly of fakes and frauds. I have not found any record of this, however, and although the general public did not come to drink at the well as Bryan had hoped, artists went there to study and copy the paintings, and educated people did occasionally drop in.[46] Perhaps James's virulence was merely an attempt to excuse his boyhood revulsion towards a form of art that he later knew to be much appreciated. In any case, frauds or not, the gallery was not a great success. Even the autobiography of

Edward Cronin, an artist who worked at the Bryan Gallery as a young man, gives more space to the recounting of an odd tale about Bryan's valet—apparently a woman masquerading as a man—than it does to the collection of paintings that Bryan had so carefully amassed.[47]

Nevertheless, the New-York Historical Society was interested enough to accept the contents of the gallery as a donation in 1864. The rest of Bryan's collection, more than three hundred paintings *in toto*, was to come to them after his death, with the promise to exhibit the paintings suitably and to keep the collection intact on pain of forfeiture.[48] Strangely, something of a stigma clung to Bryan's paintings long after his death. Not only did Henry James disparage them, but also historians as late as the 1950s continued to refer to Bryan's collection as "purchased with a lavish hand if not always what we would now consider discriminating taste."[49] As a final insult, the New-York Historical Society has largely dispersed the collection through auctions in 1971, 1980, and 1995.[50] Only Edith Wharton, in *False Dawn*, her novelette set in the 1840s and based in part on Bryan's story, shows an appreciation of what he was trying to do.[51] Wharton's hero, Lewis Raycie, who was sent to Italy by his father to buy Old Masters, comes back with a collection of Primitives and is disinherited for bringing home rubbish. On his own, then, he opens the Gallery of Christian Art because he feels ardently that his paintings must be made known to the public. But like the real New York public, the public in Wharton's book comes only at first out of curiosity and eventually ceases to come at all. Fifty years later, at the end of the story, the paintings emerge from an attic to be acclaimed as "one of the most beautiful collections of Italian Primitives in the world."[52]

That last sentence does not strictly apply to Bryan's collection but more closely describes that of Jarves, and it is likely that Edith Wharton combined elements from the lives of both Bryan and Jarves in constructing her story. Like Bryan's paintings, Jarves's also failed to be appreciated by the American public when they were first displayed in 1860, receiving from the New York press the damning description of "pre-Giottesque ligneous daubs."[53] Unlike Bryan, who could afford to give his collection to the New-York Historical Society, Jarves needed to sell his paintings. As can be expected, he had trouble finding a buyer, and finally in 1867 deposited them at Yale College in return for a loan of $20 thousand. When the loan fell due, Jarves could not pay, and so the pictures were sold "en bloc." The sale took place in Boston, attracting no buyers other than Yale itself, which offered only what it was due from Jarves, far less than the $68 thousand he was reputed to have

spent in building up the collection.[54]

Why did the American public react so negatively to the collections of Bryan and Jarves? Historians of American culture and taste have pointed out the ambivalent attitude of Americans to art. On the one hand, art was good because it was educationally and morally uplifting. On the other hand it was "dangerous" because it entailed "discriminations of taste, wealth, consumption and opinion."[55] The Middle Ages, too, suffered from an ambivalent attitude on the part of Americans, who considered it Romantic and sometimes even morally uplifting in a Puginesque way, but also dangerous because of its associations with Catholicism and feudalism, both of which were deemed undemocratic.[56] Although by the 1870s the educated American, under Ruskin's influence, might have acquired a taste for medieval styles, even in these restricted circles the conversion was only partial. Virtually nobody seems to have entertained the notion of including any authentic medieval art in their Romanesque and Gothic Revival houses. In fact, although Gothic Revival houses from A.J. Downing's cottages onward may have had Neo-Gothic furnishings, Romanesque was reserved for the exterior of buildings, not their interiors—neither Downing nor H.H. Richardon prescribed that Romanesque Revival houses be filled with furniture of the Romanesque style.[57]

Indeed, European art in general suffered from negative associations, and many Americans preferred art of the homegrown variety. An example of a more typical American collection of the 1830s is fortunately preserved in the Luman Reed Collection, now in the New-York Historical Society.[58] A sampling from Reed's collection shows a preference for American art, especially landscapes and sentimental and historical subjects, such as George Flagg's *Lady Jane Grey Preparing for Execution*, while European art was restricted to copies of the most famous paintings on the tourist itinerary. As late as the 1880s, sentimental and historical paintings by contemporary artists, such as Cesare Detti's *Departure for the Christening*, continued to be the preferred items in American collections; Americans were still conservative buyers on the European market.

A case in point is William H. Vanderbilt (1821–1885), the richest man in the United States at the time of his death. In the early 1880s, Vanderbilt built a palatial house at 640 Fifth Avenue with interior furnishings designed under the direction of the firm of Herter Brothers.[59] Not long after its completion, these interiors were made visible to the public

in a lavish series of folios, entitled *Mr. Vanderbilt's House and Collection*.[60] The introduction by Edward Strahan sets the tone for the entire publication and tells the reader how the author, a contemporary, feels this house should be viewed within the context of the time. As an example of late nineteenth-century "boosterism," as well as of American attitudes to art at that time, it is worth quoting at length:

> Like a more perfect Pompeii, the work will be the vision and the image of a typical American residence, seized at the moment when the nation began to have taste of its own, an architecture, a connaisseurship [sic], and a choice in the appliances of luxury, society, culture . . . [This]comes at the right moment, prompt and opportune, when wealth is first consenting to act the Medicean part in America, to patronize the inventors, to create the arts, and to originate a form of civilization. The country, at this moment, is just beginning to be astonishing. Re-cemented by the fortunate result of a civil war, endowed as with a diploma of rank by the promulgation of its centenary, it has begun to re-invent everything, and especially the house . . .[61]

There follows an apologia for eclecticism, which should "try, by melting all styles into its crucible, to hit upon something new."[62] Strahan goes on to praise the exterior of the house, whose generally Renaissance aspect includes some Gothic elements, as "no bad preparation for the mixture of treasures from every earthly clime which must find place within a civilized modern house."[63] Indeed, the interior architecture, furniture, and wall coverings represent an extreme eclecticism, juxtaposing a wide variety of styles with a kind of "horror vacui," which leaves no surface without some pattern painted, carved, etched or printed upon it.

Vanderbilt's art collection as published in these folios consists primarily of nineteenth-century academic paintings. While some of the artists represented (Detti, for example) might today be dismissed as third-rate, others, such as Rosa Bonheur or Alma-Tadema have experienced a turn of fortune in recent years, and still others, such as Corot, Millet, Turner or Delacroix, are usually ranked among the greatest of their century. There are no works by Impressionists or other avant-garde artists in the collection, however, which for the most part illustrates Neil Harris's observation, that "Europe's prosaic and conventional remained exciting to the visiting American."[64]

Among Vanderbilt's works of art, there is one medieval object, an ivory casket, represented in Strahan's view of the Japanese Parlor, where it sits on a shelf along the right wall. The casket is represented in detail in another of the book's plates with an accompanying text that describes it

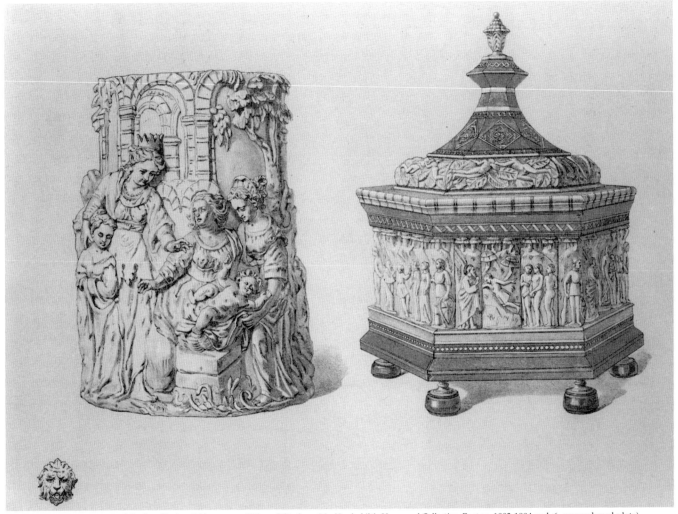

Fig. 6. On the right, Hexagonal Casket, Venice, 14th century. (Edward Strahan, *Mr. Vanderbilt's House and Collection*, Boston, 1883-1884, vol. 6. unnumbered plate)

as "in the Italian taste of the Giotto period," with marquetry work that "reflects the elegance of Giotto's campanile" (Fig. 6).[65] The placement of the Gothic casket in a so-called Japanese room is explained by the author in the following way:

> Under this sheltering roof made up of Eastern fancies, the apartment is found to be a perfect cabinet of Oriental rarities, more distinctly a collector's treasury than any room in the house, and so furnished and appointed as to give the valuables contained in it their most becoming setting. . . . The curiosities which find a shelter in this room are of the most varied kinds,—lacquers, cloisonné enamels, bronzes, potteries; as a rule, they are of Oriental origin, as befits the local genius of the place. Objects in ivory are admitted, although carved in Europe—no more appropriate repository being found in the house than the Japanese parlor; we may imagine that the presiding genius has lodged them here

> on account of the Oriental origin of the material; or that, as is often found in a Japanese palace, they have been left by the Dutch traders in exchange for rarities of the country.[66]

Thus, the medieval ivory box is a "curiosity," and is housed in the Japanese parlor, the "perfect cabinet of Oriental rarities." From the illustration and the description, the casket is identifiable as a late fourteenth-century Venetian product of the Embriachi workshop, or of one related to the Embriachi, probably a marriage casket, and therefore made of bone, not ivory. The only work of medieval art illustrated in Strahan's book, it seems to have been the only medieval object in Vanderbilt's collection.[67] In 1883 even the richest man in America had no more than one medieval object, not a hopeful sign for the future of

private collecting in this area.

Medieval art was not well represented in public collections, either, throughout most of the nineteenth century. Where the medieval did appear in museums, it was primarily in the structure itself, as was the case for the first buildings of the Boston Museum of Fine Arts and the Metropolitan Museum of Art in New York, both examples of Ruskinian Gothic; or else it was in the form of plaster casts and models.[68] Until some years after 1900, real medieval art in public collections remained a rarity, often odd or coincidental, the result of a stray bequest.[69]

There is still room for further inquiry into the motivations of the collectors we have looked at here, but I think we can ask at this point whether there is any common characteristic that informed their collecting. What made them interested in medieval art at a time when other Americans were not? Whatever else they might share, one thing that stands out is their extensive European experience. They all spent a lot of time in Europe, either in their formative years or as adults. Interestingly, the same would later be true of Isabella Stewart Gardner, J.P. Morgan, Henry Walters, and George Grey Barnard. I do not think this is merely a coincidental fact. Rather I believe this extended time in Europe taught them to regard medieval art in a different light than their compatriots. Not only were they familiar firsthand with European monuments and the historic position of the medieval period in the "rise and progress of the arts," but also they could participate in the widespread interest among Europeans in the art of the Middle Ages. Moreover, except for William Poyntell who made his own fortune, they all inherited large sums of money, and would, from childhood on, have been aloof from the American populace and its anti-European attitudes. Thus, escaping many of the negative associations that clung to medieval art in the minds of most Americans, they could be receptive to its peculiar charm.

By way of a postscript, let us return to William Poyntell. Although his transporting of medieval stained glass to America in 1803 might appear remarkable, perhaps we should not consider it so. Poyntell's collecting was in no way the act of an eccentric but of a useful citizen of Philadelphia. Among the wealthy collectors described here, Poyntell alone was deeply enmeshed in the workaday fabric of American life. And although he was born in England, he adapted himself so thoroughly to his new land that he seems in some way more representative of American culture than that of England, more representative even than our American-born collectors. If he chose to

buy medieval art, it may be because in the heady intellectual environment of those first decades after the establishment of the new nation, Americans had not yet become suspicious of European culture. The art of the Middle Ages, one aspect of that culture, might well have been acceptable, even desirable, in the Philadelphia of William Poyntell. If this was indeed the case, then Poyntell's purchase of medieval glass might, like Poyntell himself, be representative of a short-lived era of informed and ecumenical taste in middle class America, which was not to recur for almost a hundred years and then in very different circumstances.

1. For a discussion of this phenomenon, see A. P. Kenney and L. J. Workman, "Ruins, Romance and Reality: Medievalism in Anglo-American Imagination and Taste, 1750–1840," *Winterthur Portfolio* 10 (1975): 131–63.
2. Philadelphia Museum of Art, 30–24–1, 2, and 3, given by Mrs. Clement Biddle Wood in memory of her husband.
3. M. Caviness, "Three Medallions of Stained Glass from the Sainte Chapelle of Paris," *Philadelphia Museum of Art Bulletin* 62 (July-Sept. 1967): 245–59; M. Harrison-Caviness and L. Grodecki, "Les vitraux de la Sainte-Chapelle," *Revue de l'Art* 1-2 (1968): 13–6; Madeleine Caviness et al., *Corpus Vitrearum Checklist, Stained Glass before 1700 in American Collections,* vol. 2 (Washington, D.C., 1985-1991), 148–49.
4. "Memoirs of the Late William Poyntell, Esq. of Philadelphia," *Gentleman's Magazine* 82, no. 2 (1812): 294–95; H. G. Brown and M. O. Brown, *A Directory of the Book Arts and Book Trade in Philadelphia to 1820* (New York, 1950), 97–8. Additional biographical information is in notes attached to "Samuel Relf, Collected Correspondence," MS 81-11-71, microfilm, State Historical Society of Wisconsin, Madison.
5. H. L. Hotchkiss, Jr., "Wallpaper from the Shop of William Poyntell," *Winterthur Portfolio* 4 (1968): 26-63.
6. Julius Caesar, *C. Julius Caesar, quae extant, interpretatione et notis illustravit Johannes Godvinus . . .* (Philadelphia, 1804), i. On the Classic Press, see also T. Westcott, *A History of Philadelphia,* vol. 4 (Philadelphia, 1886), 1050; and William Poyntell to William Woodward, November 17, 1803, manuscript, The Library Company, Philadelphia.
7. "Thermometrical Journal of a Voyage from the Downs towards the Capes of the Delaware on board the ship Three Sisters, Capt. Smith, by Willm Poyntell, London to Philadelphia, June 26 1803–Aug 20 1803," manuscript, American Philosophical Society, Philadelphia. Poyntell's presentation is recorded in "Minutes from 1743-1838," *Proceedings of the American Philosophical Society* 22, no. 3 (1885), 343.
8. *The Collected Papers of Charles Willson Peale and His Family,* ed. L. B. Miller (Washington D.C., 1980) microfiche, IIA/37 C11-D6, F 1-2; VIA/2E5. See also J. Jackson, *Encyclopedia of Philadelphia,* vol. 1, (Harrisburg, 1931-1933), 5.
9. "Memoirs of the Late William Poyntell," 295; and obituary, *Relf's Philadelphia Gazette & Daily Advertiser,* Sept. 10, 1811.
10. Will no. 94, 1811, Archives, Philadelphia City Hall. A copy of the will also exists in the Pennsylvania Historical Society, Philadelphia.
11. Harrison-Caviness and Grodecki, "Les vitraux," 15–16.
12. "Memoirs of the Late William Poyntell," 294.

13. The basic study of Gilmor remains A. W. Rutledge, "Robert Gilmor, Jr., Baltimore Collector," *The Journal of the Walters Art Gallery* 12 (1949), 19-39. For biographical information, see also Robert Gilmor, Jr., "Printed memoir of Robert Gilmor, Sr., annotated by Robert, Jr., c.1840," and "Family memoranda booklet, 1813, with notes on Robert, Jr.'s friends and relatives, personal and business items," Robert Gilmor, Jr., Papers, MS 387, Maryland Historical Society, Baltimore.

14. On Gilmor's Book of Hours, see S. Schutzner, *Medieval and Renaissance Manuscript Books in the Library of Congress* , vol. 1 (Washington, 1989), 339-44. For his Bible, now Princeton MS Garrett 28, the best study is A. Bennett, "The Place of Garrett 28 in Thirteenth-Century English Illumination," (PhD. diss., Columbia University, 1973).

15. Quoted in full in Bennett, "The Place of Garrett 28," 5.

16. Gilmor/Graff letters, Metropolitan Museum of Art, New York.

17. *Letters of Horatio Greenough to his Brother, Henry Greenough*, ed. F. B. Greenough (Boston, 1887), 36.

18. Gilmor Letterbooks, Robert Gilmor, Jr. Papers, MS 387, Maryland Historical Society, Baltimore.

19. Robert Gilmor, Jr., to William Gilmor, Letter One, Mar., 31, 1800, Gilmor Letterbook 1.

20. Robert Gilmor, Jr., to William Gilmor, Letter Twenty-Five, Oct., 3, 1800, Letterbook 2.

21. Robert Gilmor, Jr., to William Gilmor, Letter Twenty, July, 28, 1800.

22. Robert Gilmor, Jr., to William Gilmor, Letter Six, May 23, 1800.

23. Gilmor/Graff letters, Nov. 9, 1841, Metropolitan Museum of Art, New York. I am grateful to Lance Humphries for calling my attention to these passages.

24. For a recent study of Davis and his work, see *Alexander Jackson Davis, American Architect, 1803-1892*, ed. A. Peck (New York, 1992).

25. Robert Gilmor III, "Journal of travels in Europe, 1829-1830," Robert Gilmor, Jr., Papers, MS 387, Maryland Historical Society, Baltimore. See, for example, the entry for Feb. 17, 1830.

26. Rutledge, "Robert Gilmor, Jr.," 26.

27. R. W. G. Vail, *Knickerbocker Birthday, A Sesqui-Centennial History of the New–York Historical Society 1804-1954* (New York, 1954), 126–28; and A. Blaugrund and R. J .M. Olson, "The History of the Thomas Jefferson Bryan Collection," exhibition leaflet, n.d., New–York Historical Society (hereafter, NYHS).

28. T. J. Bryan, *Companion to the Bryan Gallery of Christian Art . . ., with an introductory essay, and an index by Richard Grant White* (New York, 1853), iv.

29. Bryan, *Companion*, v–vi, ix.

30. R. Lynes, *The Tastemakers* (New York, 1980), 42.

31. [D. E. Cronin], "An Old Picture Gallery," *The World* (New York), August 18, 1878.

32. NYHS 1867.3. As of Jan. 1995, this painting entered the collections of the Brooklyn Museum (see n.50).

33. Formerly NYHS 1867.4. Sold at Sotheby–Parke Bernet Inc., New York, Oct. 9, 1980, lot no. 92, present whereabouts unknown.

34. R. Offner, *A Corpus of Florentine Painting*, (New York, 1960), vol. 2, sec. 4, 67-69; M. Boskovits, *Pittura Fiorentina alla vigilia del rinascimento 1370–1400* (Florence, 1975), 31, 320.

35. M. le Chevalier Artaud de Montor, *Considérations sur l'état de la peinture en Italie dans les quatre siècles qui ont précédé celui de Raphael* (Paris, 1808, 1811, 1825). On Artaud de Montor, see G. Previtali, *La Fortuna dei primitivi: Dal Vasari ai neoclassici*, 2nd ed. (Turin, 1989), 177–79, 221–22.

36. M. le Chevalier Artaud de Montor, *Peintres primitifs, collection de tableaux rapportée d'Italie* (Paris, 1843). Previtali, 221, suggests that Artaud's publications may in fact have made his collection more famous than it deserved to be on the basis of its intrinsic quality.

37. Bryan, *Companion*, 5–6.

38. His publications include *Art Hints* (New York, 1855), and *The Art Idea* (New York, 1862). On Jarves's collection, see C. Seymour, Jr., *Early Italian Paintings in the Yale University Art Gallery*, (New Haven, 1970).

39. F. Steegmuller, *The Two Lives of James Jackson Jarves* ,(New Haven, 1951).

40. Ibid., 112–34.

41. Ibid., 171. The following quotes are from the same letter, which Steegmuller gives in its entirety.

42. Yale University Art Gallery 1871.3.

43. Steegmuller, *Two Lives*, 150–51.

44. W. Dunlap, *History of the Rise and Progress of the Arts of Design in the United States*, vol. 2 (New York, 1834), 459–61.

45. H. James, *A Small Boy and Others* (New York, 1913), 268–69.

46. [Cronin], "An Old Picture Gallery."

47. [D. E. Cronin], *Memoirs of Major Seth Eyland* (New York, 1884), 37–47.

48. Bryan papers, Indenture between Bryan and the NYHS, March 1864, Manuscript Department, NYHS.

49. Lynes, *Tastemakers*, 42.

50. The first sale took place at Parke Bernet on Dec. 2, 1971; the others were at Sotheby-Parke Bernet on Oct. 9, 1980, and Sotheby's on Jan. 12, 1995.

51. E. Wharton, *False Dawn* (New York, 1924).

52. Ibid., 137.

53. Steegmuller, *Two Lives*, 181. For a full account of the public's reaction to Jarves's paintings, see 164–95.

54. The situation is outlined in detail in Steegmuller, *Two Lives*, 226–61.

55. N. Harris, *The Artist in American Society: the Formative Years 1790-1860* (New York, 1966), viii.

56. For a full account of the development of anti-Catholic and anti-foreign feeling in the United States, see R. A. Billington, *The Protestant Crusade 1800–1860* (New York, 1938).

57. For a discussion of A. J. Downing and the Gothic Revival in America, see below Cat. 7 and 8.

58. E. Foshay, *Mr. Luman Reed's Picture Gallery: A Pioneer Collection of American Art* (New York, 1990).

59. K. S. Howe, A. C. Frelinghuysen, and C. H. Voorsanger, *Herter Brothers: Furniture and Interiors for a Gilded Age* (New York, 1994), 200.

60. E. Strahan, *Mr. Vanderbilt's House and Collection*, 10 vols. (Boston, 1883–4).

61. Ibid., vol. 1, v.

62. Ibid., vii.

63. Ibid., 4–5.

64. N. Harris, *The Artist in American Society*, 168.

65. Strahan, *Mr. Vanderbilt's House*, vol. 6, 73.

66. Ibid., 61, 65.

67. I have not been able to ascertain how and where Vanderbilt acquired the casket. It remained in his house until the contents were dispersed by auction in May 1945. The Parke Bernet sale catalogue no. 678 lists it as "Lot #345. Embriachi Work. Ivory and Tortoiseshell Hexagonal Casket. Venetian Gothic." The casket sold for $125; its present whereabouts are unknown.

68. See below, K. McClintock, "The Earliest Public Collections and the Role of Reproductions."

69. See Cat. 13-18 for examples of early medieval acquisitions in public collections.

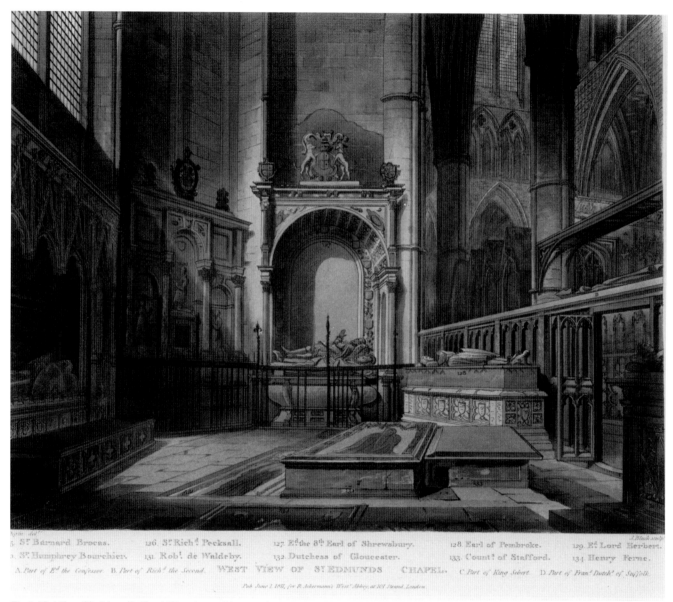

Fig. 1. *West View of St. Edmund's Chapel*, Westminster Abbey, London. (William Combe, *The History of the Abbey Church of St. Peter's, Westminster, its Antiquities and Monuments*, London, 1812, vol. 2, pl. 32)

Medieval Art in American Popular Culture: Mid-Nineteenth-Century American Travelers in Europe

Cheryl Snay

Interest in medieval art was slow to develop in the United States and only gained momentum at the turn of the twentieth century. By this time, Gothic Revival architecture had peaked but was still a popular choice for churches. Isabella Stewart Gardner had amassed a collection of medieval objects in the 1890s and opened her house in Boston to the public in 1903. The Metropolitan Museum of Art in New York had opened its medieval and Renaissance cast galleries in 1896. Universities, such as Princeton and Harvard, included medieval lectures in their academic programs. P.P. Caproni & Brother offered copies of medieval sculpture and architectural decorations available for purchase in their *Catalogue of Plaster Cast Reproductions*. These conditions argue for a tolerance of—if not always an acceptance of—medieval culture and history as aesthetically and culturally valid.

But what were the popular American perceptions of medieval art in the earlier part of the century when collectors, such as William Poyntell, Robert Gilmor, Thomas Jefferson Bryan, and James Jackson Jarves, first began buying illuminated manuscripts, stained glass windows, and Italian "Primitives"—and what shaped those perceptions? In the early nineteenth century, the American reading public's notions of the Middle Ages were formed by the Gothic romance novels of Sir Walter Scott.[1] No longer content just to read about towers and monasteries, Americans began to explore the Old World, provided political and economic factors were favorable. The desire to see the castles and churches, to hold the objects of ivory and precious metals, to try on the armor became increasingly paramount during the first half of the nineteenth century. One author of a travel diary wrote, "If, among the hitherto tarry-at-home travelers, one shall be incited by these pages, himself to go and see, the volume will not have been sent forth in vain."[2] This growing primacy of the object contributed to the interest in collecting medieval objects.[3] As the century progressed, travel writing became increasingly popular and provides one source for American perceptions of medieval art.[4] A sampling of travel books published from 1810–1870 was surveyed to learn about middle class attitudes toward the Middle Ages.[5] Who were the travelers writing these books? Why were they going abroad? What medieval monuments did they visit? How did they respond to them, and why did they respond as they did?

By virtue of having traveled abroad, the writers distinguished themselves from the general population of the United States, but they were of somewhat more modest means than the wealthy collectors about whom we know more. The writers represent a mid-point between the two extremes of social classes. Of the forty-four authors included in this survey, seven were women. One was a teacher; another described herself as "a lady from Virginia"; another, a "spinster." Among those whose occupations were identified, four were professional authors, five were ministers, and two were diplomats. Cornelius Conway Felton was a former president of Harvard University.[6] The occupations of the others have not yet been determined or were not stated in the preface of their books.

Trips to Europe were viewed as educational. Protestant ministers were sent on exchange programs or visited the Continent to see how their ministries compared to those of the Old World and to Catholicism. Authors went to gather new material for books. Women simply went to be educated. After trips abroad, travelers were petitioned by their friends or congregations to publish their journals or letters and to share their perceptions of and reactions to the sites they saw, the people they met, and the customs they witnessed.[7]

The mode of transportation (boats and coaches) and the routes taken between London, Paris, and Rome, the most popular sites, determined which monuments were seen. Most often landing in Liverpool, the typical traveler then proceeded to London then to Dover and on to Calais or Boulogne. Some entered through Portsmouth then went to Le Havre, on to Rouen, then to Paris. Once in Paris they made their way to the Rhône River via Chalon-sur-Saône, then through Lyons, Avignon, and on to Marseilles where they boarded a boat to Rome via Genoa sometimes stopping at Pisa and/or Florence. Some ventured as far south as Naples. They returned through Switzerland and went down the Rhine to Frankfort-am-Main, Cologne, and Strasbourg.

This explains why the medieval monuments of the west and southwest corner of France (Carcassonne, Moissac, Poitou) were virtually ignored by early tourists.[8] They saw the Rouen and Strasbourg cathedrals, the castles of the Rhine, the papal palace at Avignon, the cathedrals at Cologne and Frankfort-am-Main, and Kenilworth and Warwick castles because they were on their way someplace else. Although they did go out of their way to get to Edinburgh and did visit the castle and Holyrood while they were there, they primarily saw the city as the "Athens of the North," so called for its replica of the Parthenon. So the medieval monuments were secondary items on these Americans' itineraries, but the reactions to the monuments are revealing. By comparing and contrasting the comments made about a few sites, perceptions of medieval art become clear.

The clearest articulation of a perception of the Middle Ages by an American—and incidentally the most negative—was made by Mordecai Noah, consul to the city of Tunis for the United States. Comparing the sculpture of the Poet's Corner with that found in some of the chapels in Westminster Abbey (Fig. 1), he wrote:

> The ancient tombs are preposterous and absurd: a whole length figure in marble is stiffly stretched on the summit of each, clad in armour, and a few others with hands elevated in prayer. The cumbrous and inelegant specimens of sculpture convey a just idea of the rude and barbarous taste which prevailed in the darker ages: the modern monuments are light, and several of them finely executed. . . .[9]

Noah indicated by this comment that the mimetic quality of art was highly valued. Because Gothic art lacks the illusionism of "modern monuments" it was indicative of an inferior culture.

Cooper did not share Noah's opinion. The author of *The Heidenmauer or the Benedictines, a Legend of the Rhine* reveled in the abstract quality of the art that invoked the spiritual.

Fig. 2. *The festival of the laying of the corner stone for the continuing of construction, Sept. 4, 1842.*, Cologne Cathedral. (Lithograph after a drawing by G. Osterwald)

Publishing an account of his travels in 1837, he wrote:

> You have seen ivory work boxes from the east, that were cut and carved in a way to render them so very complicated, delicate and beautiful, that they please us without conveying any fixed forms to the mind. It would be no great departure from literal truth, were I to bid you fancy one of these boxes swelled to the dimensions of a church, the material changed to stone, and, after a due allowance for a difference in form, for the painted windows, and for the emblems, were I to add that such a box would probably give you the best idea of a highly wrought Gothic edifice, that any comparison of the sort can furnish.[10]

Conversely, Alfred Huidekoper, another travel author, waxed romantical about the chaotic and uncivilized character of the Middle Ages, evoked by the ruins along the Rhine River:

> . . . that barbaric age whose history was one of rapine and revenge, marred with the feuds, the plots, and counterplots of rival chieftains, with acts of arbitrary power and unrestrained passion; an age when the sword of power settled all knotty questions of propriety, and the ail of the desecrated hamlet was drowned in the bacchanalian festivity which spoke of success.[11]

Although the conception of the Middle Ages is not complete without the image of the knight in shining armor, at least two authors attempted to debunk the myth. Noah was not at all convinced about the bravery and courage of a medieval knight. Upon visiting an armory filled with antique weapons he concluded "there is more true valour in the present system."[12] He saw the gun and cannon as far superior to the sword, shield, and battle axe not only in terms of their efficacy as killing instruments, but also that their use required different and more complex strategies. Cornelius Felton, traveling in Europe in 1853, visited a collection of ancient and medieval arms in Zurich. Since he and his friends were the only visitors at the time, he asked the keeper if he could try on one of the suits of armor. The keeper complied and helped him with the equipment. After describing the general discomfort of the "garment," Felton was glad to have "been born in the present age, rather than in the time of Charles the Bold of Burgundy."[13]

The anti-Catholic sentiment expressed by Protestant ministers is also a clue to what nineteenth-century Americans thought of the Middle Ages.[14] Nicholas Murray, a Presbyterian minister, wrote under the pseudonym of Kirwin. He looked at the cathedrals and churches as evidence of the corruption of Catholicism and the superiority of Protestantism. He related this exchange between himself and a Frenchman while he was in Avignon:

> And there, too, is the old Cathedral by its side, where popes said mass, and then retired to intrigue in the affairs of kings and nations. . . .[he met an old man] "Be you a Catholique?" he again asked. "No," I replied, affecting some surprise, "I am a Protestant; there are not many Catholics in America, save those

who go there from Europe. The religion of Popery does not suit our institutions." With a peculiar shrug of the shoulder, a peculiar accent, which left you in doubt whether he spoke in fun or in faith, he replied, "You do not understand the religion Catholique in Amerique. It suits itself to all the institutions of the world." But America and the world is beginning to understand the "religion Catholique," and to regard it as it deserves.[15]

This dialogue explains his dismal attitude toward Gothic architecture. He saw it as representative of the tainted institution that produced it. About the cathedral of Notre Dame in Paris, he wrote, "It is in many respects a type of Romish church—it lifts itself high—it has much external pretensions, it is dingy and faded—while internally it is empty, and cold and damp."[16] His description of the cathedral in Cologne is equally acerbic (Fig. 2):

> Less than ten of its [Cologne's] eighty thousand inhabitants are Protestants; and hence, as we might expect, the churches abound in miracle-working relics. We issued out to the Dom, as the Cathedral is called, and soon learned its direction by the old crane which yet surmounts the not half-finished tower. As far as it goes, it is the richest specimen extant of the old German architecture. Although six centuries have passed away since its foundations were laid, it is not yet one half completed; and while the stones in some part of it are new, and recently carved and laid, in other portions of it even the stones are crumbling away. In this it is a type of the Papal Church to which it belongs.[17]

To be sure, Murray is the most scathing of the authors in his opinion of medieval monuments and the institutions they represent. Others were taken by the beauty and mystery of the environment created by light filtered through stained glass windows, reliquaries of precious materials, and the music or the sound of whispered prayers. Cornelius Felton provided an illustration of the Romantic concept of the "Beautiful" in his description of Milan Cathedral:

> I walked slowly around this assemblage of wonders, and was compelled to admit that all I had yet seen of the splendor of Christian temples fell below this one most magnificent act of devotion, still unfinished, though already five hundred years in performing. This morning, as soon as I was dressed, I went again to the Cathedral. The sun was streaming through the eastern colored windows, and filling the vast spaces of the interior with a subdued, but rich and splendid light; and hundreds of worshippers were kneeling and repeating their prayers, in different parts of the church. Whether you look up to the lofty and wonderfully curved ceiling, down the lengthening aisles, across the transept—whether you dwell upon the clustered columns, or fretted vault, or painted windows of the apsis—your senses are enchanted and your mind is filled by the vastness of the conception, the matchless beauty of the details, and the wealth of genius with which they have been executed. The Alps are unique, in their way. It is absurd to compare our mountains with them. You feel in the immediate presence of the Almighty as you traverse their mighty passes, or cross their mountain aisles, and look up to the pinnacled heights that bound them. . . . But of all things I have ever seen, the effect of the Milan Cathedral comes nearest to that of one of the great works of God."[18]

Fig. 3. Strasbourg Cathedral. (source unknown)

Strasbourg Cathedral itself was regarded as secondary to the remarkable clock it housed, a must-see for the well-heeled traveler (Fig. 3). But the cathedral was also described as the most distinguished and beautiful of Gothic structures. Felton's wonder at the cathedral in Milan is similar to that of George Calvert in Strasbourg about twenty years earlier:

> These airy Gothic structures, rising lightly from the earth as if they were a growth out of it, look, amidst the common houses about them, like the product of another race. They have an air of inspiration. Their moulds were thoughts made musical by deep feelings. They are the poems of an age when religion yearned for glorious embodiment. They declare the beauty and grandeur of the human mind, that it could conceive and give birth to a thing so majestic. Those high-springing vaults, those far-stretching aisles solemnized by hues from deeply colored windows; those magnificent vistas, under roof; those outward walls, so gigantic, and yet so light with flying buttresses and the relief of delicate tracery; that feathery spire, which carries the eyes far away from earth; so thin, that the whole wondrous fabric, so

huge and graceful, so solid and airy, so complex and harmonious, as it stands there before you, stood first in its large, beautiful completeness in the brain of its architect. . . .[19]

Tourists' reactions to the ruins of secular buildings are equally telling. Huidekoper identified a ruin as ". . . something timeworn, and going into decay, [it] is one of the novel and interesting things to the eye of an American, accustomed alone to the progressive and productive energies around him at home."[20] Perhaps what made the ruins so poignant was the realization that the United States, bounding with "progressive and productive energies" would itself lie in ruin one day.

The transience of life and the futility of power are explicit in a visit to castles. The theme recurs often. Regarding Warwick Castle, Calvert wrote, "There stands the magnificent feudal giant, shorn of its terrors . . . disarmed by Time's transmuting inventions . . . not less a token of present grandeur than a monument of former glories."[21] Such is the underlying sentiment of Thomas Cole's *Past* and *Present* (Mead Art Gallery, Amherst College), painted in the years following his return from a tour of Europe in 1829–32. *Past* depicts an impressive edifice with turrets, towers, and crenellations. In the foreground a tournament is in progress. The pendant piece, *Present*, shows the same castle in ruin; the tournament replaced with grazing sheep and a shepherd.[22]

Samuel Prime had a similar opinion regarding Kenilworth (Fig. 4). "Its huge, sublime, but mouldering towers with ivy overgrown, are signs of former greatness and glory wasted and forgotten, and this is the end of man's mightiest works."[23] Huidekoper was also struck by the poignancy of Kenilworth. During his visit to this site, children were playing near the tower. "The blending of youth and old age, of crumbling ruins and departed grandeur on one side, and rosy-cheeked health and buoyant spirits on the other, presented a picture not easily forgotten."[24]

After describing a castle in Baden-Baden, Felton, with tongue in cheek, launched into a short tale along the lines of a Gothic romance about a fair maid who committed suicide because her father forced her to marry a "grisly old count" when she was really in love with a handsome, brave, young man. He concluded, "Seriously, it is a wonderful old castle, and is worth a hundred histories to give one an idea of the Middle Ages."[25]

Authors, ministers, and educators were not the only Americans to visit Europe. It was common for artists to further their skills and expand their experiences by touring the great centers of European art. Thomas Cole was one such artist. Making his first trip from 1829 to 1832, financed by Robert Gilmor, Jr., a well-known Baltimore art collector, he wrote to his family of his disappointment in the so-called great art. He escaped from the city centers and their moldering museums and academies into the surrounding countryside to sketch. He came back to the United States with notebooks filled with ruined castles, meandering rivers, and rolling hillsides. These he worked into medievalizing commissions including, *The Departure* and *The Return*, 1837 (The Corcoran Gallery of Art, Washington, D.C.), *Past* and *Present*, 1838, and *Romantic Landscape with Ruined Tower*, 1832–36 (Albany Institute of History and Art). He made a second trip to Europe in 1841 and upon his return a year later, he made single nostalgic images of ruined castles in landscapes, such as *The Valley of Vaucluse*, 1841 (Metropolitan Museum of Art); *An Italian Autumn*, 1844 (Walker Art Center, Minneapolis); and *Gothic Ruins at Sunset*, ca. 1844–48 (Kennedy Galleries, New York). These paintings, however, constitute a relatively small portion of Cole's *oeuvre*. He is most noted for his landscapes and his two grand series, *The Course of the Empire*, 1834–36 (New-York Historical Society) and *The Voyage of Life*, 1842 (National Gallery of Art, Washington, D.C.), the former loosely based on classical antique models. It is likely, then, that Cole was more attracted to the ruinous state of the buildings than to their being medieval. Ruined classical buildings served his purposes just as well.

By surveying these travel guides from the nineteenth century, the most one can conclude is that the attitude toward medieval art is diverse. Negative assessments of medieval aesthetics, the corruption of their religious institutions, and the barbarity of their political situation help explain why there was little interest in medieval art during most of the nineteenth century. It makes those collectors who were interested in medieval art all the more remarkable by contrast. Nevertheless, this study also reveals that negative perceptions were balanced by Romantic notions of the sublime and the beautiful. Some authors stressed the profundity and depth of emotion experienced before a cathedral or castle. Writers who were more favorably inclined to the Gothic found in its monuments a serenity and solemnity that was surpassed only by nature. Although inconclusive, this notion may provide a clue as to the motivations of the early connoisseurs of medieval art.

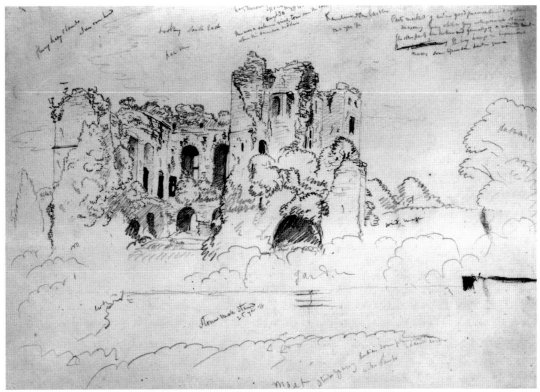

Fig. 4. Thomas Cole, *Study for Ruins of Kenilworth Castle, England*, 1841. Pencil drawing on paper.
(Detroit Institute of Arts, Founders Society Purchase, William H. Murphy Fund)

1. M. Bloomfield, "Reflections of a Medievalist: America, Medievalism, and the Middle Ages," *Medievalism in American Culture*, eds. B. Rosenthal and P. Szarmach (New York, 1989), 14 . Bloomfield defined medievalism as "the idealization of medieval life and culture with emphasis on a rich, mysterious and imaginary world of nobility, honor, class-consciousness, defenders of women, battles and so forth that, it was believed, flourished in the Middle Ages."

2. F. de Wilton Ward, *Summer Vacation Abroad or Notes of a Visit to England, Scotland, Ireland, France, Italy and Belgium* (Rochester, N.Y., 1856), preface.

3. While this notion seems to contradict the practice by museums of collecting plaster casts rather than authentic objects, it can be explained. First, the collectors and viewers did not seem to make a distinction between a reproduction and the orginal object. The reproduction was used as a souvenir, a touchstone, the sight of which triggered a cascade of feelings, memories, and ideas. Second, the *Catalogue of Plaster Cast Reproductions* published by P. P. Caproni & Bros. (Boston, 1901) lists few casts of medieval objects and those are mostly architectural decorations. The collection is dominated by classical and Renaissance sculptures.

4. N. Harris, *The Artist in American Society: The Formative Years 1790–1860* (New York, 1966). Harris's survey of travel guides written during the nine-

teenth century serves as a model for this project, which is narrower in scope.

5. According to Smith, 1,822 travel books were published by Americans prior to 1900. H. Smith, *American Travellers Abroad: A Bibliography of Accounts Published Before 1900* (Carbondale-Edwardsville, Ill., 1969). For this study, seventy sources were identified, though only the most representative and relevant are cited here.

6. W. W. Stowe, *Going Abroad: European Travel in Nineteenth-Century American Culture* (Princeton, N.J., 1994), 7, 10. Stowe regards clergymen, teachers and authors as "members of these nonproductive classes" who publish their travel journals and letters in order to justify their privilege, ease their guilty consciences, and cement their social status. It may be argued that these professionals produce something other than material goods and cannot, therefore, be construed as "nonproductive," although the evidence may not be found in the travel literature.

7. This may account for the fragmentary and disjointed nature of some of these books. See, for example, J. P. Rives, *Tales and Souvenirs of a Residence in Europe by a Lady of Virginia* (1842).

8. Of the authors surveyed, only Mordecai Noah visited this area of France and went into Spain. His case is unusual, however, because he was a diplo-

mat on government business and had to go there out of necessity, not choice. Henry James visited Carcassonne, but not until the late nineteenth century, putting his work beyond the scope of this study.

9. M. Noah, *Travels in England, France, Spain and the Barbary States in the Years 1813–14* (New York, 1819), 35–36.

10. J. F. Cooper, *Gleanings from Europe: France* (New York, 1983), 37.

11. A. Huidekoper, *Glimpses of Europe in 1851 and 1867–8*, (Meadville, Pa., 1882), 39.

12. Noah, *Travels in England*, 43.

13. C. C. Felton, *Familiar Letters from Europe*, (Boston, 1864), 100–101.

14. R. A. Billington, *The Protestant Crusade 1800–1860, A Study of the Origins of American Nativism* (New York, 1938; Gloucester, Mass., 1963). See Billington for a discussion of propaganda, the organization of the Protestant Reformation Society, and Protestant missionary movements.

15. N. Murray, *Men and Things as I Saw Them in Europe* (New York, 1853), 98–99.

16. Ibid., 53–55.

17. Ibid., 227.

18. Felton, *Familiar Letters*, 134–35..

19. G. H. Calvert, *Scenes and Thoughts in Europe* (New York, 1846), 59–60.

20. Huidekoper, *Glimpses of Europe*, 39.

21. Calvert, *Scenes and Thoughts*, 7.

22. Cat. 4 and 5 are oil sketches for these paintings.

23. S. I. Prime, *Travels in Europe and the East: A Year in England, Scotland, Ireland,* (New York, 1855), 139–40.

24. Huidekoper, *Glimpses of Europe*, 23.

25. Felton, *Familiar Letters*, 53–54.

The Classroom and the Courtyard: Medievalism in American Highbrow Culture

Kathryn McClintock

Over the course of the nineteenth century, American society experienced both the benefits and disadvantages of rapid technological and economic development. For those who equated material progress with moral advancement, the times could not have been better. American society, in their eyes, was making great strides toward national greatness. There were others, primarily members of the educated middle and upper classes, though, who saw spiritual sterility and fragmentation at the core of progressive modernism and concluded that America could only be saved by the recovery of a more rigorous moral ideal.

This "antimodern" perspective took many forms in the second half of the nineteenth century and was a response to the secularizing tendencies in modern American society.[1] This is clearly seen in the medievalism of men such as Charles Eliot Norton, who turned to the European past to provide guidelines for the present and who also spoke of the fine arts in religious terms (Fig. 1).

Charles Eliot Norton: The Classroom

Charles Eliot Norton (1827–1908) was the son of a famous Unitarian biblical scholar, Andrews Norton, and a member of one of the so-called Fifty First Families of Boston.[2] He was educated at Harvard (Class of 1846) and for a few years after graduation, pursued a career in business. But his first love had always been literature, and he began to write articles for the *North Atlantic Review* in 1851. Eight years later, Norton published a translation of Dante's *Vita Nuova*. The age of Dante remained his scholarly interest and passion from that time on. He was also a founding member of the *Atlantic Monthly* and *The Nation*, publishing essays and reviews of art and scholarship in both magazines for four decades.[3]

Norton's interest in the arts was not fundamentally aesthetic, however, because he was essentially a social critic at heart.[4] For him, the meaning and value of the fine arts lay not in their visual effects but in the understanding that "they are the only real test of the spiritual qualities of a race, and the standard by which ultimately [a nation's] share in the progress of humanity must be measured. For [the fine arts] are the permanent expression of its soul; of the desires and aspirations by which it has been inspired."[5]

Fearing that America would never realize its potential as a great nation without first developing what he called "the higher culture of the mind," Norton decried the materialism of contemporary society that fed the body but numbed the soul:

Fig. 1. Charles Eliot Norton in 1908. (Courtesy, Harvard University Archives)

The imagination of our time has for the most part taken a different direction from the fine arts in their high sense. It has been dazzled by the magnificent achievements of science and by the splendid promises of the spirit of this world; it has been allured from the pursuit of the lofty ideals of the mind by the material charms of the practical ends embodied in wealth and luxury. Especially here in America the success of our experiment has been so unexampled in the mastery of nature, in the rapidity of the physical growth of the nation, and in the diffusion of material comfort, as to engender a spirit of self-satisfaction that deadens the imagination and takes little heed of what may be deficient in our national life of true elegance, dignity, and elevation. Of all civilized nations we are the most deficient in the higher culture of the mind, and not in culture only but also in the conditions on which this culture depends. We are both ignorant and largely indifferent to our ignorance.[6]

Mere exposure to the monuments and masterpieces of Europe was not sufficient; one must be educated to appreciate their true significance:

We come abroad utterly ignorant of Art, and with natural and national self-confidence, at once constitute ourselves judges and critics of paintings and statues. The audacity of our ignorance halts at nothing; and a five-minutes' visit to the Sistine Chapel

qualifies us to decide on the powers of Michel Angelo. The majority of American travelers have yet to learn that some previous knowledge is to be acquired before one can be judge even of the externals of Art; that it is not the eye alone that needs cultivation, but the heart and the intellect as well, by those who would understand and enjoy the works of the great masters.[7]

Norton himself not only traveled to the museums, galleries, and churches of Europe, but he also conducted research in its libraries and archives as well. A scholar and a gentleman, he met the greatest minds of his day in both Europe and America and moved comfortably within the intellectual circles of both continents. Norton also possessed a "genius for friendship," and counted among his intimates Emerson, Longfellow, Dickens, Carlyle, and Matthew Arnold.[8]

One of his closest associations was with John Ruskin whom Norton had met in 1855 on a trip to Europe (James Jackson Jarves had provided the letter of introduction). Ruskin was already established as the leading proponent of the Gothic revival (with its emphasis on the moral interpretation of art) and Norton, too, saw Gothic architecture as the ultimate reflection of a community united in will and in faith:[9]

> By a great impulse of popular energy, by a long combination of popular effort with trained skill, [Gothic] cathedrals, each requiring almost the revenues of a kingdom for its construction, sprang up from the soil in the hearts of scores of rival cities. There have been no works of architecture in later times comparable with them in grandeur of design, in elaborateness of detail, in that broad unity of conception which, while leaving the largest scope for the play of fancy and the exercise of special ability by every workman, subordinated the multifarious differences of parts into one harmonious whole. The true cathedral architecture partook of the qualities which Nature displays in her noblest works,–out of infinite varieties of generally resembling, but intrinsically different parts, creating a perfect and concordant result.[10]

In addition, Ruskin and Norton shared a passion for the medieval Republic of Venice and considered it to be at the pinnacle of humanity's cultural achievement:

> One lives there only and wholly in the past. For largeness of design within the limits of the State, for method of policy, for gravity of purpose, for splendour in life, for the union of beauty with strength, elegance with force, luxury with self control, Venice and the Venetians of old were never matched in history.[11]

The architecture of the city was of particular interest to both men. Ruskin had published his classic work, *The Stones of Venice* (1850–1853), prior to meeting Norton, and was most supportive when his friend began to work in the Archives of St. Mark's: "I am <u>so</u> glad you are at work on Venice. You can't have any subject so fine. She's too big for me, now, but I'm going to do Pisa better than I've done

anything yet—if I live—(your getting those font fragments for me was immense benefit)."[12]

Norton discovered these sculptures on one of his trips to Italy, and although Ruskin was reluctant at first to acquire them, Norton was most enthusiastic:

> I think, but I will not assert it with positiveness, that you make a mistake in not letting me get for you one of the pieces of the Pisano sculpture of which I wrote to you. They show perfectly not only the technical style of the school, but the characteristic effort of Niccolo toward truth to nature in his rendering. They are full of touches of genuine realism. Two of them corresponding one to the other represent two angels one above another blowing trumpets (prefiguring Fra Angelico), and the action is admirably given. The third piece is a single somewhat large figure, supported by the symbols of the Evangelists. The angels are perhaps 3 feet high each about a foot & a half, and the block is perhaps a foot wide,–not too large or cumbrous.[13]

Norton's letter was successful in convincing Ruskin to purchase all three sculptures which have since been acquired by the Metropolitan Museum of Art in New York (Fig. 2).[14]

Their correspondence reveals an intimate relationship based on mutual interests, which included not only medieval sculpture and architecture, but also the paintings of the Italian Primitives, and it is clear that Ruskin greatly respected Norton as a colleague. "You yourself know more than I (—in many points) of mediaeval art—incomparably more than I of mediaeval literature,—but—as soon as you have a little more confidence in me, you will find me opening out much both new and firm ground to you in the classics, . . ."[15]

Over the course of their friendship, there would be periods of strain related to intellectual disagreements and, later, to Ruskin's bouts with insanity, but Norton remained protective to the end. As literary executor of Ruskin's estate, he destroyed many of Ruskin's papers (including some of his own correspondence) because he wished nothing to tarnish the reputation of the man he had so loved and admired. The legacy that Norton wanted to leave the world was the legacy that Ruskin had given his readers and his students at Oxford. It was the same essential love of the fine arts and the moral lessons contained therein that Norton wanted to pass on to his own students.

Norton became the first Professor of Fine Arts at Harvard University in 1875 after a year as lecturer in the "History of the Arts of Construction and Design, and their Relation to Literature." He began his teaching career with a course on the arts of two republics—Greece and Venice—and the art of medieval Italy (and classical Greece) remained an integral part of Norton's courses throughout his tenure at Harvard.

For Norton (as well as for Ruskin) the social and moral conditions under which art was created were intrinsic to its aesthetic quality. "There is no contrast between beauty & goodness, but on the contrary beauty is obtained through goodness, beauty might be measured through goodness."[16] Medieval Venetian art, therefore, was the most beautiful because it had been produced by good men of true faith living in a republic.

It was Norton's goal to achieve a similar environment in America by presenting the educated elite of Harvard with the highest moral ideals through the study of the fine arts. For Norton (and Ruskin), the decline of European art and civilization began with the Renaissance and resulted from the separation of true spirituality from the lives and works of the artists and the merchant class who patronized them. This circumstance offered striking parallels to the then current situation in Boston.

Boston, like Venice, was a seafaring city and many of the leading families had made their fortunes in the China trade. Boston also had its own form of aristocracy (the Boston Brahmins) and existed under a republican government. In Norton's mind, therefore, it possessed a social structure similar to that found in the medieval Republic of Venice, which had reached great cultural heights. But also like Renaissance Venice, the society of Boston was experiencing a spiritual crisis under the weight of modern materialism, and the only solution seemed to be a return to the moral values revealed in Venetian society and art.

Norton not only shared Ruskin's ideas on the morality of art and the place of medieval Italy in establishing standards, but he also employed Ruskin's methods of teaching, which included the study of drawings and watercolors of monuments and of objects taken from nature. Early in his teaching career, Norton had asked Ruskin to "send me all your <u>rubbish</u>; what is not good enough for Oxford will serve some good purpose here. There is a lively spirit & genuine interest & deep respect for you here, which will bye & bye bear good fruit."[17] Norton quickly discovered, however, that illustrative materials, such as drawings, photographs, and small plaster casts, were not effective in his classroom, and turned the drawings over to Charles Herbert Moore for his fine arts courses on technique.[18]

Ruskin's books, which Norton often used as texts, were of more enduring visual value for his instruction of the undergraduates at Harvard. He recommended that his students begin with *Aratra Pentelici* and made all of Ruskin's other works available to his first students.[19] Norton also

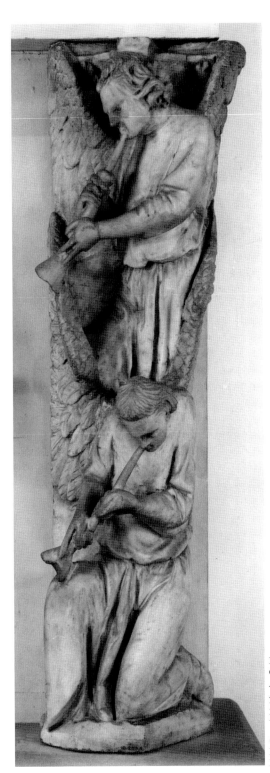

Fig. 2.
Giovanni Pisano,
*Angels of the
Apocalypse*,
Pisa, c. 1301–1310.
Marble pilaster
from a pulpit.
(The Metropolitan
Museum of Art,
Hewitt Fund, 1910)

43

employed readings from *The Stones of Venice* extensively for Fine Arts IV (Arts of Venice) as the class notes of Grenville L. Winthrop demonstrate.[20] Norton described his lectures thusly: ". . . after fitting up the skeleton of my lectures with the dry bones of German erudition, I come to you [Ruskin] always to help me clothe it with living flesh."[21]

The aesthetic analysis of individual works, however, was less important than the underlying spiritual principles governing the creation of art:

> The value and interest of art to mankind consists not so much in the character and circumstances of artists as in those moral causes which led to the manifestation of genius in this form [and]. . . it is only so far as those conditions are investigated and elucidated that the study of art becomes one deserving the attention of serious thinkers interested in the progress of the [human] race.[22]

As Norton presented his lectures on art, he wished to stimulate the minds of his students towards a love of beauty and the morality that created it. This is clearly evident in Norton's closing remarks for the course on Venetian art:

> The lessons to be learned from the stories of Venetian art are very simple—The main one is the lesson that only by self-discipline that invigorates the whole man, can the life of an individual or of a community be made vigorous. Life of moderation. balance of body & intellect. The highest source of pleasure is love of Beauty—It is impossible to separate high moral life from beauty of action & expression. Most men never rise above well-bred animals. We cannot separate in a highly refined & cultivated man the pleasure that comes to him through the soul. The senses are inlets into the soul. There is a great want of seriousness in the real objects of life among young men; they begin too late to see their folly. There is no reason to limit the sources of pleasure of youth . . . What does success mean? There is no success worth having which is not moral. Happiness in life consists in the fact that success is always in the power of each individual to attain for himself.
> Nor love thy life nor hate; but what thou liv'st live well; how long or short permit to heaven.[23]

Norton was joined in his efforts in the Department of Fine Arts by Charles Herbert Moore (1840–1930).[24] Moore had been a successful landscape painter and member of the circle of American Pre-Raphaelites when he accepted the position as Instructor in Freehand Drawing at the Lawrence Scientific School in 1871. Three years later, he transferred to the Fine Arts Department where he and Norton organized the curriculum according to the teaching methods of John Ruskin. In his courses, Moore conducted technical drawing exercises, which supplemented Norton's lectures on art history, and taught his students to "see" in the Ruskinian manner by having them copy the drawings of Ruskin or his copies after Ruskin. Moore also gave lectures on Renaissance painting.

Moore began to focus his attention on medieval architecture in 1885 and published the *Development and Character of Gothic Architecture* five years later. Although Moore used Ruskin's teaching methods in the classroom, when he began to write on architecture, he followed the structural approach of the great French medievalist, Viollet-le-Duc.[25] Moore may have had a greater appreciation of the structural dynamics of buildings as the result of his work with the engineering students at the Lawrence Scientific School in the early 1870s, and his own training as an artist undoubtedly made him more sensitive to the unique qualities of individual works.

When he wrote the *Development and Character of Gothic Art*, Moore declared that the only true Gothic architecture had been produced in the Ile-de-France during the twelfth and thirteenth centuries. All other "Gothic" buildings in England, Germany, Italy, and Spain were more accurately referred to as pointed construction as they did not reflect the totality of the Gothic system but, for the most part, only copied the pointed arch and other decorative elements:

> In fine then, Gothic architecture may be shortly defined as a system of construction in which vaulting on an independent system of ribs is sustained by piers and buttresses whose equilibrium is maintained by the opposing action of thrust and counterthrust. This system is adorned by sculpture whose motives are drawn from organic nature, conventionalised in obedience to architectural conditions, and governed by the appropriate forms of ancient art, supplemented by colour design on opaque ground and more largely in glass. It is a popular church architecture,— the product of secular craftsmen working under stimulus of national and municipal aspiration and inspired by religious faith.[26]

It was the last sentence that Norton would have considered the most important, but Moore's approach to medieval art was basically formal and structurally analytical rather than moral.

The Gothic art of France so highly prized by Moore was also of paramount interest to another former faculty member, Henry Adams (1838–1918, Harvard, Class of 1858). The descendant of two American presidents, Adams had existed on the margins of the political and literary scene before teaching medieval history at Harvard (1870–1877). His most significant exploration of the Middle Ages, *Mont-Saint-Michel and Chartres*, was privately printed in 1904 (copyright 1905), and a revised edition was published in 1912. Although relying heavily on Viollet-le-Duc for his descriptions of the Romanesque Mont-Saint-Michel and Gothic Chartres, Adams's book was a more psychological and intimate work than the writings of Norton or Moore.

Adams shared with Norton the antimodernist perception that contemporary American society was fragmented and spiritually sterile, but felt the corresponding fragmentation of the self more deeply.[27] His search for a model of coherence and harmony led Adams to the century between 1150 and 1250, "the point in history when man held the highest idea of himself as a unit in a unified universe."[28] Adams concluded that the reunification of the self could only occur through a personal subordination to irrational faith (represented in his writings by the Virgin) and rejection of scientific rationalism (represented by the Dynamo). He advised his readers that "to feel the art of Mont Saint Michel and Chartres we have got to become pilgrims again" and "if you are to get full enjoyment of Chartres, you must, for the time, believe in Mary as Bernard [of Clairvaux] and Adam [of St. Victor] did, and feel her presence as the architects did, in every stone they placed, and every touch they chiseled."[29] His passion for the Middle Ages and his intuitive insight added new dimensions to the perception of medieval art not found in the moral interpretation of Norton or in the structural approach of Moore.

Among the faculty of Harvard, however, no one had a greater impact on the appreciation of the fine arts than Charles Eliot Norton, perhaps because he was the first, but also because he believed so ardently that America needed men of cultivated taste and good morals to achieve national greatness. Norton was a man committed to improving society by the education of its elite, and he turned out to be an effective and beloved teacher. When he began to teach informally in 1873, he only had six students. Two years before his retirement in 1897, Norton had 446. His lectures were considered an essential part of the Harvard experience for twenty-five years, and some enterprising students even produced pamphlets based on class notes, which were sold to other undergraduates.[30] Although it has been recorded that "at certain hours [the fire-escapes of Massachusetts Hall] would be black with students retiring [after roll had been taken] from Charles Eliot Norton's course in the fine arts," it is undeniable that his ideas deeply affected the lives of many of his students.[31]

At the time of his death, a former student evaluated Norton's goals as follows:

> His object was in all his teachings, if it were put in words, might be said to be to inspire in the men who attend, and more especially in those men by reason of inherited wealth are likely to lead leisurely lives, an intellectual interest and purpose, and some sense of artistic appreciation. It is not so much the plan of the professor to give these young men any profound knowledge of the formal things in art, but rather to awaken in them an art sense, to inspire them to a kind of study and investigation of a

man of leisure, into the intellectual phases of life. In simpler terms, the purpose is to teach a man to look more to Shakespeare or to Tennyson, than to horse racing and rat baiting—in a word, to establish cultivated tastes.[32]

Although the true extent of Norton's influence is probably incalculable, it is clear, however, that a number of his students were so touched by his spirit that they chose to dedicate themselves to art as collectors and active participants in the burgeoning institutions of high culture in Boston.

Bernard Berenson (Class of 1887), became a connoisseur of Italian painting and was an invaluable advisor to Isabella Stewart Gardner, while others, such as Denman W. Ross (Class of 1875), J. Templeman Coolidge, Jr. (Class of 1879), Grenville L. Winthrop (Class of 1889), Edward W. Forbes (Class of 1895), and Paul J. Sachs (Class of 1900), were intimately connected with the Boston Museum of Fine Arts and/or the Fogg Art Museum. They were also collectors in their own right, and though none was primarily a collector of western medieval art, each acquired works from the Middle Ages. Norton had imparted a love of beauty, not only in its medieval forms, but also in its many other aspects.

Even Norton, who was an ardent admirer of the Middle Ages, was primarily a collector of Renaissance manuscripts and printed books, many written and autographed by the famous men he knew in both America and Europe.[33] He did, however, possess several medieval manuscripts and leaves, which he had received as gifts. James Russell Lowell presented Norton with a twelfth-century manuscript of St. Augustine's *Tractatus decem in epistolam S. Johannis* in 1886 while Ruskin gave him a fourteenth-century Flemish breviary in addition to three leaves from a late thirteenth-century St. Louis Missal.[34] Among the select works of art in Norton's collection were drawings by Turner and Ruskin (Cat. 11) in addition to paintings by Tintoretto, Burne-Jones, and William Blake. He also owned a painting by the fifteenth-century Sienese artist, Sano di Pietro, and a Florentine panel which he eventually returned to Ruskin.[35]

In 1877, Norton wrote a letter to Ruskin, describing the pleasure he derived from reminiscences of Venice and the objects in his collection:

> I have today been rereading the 2 numbers of St Mark's Rest, and have spent a happy hour with you in Venice. I am afraid that we shall never be there together in other than spiritual companionship;—and yet if I had any choice of places and of friends I would tonight choose to be in Venice with you. I am thankful that I have so much of Venice and of you always with me. I have only Venetian pictures in this study of mine; a little Margate

sketch of sunset by Turner which you gave me on an easel, and your sketch of Schaffhausen Falls on a stand near by. The book-case ledge in the next room holds only your sketches and one bit of Turner. Everything here that delights my eye, and refreshes my soul is associated in some way with you.[36]

It is undoubtedly that feeling of spiritual replenishment through the enjoyment of beauty that Norton tried to inspire in the undergraduates of Harvard and the readers of his articles.

Isabella Stewart Gardner: The Courtyard

The love of beauty and artistic pursuits that Norton strove to instill in his students found concrete and dramatic expression through his dear friend, Isabella Stewart Gardner (1840–1924).[37] She was the most prodigious collector of medieval art in Boston, and Fenway Court, the house-museum she created, is a unique monument to her individual taste. Although the medieval sculpture incorporated into the fabric of Fenway Court and the ivories, enamels, and Gothic statues it contains are important aspects of her collection, they are only a part of the wide range of art in Fenway Court, incorporated in 1900 for the purpose of "art education, especially by the public exhibition of works of art."[38]

In addition to medieval art, Mrs. Gardner acquired Greek and Roman sculpture, early Italian panels, Old Master paintings, and Oriental art, and patronized contemporary artists such as John Singer Sargent, James MacNeill Whistler, and the young American Impressionist, Dennis Bunker.[39] Her interests were not limited to the visual arts, however, and Mrs. Gardner was an ardent supporter of the Boston Symphony Orchestra, local literary associations, and the performing arts as well. She has been called a modern-day counterpart to Isabella d'Este, the great Renaissance patroness and namesake, but to her admirers Mrs. Gardner was, "not only the lover of Art, and the Collector, but the Artist, having built the house and having arranged all the objects which it contains in the order and unity of a single idea—an idea in which you have expressed your whole life with all its varied interests."[40]

Isabella Stewart's life began as the daughter of a wealthy family in New York City where she was educated by private tutors and at St. Mary's Convent. In 1856, she went to finishing school in Paris and the following year traveled to Italy with her parents. While in Italy, Isabella visited Rome, Milan, and Venice and saw the eclectic Milanese collection of Gian Giacomo Poldi Pezzoli, which seems to have inspired her own dream of a house containing beautiful art made available to the public.[41] In 1860, she married John Lowell Gardner, scion of a prominent Bostonian family and

the brother of her friend, Julia Gardner, and took up residence at 152 Beacon Street.

Her early years in Boston were relatively uneventful, but the death of her infant son in 1865 profoundly affected her physical and mental health. Two years later, John Gardner took his wife to Europe to recuperate, and when they returned to Boston, she threw herself into the city's social life. Fashionable and flamboyant, Mrs. Gardner attracted the most creative minds in Boston through the charm and force of her personality, and her home became a salon for the leading writers, artists, and musicians of the day. Among her circle of friends were Henry Adams, F. Marion Crawford, Henry and William James, Bernard Berenson, and Charles Eliot Norton, all men of literary bent and impeccable taste.

Mrs. Gardner had been abroad several times before she heard Norton give a series of lectures in 1878, but her trips became more frequent after their meeting. They shared a love of things European and cultural and soon became devoted friends. Mrs. Gardner joined the Dante Society, which Norton had founded, and at his urging, bought several Dante manuscripts in 1886 and 1887. Over the years, Norton also occasionally advised her on the acquisition of Italian paintings, and when he found himself in financial difficulty, Mrs. Gardner bought Venetian manuscripts and two Tintorettos from him.[42]

Norton and Mrs. Gardner shared with the Bostonian upper class a singular reverence for the art of Italy, and both had a special fondness for Venice. After hearing Norton's lectures on the fine arts, the city became her favorite destination on trips abroad. In 1884, Mrs. Gardner stayed at the Palazzo Barbaro with her husband's cousins, Mr. and Mrs. Daniel Curtis, and used John Ruskin's *The Stones of Venice* as her guidebook. An album of photographs collected on that trip concludes with a hand-written note: "O Venezia benedetta, no le voglio più lasar [sic]."[43] Norton responded to one of Mrs. Gardner's letters with similar affection:

Your letter brings me a pleasant breath of Venetian air. Seventeen years ago I saw Venice for the last time. My heart has remained true to her through all these years, and though I cannot, like my dear friend Rawdon Brown, thank God every morning for letting me pass my life in Venice, I am thankful to have spent so much time there that so long as I live her image will remain fresh and undimmed in my memory. I sometimes fancy that I will follow the example of the banished Norfolk who toil'd with works of war, he retir'd himself to Italy; and there, at Venice, gave His body to that pleasant country's earth. I should like at any rate to see her once more.[44]

Norton must have felt in some way that his wish had been fulfilled when Mrs. Gardner completed Fenway Court several years later.

Although Mrs. Gardner had fashionably outfitted her earlier home at 152 Beacon Street with a few objets d'art and some pictures in the 1860s and 1870s, she did not begin to collect art seriously until the 1880s. She began by purchasing nineteenth-century French paintings, Gobelins tapestries, and works by leading American artists, such as William Morris Hunt, and her efforts did not go unnoticed:

> A sober elegance is the distinctive trait of this [Boston] society which wishes to show its refinement in all things. To be sure the splendors of luxury are not absent, but their éclat is muted, so to say tempered by good taste, which is not always the case. I could, for example, name a particularly opulent home which might all too easily have looked like some well-furnished bric-a-brac shop or some pretentious museum of decorative arts. But with the greatest tact succeeded precisely in avoiding this danger, so that nothing was de trop. From the altarpieces dislodged from Italian churches, bibelots from the eighteenth century, masterpieces of German and French painting, to the portrait of the lady of the house,—the most beautiful Sargent ever painted, everything was in its place, even the flag of Napoleon's Grenadier Guards which, by the corner of a Renaissance chimney, tells the glories of French armies. No clutter, no profusion, no show; it all fitted into a savant harmony; it was simply the exquisite frame for a charming woman. (Fig. 3)[45]

As Mrs. Gardner's personal financial situation improved, the "frame" became filled with ever more precious and rare objects.

When her father died in 1891 and left a substantial inheritance, Mrs. Gardner decided to concentrate on the purchase of first-rate works of art. Her most trusted advisor became Bernard Berenson, a former student of Charles Eliot Norton and leading connoisseur of Italian Renaissance painting, who helped Mrs. Gardner secure many of her priceless masterpieces. By 1896 she owned paintings by world-renowned artists such as Zurbarán, Vermeer, Titian, and Rembrandt.

As the purchases continued, Mr. and Mrs. Gardner decided it would be more practical to build a new residence for themselves and the collection, and the idea for Fenway Court was born. After the death of John Gardner in 1898, plans for a house-museum, in the manner of the Wallace Collection in London and the Musée Jacquemart-André in Paris, intensified.[46] Within the space of a few years, Mrs. Gardner created an environment for art without parallel in the United States, and with comparatively limited funds built a collection of masterworks that rivaled the later acquisitions of J.P. Morgan of New York and Henry Walters of Baltimore, in quality if not in quantity.
Mrs. Gardner bought most of her collection between 1896 and 1900. During that time, she also made two trips to Venice and Florence to purchase architectural sculpture for

Fig. 3. John Singer Sargent, *Isabella Stewart Gardner*, 1880. (Isabella Stewart Gardner Museum, Boston)

the construction of Fenway Court. She took the architect's plans with her when making selections of capitals, columns, bases, and door frames as she intended to create a Venetian palace to house her collection. Unlike earlier revival-style houses built in America, however, Gardner bought real "stones of Venice" to construct Fenway Court:

> There are Venetian colonnades about the cloisters, Venetian windows looking upon the court, Venetian balconies, Venetian loggia, Venetian carvings embedded in the walls, Venetian

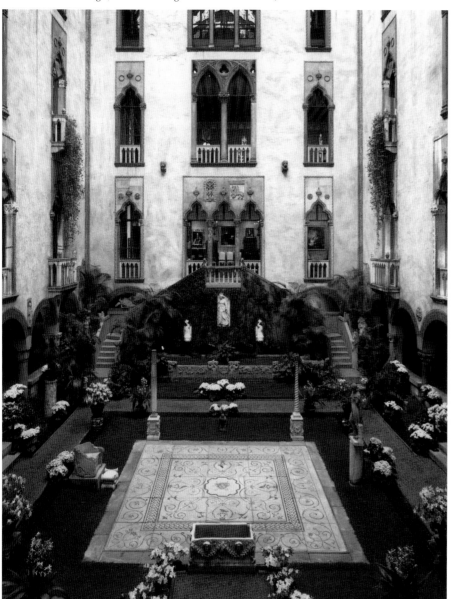

Fig. 4. Courtyard at Fenway Court. (Isabella Stewart Gardner Museum, Boston)

stairs—all genuine, all ancient, all Stones of Venice, bearing the incomparable hue of age, touched with the friendly touch of time, weather-worn, smoothed and rounded by the centuries, and here reverently placed to endure a new lifetime in a new Renaissance for the New World.[47]

In the creation of an environment using medieval sculpture, Gardner anticipated the construction of George Grey Barnard's Cloisters in New York by about a decade.

Mrs. Gardner also strove for authenticity in other areas, insisting that no modern reinforcements be used and hiring Italian immigrant workers to erect the structure. She bought the sculpture used to construct Fenway Park in bulk, guided primarily by the plans drawn up by Willard T. Sears of Boston. Although Sears was the nominal architect at Fenway Court, it is generally accepted that Mrs. Gardner made all the aesthetic decisions from design to execution and was a constant presence on the site.

She acquired eight balconies from the Ca' d'Oro, featured prominently in Ruskin's *The Stones of Venice*, and a variety of Venetian window frames and roundels (Cat. 12) in addition to numerous Romanesque capitals and bases to build the elaborate courtyard that forms the heart of Fenway Court (Fig. 4 and Color plate p. 7). At the end of the nineteenth century, many of the structures of Venice were undergoing renovation, and a considerable supply of relatively inexpensive architectural sculpture was thus available. Mrs. Gardner was careful, however, to avoid the appearance of a ravenous American pillaging Italy's cultural heritage:

> Particular stress should be laid upon the circumstance that the materials wrought into this building have in no instance been obtained from any structure that was demolished or dismantled for the purpose, or that to this end was deprived of any feature. The spirit in which Fenway Court was conceived and carried out was one of too great reverence for monuments of the past to countenance in any degree their destruction or their spoliation for its own purposes.[48]

Function seems to have been a primary consideration in the selection of medieval architectural sculpture for the fabric of

Fenway Court, and it has been noted that she acquired these pieces "often with greater enthusiasm than discrimination."[49] The eclectic nature of the sculptures imitated the character of Venetian Gothic ornament where sculptures from different periods were often added to buildings as the result of commerce or conquest. While most of the medieval architectural sculpture bought at this time was Italian, Mrs. Gardner also acquired three French Romanesque capitals in 1897 from the Emile Peyre Collection in Paris.

The influence of Norton and Ruskin is most evident in the conception of Fenway Court as a Venetian palace complete with real medieval architectural members, but Mrs. Gardner may have also evoked the Venetian aesthetic as the epitome of sophisticated elegance and masterful artifice.[50] Venice, more than any other European city, captured the imagination of artists, writers, and musicians in the nineteenth century, speaking to Romantic and Decadent sensibilities alike. The image of Venice as a community of royalty in exile might have also appealed to a woman who traced her ancestry to Robert the Bruce and the Stuarts of England and who included the Scottish thistle and white rose as ornamental details throughout Fenway Court.[51] "In the old regime possession by nobility conferred cache upon the work; in the bourgeois world it was the other way around."[52]

Construction of Mrs. Gardner's Venetian palace began in 1899, and the secrecy surrounding the construction of Fenway Court resulted in some rather fanciful "reports." An early newspaper article indicated that Mrs. Gardner planned to dismantle and transplant a Florentine palace, stone by stone, to America.[53] Another article was accompanied by a photograph of the interior of Sant'Apollinare in Classe in Ravenna, claiming that it was the model on which Mrs. Gardner based the lower part of Fenway Court.[54]

Speculation quickly gave way to admiration, however, when Fenway Court was unveiled on New Year's night 1903. Boston's social and intellectual elite were invited to hear a concert and to see the courtyard lit with Japanese lanterns; the garden, with flowers from Mrs. Gardner's greenhouses, was also in full-bloom in the dead of winter. The effect was truly magical: "I have heard in my youth how Aladdin touched his lamp and the Genie gave him a wondrous palace of gold and silver and all precious stones, but now I know a greater than he who outstretched her arms to Genius and created one of the great wonders of this century."[55] Charles Eliot Norton, who had access to

Fenway Court prior to its opening was less poetic, but equally impressed:

> Palace and gallery (there is no other word for it) are such an exhibition of genius of a woman of wealth as was never seen before, and indeed was only possible under such conditions as exist with us to day. It would have been incredible to our fathers . . . the whole thing is amazing, and after my last visit I came away with greater admiration than even after my first. The sculptures are hardly less interesting than the pictures. The Tapestries are magnificent and,—but neither description or enumeration can serve to convey a true impression of the interest and surprize [sic] of it all.[56]

After years of anticipation, Fenway Court was open to the general public on February 23, 1903. Visitors could not only see the great courtyard, but also rooms filled with European masterpieces and medieval or Renaissance furnishings. A rare painting by Giotto of *The Presentation in the Temple* (ISGM P30w9) was on display in the Gothic Room, while the Early Italian Room had a extraordinary sampling, including a panel of the *Virgin and Child with Saints* by Simone Martini (ISGM P15e4). Many of the medieval furnishings (including lecterns, torchères, and candle stands) and French Gothic statuary were acquired from the Emile Peyre collection in 1897 and 1899, in much the same fashion as the Italian architectural sculpture had been bought for Fenway Court.

Mrs. Gardner also assembled a small collection of medieval minor arts (ivories, enamels, and liturgical objects in metal), which was kept in cases in the Long Gallery. The manner of display is reminiscent of the early nineteenth-century cabinet collections of European connoisseurs, and this collection of minor arts presaged the twentieth-century interest in the sumptuary arts by New Yorkers, such as J.P. Morgan, Theodore M. Davis, Michael Friedsam, and George Blumenthal.

Although many of the medieval objects (exclusive of the minor arts) were displayed together in the Gothic Room (Fig. 5) and in the Chapel, their arrangement was based on aesthetic criteria (rather than on chronology, medium, or region), which represented "her conception of the way works of art should be presented if they are to uplift the spirit and serve for the education and enjoyment of the public forever."[57] Fenway Court provided Mrs. Gardner with the opportunity to correct the errors that she saw in the current practices of public museums, "which were already being called mausoleums of art and which, instead of bringing spiritual refreshment and life-enhancing joy to their visitors, were producing a new ailment called `museum fatigue.'. . . Nor would there be any class-room atmosphere in her house; love of art, but not knowledge about art was her aim."[58]

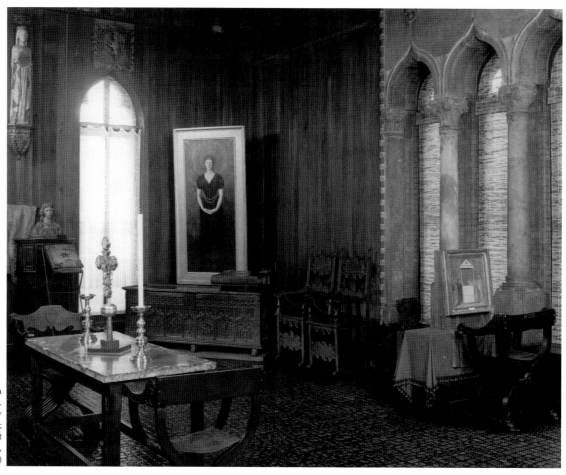

Fig. 5. Gothic Room at Fenway Court. (Photograph by David Bohl; Isabella Stewart Gardner Museum, Boston)

Mrs. Gardner's plan for a house-museum was ambitious and initially ran into some difficulties. She had not anticipated the problems inherent in opening her home to the public four days every month and almost despaired that her intentions were beyond the understanding of the people of Boston: "I think the American public will take a long time before the Boston Museum of Fine Arts educates it enough to permit it to go into a house like Fenway Court."[59]

As her home, Fenway Court was a private residence, but as a museum, it had been incorporated as a public institution and had been able to import much of the art exhibited duty free (or at reduced rates). Rather than lose control of her unique creation, Mrs. Gardner paid the duties to the government owed on her collection, which has remained part of a private foundation ever since.[60] Mrs. Gardner did not abandon her commitment to provide the American public with a

singular aesthetic experience, however, and continued to permit public access to Fenway Court during her lifetime:

> The periodical opening of Mrs. Jack Gardner's famous palace, Fenway Court, Boston, to the public suggests the justice of calling attention of the American people to the fact that Mrs. Gardner is the only possessor of a great private collection in this country who is willing to share her house and her treasures with the general public. All the other dwellers in palaces close them hermetically to all but personal friends. Mrs. Gardner, on the contrary, opens hers at frequent intervals every winter and allows all the world to enter and enjoy the fairyland she has created.[61]

The duties paid by Mrs. Gardner in 1904 and the need to preserve capital to endow the museum significantly slowed the pace of acquisition in the first years after the opening of Fenway Court. Only the best and most extraordinary objects could be considered, and one of the few medieval purchases at this time was the great thirteenth-century stained glass window from Soissons recommended by Henry Adams in

1906 (ISGM C28s2). The situation changed somewhat at the time of the renovations in 1913 when the Music Room in Fenway Court was removed to make way for a two-story extension (with the Tapestry Room above and the Spanish Cloister and Chinese loggia below).

Mrs. Gardner incorporated some old windows and door-ways into the extension which had not been previously on exhibit, and also installed pieces of late fifteenth-century German stained glass, purchased in 1875, in the window of the Spanish Chapel.[62] Moreover, Mrs. Gardner bought medieval sculpture for the Spanish Cloister, and the new acquisitions included two reliefs from Parthenay (ISGM S7n1-2) and a late twelfth-century portal from La Réole (ISGM S7w10), all coming to Mrs. Gardner's attention through Bernard Berenson:

> I am sending you on a roll four photographs of things I would strongly recommend you acquire. They are not Chinese but of the same quality only more so—so to speak—being more virile, and they have the advantage of being our own art—the art of Europe. As the dealer's enclosed letter will tell you they are French of the most glorious periods, the door as architectonic sculpture being in every way one of the most masculine products of human genius, and the two prophets and the Christ entering Jerusalem being the very highest reach of European medieval art
>
> Unfortunately the prices are a good bit of money 150,000 fr. for the [Parthenay] sculptures and 80,000 for the door. But it is literally the case that the Louvre is paying an exactly identical price for a similar trio, in no way preferable to this one.[63]

Increasingly, however, works could only be added that had a predetermined spot, such as the fifteenth-century Spanish panel of St. Michael (ISGM P19s7):

> You are very very kind to take so much trouble and to be so much interested for me. If the picture [of St Michael] is small enough to go into the place over the fireplace in my tapestry room I surely will take it for $3000. Unfortunately I have no idea of the size of the picture—and I therefore cannot say definitely that I will take it until I know as that is the only place I can put it in. Would it be possible to let me know the size? And I surely want it if you can get it in. But I have another favour to ask you. Would it be possible for you to act with Demotte leaving my name out; as I have rather ruffled relations with Demotte which would complicate matters. . . .[64]

After a stroke in 1919, Mrs. Gardner's activities were great-ly curtailed, but her friends still kept her apprised of worthwhile objects for possible acquisition. Denman W. Ross was particularly enthusiastic about a twelfth-century head from Saint-Denis, which was eventually purchased by the Fogg Art Museum (FAM 1920.30):

> I have asked Marcel Bing to send you the photograph of the head of a King that he has, of the Romanesque period, which is, in my judgement, one of the very finest things of its kind. . . .
> There is some talk of Mrs Blumenthal buying the head but she

has not yet seen it nor any photograph of it. She was asked to come and see it, but did not turn up. The head may not interest you in the photograph, which I have not seen, and you may not wish to act in this matter. If you decide to take no action, please let me know, because I want to suggest the purchase to Edward Forbes [Director of the Fogg], as appropriate for the Wetzel Bequest; but I want to give you the first chance, as you have so many fine pieces of Romanesque and Gothic Sculpture. This will go with them admirably.[65]

Despite her failing health, Mrs. Gardner's interest in the beautiful never faded, and just before her final illness, she made the effort to visit the Museum of Fine Arts:

> She had been in her usual health and on the previous Sunday had passed an hour and a half or two hours at the Boston Museum. She spent a long time in the Chapel admiring the Spanish fres-coes, Mr. Fairbanks [the museum's director] said he had never seen her more alert or more interested in everything. . . .[66]

Gardner lived at Fenway Court until her death in 1924, and her will stipulated that it was to remain as she conceived and arranged it, a house-museum combining the atmos-phere of a domestic residence with the finest works of art as furnishings. She disdained the method of installing works of art, according to chronology or region, then cur-rent in other museums, and was appalled at the use of committees to decide on acquisitions. Hers was a unique vision, tempered by the lessons of Norton and the advice of Berenson and others, but ultimately Fenway Court was a reflection of Mrs. Gardner's taste and a rare thing unto itself. It was a supreme work of artifice like the city of Venice, which helped to inspire it, and Mrs. Gardner was its architect.

Medieval Venice had been a starting point for the visions of both Charles Eliot Norton and Isabella Stewart Gardner, and each had striven to improve the cultural conditions of society, first in the classroom and then through the court-yard. Norton inspired many of his students to dedicate themselves to the fine arts for the betterment of their fel-low citizens, and Mrs. Gardner built a house-museum for the further enjoyment and education of the public. Both believed that the love of beauty had positive effects on the hearts and minds of people, and the art of the Middle Ages played a central role in their understanding of what consti-tuted the Beautiful.

1. T. J. J. Lears, *No Place of Grace: Antimodernism and the Transformation of American Culture 1880-1920*, (New York, 1981), xiii.

2. E. D. Baltzell, *Puritan Boston and Quaker Philadelphia: Two Protestant Ethics and the Spirit of Class Authority and Leadership* (Boston, 1979), 466. The most complete biography remains K. Vanderbilt, *Charles Eliot Norton, Apostle of Culture in a Democracy* (Cambridge, Mass., 1959). For Norton's correspondence, see *Letters of Charles Eliot Norton with Biographic Comment*, 2 vols., eds. S. Norton and M. A. De Wolfe Howe (Boston, 1913); and *The Correspondence of John Ruskin and Charles Eliot Norton*, eds. J. Bradley and I. Ousby (Cambridge, 1987). The secondary literature on Norton is extensive, but of particular note are: V. W. Brooks, *New England: Indian Summer, 1865-1915* (New York, 1940); M. Green, *The Problem of Boston: Some Readings in Cultural History* (New York, 1966); D. Sutton, "A Gentleman from New England," *Apollo* 107 (May 1978): 356–61; and M. W. Brooks, "New England Gothic: Charles Eliot Norton, Charles H. Moore, and Henry Adams," *The Architectural Historian in America*, ed. E. B. MacDougall (Hanover, N. H., and London, 1990), 113–25.

3. For a list of Norton's published works, see Vanderbilt, *Norton, Apostle of Culture* , 243-53.

4. As a young man, Norton had written *Considerations on Some Recent Social Theories* (1853) on the dangers inherent in the radical "republicanism" espoused in Europe, and his essays frequently dealt with contemporary political and economic issues.

5. C. E. Norton, "A Definition of the Fine Arts," *Forum* 7 (Mar. 1889): 39.

6. Ibid., 36.

7. C. E. Norton, *Notes of Travel and Study in Italy* (Boston, 1860), 179.

8. Charles Eliot Norton Obituary file, *Boston Advertiser*, Oct. 21, 1908, Harvard University Art Museums Archives.

9. For Ruskin's influence in the United States, see R. B. Stein, *John Ruskin and Aesthetic Thought in America 1840–1900* (Cambridge, Mass, 1967).

10. Norton, *Notes of Travel* , 102–3.

11. Norton to Ruskin, [July 1871], *Correspondence of Ruskin and Norton*, no. 166.

12. Ruskin to Norton, Sept. 3, 1873, *Correspondence of Ruskin and Norton*, no. 237. The results of Norton's research were published as *Historical Studies of Church Building in the Middle Ages: Venice, Siena, Florence* (New York, 1880).

13. Norton to Ruskin, Dec. 15, 1870, *Correspondence of Ruskin and Norton*, no. 147.

14. MMA 10.203.1-2 and 21.101. These pieces are now attributed to Giovanni Pisano and are thought to come from the pulpit at Pisa. See C. Gómez-Moreno, "Giovanni Pisano at the Metropolitan Revisited," *Metropolitan Museum Journal* 5 (1972): 51-73.

15. Ruskin to Norton, [Sept. 30, 1870], *Correspondence of Ruskin and Norton*, no. 143.

16. G. L. Winthrop, class notes for Fine Arts 5, 1885-1886 (MS. Notebooks, FAM 1943.1815.22), 187, Harvard University Art Museums Archives.

17. Norton to Ruskin, Nov. 13, [1873], *Correspondence of Ruskin and Norton*, no. 238.

18. Vanderbilt, *Norton, Apostle of Culture*, 125.

19. Norton to Ruskin, Oct. 30, 1874, *Correspondence of Ruskin and Norton*, no. 269.

20. G. L. Winthrop, MS. Notebooks, FAM 1943.1815.22, Harvard University Art Museums Archives.

21. Norton to Ruskin, Oct. 30, 1874, *Correspondence of Ruskin and Norton*, no. 269.

22. C. E. Norton, "[Review of] Tuscan Sculptors: Their Lives, Works, and Times by Charles C. Perkins," *Nation* 2 (Jan. 25, 1866): 116.

23. G. L. Winthrop, class notes for Fine Arts 5, 1885-1886 (MS. Notebooks, FAM 1943.1815.22), back cover, Harvard University Art Museums Archives.

24. F. J. Mather, Jr., *Charles Herbert Moore, Landscape Painter* (Princeton, N.J., 1957).

25. M. W. Brooks, "New England Gothic," 113–25.

26. C. H. Moore, *Development and Character of Gothic Architecture* (New York, 1890), 30.

27. Lears, *No Place of Grace*, 279–97. See also O. Cargill, "The Medievalism of Henry Adams," *Toward a Pluralistic Criticism* (Carbondale, Ill., 1965), 36–68; E. Scheyer, *The Circle of Henry Adams: Art and Artists* (Detroit, 1970); R. Mane, *Henry Adams on the Road to Chartres* (Cambridge, Mass., 1971; and J. F. Brynes, *The Virgin of Chartres: An Intellectual and Psychological History of the Work of Henry Adams* (East Brunswick, N.J., 1981).

28. H. Adams, *The Education of Henry Adams*, rev. ed. (Boston, 1918; Boston, 1974), 434–35.

29. H. Adams, *Mont–Saint–Michel and Chartres* (Boston, 1904; Boston, 1913), 17, 99.

30. E. W. Forbes, "History of the Fogg Museum of Art," vol. 1, [1953], 2, Harvard University Art Museums Archives.

31. Quoted in Vanderbilt, *Norton, Apostle of Culture*, 137.

32. Charles Eliot Norton Obituary file, *Boston Herald*, Oct. 21, 1908, Harvard University Art Museums Archives.

33. For the sale of Americana in Norton's collection, see the *New York Times*, Mar. 2, 1922, 37: 3. For the sale of his other books and paintings, see the *New York Times*, May 3, 1923, 18:7.

34. Two of the leaves from the *Histoire et Chronique de Roi Saint Louis* are mentioned in a letter from Ruskin to Norton, Feb. 25, 1861, *Correspondence of Ruskin and Norton*, no. 25. All three leaves were apparently still in private hands at the time of S. de Ricci's *Census of the Medieval and Renaissance Manuscripts in the United States*, vol. 1 (New York, 1935), 1059. The other two medieval manuscripts are now part of the collection at Houghton Library, Harvard University (MSS Lat. 213 and 267).

35. The former is mentioned in "Painting by Sano di Pietro," *Boston Museum of Fine Arts Bulletin* 6 (June 1908): 21. The latter is discussed in a letter from Norton to Ruskin, Nov. 2, 1877, *Correspondence of Ruskin and Norton*, no. 307.

36. Norton to Ruskin, [Nov. 2, 1877], *Correspondence of Ruskin and Norton*, no. 306.

37. For an overview of Mrs. Gardner's life and career as a collector, see: M. Carter, *Isabella Stewart Gardner and Fenway Court*, 3rd rev. ed. (Boston, 1925; Boston, 1972); A. Saarinen, "C'est Mon Plaisir: Isabella Stewart Gardner," *The Proud Possessors: The Lives, Times, and Tastes of Some Adventurous Art Collectors* (New York, 1958), 25-55; L. Tharp, *Mrs. Jack* (Boston, 1965); *The Letters of Bernard Berenson and Isabella Stewart Gardner 1887-1924*, ed. R. Van N. Hadley (Boston, 1987); A. Higgonet, "Where There's a Will . . . ," *Art in America* 79 (May 1989): 65-75; K. McCarthy, "Isabella Stewart Gardner and Fenway Court," *Women's Culture: American Philanthropy and Art, 1830-1930* (Chicago, 1991), 149–76; and H. T. Goldfarb and S. Sinclair, *Isabella Stewart Gardner: The Woman and the Myth* (Boston, 1994). Correspondence and the dealers' files related to Gardner and the Isabella Stewart Gardner Museum are also available through the Smithsonian Institution's Archives of American Art.

38. Articles of Incorporation, Isabella Stewart Gardner Museum Archives, Boston, reel 632 (frame 902) in the Archives of American Art–Smithsonian Institution.

39. See G. W. Longstreet, *The Isabella Stewart Gardner Museum General Catalogue* (Boston, 1935); P. Hendy, *European and American Paintings in the Isabella Stewart Gardner Museum* (Boston, 1974); and C. C. Vermeule, W. Cahn, and R. Van N. Hadley, *Sculpture in the Isabella Stewart Gardner Museum* (Boston, 1977).

40. Denman W. Ross to Mrs. Gardner, Apr. 19, 1911, Isabella Stewart Gardner Museum Archives, Boston, reel 407 (frame 185) in the Archives of American Art–Smithsonian Institution.

41. Goldfarb and Sinclair, *Gardner: The Woman and the Myth*, 5.

42. Norton to Mrs. Gardner, July 3, 1903, and Apr. 3, 1905, Isabella Stewart Gardner Museum Archives, Boston. Mrs. Gardner also received advice from Norton's son, Richard, on the acquisition of Greek and Roman sculpture.

43. "O blessed Venice, I wish to leave you no more." Quoted in Carter, *Gardner and Fenway Court*, 87.

44. Norton to Mrs. Gardner, July 20, 1888, Isabella Stewart Gardner Museum Archives, Boston.

45. T. Bentzon, *Les Américaines chez elles* (Paris, 1893), 113. Quoted in R. G. Saisselin, *The Bourgeois and the Bibelot* (New Brunswick, N.J., 1984), 107.

46. For the importance of the museum's character as a residence, see Higonnet, "Where There's a Will . . . ," 65-75.

47. S. Baxter, "An American Palace of Art: Fenway Court," *Century* 67 (Jan.

1904): 368. Although the great majority of sculpture in the courtyard is genuine, Mrs. Gardner did have modern copies fabricated for the sake of compositional and aesthetic balance. On the third floor, for example, the triple windows on the east and west sides were made to correspond to the Gothic double windows on the south and north. Both these old and new windows were supplied by the same Venetian dealer, Moisè dalla Torre & Co. See Longstreet, *Gardner Museum General Catalogue*, 42.

48. Baxter, "An American Palace of Art," 370. A note at the beginning of this article states that it is "an authorized pictorial and literary record," owing to the courtesy of Mrs. Gardner.

49. W. Cahn, "Romanesque Sculpture in American Collections. IV. The Isabella Stewart Gardner Museum, Boston," *Gesta* 8, no. 2 (1969): 47.

50. For perceptions of Venice in this period, see J. Pemble, *Venice Rediscovered* (Oxford, 1995).

51. Goldfarb and Sinclair, *Gardner: The Woman and the Myth*, 3.

52. Saisselin, *The Bourgeois and the Bibelot*, 30.

53. "The Latest Whim of AMERICA'S MOST FASCINATING WIDOW," *New York Journal and Advertiser*, 1899, Newspaper Clippings Scrapbooks, no. 172, Isabella Stewart Gardner Museum Archives, Boston.

54. "The Rivalry over the Building of Italian Palaces," [n.p.], Dec. 16, 1902, Newspaper Clippings Scrapbooks, no. 48, Isabella Stewart Gardner Museum Archives, Boston.

55. Frank G. Macomber to Mrs. Gardner, Feb. 21, 1903, Isabella Stewart Gardner Museum Archives, Boston, reel 403 (frame 215) in the Archives of American Art–Smithsonian Institution.

56. Norton to Samuel Gray Ward, Mar. 2, 1902, Isabella Stewart Gardner Museum Archives, Boston.

57. M. Carter, "Accent on Beauty," [n.d.], Isabella Stewart Gardner Museum Archives, Boston, reel 632 (frame 1263) in the Archives of American Art–Smithsonian Institution.

58. Ibid., Isabella Stewart Gardner Museum Archives, Boston, reel 632 (frames 1273-74) in the Archives of American Art-Smithsonian Institution.

59. Mrs. Gardner to Henry Swift, Mar. 16, [1903?], Isabella Stewart Gardner Museum Archives, Boston, reel 632 (frame 188) in the American Archives of American Art–Smithsonian Institution.

60. "Mrs. Gardner Pays $200,000," *New York Times*, Jan. 12, 1904, 1.

61. "In Praise of Mrs. Gardner," [n.p.], Dec. 1908, Newspaper Clippings Scrapbooks, no. 147, Isabella Stewart Gardner Museum Archives, Boston.

62. These examples of stained glass represent the earliest European acquisitions by Mrs. Gardner to be included in Fenway Court. See Carter, *Gardner and Fenway Court*, 47.

63. Berenson to Mrs. Gardner, July 12, 1914, *Letters of Berenson and Gardner*, 524. The lower portions of both reliefs are modern, and the museum was informed in 1926 that the sculptor responsible for the "restorations" was Boutron. See Vermeule, Cahn, and Hadley, *Sculpture in the Gardner Museum*, 75.

64. Mrs. Jack Gardner Collector file, Mrs. Gardner to Paul J. Sachs, Apr. 15, [1916], Harvard University Art Museums Archives.

65. Denman W. Ross to Mrs. Gardner, Aug. 3, 1920, Isabella Stewart Gardner Museum Archives, Boston, reel 407 (document 337) in the Archives of American Art–Smithsonian Institution.

66. W. G. Endicott to John Singer Sargent, July 24, 1924, Isabella Stewart Gardner Museum Archives, Boston, reel 632 (frame 1088) in the Archives of American Art–Smithsonian Institution.

Fig. 1. Casts of medieval sculpture, Gem Room, 1902. (MFA Lib. #N520. A53 #5562, Courtesy, Museum of Fine Arts, Boston)

The Earliest Public Collections
and the Role of Reproductions (Boston)

Kathryn McClintock

The plaster cast as a substitute for original works of art held an honored place in the art schools and museums of nineteenth-century America.1 The cultural heritage of Europe as represented by original works of art was inaccessible to most Americans due to the distance and expense of travel, and familiarity with the masterpieces of the Western world (and especially those of the classical past) was seen as a way to elevate the tastes of the citizens of an emerging nation. America, however, was sorely deficient in the type of art then recognized as upholding the highest aesthetic ideals. Plaster casts were accepted as inexpensive and suitable vehicles for transmitting culture to the general public as well as to the artist in training.

Early cast collections in the United States were often associated with art schools, such as the Philadelphia Academy of Fine Arts (founded in 1805). These schools followed the examples of European academies, such as the Ecole des Beaux-Arts in Paris, where students mastered their drawing skills by sketching reproductions of antique sculpture. The Boston Athenaeum (founded in 1807) received a collection of twenty-five classical plaster casts from Augustus Thorndike in 1822. Although a private institution, the Athenaeum made its reproductions available to professional artists with the proper introductions. To encourage the development of native talent, the Athenaeum agreed to open its gallery three nights a week, and when asked, moved the casts to the first floor for the greater convenience of the artists.[2]

Casts of continental art were most often acquired through orders to the museums of Europe or their agents. Several museums were devoted exclusively to the exhibition of reproductions, such as museums of plaster casts in Dresden, Munich, and Vienna. Many of the larger European institutions also had special departments to process requests for casts from the continent and abroad. In 1867, the rulers of Europe met in Paris to discuss the exchange of plaster casts from their national collections and issued a resolution, *Convention for Promoting Universal Reproductions of Works of Art for the Benefit of Museums of All Countries*. This resulted in the establishment of a canon of European masterpieces in plaster, which were readily available to the American market. The vast majority of casts provided by European museums were taken from Greek, Roman, and Renaissance sculpture, supplemented by a small number of Baroque and modern examples. Reproductions of medieval sculpture were comparatively limited and consisted mainly of architectural details. After the Civil War, the American demand for European

casts increased due to the growth of art education and public art museums. Institutions such as the Metropolitan Museum of Art in New York and the Museum of Fine Arts in Boston (both founded in 1870) initially depended on reproductions of Europe's masterpieces to build their collections. No museum was more committed to the instructional benefits of plaster casts than the Museum of Fine Arts under the guidance of Charles Callahan Perkins, a driving force of the American art education movement.[3]

Perkins, one of the founding trustees, was pivotal in defining the fundamentally educational role of the museum in its formative years. He promoted the use of plaster casts for sculpture, coins, gems, and medals and the use of photographs of the drawings of the Old Masters "which are nearly as perfect as the originals," but he deemed reproductions of paintings too expensive.[4] Moreover, Perkins considered the acquisition of original works of art beyond the museum's limited funds. The ease with which documentation could be forged for spurious "originals" made the purchase of reproductions of known masterpieces a much safer investment.[5] "For a few thousand dollars, all the masterpieces of Greece, Rome, Egypt, modern times, etc., could be seen [in reproduction]"; a collection made up exclusively (or predominately) of original works of art was regarded as too partial and too limited for the educational goals of the new institution.[6]

In Perkins's opinion, the purpose of the museum was to elevate the artistic tastes of the general public and thereby improve the level of craftsmanship in the United States. Knowledgeable consumers, he believed, would demand products of higher quality and better design, which would make American manufactures more competitive in the international market. The museum would also serve as a repository of objects useful in training artists and artisans.

In the organization of the exhibits at the Museum of Fine Arts, Perkins followed the example of the South Kensington Museum (now the Victoria & Albert Museum in London), which not only provided casts, but also arranged works according to their material rather than by chronology or region. "We aim at collecting material for the education of a nation in art, not at making collections of objects of art."[7] Since he was the honorary director and chairman of the Committee on the Museum, charged with acquisitions from 1876 until his death in 1886, relatively few original works of art were bought by the museum during his tenure. When the first building of the Museum of Fine Arts on Copley Square opened to the general public on July 4, 1876, it contained a motley assortment of reproductions

18. Casts and reproductions file, Benjamin I. Gilman to Samuel D. Warren, Oct. 22, 1904, Archives, Museum of Fine Arts, Boston.

19. Casts and reproductions file, "Casts from the Antique," 1899, Archives, Museum of Fine Arts, Boston. Robinson's descriptions from the catalogue are included in Gilman's report.

20. Casts and reproductions file, R. Clipston Sturgis to Samuel D. Warren, Sept. 27, 1904, Archives, Museum of Fine Arts, Boston.

21. Casts and reproductions file, two approximate layouts of the cast department, [Mar. 1903], Archives, Museum of Fine Arts, Boston.

22. "The Collections of Casts," *Boston Museum of Fine Arts Bulletin* 7 (Dec. 1909): 60.

23. E. R. Abbott, "Report on Reproductions," *Bulletin of the College Art Association of America* 3 (Nov. 1917): 16–21.

24. C. R. Morey, "Reproductions of Romanesque and Gothic Art for the College Museum and Art Gallery," *Art Bulletin* 2 (Sept. 1919): 54.

1

Catalogue Entries

1. Graphical & Literary Illustrations of Fonthill Abbey, Wiltshire, with Heraldic and Genealogical Notices of the Beckford Family

John Britton (1771–1857)
London, printed for the author, 1823
viii, [5] – 68 p., [11] leaves of plates. ill.
(some col.), genealogical tables
31 x 24.4 cm
The Pennsylvania State
University Libraries,
Rare Books Room

2. Delineations of Fonthill and Its Abbey

John Rutter (1796–1851)
Shaftesbury, the author; London,
C. Knight, 1823
[vii] – xxvi, 127 p. incl. illus., III
genealogical tables, 14 pl.
(part col., incl. front.
fold. map, plan)
34.6 x 29.5 cm
The Pennsylvania State
University Libraries,
Rare Books Room

William Beckford and Fonthill Abbey

Fonthill Abbey in Wiltshire, "the most romantic of Gothic houses for the most romantic patron," was built for William Beckford (1760–1844), heir to one of the largest fortunes of his day, derived primarily from sugar plantations in the West Indies.[1] In the course of his life, Beckford ran through most of this fortune, spending a large portion on the construction of Fonthill, which he was forced to sell before it was finished. Son of a Lord Mayor of London, William Beckford was raised and educated to be a gentleman of leisure, a role for which he seems to have been admirably suited by virtue of his intelligence and sensitive nature not less than by his training. Blessed with more than average talent in a variety of areas—languages, art, and music— Beckford also possessed sufficient literary talent to produce *Vathek* (1786), one of the earliest and most popular Gothic novels, set not in the Middle Ages but in the exotic East. Indeed, from an early age Beckford manifested an abiding interest in the culture of other times and places, in both the distant past and in distant lands. Apparently as a teenager he dreamed of making an addition to his father's house in the form of a baronial hall with stained glass and heraldic decorations.[2] After extensive travel in his youth, Beckford returned home, and in 1795 embarked with the architect James Wyatt upon the creation of what at first was intended to be no more than a "lodge in the fair wilderness" set upon a hill, a pseudo-monastic folly, consisting of a tower from which to admire the view and a suite of rooms in which to take refreshment. At that time the structure was referred to as "the Convent in Ruins."[3]

Beckford chose his architect well. Wyatt had already worked in the Gothic mode at Lee Priory in Kent. In addition, as the restorer of Salisbury Cathedral and of Henry VII's chapel in Westminster Abbey, Wyatt had experience with real medieval architecture.[4] Apparently, Beckford was pleased with Wyatt's "Convent in Ruins" and with the effect it had on others (he gave an elaborate medieval feast for the visit of Lord Nelson and Lady Hamilton in 1800), and he subsequently decided to enlarge the structure, converting it into a residence and changing its name to Fonthill Abbey. Like the earlier construction, this ambitious project proceeded with great speed, and although money was no object, solidity of structure was sometimes sacrificed in favor of quick results. Thus, the great tower of

Fonthill collapsed several times during the process. Rutter's account of the first fall, when the tower was brought down by a strong wind, gives us a glimpse of Beckford's deep pockets and of his Romanticism in full flight: "The fall was tremendous and sublime, and the only regret expressed by Mr. Beckford upon the occasion, was that he had not witnessed its destruction."[5]

Although the interiors of Fonthill Abbey were not finished by the time Beckford was obliged to sell it in 1822, its overall outline was complete. Distinguished by its enormous central tower, estimated somewhere between 270 and 300 feet high, and by the pinwheel shape of its ground plan, measuring over 300 feet across at its point of greatest extension, Fonthill was the epitome of the Picturesque so much admired by the Romantic movement. Its irregular plan and asymmetrical massing were in strong contrast to the rigidly symmetrical blocks of eighteenth-century classicism. Even its flimsy construction, by adding an element of unreality, as if by magic it had suddenly arisen on the hillside, may have made it appealing to Romantics. As one historian summed it up, Fonthill was the place where "the potential of Gothic was first fully realized . . . Fonthill was heady stuff."[6]

For the furnishing of Fonthill Abbey, Beckford commissioned both neo-Gothic and neo-Renaissance furniture and decorative arts. Numerous stained glass windows depicting his illustrious ancestry were made to order. Fonthill was also filled with the fruits of Beckford's passion for collecting. The two long galleries essentially served as libraries, housing many of the 20,000 volumes in his possession, while his hundreds of Old Master paintings and the multitude of other works of art he had amassed over some forty years of buying were liberally spread throughout. Interestingly, although Fonthill was built in the neo-Gothic style, Beckford's collection does not reflect any special interest in medieval art, but was that of a connoisseur devoted to works displaying fine craftsmanship and rare and exotic materials. Thus, his collection consisted, for the most part, of French furniture and decorative arts of the seventeenth and eighteenth centuries, Japanese lacquer, and objects made from semi-precious stones, ideally combined with gold, silver, or enamel. While objects in the latter category were often of Renaissance or Baroque manufacture, Beckford did, however, possess a fine medieval enamelled casket from the workshops of Limoges dating to the first half of the thirteenth century. This casket, represented

St. Michael's Gallery (pl. 9). **1**

View of the West and North Fronts, from the End of the Clerk's Walk (pl. 11). **2**

in Britton's view of the south end of St. Michael's Gallery, where it is visible sitting on the mantelpiece on the left side, is especially relevant to the history of American collecting of medieval art. After being bought at the 1823 auction by Anne Countess of Newburgh, it later came into the possession of J. Pierpont Morgan, from where it entered the collections of the Metropolitan Museum of Art in New York (MMA 17.190.523). The casket is listed in the Christie's catalogue for the 1823 sale as lot 1263, a "Greek shrine of metal, for containing relics, brought by St. Louis from Palestine, and had been deposited at St. Denys, whence it was taken during the French Revolution."[7] Although Beckford misidentified the casket as Greek, the Saint-Denis provenance, also no doubt provided by Beckford, is plausible, since the treasury of the Abbey of Saint-Denis did become the property of the French state during the Revolution. While much of the treasury remained together and is today in the Louvre, some objects were sold at auction in 1797 to raise money for the revolutionary government. Beckford was not himself in France at that time, but he could have purchased the châsse through an agent as he is known to have done for other works. Furthermore, Beckford seems to have conducted extensive research on the pieces in his collection, and his provenances have often proven to be correct.[8]

Strangely, it seems that not only did Beckford lack any great love for works of medieval art, he also seems not to have been especially drawn to medieval architecture. Indeed, in the face of criticism of Fonthill Abbey by the contemporary architect and art historian Thomas Hope, Beckford is reported to have explained his choice of the Gothic style as simply due to its being better suited to the display of stained glass windows depicting the arms of his ancestors.[9] This may at first seem a facetious remark on his part, but Beckford's lineage was obviously an important factor at Fonthill, where it was celebrated not only in the stained glass, but also everywhere and on every scale, from the very names given to the long galleries—King Edward's because Beckford claimed Edward III as an ancestor and St. Michael's after the knights of the Order of St. Michael, from whom he traced descent—to the Latimer cross repeated as a motif on the furniture made for the Abbey. In this sense, Fonthill was the realization of Beckford's childhood dream to build a baronial hall honoring his ancestors. Further evidence of what might almost be called his casual use of the Gothic when it suited his purpose is the fact that after the sale of Fonthill, Beckford moved to

Bath, where the house he built for himself, Lansdown Tower, was strictly classical.

Nevertheless, in spite of this fact, Beckford and Fonthill Abbey were tremendously important in the history of the Gothic Revival. This was so on two levels and as a result of two separate events, for both of which the impact on the public would have been much less if Beckford were not already known to all as one of the richest and most eccentric men in England—and as one of the most private. He was accordingly the object of much attention and speculation, which Britton referred to as "a feverish curiosity."[10] The first seminal event in the spread of the fame of Fonthill was Beckford's entertainment for Lord Nelson in 1800, to which a number of luminaries from the world of arts and letters had been invited. This medieval fete was to have major repercussions on the arts.[11] The second event was Beckford's decision in 1822 to sell Fonthill, which caused both the architecture and the interiors to be made known to a wide public: to the 7,200 people who bought tickets to view the Abbey when it was first up for sale; to those who perused the catalogue of its contents on the occasion of the 1823 auction; but more importantly, to the many, many more among the general public who were able to accomplish an armchair visit of Fonthill with the aid of the publications of John Britton and John Rutter. Finally, everyone's attention would certainly have been caught when in 1825 the central tower over the octagon collapsed for the final time, "with a tremendous crash . . . instantaneously presenting an immense mass of ruins."[12] Given the boom in neo-Gothic villas for the middle classes, which spread through England and then to the United States not long after, one might almost say that the repercussions of the tower's collapse were felt as far away as America. Fonthill Abbey, perhaps by its very excess, had succeeded in capturing the public's imagination in a way that earlier more restrained essays in the Gothic mode had failed to do.

Britton's *Illustrations*

Originally conceived as a means of publicizing Fonthill Abbey in preparation for its intended sale at auction in 1822, Britton's *Illustrations*, in fact, appeared the following year, after Beckford had privately sold the abbey and its contents to John Farquhar, Esq. A great deal of information about Fonthill and about the author of this volume can be derived from the title page alone. The subtitle, "With Heraldic and genealogical Notices of the Beckford Family," and the facing

frontispiece displaying Beckford's arms proclaim Beckford's quasi-obsession with his ancestry. The author and publisher of the book, John Britton (1771–1857), is identified here as "Fellow of 'The Society of Antiquaries of London,' Fellow of 'The Royal Society of Literature,' Honorary Member of 'The Antiquarian Society of Newcastle,' Honorary Secretary and Treasurer of 'The London Architects and Antiquaries Society,' Honorary Member of 'The Norwich Society of Artists,' Honorary Secretary of 'The Wiltshire Society,' Etc. Etc.," a list that makes palpable his position as a respected antiquarian. Indeed, the *Illustrations of Fonthill* was an unusual undertaking for Britton, whose publications, such as *The Architectural Antiquities of Great Britain*, in five volumes, London, 1805–1814 and 1818; or *Cathedral Antiquities of England*, London, 1814–1835, normally focused on real medieval architecture rather than on the imitation.

As expected, Britton's text provides descriptions of the house and grounds, as well as appendices containing elaborate genealogical tables for Beckford's family. It also includes the "Literary Illustrations" referred to in the title, which constitute its most valuable contribution to scholarship. These consist of contemporary accounts, such as an eyewitness description of Beckford's famed party for Lord Nelson, the "Hero of the Nile," in 1800, and reactions to Fonthill itself among contemporary journalists, literati, and other critics. Britton's illustrations of both the exterior and the interior of Fonthill—ten engravings in black and white and two in color—present it to the viewer in all its Romantic grandiosity. The two color plates, both of the interior of St. Michael's Gallery, and both based on drawings by G. Cattermole, appear on facing pages. The most comprehensive of the two is the view of the south end of the gallery, in which the Beckford/Morgan casket is visible on the left, while part of Beckford's extensive library is visible along the right wall. This view shows many of the distinctive features of Fonthill, such as the ebony furniture, Beckford's "Wolsey chairs," which he thought were English Renaissance but which were really seventeenth-century Indo-Portuguese, and the newly made stained glass with Beckford's armorial bearings.[13] It also gives a sense of the architect James Wyatt's gift for Gothic design, as seen in the harmonious transition from the tracery of the bay window, through the series of framing arches up to the fan-vaulted ceiling. Through the window, the lower part of which was glazed with the most modern (and very expensive) plate glass, can be perceived as one of Beckford's reasons for building Fonthill as he did: the glorious view that the

Abbey commanded of the Wiltshire countryside.

Rutter's *Delineations*

John Rutter (1796–1851) published his *Delineations*, as Britton did his *Illustrations*, in connection with the sale of Fonthill, and its numerous engravings provided alternate but similar views of the Abbey. In a number of respects, however, Rutter's book differs from Britton's. It provides a more complete guided tour of the grounds and through the many rooms of the house, and the inclusion of a fold-out map of Fonthill Domain and detailed cross sections of the house better enable the armchair visitor to follow Rutter's exhaustive written descriptions. Although Rutter's Appendix C, "Geneological Tables of William Beckford, Esq.," was apparently intended to appease Beckford's household gods, his Appendix B, "Memoranda of the Origin and Progress of Fonthill Abbey," constitutes a valuable primary source concerning the actual building of Fonthill for historians of architecture.

The engraving, "View of the West and North Fronts, from the End of the Clerk's Walk," shows to advantage the Romantic qualities of Fonthill Abbey, its Picturesque Gothic asymmetry, and its outsize octagonal tower. In front of the structure, five tiny human figures can be perceived, dramatically lit, three in the foreground and two just to the left of the great arch over the west entrance. Over all looms a troubled sky, which threatens to unleash a violent storm—in sum, the perfect setting for "the most Romantic of Gothic houses."

1. M. Aldrich, *Gothic Revival* (London, 1994), 82.
2. Ibid., 84.
3. J. Rutter, *Delineations of Fonthill and its Abbey* (London, 1823), 109. He outlines the building process of Fonthill on 108–12.
4. Aldrich, 80.
5. Rutter, 110.
6. J. Macaulay, *The Gothic Revival 1745-1845* (Glasgow, 1975), 147.
7. J. Britton, *Graphical & Literary Illustrations of Fonthill Abbey* (London, 1823), 55.
8. C. Wainwright, *The Romantic Interior: The British Collector at Home 1750-1850* (New Haven, Conn., 1989), 133–35, 143.
9. Wainwright, 144.
10. Britton, 15.
11. Wainwright, 128–29.
12. *Salisbury Journal*, Dec. 23, 1823. Quoted by Wainwright, 144.
13. Wainwright, 131–32.

Ruins of Melrose Abbey, first page of Canto II, engraving
by Edmund Evans after Birket Foster.

3

Front cover.

3

It took one hundred years of exposure to Gothic and historical literature before Americans began to collect medieval art on a significant scale. Gothic novels first began to appear in the catalogues of American book dealers in the 1790s, but it was not until the 1890s that Americans began to acquire medieval art in quantity. In the intervening century, the American public read great numbers of Gothic tales, metrical romances, and medieval historical novels. These tales of ruined castles, heroic chivalry, and an exotic and almost mythic past must certainly have helped generate interest in the art of the Middle Ages, even if it also produced many misconceptions along the way. Some of the authors of these stories were American, but most were European, and it was in Europe that this literature first appeared. The most influential writer by far, on either side of the Atlantic, was Sir Walter Scott.

Scott and his *Lay of the Last Minstrel* represent two literary traditions that are relevant to American medievalism: Gothic literature and historical fiction. The meaning of "Gothic" in this sense, of course, refers to Romantic tales of ruined castles by moonlight, ghosts and goblins and other supernatural elements, secret corridors and dramatic revelations and so forth, and not to the style of art of the twelfth to the fifteenth centuries. However, Gothic stories frequently made use of medieval buildings, often as ruins, for their settings, and sometimes they took place in medieval times as well. Most of these characteristics can be found in Horace Walpole's *Castle of Otranto* (1765) considered to be the first Gothic novel. Gothic literature as a genre remained popular in America from the time of its introduction in the 1790s until well into the nineteenth century, although the use of medieval settings seems to have diminished. But, the considerable use of medieval props in the earlier Gothic novel, usually in a highly dramatic fashion, must have helped create some enthusiasm for, or at least a Romantic fascination with, the arts of pre-Renaissance Europe.

Although the early school of medievalizing Gothic fiction seems to have gradually died out in the nineteenth century, medievalism in literature did not. It remained and flourished in historical fiction. The modern historical novel grew out of the Gothic novel. Although fictional works set in earlier times had been produced for centuries, for example, Shakespeare's history plays, no attempt was made in these works to recreate the period in which the action ostensibly took place. Shakespeare's medieval kings acted with Elizabethan manners and lived in an Elizabethan world. The development of historical fiction that attempts to realistically create the settings and attitudes of the past is universally credited to Walter Scott; he created the modern historical novel. His work is particularly significant with regard to American taste for the medieval because so many of his writings, including the most popular of his novels, were set in medieval times. Scott was one of the most widely read and critically acclaimed authors of the nineteenth century. His popularity was at least as great in America as in Europe, and his books were readily available in this country. The American demand was such that pirated editions were sometimes published here before the first edition was available in Britain.

Scott initially achieved fame and popularity as a writer of epic-length narrative poems. His first major work in that genre, the *Lay of the Last Minstrel*, was published in 1805. It was an enormous success and remained popular through the end of the century. In 1895, for example, an American columnist discussing New England politics made extensive reference to characters from the *Lay* and also from *Ivanhoe*, without specifically naming either work. The author simply assumed these works were so well known that the references would be easily recognized and understood.[1] The *Lay* is both a Gothic tale and a work of historical fiction. The Gothic elements include a goblin, the ghost of a great sorcerer, and a ruined abbey (by moonlight). The historical elements are multiple. The *Lay* is told as a story within a story. The outer story takes place about 1690. An ancient minstrel, "the last of his race," seeks refuge with a duchess, and in gratitude for her kindness, tells his tale. The story *he* recites takes place in the mid-fifteenth century. The style of Scott's writing, and many of the details of his story, are taken from medieval romances and histories, such as Froissart's *Chronicles*, written shortly after 1400. Scott himself admits this, and a late nineteenth-century editor of the *Lay* stated that:

> The artificial dress in which Scott clothes his Border pageant is taken from medieval romance and the history of countries more civilized than the Borderland was in the sixteenth century. The manners are more the manners of English and French chivalry as depicted by Froissart than the manners of the Borderers . . .[2]

3. *The Lay of the Last Minstrel*

Sir Walter Scott (1771–1832)
Engravings by Edmund Evans and
J. W. Whymper after Birket Foster
and John Gilbert
Edinburgh, A. & C. Black, 1854
Binding: leather-grained cloth with
embossed design, blocked in gold on
front cover and spine;
354 p., front. ill., 20.5 x 14.3 cm
The Pennsylvania State
University Libraries,
Rare Books Room

The plot of the story told by the minstrel is rather complex. This synopsis is much simplified. A recently widowed Scottish duchess finds that her daughter is in love with the leader of the rival clan that killed her husband. The duchess, who is skilled in magic, sends her retainer, Sir William of Deloraine, to the ruined Abbey of Melrose where lies the tomb of her ancestor, the great wizard Michael Scott (a distant ancestor of Sir Walter). Deloraine arrives at the abbey at night in full armor and is met by an old monk. The knight's task is to retrieve the book of spells of the wizard so the duchess may use it to prevent magically the union of her daughter and her enemy. The book is stolen from Deloraine by the goblin page of this enemy leader of the rival clan. A border war breaks out between the Scots and the English. The duchess's son and heir is taken captive by the English. The goblin page uses the wizard's book to cast a spell, which enables his master to rescue the son of the duchess. This noble act reconciles the duchess to her former enemy, and the leader of the rival clan is married to the duchess's daughter. At the wedding festivities, the spirit of the wizard whisks away the goblin page, those present vow to go to Melrose to pray for the wizard's soul, and the monks of Melrose sing a hymn for the dead.

Aside from the elements taken from medieval literature mentioned above, the great medieval, and medievalizing, element in this work is Melrose Abbey, a Gothic monastery on the Scottish border built in the fourteenth and fifteenth centuries, and partly destroyed by raiding English in the 1540s. Melrose was quite near Scott's manorial home, Abbotsford; visitors to the manor were often taken to see Melrose as well. Most of the second canto of the *Lay* takes place at the abbey, and includes many passages describing the buildings. The canto opens with a Romantic description of the abbey church:

> If thou wouldst view fair Melrose aright,
> Go visit it by the pale moonlight;
> For the gay beams of lightsome day,
> Gild, but to flout, the ruins grey.
> When the broken arches are black in night,
> And each shafted oriel glimmers white;
> When the cold light's uncertain shower
> Streams on the ruin'd central tower;
> When buttress and buttress, alternately,
> Seem framed of ebon and ivory;
> When silver edges the imagery,
> And the scrolls that teach thee to live and die;
> When distant Tweed is heard to rave,
> And the owlet to hoot o'er the dead man's grave,
> Then go—but go alone the while—
> Then view St. David's ruin'd pile;
> And, home returning, soothly swear,
> Was never scene so sad and fair!

Scott's description is representative of the attention given to medieval architecture as a result of the rising tide of Romanticism, historicism, and the Gothic Revival. Scott's own works, beginning with the *Lay*, greatly contributed to these trends. The results of his influence, which began with the first edition of this poem, can be seen in this mid-nineteenth-century edition. Filled and covered with medieval imagery, it illustrates the degree to which medievalism had permeated European and American culture by that time. (The early editions of Scott's works, like most other novels and poems of the time, were not illustrated. Later in the century illustrated printings were more usual.) This edition has numerous engravings of Melrose Abbey, Scottish castles, and knights and ladies. The large illustration at the opening of Canto II shows the great east window of the ruined abbey.

Medieval images cover the exterior of the book as well. The volume is bound in a "cathedral" binding, a type common in Britain and the United States from the 1820s to the 1840s. These bindings were another facet of the widespread medievalism of the nineteenth century, which Scott helped create. They typically have a large Gothic window decorating the cover, sometimes bordered by other architectural elements. Cathedral bindings were usually of embossed leather, and were most often used for Bibles, prayer books, and gift books—items that would be published in large quantities to absorb the cost of producing the stamping plate for the cover. That such an elaborate stamped cover was produced for this book may be an indication of Scott's great popularity. One of the few other cathedral bindings done for a work of fiction was also done for a Scott poem, *Marmion*.[3] This binding for the *Lay* is of leather-grained cloth; designers of cloth bindings followed current leather binding styles closely. The same design appears on the reverse, but without gold blocking. A. & C. Black's edition was available in two colors, red (or violet) like this copy, which is much faded on the front and spine, and an emerald green.[4]

Black's binding for the *Lay* appears to be somewhat unusual in that the elements represented on the cover, unlike those on most cathedral bindings, refer explicitly to the work it contains. The cover is not simply a generic Gothic or Gothic Revival window, but a stylized representation of the east (presbytery) end of Melrose Abbey, constructed in the 1390s.[5] The window tracery and the gable details are copied accurately and in correct

proportion. The very rectilinear tracery pattern is highly distinctive and virtually unique in English Gothic architecture. The undecorated base of the wall under the window has been filled with an arcade on the book cover. In addition, the pinnacled buttresses flanking the window have been broadened, and some of the architectural details changed. There are empty sculpture niches halfway up the abbey's buttresses. There are sculpture niches halfway up the cover's "buttresses" as well, but here they have been populated with figures. The three vertical elements above the figures parallel the three vertical elements above the sculpture niches on the real buttresses. The figures are not arbitrary, but represent some of the principal actors in the story. Although the tale takes place in the fifteenth and seventeenth centuries, these people have the look of an earlier time, another demonstration of the pervasive medievalism of the nineteenth century. The knight represents either William of Deloraine, the duchess's champion, or Lord Cranstoun, the leader of the rival clan and lover of the duchess's daughter. The Robin Hood-like figure is Watt Tinlinn, a person well known in Scottish border tales, who figures in the story as the individual who kidnaps the son and heir of the duchess. The minstrel himself is shown on the spine with the harp he used to accompany his recitation. The shields on the cover probably refer to the various families taking part in the climactic combat sequence of Cantos IV and V.

Although Scott achieved considerable contemporary fame with his early poems, he is best remembered today for his prose fiction, collectively referred to as the Waverly novels, after the title of the first of them. Modern readers are most likely to be familiar with his medieval novels, especially *Ivanhoe*, published in 1820, Scott's first novel with a medieval setting. *Ivanhoe* takes place in the time of Richard II, the Lionhearted, of England (1189–1199), and includes Coeur de Lion and Robin Hood as supporting characters. One of the great set pieces of the novel is the tournament at Ashby-de-la-Zouche, where Ivanhoe, the hero of the story, makes a dramatic appearance. Until the publication of *Ivanhoe*, all of Scott's novels had taken place in the Scotland of the recent past. *Ivanhoe* proved so popular that many of the novels he produced thereafter were set in medieval times.

As a staple of popular fiction, Sir Walter Scott was much read in the nineteenth and early twentieth centuries. His readers probably included many of our American collectors, although this is difficult to document. We know that Robert Gilmor III, the builder of Glen Ellen (Cat. 6), visited Scott at Abbotsford in 1828. Major American literary figures, such as James Fenimore Cooper and Washington Irving, also went there. We cannot be sure that the great collector of medieval art, J. P. Morgan (1837–1913), read Scott as a child, but his early library included a complete edition of Scott, and he went on to create one of the most important collections of Scott manuscripts and incunabula in the world. John D. Rockefeller, Jr., the patron of the Cloisters, the medieval branch of the Metropolitan Museum of Art, probably also read Scott. We know that Rockefeller visited Kenilworth Castle in England, the setting for a Scott novel of the same name, and suggested that the new Cloisters building (constructed 1935–1938) be modeled after it. A finished drawing for such a design was produced by his architect. Although most of this design concept was rejected in favor of architecture based on medieval religious monuments, the castle-like ramparts around the base of the finished structure stand as evidence of the long and pervasive influence of the medievalism of Sir Walter Scott on America.

A R

1. "Medieval Methods," *Nation* 60 (June 13, 1895): 456–57.
2. W. Minto, Editor's preface to *Lay of the Last Minstrel* by W. Scott (Oxford, 1886).
3. W. Scott, *Marmion, A Tale of Flodden Field* (London, 1839). See A. Beckwith, *Victorian Bibliomania* (Providence, R.I., 1987), 39, no. 24.
4. For a color photograph of the latter, see R. McLean, *Victorian Publishers' Book-Bindings* (Berkeley, 1973), 35.
5. For more about Melrose, see R. Fawcett, *Scottish Architecture...1371-1560* (Edinburgh, 1994), 28–33, 42.

4. Sketch for Past

Thomas Cole (1801–1848)
American, 1838
Oil on cardboard,
21.5 x 32.2 cm
Mead Art Museum,
Amherst College,
Museum Purchase
1951.338
Ex. coll. Estate of the artist
by descent to his granddaughter,
Mrs. F. Cole Vincent,
Catskill, New York

Color plate (p. 5)

Thomas Cole's pendant paintings *Past* and *Present* (represented here by these oil sketches) serve to illustrate Morton Bloomfield's definition of nineteenth-century medievalism: ". . . the idealization of medieval life and culture, with an emphasis upon a rich mysterious and imaginary world of nobility, honor, class-consciousness, defenders of women, battles and so forth, that it was believed, flourished in the Middle Ages."[1] That Cole entertained such Romantic notions is evident, not only in these paintings, but also in a letter dated May 22, 1831, written during his trip down the Rhône River in southeast France:

> Crowning the abrupt precipices which sometimes rise into very grand forms, are numerous castles in ruins . . . these castle views carry the mind back to feudal times through the crumbling gate-ways fancy easily calls forth the steel clad warriors, and sounds the trumpet, or sees the dark-eyed ladies looking through the narrow windows of the mouldering towers for the return of their beloved knights from the wars.[2]

Although this passage generally describes these paintings, a specific castle on the Rhône serving as a model for *Past* and *Present* has not been identified. Indeed, a sketch of Italian ruins very similar to those depicted here is in the collection of the Detroit Institute of Arts. Variations on the ruined tower theme can be found in other Cole sketches of the period, namely, *Ruined Tower*, c. 1832 (Albany Institute of History and Art) and *Landscape Composition: Italian Scene*, 1831–32 (Memorial Art Gallery, University of Rochester, New York). It has been suggested that ruins at Nemi and Tivoli may have served as preparation for *Present*. Several years later, Cole worked these sketches into finished paintings, popularizing and moralizing upon aspects of European culture for the American public. For example, the ruin shown in *Present* reappears in *Landscape with Tower in Ruin*, dated 1839 (Currier Gallery of Art, Manchester, New Hampshire).[3]

Thomas Cole's biography helps us understand his experiments with medieval themes. Cole emigrated from England with his family when he was eighteen years old. After having worked in Ohio, Pennsylvania, and New York, he desired to travel to Europe to study the work of the Old Masters, as well as of contemporary artists. His trip (1829–1831) was funded by an advance from Robert Gilmor, Jr., a Baltimore art connoisseur whose collecting included medieval manuscripts (Cat. 9). But Cole was disenchanted with the paintings he saw there, finding solace only in the work of Claude Lorraine and Ary Scheffer. Instead, he studied and sketched from nature and filled notebooks with Romantic drawings of ruined castles and picturesque landscapes. When he returned to the United States from his first trip abroad (he was to make another journey in 1841–2), he began a series of painting cycles on moralizing and historical themes, emphasizing the transience of life, culture, and society—sobering thoughts for a country so young and optimistic about its future.

Cole's first great cycle was *The Course of Empire* (The New-York Historical Society). This series of five paintings, made between 1834 and 1836, features a Greco-Roman society to illustrate the contemporary notion of the cyclical nature of history as one of growth and decay. Gilmor was solicited to finance the paintings but declined. A few years later, Cole produced two more abbreviated cycles, both featuring medieval subject matter. In 1837, Cole created for William P. Van Rensselaer of New York a two-painting cycle: *The Departure* and *The Return* (The Corcoran Gallery of Art, Washington, D.C.), which he later subtitled "Scenes Illustrative of Feudal Manners and Times." The following year he created a similar pair of paintings, *Past* and *Present*, for another New Yorker, Peter Gerard Stuyvesant. Aside from these cycles, Cole also produced a few other large paintings that included medieval subject matter: the well-known *Architect's Dream*, 1840 (Toledo Museum of Art), which includes in the foreground a Gothic church; and *The Return from the Tournament*, 1841 (The Corcoran Gallery of Art, Washington, D.C.), which shows a state barge returning to a riverside castle. The ruins shown in *Present* also reappear in the medium-sized *Landscape with Tower in Ruin* of 1839 (Currier Gallery of Art, Manchester, New Hampshire).

The finished versions of *Past* and *Present* were shown in New York at the American Art Union Memorial Exhibition of 1848, the year of the artist's death. Cole wrote the catalog entries himself:

> The Past. In this picture the artist has attempted to represent the Castle of some Prince or Noble of the middle ages, in its primal strength and magnificence. A Tournament is passing beneath its walls. Two Knights are tilting before the assembled multitude of Nobles and Peasantry. Fronting the spectator, is the Royal Pavillion [sic], and immediately in the foreground of the picture, the Throne of the Queen of Beauty, and on the left are the Tents of the Knights, Challengers, etc. The artist has endeavored to depict the Tournament with the strictest regard to "Costume," and the whole scene is intended to be an illustration of Feudal power and splendor.

The Present. The scene of the last Picture is still before the spectator; but greatly changed. The Halls of the Castle are roofless; the sunlight and breezes play on the weeds and flowers, which cling to their ruined arches. The massive and lofty tower that seemed to bid defiance to man and the elements, is dilapidated and crumbling to decay. A stagnant pool stands on the tilting ground, and a solitary Shepherd feeds his flock where once stood the Royal Pavilion and the Throne of the Queen of Beauty.[4]

American collectors were inclined to purchase portraits, landscapes, and genre scenes. History and religious paintings were not well received by a predominantly Protestant public that had just severed its political ties with the Old World. For similar reasons, art showing medieval themes was also widely ignored by collectors. But Cole sugarcoated his allegories of transience in the leafy mantle of landscape painting, a pill much easier for American patrons to swallow.

C S

Literature: F. A. Sweet, *The Hudson River School and the Early American Landscape Tradition*, Chicago, 1945, 66 and 118; L. A. Shephard et al., *American Art at Amherst: A Summary Catalogue of the Collection at the Mead Art Gallery*, Middletown, Conn., 1978, 51.

1. M. Bloomfield, "Reflections of a Medievalist: Americanism, Medievalism, and the Middle Ages," eds. B. Rosenthal and P. Szarmach, *Medievalism in American Culture* (Binghamton, N.Y., 1989), 14. The finished paintings are also in the collection of the Mead Art Museum at Amherst College. For these paintings, see H. S. Merritt, *Thomas Cole* (Rochester, N.Y., 1969), nos. 33 and 34; and *Thomas Cole Landscape into History*, eds. W. H. Truettner and A. Wallach (New Haven, Conn., 1994), 98.

2. Quoted in L. L. Noble, *The Life and Works of Thomas Cole* (Cambridge, Mass., 1964), 90.
3. For other ruined towers, see B. Chambers, "Thomas Cole and the Ruined Tower," *Currier Gallery of Art Bulletin* (1983): 2-32; E. C. Parry, *The Art of Thomas Cole: Ambition and Imagination* (Newark, N. J., 1988); and E. A. Powell, *Thomas Cole* (New York, 1990), 60.
4. Quoted in L. A. Shephard et al., *American Art at Amherst* (Middletown, Conn., 1978), 52–53.

5. Sketch for Present

Thomas Cole (1801–1848)
American, 1838
Oil on cardboard,
21.1 x 32.3 cm
Mead Art Museum,
Amherst College,
Museum Purchase
1951.339
Ex. coll. Estate of the artist
by descent to his granddaughter,
Mrs. F. Cole Vincent,
Catskill, New York

Color plate (p. 5)

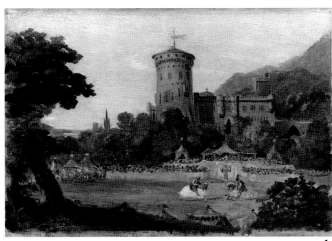

4

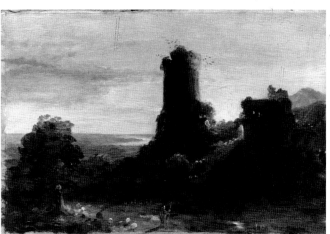

5

6. *Design for Glen Ellen, home of Robert Gilmor III, Towson, Maryland*

Alexander Jackson Davis (1803–1892)
American, 1832–1833
Design by Ithiel Town (1784–1844)
and Davis
Watercolor, ink and graphite on paper,
55.2 x 39.7 cm
The Metropolitan Museum of Art,
Harris Brisbane Dick Fund, 1924
24.66.17

*G*len Ellen, designed in 1832 as a country house for Robert Gilmor III (1808–1875) of Baltimore, was one of the major landmarks of Gothic Revival architecture in the United States. The architectural firm of Town and Davis, which was responsible for the design, was one of the major proponents of that style. Ithiel Town's earlier Gothic efforts included Trinity Church, New Haven (1813), and the New York University building in New York City, but he was primarily a classicist until he was joined in 1829 by Alexander Jackson Davis (1803–1892). Davis, who began his career as an architectural draftsman (perhaps the best in the United States at the time), went on to become the first great architect of the American Gothic Revival, helping to make medieval revival styles dominant throughout much of the nineteenth century. He was also the primary architectural influence on Andrew Jackson Downing, who, in turn, had a massive impact on American taste, making Gothicisms ubiquitous (Cat. 7, 8).[1] Glen Ellen itself is important as a monument because of its place as the first truly Gothic Revival residence in America, leaving aside its classically symmetrical antecedents, such as Benjamin Latrobe's Sedgely outside of Philadelphia, built in 1799.

It is thought that Robert Gilmor III decided to build a Gothic Revival house after going to Scotland in 1828 (his grandfather had emigrated from there before the American Revolution), and visiting Abbotsford, home of Sir Walter Scott, whom he admired. Scott, author of numerous poems and novels set in the Middle Ages, built the neo-Gothic Abbotsford for himself between 1812 and 1815 (Cat. 3). Many of his American readers came to visit the great author, Robert Gilmor III among them, and many were apparently impressed by Abbotsford, one of the greatest examples of Gothic Revival in Scotland.[2] Upon his return from Europe, Gilmor commissioned the design for Glen Ellen, which was named after his wife, with the addition of Glen to give it a Scottish touch. Like Abbotsford, Glen Ellen had a polygonal corner tower rising above the structure's mass. The asymmetry of Abbotsford, one of the main components of the Neo-Gothic Picturesque, is clearly reflected in Glen Ellen's ground plan. This asymmetry places Glen Ellen in the forefront of the American Gothic Revival, as "the first American house since the seventeenth century to be deliberately designed with an off-center balance."[3] Glen Ellen's site, too, was picturesque. Approached by a road leading in

from a gate house disguised as a Gothic ruin, the house sat on a rise overlooking the Gunpowder River.

Davis's presentation drawing for Glen Ellen shows two stages of the design. The uppermost view gives the original project for a two-storey elevation, and the lower view gives the one-storey house as executed. The ground plan shows the larger axis of the building, reserved for the family, crossed at right angles by a counteraxis of three reception rooms *en suite*: an entrance hall, a circular saloon, and a library, ending in a strongly projecting polygonal bay window with Gothic tracery. The cross-axis also includes an enormous parlor to the right, which opens onto a curved veranda bordered by a Gothic arcade.

Although much of Gilmor's inspiration for Glen Ellen may have come from Scott and Abbotsford, there is another possible source nearer to home for his medievalizing tendencies: his uncle, Robert Gilmor, Jr. (1774–1848). Robert Gilmor III was named after his uncle and apparently was very close to him, since the elder Gilmor and his wife were childless. Robert Gilmor, Jr., inherited a large fortune and, while managing the family's investments, privately indulged in his passion for art. He was known in his day as one of the greatest American collectors of Old Master paintings and as a patron of living American artists, among them Thomas Cole and Horatio Greenough. He was also one of the first Americans to take an interest in medieval art and to collect it, in the form of illuminated manuscripts.[4] Among the many volumes in his extensive library, of which Gilmor was very proud, were a dozen medieval manuscripts. One of them, a Book of Hours, was purchased as early as 1807 (Cat. 9). Gilmor housed his books and manuscripts, as well as some of his art collection, in a Gothic library described by Horatio Greenough in 1828 as "finished in the Gothic style receiving the light through a painted window."[5] Thus, Robert Gilmor, Jr., had a Gothic library complete with stained glass windows, a collector's cabinet in the manner of an eighteenth-century English Romantic collector. Gilmor's town house, where the library was located, was destroyed long ago, but it was presumably of Georgian or Federal design. Although it is not known to which architect or builder Gilmor turned for the "Gothicization" of his library, nor when this took place, Greenough's description of 1828 makes it one of the earliest documented Gothic Revival libraries in this country and

demonstrates that it was most likely in place before Robert Gilmor III visited Abbotsford. This, coupled with the elder Gilmor's possession of medieval manuscripts, suggests that Robert Gilmor III may have developed his appreciation of the medieval and the Gothic Revival not from Sir Walter Scott and Abbotsford, but from his uncle right at home in Baltimore. Glen Ellen's traceried windows may be partly inspired by a Scottish precedent, but the ground was made fertile by the example of Robert Gilmor, Jr.'s library.

1. See *Alexander Jackson Davis: American Architect 1803-1892*, ed. A. Peck (New York, 1992).

2. W. H. Pierson, Jr., "Technology and the Picturesque: The Corporate and the Early Gothic Styles," *American Buildings and their Architects*, vol. 2, pt. 1 (Garden City, N.Y., 1978), 290–91.

3. Ibid., 295.

4. For a general discussion of Robert Gilmor, Jr., as a collector, see above, E. Smith, "The Earliest Private Collectors: *False Dawn* Multiplied."

5. *Letters of Horatio Greenough to his Brother, Henry Greenough*, ed. F. B. Greenough (Boston, 1887), 36. For the complete text of Greenough's description, see Smith, "The Earliest Private Collectors."

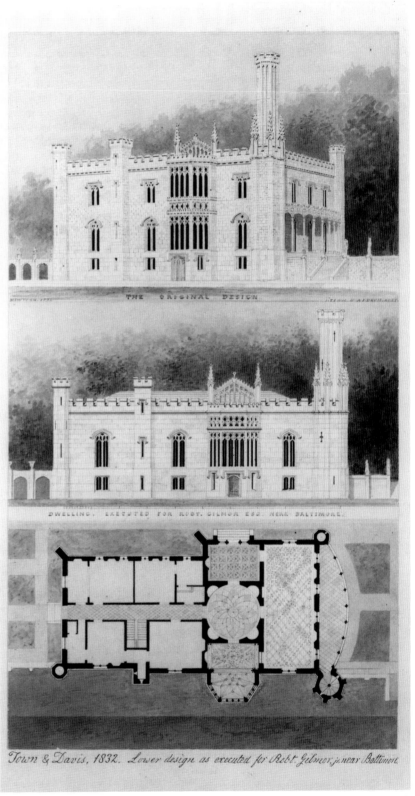

THE ORIGINAL DESIGN

DWELLING, EXECUTED FOR ROBT. GILMOR ESQ. NEAR BALTIMORE.

Town & Davis, 1832. Lower design as executed for Robt. Gilmor, jr near Baltimore

6

Fig. 276 shows a high-backed armchair, which Downing considers "too elaborate and ecclesiastical;" Fig. 277 shows a chair that he calls "quaint," a positive term for Downing; and Fig. 278 represents a chair that is "the most chaste and refined of the three, and, if made rather smaller than here shown, [it] would be a very suitable drawing-room chair for a villa in this style." Downing also apparently approves of the dining-room table illustrated in Fig. 281 on p. 447, noting it is of oak, it extends to seat sixteen, and it can be had from Mr. Roux in New York.

Part III, the final section in the chapter on furniture, is entitled "Furniture in the Elizabethan and Romanesque Styles." Although Downing seemingly lumps these two together, he acknowledges their real differences. Romanesque furniture he finds useful only in entrance halls in Romanesque or Norman houses, as he fears that "most of the furniture designed in this antique Romanesque or Norman manner is too clumsy and heavy for modern use" (p. 460). Overall, Downing prefers Elizabethan furniture to Romanesque. In fact, he goes so far as to prefer it to Gothic furniture, even in Gothic houses, because it is intrinsically picturesque and "more domestic than strictly Gothic furniture." He even suggests that readers look for examples of authentic Elizabethan furniture, as "many fine specimens . . . brought out by the Puritans from England" are still to be found in New England (p. 451).

Country Houses was, like Downing's other books, heavily read in his day and, thus, highly influential. It was reprinted many times and inspired later publications on interior design, such as *The House Beautiful*, New York, 1878, by Clarence Cook, who in his youth had studied with Downing.[8] And although Downing may not have wholeheartedly believed in the viability of furniture in the Romanesque and Gothic styles in domestic settings, the fact that he extensively illustrated and discussed them in *Country Houses* assured that in the 1850s these styles were well known by his readership, that is to say by much of middle class America.

1. J. B. Davies, "Davis and Downing: Collaborators in the Picturesque," *Prophet with Honor: The Career of Andrew Jackson Downing, 1815-1852* (*Dumbarton Oaks Colloquium on the History of Landscape Architecture*, 11), eds. G. B. Tatum and E. B. McDougall (Washington, D.C., 1989), 81–123, esp. 119–20.
2. Ibid., 119–20.
3. K. L. Ames, "Downing and the Rationalization of Interior Design," *Prophet with Honor*, 191–217, esp. 209.
4. Ibid., 192.
5. Ibid., 213.
6. Davies, 122.
7. Ames, 215.
8. Ibid., 213–14.

extended along both sides or all round the library The spaces below, afford excellent closets for pamphlets and manuscripts, and the busts of distinguished men, in different departments of letters, may be so placed along the top as to designate to what particular class of books the space directly below is allotted.

[Fig. 276.]　　　[Fig. 277.]　　　[Fig. 278.]

Drawing-room and library chairs in the Gothic style are generally expensive and elaborate, being covered with rich

stuffs, and highly carved. Fig. 276 is an arm chair in the English taste, partly Elizabethan and partly Gothic. Fig. 277

[Fig. 280.]

is a quaint arm chair, very suitable for the library. Fig. 278 is the most chaste and refined design of the three, and, if made rather smaller than here shown, would be a very suitable drawing-room chair for a villa in this style. The top of Fig. 276 is too elaborate and ecclesiastical in character for most private houses—or, at least, only one or two such chairs, at the most, are all that should ever be introduced there. We much prefer, when richness is requisite, to get it, in Gothic furniture, by covering rather plain and simple designs with rich stuffs, rather than by the exhibition of elaborate

[Fig. 281.]

Furniture in the Gothic Style.

8

9. Book of Hours

Boucicaut Master Workshop
France, Ile-de-France, c. 1420
Tempera and gold on parchment, 13.3 x
10.2 cm
Library of Congress, Rare Books and
Special Collections Division
MS 56
Ex. coll. J. M. Winkler, Baltimore; R.
Gilmor, Jr., Baltimore

Color plate (p. 6)

Book of Hours for use at Paris, c.1420,
221 folios; in Latin, with French rubrics
in red; written in one column of 14 lines
(textblock ca. 75 x 47 mm), the calendar
in 17 lines, in French.

Contents: Fols. 1-12v, calendar; fols. 13-
18, Gospel readings; fols. 18v-20v,
Passion of John; fols. 21-73, Hours of
the Virgin; fols. 74-93v, Penitential
Psalms and Litany; fols. 94-112, Office
of the Dead; fols. 113-118v, Hours of the
Cross; fols. 119-124v, Hours of the Holy
Spirit; fols. 124v-221v, Prayers [fols.
124v-200; with *Obsecro te* (variant) on
fols. 200-201v; Marian prayers on fols.
201v-208v; prayers to guardian angel
on fols. 209-212v; *Obsecro te* on fols. 213-
217; and *O intemerata* on fols. 217-221v].

Decoration: Five extant miniatures sev-
eral lines high decorate the manuscript;
the others have been excised (fol. 21,
Annunciation; fol. 33, *Visitation*; fol. 45v
[Color Pl.], *Adoration of the Child*; fol. 93,
Dead man and battle for the soul; fol. 176v,
Trinity [shown]). Each miniature is
within a gold, arched frame outlined in
black penline. Miniatures consist of
monumental figures in the foreground
and fully developed architecture or
landscapes in the middle and back
grounds. The palette consists of blue,
orange, pink, red, deep red-violet,
green, black, and some silver, gold, and
gold leaf. Minor decoration consists of
acanthus-leaf bar borders (now slightly
trimmed) in the left and gutter margins
of every page. Those on the miniated
pages are especially elaborate, filling all
four margins.

Created at Paris for a certain Phillipus
around 1420, who, according to
Schutzner, "may have had reservations
about religious orders," this manuscript was
identified by Millard Meiss as a late produc-
tion of the Boucicaut Workshop.[1] The shop
produced a remarkable range of manuscripts,
although its output has not been assessed
since Meiss did so in his monograph on the
Boucicaut Master. Noted for introducing strik-
ing stylistic and iconographic innovations into
the Hours begun around 1405 for the
Maréchal de Boucicaut, the Boucicaut Master,
active at Paris to around 1417, became an
influential force in manuscript illumination in
the early fifteenth century. Erwin Panofsky,
who was the first to recognize the Boucicaut
Master's contribution to new directions in
manuscript decoration, observed the painter's
interest in naturalism, developed interiors,
and the use of landscape and aerial perspec-
tive.[2] Panofsky, and later Meiss, added that the
master's originality lay in the ability to com-
bine fresh approaches to naturalism with mon-
umental figures, dynamic color patterns, and
fantastic skies—all hallmarks of the Boucicaut
style.[3]

The decoration of the Library of Congress
manuscript exhibits these traits to an
admirable degree. Monumental form united
with naturalistic detail is illustrated, for exam-
ple, in the miniature of the *Annunciation*, and
the figures of the *Visitation* miniature are
painted in a similar manner. The Virgin gath-
ers the folds of her robe in her right hand,
although her left hand is awkwardly extended
to grasp that of Ann's. Ann kneels slightly, a
format seen at the beginning of the fifteenth
century in Flemish manuscript illumination,
although at the Arena Chapel the type was
pioneered in the work of Giotto.[4] The blend of
large figures, naturalistic gestures, and espe-
cially expressive glances is, according to
Meiss, typical of the Boucicaut style.[5] Figures
are static yet heroic and never emotive. It is
"scope, rather than excitement," as Meiss
explained, that characterizes the Boucicaut
style, anticipating van Eyck and the
Netherlandish tradition.[6]

The influence of the Boucicaut Master on our
artist is most fully expressed, however, by the
interest in sophisticated landscapes, especially
that depicted in the *Visitation* miniature. The
story, after Luke I:39–56, recounts how the
Virgin went into the hill country to see her
cousin, Elizabeth, who was the first to hear the
news of the Incarnation.[7] In the foreground,

the Virgin and Ann stand in an open space of
lush greenery that gives way in the middle-
ground to upward-sweeping rock. These
motifs are traceable to trecento painting and
were first adopted by Jean Pucelle, but in this
manuscript—as in the Boucicaut Hours—they
become organic forms.[8] Modeling of the
mountainous shapes is achieved with delicate
brushstrokes of alternating bands of yellow-
ochre, brown, and green, and the light green
and yellow leaves of the trees are highlighted
with fine brushstrokes of dark green and
flecks of yellow-brown.[9] The illuminator's
penchant for detailed observation is illustrated
by both the wooden plank bridge crossing the
silver-colored stream as it flows beneath the
arch of the fortifications, and by the architec-
tural details of the town.[10] Last, the rock forms
and the forests of trees are ingeniously placed
to the sides of the miniature, providing an
uninterrupted vista of the fortified town in the
background, like the *Visitation* landscape in
the Boucicaut Hours. It is, above all, the deep
blue sky of atmospheric haze combined with
dazzling light that connects this manuscript
with the innovations of the Boucicaut Master.
At the top of the miniature is a dark cloud-like
mass from which emanates gold, unnaturalis-
tic, serpentine rays; star-like crosses shine on
the town below, with reflected sun rendered as
strokes of orange brushwork on the architec-
tural forms.[11] While illuminators, such as
Jacquemart de Hesdin and the Limbourg
Brothers, began to paint city and townscapes
around the same time as the Boucicaut Master,
it was the latter who skillfully depicted, as
seen in this manuscript, expanses of space by
way of light, color, and atmospheric effects.[12]

The interest in depicting light and the effects of
light that characterizes stylistic changes associ-
ated with early fifteenth-century painting may
also express the influence of mystical writings
that became increasingly popular in the four-
teenth and, especially, fifteenth centuries. From
early on, metaphors of light were used as a
means of explaining Christian mysteries, and
light was equated with the creator, beauty, and
the harmonic order of the universe.[13] These
ideas were given fresh impetus by Suger and
the scholastics, who rediscovered the writings
of the pseudo-Dionysius in the twelfth century,
and were made popular by the mendicants in
writings such as the *Meditations on the Life of
Christ*, where the soul in contemplation is ". . .
dwelling in light"[14] Metaphors of light were
especially popular as a means to describe the
Virgin and may perhaps relate to the celestial
imagery of the *Visitation* miniature. From early

on, she was identified both with the beloved spouse in the Canticle VI:10 who was as "clear as the sun" (*electa ut sol*) and the woman "clothed with the sun" (*mulier amicta sole*) mentioned in Revelations XII:1, which in the fourteenth century was translated into the devotional image of the Madonna of Humility surrounded by the sun, moon, and stars.[15] The Virgin was *astrum maris* and *stella maris*, the morning star that, for Bernard of Clairvaux and others, was the guiding light of faithful pilgrims, and invoked in the antiphon *Ave maris stella* of the Office of the Virgin.[16] The stars and sunburst depicted in the Library of Congress Book of Hours recall the Virgin's celestial character suggested, for example, in Wisd. of Sol. VII:29, where the beloved is described as ". . . more beautiful than the sun, and above the whole ordering of the stars; when compared with light, she is found before it."[17]

The miniature of the *Visitation* and those decorating the remainder of the manuscript reflect the changes introduced in illumination by the Boucicaut Master, who successfully interwove trecento sources into compositions and drew inspiration from contemporaries, such as Hesdin, who explored new approaches to naturalistic representation.[18] The Boucicaut Master, however, and those who came after, such as our artist, never entirely abandoned the decorative elements associated with Parisian manuscript illumination. These included the extensive use of gold and, as in the Library of Congress manuscript, the music-making angels and hybrid creatures in the border decoration.[19] The crosscurrents represented in illumination around 1420, raise, rather than answer, questions of artistic interchange in fifteenth-century Paris and call for, as J.J.G. Alexander recently did, a reevaluation of terms, such as "workshop" and "follower," used by Meiss to describe the artists associated with the Boucicaut Master—including artists of the Library of Congress Book of Hours.[20] The similarity of modest format and decoration among the Hours associated with artists influenced by the Boucicaut Master illustrates both the ongoing trend towards the standardization of manuscript production and the widening sphere of lay patronage in fifteenth-century Paris, which would include a literate bourgeoisie with resources to purchase books.

In addition to its connection with fifteenth-century innovations in Parisian illumination, the modern history of this Book of Hours is of special interest. It was purchased in Charleston in 1807 by Robert Gilmor, Jr., of Baltimore, whose family operated a great commercial house.[21] In his *Memorandum about my family and self*, Gilmor relates that his first wife died in 1803 after only eleven months of marriage, after which he traveled north to Quebec. There he became ill with a chest cold, and his physician recommended he spend the winter of 1806 in a milder climate. He went to South Carolina, arriving in January of 1807, where he met Sarah Reeve Ladson, of the Ladsons of Charleston, and married her that April.[22] His purchase of the Library of Congress Book of Hours shortly after arriving in Charleston is the earliest known instance of an illuminated manuscript to have been acquired by an American collector.[23]

From whom would Robert Gilmor, Jr., have purchased such an object? Despite the presence in Charleston around 1800 of a wealthy planter aristocracy, patronage was largely of portraiture and decorative arts.[24] That interest in supporting fine art in Charleston was slight is further evidenced by the fact that an academy for art that was not even chartered until 1821, well after other major post-colonial cities, such as New York, Philadelphia, and Boston, had established art societies and public collections in the early nineteenth century.[25] Charleston, however, by 1800 had nevertheless emerged as not only the commercial hub of South Carolina, but also its intellectual and cultural center as well.[26] Several possible sources for Gilmor's purchase existed.

There were, for example, in and around Charleston at the turn of the century, collectors among the affluent landowners and merchants, and Gilmor bought from at least one of them. They had become wealthy with the development of the rice and cotton trade, and prosperity continued. The cotton market increased eightfold between 1794 and 1804 after the invention of the cotton gin in 1793.[27] Their aristocratic status was assured through intermarriage and the tradition of providing land grants to family members and the favored.[28] Their resources allowed them to travel widely and for extended periods of time in Europe, where they purchased art to add to their collections. There was, for example, William Brisbane (1759–1821), a slightly older contemporary of Gilmor, who sold a portion of his estate to finance his travels and passion for collecting art.[29] John Izard Middleton (1785–1849), whose family had plantations along the Ashley River and Goose Creek near Charleston, lived most of his life in Italy and

Paris, where he moved in the circle of Madame Récamier and Madame de Staël. His interest in antiquities culminated in his early contribution to the field of classical archaeology, *Grecian Remains in Italy, a Description of Cyclopian Walls and of Roman Antiquities*, a collection of his drawings of classical sites made with a camera obscura and published in London in 1812.[30] Although it is unknown if Robert Gilmor, Jr., purchased art from either Brisbane or Middleton, he did so from Joseph Allen Smith (1769–1828), also a wealthy planter with marriage connections to prominent Carolina families—the Wraggs, Elliots, Gibbes, and Izards.[31] Like many of his contemporaries of the leisure class, Joseph Smith went to Europe, traveling for fourteen years, first to London in 1793, then to France in 1800, and later to Russia—one of the earliest journeys to the east.[32] Smith is distinguished for not only having been an early collector, but also, inspired by the sculpture galleries he had seen in Florence and Rome, for having been the first to collect with the intent of bringing art to America to create a public gallery.[33] His half-brother, William Loughton Smith (an uncle of Gilmor's wife, Sarah), who had traveled with Joseph to Amsterdam, returned to America in 1804 and brought with him much of the collection, which consisted of sculpture, plaster casts, engravings, coins, and gems. A portion was presented to the Charles Willson Peale Museum in Philadelphia, then located on the second floor of Independence Hall, and it was later transferred to the Pennsylvania Academy of the Fine Arts—the first donation to the institution.[34] William Loughton Smith, to whom Joseph Smith would give a portion of his collection, arranged for the collection to be displayed in Charleston at the home of the city's wealthiest merchant, Gabriel Manigault.[35] Smith, however, spent most of his adult life abroad, and it is perhaps more likely that a manuscript would have become available to Gilmor through either an individual with a private library or a bookdealer established at Charleston. By the third quarter of the eighteenth century, thirty firms at Charleston publicized the sale of books.[36] The most significant was Robert Wells, who boasted the largest selection of books in America in his Great Stationery and Book Store on the Bay. Other booksellers included Woods, Viart, and the Timothy family who had started their business in Philadelphia with the help of Benjamin Franklin.[37] These merchants advertised to the public in local newspapers, but individuals also purchased directly from abroad, such as Henry Laurens or Peter Manigault

(1731–1773), the latter having the largest private library in colonial South Carolina.[38] In addition to imports, books had also been brought over by the early settlers.[39] By the close of the American Revolution, personal libraries were found in the homes of South Carolina merchants, planters, professionals, and artisans.[40] It is not impossible that manuscripts were among the books of these earliest libraries, such as the fourteenth-century Bible brought to Charleston in the late eighteenth century from Cornwall by a lawyer named Parsons, who had a substantial collection of books in Latin, Greek, French, Spanish, Italian, and English.[41] Although it is not illuminated, the manuscript's elaborate red and blue filigree initials and clear, precise, page layout are characteristic of the fine, diminutive pocket Bibles made in Paris and northern France in the thirteenth and fourteenth centuries.[42] The later history of this Bible at Charleston is typical of private libraries of the colonial era, the contents of which were often sold at auction at the time of the owner's death, or changed hands through inheritance and private purchase.[43] Parsons's Bible was bought at a public sale by a Mr. Sutliffe, who then offered it to Reverend Daniel McCalla, pastor of the Independent Church near Charleston.[44] Other individuals who brought libraries with them when they emigrated to South Carolina include, for example, Peter Porcher (d. 1753), a French Huguenot descendant like Laurens and Manigault, who owned a considerable number of books in French.[45]

In fact, a substantial number of people who were either French or of French descent were found in Charleston in the late eighteenth and early nineteenth centuries, and it may also be by way of a cultivated bibliophile associated with this community that Gilmor came into contact with the Library of Congress Book of Hours. The history of Charleston's rich French culture begins with the Huguenots. In 1685, responding to Louis XIV's revocation of the Edict of Nantes (issued by Henry IV in 1598 granting religious freedoms for Protestants) the Huguenots left France for London, Rotterdam, Amsterdam, and Geneva—the principal Protestant refugee centers in Europe.[46] As a means of attracting settlers, South Carolina promoters distributed French-language pamphlets in London, such as *Nouvelle relation de Caroline* and *Plan pour former un établissement en Caroline*, which described opportunities including substantial land grants.[47] The response was significant, and between the 1670s and 1690s the largest

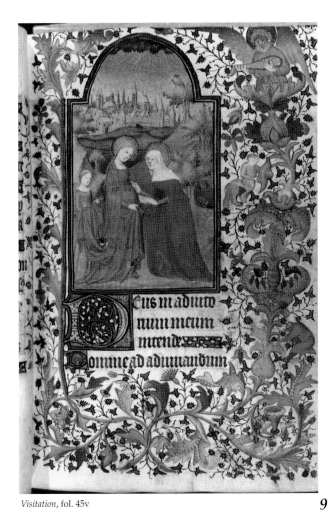

Visitation, fol. 45v **9**

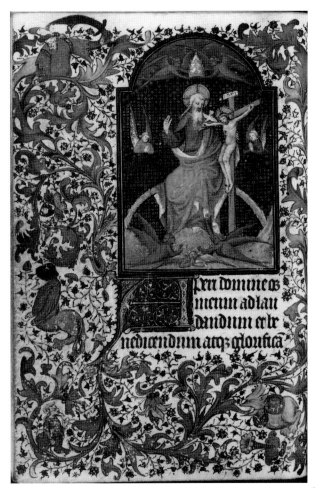

Trinity, fol. 176v **9**

emigration of French Protestants to the new world was to South Carolina. This group was composed of bourgeois skilled artisans, merchants, and craftsmen, as well as propertied individuals, such as Peter Huger and Pierre Gaillard, who brought their servants and some individuals of aristocratic lineage, such as pastor Elias Prioleau.[48] The Huguenots in colonial South Carolina soon constituted between ten and fifteen percent of the population, and their names figure among the province's uppermost families: Gaillard, Gourdin, Laurens, Légaré, Le Jau, Manigault, Mazÿck, Poinsette, Porcher, Prioleau, Ravenel, and St. Julien, as well as names such as Timothée, mentioned above, that were Anglicized.[49] The French Huguenots played a prominent role in the political, economic, and religious life of the colony, and their wealth allowed them to patronize Charleston portraitists, such as Jeremiah Theus and Henrietta Johnson; fully one-third of Johnson's clientele between her arrival in 1707 and 1728, the year of her death, were

French Huguenot families.[50] The considerable stature of the Huguenots in the community was noted as late as 1766 in an account of the Huguenot parish at Charleston—the only French Protestant church in the United States to survive to the present day—where the congregation was described as "Rich, & well endow'd."[51] Books figured among the possessions of the prosperous Huguenots and their descendents. In addition to the example of Laurens, Manigault, and Porcher mentioned above, Mary Marion owned a French prayerbook at the time of her death in 1750, and Peter Benoist left a "very good folio Bible" in silver mounting.[52]

There were at Charleston other individuals of means within the French community, which grew between 1790 and 1810 when refugees arrived both from French Saint Dominigue in the West Indies after the slave rebellion as well as from revolutionary France.[53] Charleston was second only to New Orleans in the number of

emigrés it attracted, and a large number participated in the intellectual and cultural life of Charleston.[54] Two French-language newspapers were published by refugees, *Le Patriote Français* and *L'oracle, Français-Americain*, a bilingual paper printed between 1807 and 1808 by John James Negrin from Saint Dominigue, who advertised in his newspaper the sale of books out of his shop.[55] In 1794, a French theater was established by Paris-born Alexander Placide (1750–1812), and he also developed the French-style ornamental gardens at Vaux Hall.[56] In addition to the French comedians, musicians, acrobats, dressmakers, and landscape gardeners associated with Placide's enterprises, there were many other French expatriates residing at Charleston, among them aristocrats who supported themselves by practicing "genteel accomplishments" as mathematicians, language teachers, architects, and portraitists such as Févret de St. Mémin.[57]

Indeed, there was at Charleston on either side of 1800—as elsewhere in the United States at that time—a great interest in and a vogue for French culture, manners, and customs that grew out of sympathy for the ideals of the French Revolution. French patriotic clubs sprang up in all of the major cities, although the first of six and the most active was in Charleston, affiliated with the Jacobin clubs in Bordeaux, Paris, and Saint Dominigue.[58] The revolutionary spirit in Charleston was expressed by the public display of the American and French colors at public events, the popularity of the Marseillaise, and the *fetes civiques* celebrating the fall of the Bastille, which were described in the Charleston *City Gazette* as rivaling those that might have been held in France.[59] Although it would be impossible to survey the subject, the preference of the leisure class in Charleston for Gallic fashion was seen in the enthusiasm for Empire dress, hairstyles, and even French cuisine.[60] Ships, too, arrived regularly from Bordeaux, Le Havre, Nantes, and Marseilles, and their cargoes of luxury goods were advertised in the Charleston newspapers.[61] The French upholsterer Mr. De L'Orme, for example, publicized that among his merchandise was ". . . an assortment of handsome paper hangings from Paris, in the latest taste, some emblematic of the late Revolution."[62] La Rochefoucauld-Liancourt observed the Carolina preference for French fashion when he wrote in his *Voyages dans les États-Unis d'Amérique*: ". . . la plupart des riches habitans de la Caroline du Sud, ayant été élevé en Europe, en ont apporté plus de goût, et des

connaissances plus analogues à nos moeurs, que les habitans des provinces du Nord, ce qui doit leur donner généralement sur ceux-ci de l'avantage en société."[63] The extent to which French culture penetrated Charleston in the early nineteenth century was also noted by the Baron de Montlezon, who remarked in his travel diaries that there were quarters where only French was spoken and ". . . entire streets where one only sees French shops."[64] Although it would not be possible to trace our manuscript to one of the privileged emigrés—or a descendent—living in Charleston, perhaps their presence combined with the vogue for French culture and manners may have interested Gilmor in an object of French origin such as a Book of Hours.

The Library of Congress Hours was not the only manuscript Gilmor would purchase, however. At the time of his death in 1848, according to A. Rutledge, he owned twelve manuscripts, which are listed in the catalogue Joseph Robinson published in 1849 of Gilmor's library of over two thousand books.[65] Among the manuscripts catalogued is "An old Roman Breviary, of the 14th century," probably our Book of Hours, which has a flyleaf inscription incorrectly identifying it as such.[66] Other manuscripts mentioned are: "Bible in black letter, on vellum, illuminated; Manuscript Missal of 14th Century; Manuscrit de Lile D'Elbe; Manuscript of the 15th Century," and "Seven Manuscripts of 14th Century." It is unknown if the Bible just mentioned is the one at Princeton University Library, MS Garrett 28, a thirteenth-century English Bible purchased for Gilmor in 1832 by Obadiah Rich (1783–1850) of Boston from the collection of London bookdealers John and Arthur Arch (active 1792–1838).[67] Two years later Gilmor would purchase another illuminated Latin Bible at the sale of Dr. William Howard of Baltimore (1793–1834). According to a handlist of "Ancient Mss." made by Baltimore physician Joshua I. Cohen, who also attended the sale, Robert Gilmor purchased nine manuscripts, among them a small Bible and a missal—perhaps those mentioned later in the Gilmor library catalogue.[68] Another purchase made at the Howard sale was a *Tractatus ascetici septem* from the Carthusian monastery of St. Alban at Trier, which in 1936 was in the possession of Reverend William W. Gunn of Cambridge, Massachusetts.[69] Cohen also noted that Robert Gilmor spent a total of $55 at the Howard sale, outspending the others in attendance. The purchases made at the 1832 Howard sale are thus not only evidence of

Robert Gilmor's lifelong interest in collecting medieval manuscripts, but also point to local markets for his supply.

P H

Literature: S. de Ricci, *Census of Medieval and Renaissance Manuscripts in the United States and Canada*, vol. 1, New York, 1935, 235, no. 120; A. W. Rutledge, "Robert Gilmor, Jr., Baltimore Collector," *Journal of the Walters Art Gallery* 12 (1949): 21; Walters Art Gallery, Baltimore, *Illuminated Books of the Middle Ages and Renaissance: An Exhibition Held at The Baltimore Museum of Art, January 27-March 13*, Baltimore, 1949, 35, no. 92; C. U. Faye, *Supplement to the Census of Medieval and Renaissance Manuscripts in the United States and Canada*, New York, 1962, 120, no. 92; M. Meiss, *French Painting in the Time of Jean de Berry: The Boucicaut Master*, New York, 1968, 137, figs. 165, 296; S. Schutzner, *Medieval and Renaissance Manuscripts in the Library of Congress: A Descriptive Catalog*, vol. 1, Washington, D.C., 1988, 339–44, color pl. 24.

1. Both the Office of the Virgin and Office of the Dead are for use at Paris and the calendar celebrates many of the Paris feasts noted by P. Perdrizet, *Le Calendrier parisien à la fin du moyen âge d'après le bréviaire et les livres d'heures* (Paris, 1933), 35-36. The name is inscribed on fols. 142 and 200v. Changes in text and references to clerics are noted by S. Schutzner, *Medieval and Renaissance Manuscripts in the Library of Congress: A Descriptive Catalog*, vol. 1 (Washington, D.C., 1988), 344. I would like to thank Glenda Meckley at Schmidt Library of York College of Pennsylvania for her assistance in locating materials.

2. E. Panofsky, *Early Netherlandish Painting, Its Origin and Character*, vol. 1 (Cambridge, Mass., 1953; New York, 1971), 53–61.

3. M. Meiss, *French Painting in the Time of Jean de Berry: The Boucicaut Master* (New York, 1968), 14.

4. See G. Schiller, *Iconography of Christian Art*, trans. J. Seligman, vol. 1 (Greenwich, Conn., 1971), 55–56.

5. Meiss, *The Boucicaut Master*, 19.

6. Ibid., 19, 24; and Panofsky, vol. 1, 58–59.

7. *Exsurgens autem Maria in diebus illis abiit in mantana cum festinatione, in civitatem Judah* (Luc. I:39).

8. F. Avril, *Manuscript Painting at the Court of France: The Fourteenth Century (1310-1380)*, trans. U. Molinaro (New York, 1978), pl. 5.

9. Meiss, *The Boucicaut Master*, 19–20.

10. The same format was repeated by Roger van der Weyden. See Panofsky, vol. 2, fig. 311.

11. An early example of the *Visitation* with a depiction of a bust of Christ issuing from a cloud in the upper right of the initial is to be found in Walters Art Gallery MS W86 (fol. 50), a Book of Hours for use at Arras executed in the late thirteenth century. See L. M. C. Randall, *Medieval and Renaissance Manuscripts in the Walters Art Gallery*, vol. 1 (Baltimore, 1989), no. 47, fig. 97.

12. Meiss, *The Boucicaut Master*, 20, 27.

13. M. Meiss, "Light as Form and Symbol in Some Fifteenth-Century Paintings," *Art Bulletin* 27 (Sept. 1945): 175.

14. G. Zinn, "Suger, Theology, and the Pseudo-Dionysian Tradition," *Abbot Suger and Saint Denis: A Symposium*, ed. L. P. Gerson (New York, 1986), 33–40; E. de Bruyne, *Etudes d'esthétique médiévale*, vol. 3 (Bruges, 1946; Geneva, 1972), 3–29; and *Meditations on the Life of Christ, An Illustrated Manuscript of the Fourteenth Century (Paris, Bibliothèque Nationale, MS. Ital. 115)*, trans. and eds. I. Ragusa and R. B. Green (Princeton, N.J., 1961), 259. In the same text Christ is described as the "supercelestial Sun, the Sun of justice" (Ibid., 383, after Bernard's *Serm IV in ascensione Domine* [J.-P. Migne, *Patrologia latina*, CLXXXIII, col. 309]). After 1380, St.

Bridget described in her *Revelations* the vision of the Nativity she had while on pilgrimage to the Holy Land. The Christ Child "radiated such an ineffable light and splendour, that the sun was comparable to it. . .[and]. . .the Child himself gave forth powerful rays all about him like the sun." In Library of Congress MS 56, as elsewhere in manuscript illumination after 1400, the miniature of the *Adoration of the Child* depicts the Virgin and Joseph kneeling before a nude Christ Child surrounded by thin strands of golden rays, and the background is also dotted with six-pointed starlike forms, recalling how the child was described by the pseudo-Matthew as the brightest star. See Meiss, "Light as Form and Symbol," 176, n. 2; and Panofsky, vol. 1, 46, 126.

15. M. Warner, *Alone of All Her Sex: The Myth and the Cult of the Virgin Mary* (New York, 1976; New York, 1983), 256; and M. Meiss, "The Madonna of Humility," *Art Bulletin* 38 (Dec. 1936): 435–64.

16. Warner, 262–63. She quotes from Bernard of Clairvaux, Hom. II, *In missus est*.

17. Meiss, "Light as Form and Symbol," 180. *Hec est speciosior sole super omnem stellarum disposicionem luci comparata invenitur prior candor est enim lucis eterne speculum sine macula dei maiestatis.*

18. Panofsky, vol. 1, 56.

19. The combination of monumental naturalism with vibrant color patterns is seen elsewhere in the Library of Congress manuscript, for example, in the borders of pseudo-acanthus leaves with elaborate filigree work. This can be compared to Walters Art Gallery MS 287 (fol. 138), a Book of Hours for use at Paris produced in the 1420s by the Master of the Harvard Hannibal, an associate of the Boucicaut Master who absorbed many of the master's innovations. (See Randall, *Medieval and Renaissance Manuscripts in the Walters Art Gallery*, vol. 2, pt. 1, 15, no. 103; vol. 2, pt. 2, fig. 194). Another parallel is found in a Book of Hours for use at Rome in the collection of H. L. Bradfer-Lawrence, Ripon (Yorkshire), fol. 27, dated to the second decade of the fifteenth century by Meiss, although there the filigree work is more elaborate. Meiss, *The Boucicaut Master*, 135, fig. 124.

20. J. J. G. Alexander, *Medieval Illuminators and Their Methods of Work* (New Haven, Conn., 1992), 127–30. Meiss assigned four of the five miniatures to the Boucicaut Workshop (fol. 21, *Annunciation*; fol. 33, *Visitation*; fol. 45v, *Adoration of the Child*; and fol. 176v, *Trinity*); the fifth (fol. 93, *Dead man and the battle over the soul*) he attributed to a follower of the Boucicaut Master.

21. Recorded in a nineteenth-century inscription on the end flyleaf: "An Old Roman Breviary splendidly illuminated, supposed to have been written in the Fourteenth century. Purchased at Charleston, South Carolina in the year 1807 by Robert Gilmor Jr." For Gilmor's family background, see Museum of Art, Baltimore, *A Century of Baltimore Collecting, 1840–1940* (Baltimore, 1941), 10–12.

22. Robert Gilmor, Jr., "Family memoranda booklet, 1813," Robert Gilmor, Jr., Papers, MS 387, Maryland Historical Society, Baltimore. I thank Elizabeth Smith for providing this information after her reading of the manuscript.

23. In 1714 Elihu Yale (1649–1721) donated a fifteenth-century illustrated *Speculum humanae salvationis* to what would become Yale University. Yale was born in New England but moved with his family to England at the age of three, never to return. Many years later he presented a gift of some two hundred books to the fledgling college. These were for the most part theological texts, the *Speculum* being one of them. The fact that it contained illustrations (line drawings) was surely incidental as far as Yale was concerned. See B. A. Shailor, *Catalogue of Medieval and Renaissance Manuscripts in the Beinecke Rare Book and Manuscript Library Yale University*, vol. 1 (Binghamton, N.Y., 1984), 42–47, pls. 19 and 32.

24. C. M. Hickman, "Perspectives on Art Patronage in the Carolina Low Country to 1825," *Southern Quarterly (Art and Artists: From a Southern Point of View)* 24 (1985): 97. Among Charleston's early portraitists were Henrietta Johnson (d. 1729) and Jeremiah Theus (d. 1774). John Trumbull was in Charleston in 1791 to paint miniatures of South Carolinians who had played a role in the Revolutionary War and he was

11. Roundel with Addorsed Birds

Italy, Venetian, 12th–13th century
Stone, 40.5 cm diameter
The Walters Art Gallery, Baltimore
27.248

The use of stone or terra-cotta roundels to ornament the walls of residences and public buildings in Venice became popular in the twelfth century under the influence of Byzantine imports. Birds and animals were often chosen as subjects; scenes of combat were common as were symmetrical arrangements. This roundel from the Walters Art Gallery is representative of the latter type of Venetian decoration with a pair of addorsed birds (parrots?) turning their heads back towards a central floral motif. The birds are encircled by an inner border of bead-and-reel and an outer border of double dentil. A similar roundel of addorsed birds (but without the border) is found at Fenway Court (ISGM S5e8).

When Isabella Stewart Gardner envisioned her house-museum at Fenway Court, she conceived it as a Venetian palace built around a central courtyard. Ruskinian Gothic had been chosen for the first building of the Boston Museum of Fine Arts in 1870, and pattern books of Gothic ornament were plentiful. Gardner, however, chose to construct her residence "authentically," using immigrant Italian workmen as well as numerous pieces of medieval sculpture acquired from shops in Venice and Florence. Gardner purchased most of the medieval architectural sculpture found at Fenway Court on trips to Italy in 1897 and 1899, on the latter occasion carrying the plans of Fenway Court with her. Within a matter of years, Gardner was able to "re-create" an ambience that it had taken generations of Venetian noblemen to achieve.

Medieval Venice's penchant for incorporating works of art, acquired through conquest or commerce, into existing monuments gave Venetian Gothic an eclectic character. The combination of Byzantine, Romanesque, and Gothic sculpture found in Venice was duplicated by Gardner with architectural sculpture selected for its function (column, capital, base or arcade) as well as its beauty. Her Old Master paintings and Oriental artifacts completed the effect of a noble European household, formed over time.

The sculpture at Fenway Court is part of a permanent installation and is unavailable for loan. This roundel from the Walters Art Gallery is, therefore, an evocation of Gardner's Venetian palace as well as of her role as the first major American collector of medieval sculpture, particularly the art of Italy. A preference for Italian monumental art of the Middle Ages is also reflected in the patterns of institutional collecting at the Metropolitan Museum of Art in New York. The Met's purchases of medieval sculpture prior to 1910 were all Italian and included six Venetian roundels (MMA 1909.152.8–13).

K McC

Literature: D. Glass, "Romanesque Sculpture in American Collections. V. Washington and Baltimore," *Gesta* 9, no. 1 (1970): 54, fig. 15.

11

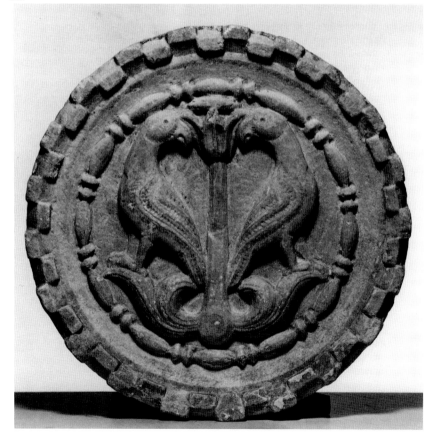

This pencil drawing, with touches of watercolor and gouache, is a copy of a sketch (now in the care of the Bembridge Education Trust Ltd.) made two years earlier during John Ruskin's revision of *The Stones of Venice*. Ruskin sent the copy to his dear friend and colleague, Charles Eliot Norton, but asked for its return at a time when an intellectual dispute and Ruskin's mental instability had placed a strain on their relationship. Ruskin considered this work one of his better drawings of St. Mark's, and it was sent back to Norton when conditions between the two men improved.

Norton and Ruskin shared a lifelong love for the Republic of Venice and its art as an expression of man's most fully realized ideals. Ruskin immortalized the monuments of Venice, including St. Mark's, in *The Stones of Venice* (first published in 1851–1853). Norton included St. Mark's in *Historical Studies of Church Building* (1880) and taught courses about the art of the Venetian republic throughout his years at Harvard. This drawing, therefore, represents not only the intellectual connection between Norton and Ruskin, but also symbolizes the central position medieval Italian art occupied in their teachings.

Norton organized the fine arts curriculum at Harvard in imitation of the courses taught by Ruskin as Slade Professor at Oxford and requested all the sketches Ruskin could spare, as well as "some piece, no matter how small or insignificant, but the bigger the better, of your own architectural pencil drawing."[1] *The Stones of Venice* also served as the textbook for Norton's lectures on Venetian art (Fine Arts 5). Because visual aids were used sparingly during Norton's lectures, Ruskin's illustrations became all the more significant in creating an image of the Middle Ages among the students of Harvard.

Norton also wanted to present the original works of Ruskin to a broader audience and in 1879 organized an exhibition of Ruskin's drawings to be shown publicly in Boston and New York City. Ruskin provided some of his most recent drawings for the exhibition, as well as this representation of the northwest porch of St. Mark's, which was expressly copied for the exhibition.

The funds for the purchase of this drawing were donated by Samuel Sachs, a partner of Goldman, Sachs & Co. in New York and the father of Paul Joseph Sachs (Harvard, Class of 1900), assistant director of the Fogg Art Museum (1915–1944). The elder Sachs also provided funds for five additional Ruskin works acquired at the same time, all recommended for purchase by his son.

Paul Sachs was a student at Harvard during Charles Eliot Norton's tenure, and as assistant director of the Fogg Art Museum (in partnership with Edward Waldo Forbes, the director), was greatly influenced by the artistic ideals of his mentor in the creation of the museum's permanent collection. The close relationship between Ruskin and Norton was commemorated by a loan exhibition of Ruskin's drawings in honor of Norton in 1908, the year of his death. The purchase of this drawing was undoubtedly reaffirmation of the position both men occupied in the development of artistic sensibilities among Harvard's undergraduates.

K McC

Literature: J. Unrau, *Looking at Architecture with Ruskin*, London, 1978, 21, 108, no. 58; R. Hewison, *Ruskin and Venice*, London, 1978, 88, no. 76; G. Weinberg, *Drawings of John Ruskin (1819–1900)*, Cambridge, Mass., 1979, 31, no. 60; J. Unrau, *Ruskin and St. Mark's*, London, 1984, 83, 206, 208, 210, color pl. 38; A. Bradley, *Ruskin and Italy*, Ann Arbor, Mich., 1987; T. B. Stebbins, *The Lure of Italy: American Artists and the Italian Experience 1760–1914*, Boston, 1992, 121, fig. 7.

1. Charles Eliot Norton to John Ruskin, Nov. 13, [1873], *Correspondence of John Ruskin and Charles Eliot Norton*, eds. J. Bradley and I. Ousby (Cambridge, 1987), no. 238.

12. Part of a Sketch of the Northwest Porch of St. Mark's, Venice

John Ruskin (1819–1900)
England, 1879
Watercolor, graphite and white gouache on cream wove paper, 38.2 x 25.8 cm
Fogg Art Museum, Harvard University Art Museums, Gift of Samuel Sachs
1919.259
Ex. coll. E. G. Norton; C. E. Norton, Cambridge

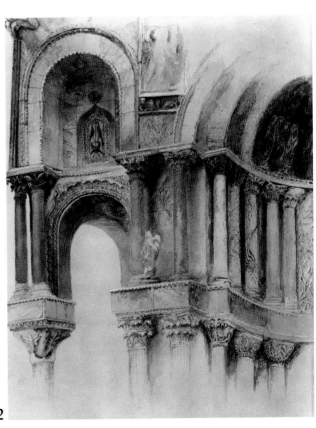

12

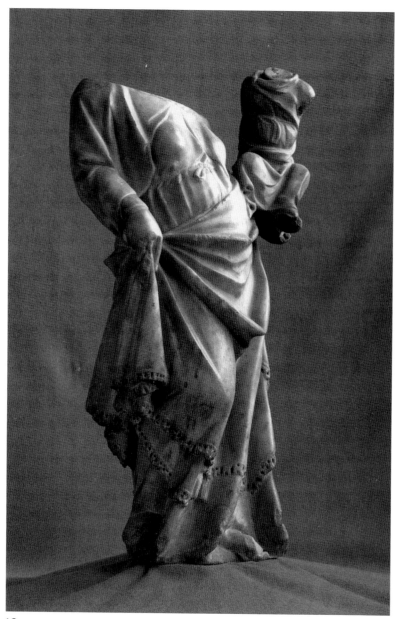

13

This statuette, attributed to a follower of Giovanni Pisano, remains a striking work of art in spite of the loss of the heads for both the Virgin and Christ Child. The pose of the Madonna and the heavy drapery of her mantle are highly reminiscent of Giovanni's work, especially his Madonna in the Museo di Sant'Agostino, Genoa. The Genoa Madonna has been attributed to the tomb of Margaret of Luxemburg, dated 1313. Several other statues of the Madonna and Child have also been related to the work of Giovanni Pisano, including sculptures in the museums of Berlin, Turin, Pisa, and Munich.

Gillerman has suggested that the smooth diagonal cut at the Madonna's shoulders may be the result of tampering by the dealer: a purposeful cut intended to create two sculptures out of one, both attributable to Giovanni Pisano. It is more likely, however, that the smooth cut was made to even out a rough break and, thereby, create a clean base for the addition of a "restored" head to the Virgin. This is borne out by the scoring of the surface and the drilled holes in the center where dowels could be fitted to secure an attachment.

Although an American collector might buy a medieval sculpted head without a body, the preference for "complete" figures is evident by the number of medieval statues with restored heads purchased by individuals and institutions well into the twentieth century. This statuette, therefore, represents a rather unusual acquisition for a nineteenth-century American. Collectors did value the antique torso, nude or clothed, however, and the rather "classicizing" rendering of the Virgin's upper body may have added a visual appeal more often associated with ancient or Renaissance sculpture.

This statuette was part of the collection of Charles Callahan Perkins, one of the founding members of the Boston Museum of Fine Arts and its honorary director (1876–1886). A graduate of Harvard (Class of 1843), Perkins studied art in Rome and Paris and spent extended periods of time in Europe prior to 1870. While in Europe, he wrote *Tuscan Sculptors* (1864) and *Italian Sculptors* (1868). These works, in conjunction with the writings of James Jackson Jarves and Charles Eliot Norton, represent the earliest art historical treatises produced by Americans.

Perkins's taste in sculpture followed his literary interests and also reflected the preference for Italian art found among other nineteenth-century collectors of Boston, such as James Jackson Jarves and Isabella Stewart Gardner. An avid collector of classical and Renaissance sculpture, Perkins also shared Norton's and Ruskin's admiration for Nicola and Giovanni Pisano and devoted the first chapter of *Tuscan Sculptors* to them.

In addition to the Virgin and Child, Mrs. Perkins donated other works of Italian sculpture from her husband's collection to the Museum of Fine Arts. Two years before this statuette was donated, she had written: "I should like to send to the Museum a few small reliefs etc – wh. were always in my husband's study. I know he would wish them to be with you. They are not of any special value – but he valued them."[1] A photograph taken inside the Museum of Fine Arts by Thomas E. Marr in 1902 shows the statuette of the Virgin and Child on a pedestal next to a wall where these sculptural fragments from Rome were on display.[2] Whether or not the statuette was also kept in Perkins's personal library is open to question, but the fact that it was given to the museum separately may indicate that it held a special significance for his widow.

K McC

Literature: W. R. Valentiner, "Werke um Giovanni Pisano in Amerika," *Zeitschrift für Bildende Kunst* n.s. 31 (1920): 111; M. Seidel, "Die Berliner Madonna des Giovanni Pisano," *Pantheon* 30, no. 3 (1972): 181–92; M. Seidel, "Studien zu Giovanni di Balduccio und Tino di Camaino," *Städel–Jahrbuch* 5 (1975): 37–84; D. Gillerman, *Gothic Sculpture in America I. New England Museums*, New York, 1989, 97–98, no. 70.

1. Frances D. Perkins to Charles G. Loring, Nov. 17, [1893], Archives, Museum of Fine Arts, Boston.
2. Marr's photographs are kept in the Library of the Museum of Fine Arts, Boston, and provide an invaluable record of the interior and exterior of the building on Copley Square.

13. Statuette of the Virgin and Child

Follower of Giovanni Pisano
Italy, Tuscany, early 14th century
Marble, 47.6 x 14.6 x 15.9 cm
Museum of Fine Arts, Boston,
Gift of Mrs. C. C. Perkins
95.1383
Ex. coll. C. C. Perkins, Boston

Color plate (p. 6)

14. Plaque, Christ Triumphant

France, Limoges, first third of the 13th century
Champlevé enamel on copper, 12.4 x 9 x .16 cm
Museum of Fine Arts, Boston, Gift of Estate of Alfred Greenough
85.86
Ex. coll. A. Greenough, Paris

Color plate (p. 6)

14

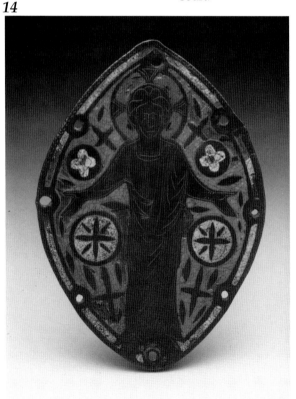

This small plaque was probably from the back face of a standing or processional cross. The mandorla shape points to the period between 1190 and 1235, while the richly enameled, star-studded ground suggests it belongs to the so-called Star Group of early thirteenth-century Limoges enamels. The plaque shows Christ the Redeemer, executed in reserve, standing with arms outstretched. A similar treatment of the subject is found on enamels in the Vatican Museum, Rome, the Cluny Museum, Paris, and the Victoria & Albert Museum, London. The Boston plaque is very unusual, however, in that Christ is represented beardless and without visible wounds on his hands or feet.

The plaque of Christ Triumphant is one of the first original works of medieval art acquired by the Museum of Fine Arts and one of the earliest medieval pieces to enter a public collection in the United States. Enameled objects from Limoges had been avidly collected by Europeans in the eighteenth and nineteenth centuries, and by the beginning of the twentieth century were to become highly desired by American collectors, such as J. Pierpont Morgan and Henry Walters, as well. Isabella Stewart Gardner also had a small collection of enamels displayed with other works of the minor arts in the Long Gallery at Fenway Court.

There seems to have been, however, a general reluctance to collect luxury items, such as medieval enamelwork, ivories, and liturgical vessels in precious metals, within the Boston community, which may have associated the sumptuary arts with the perceived excesses of Catholicism. The handful of Boston collectors who owned any pieces generally acquired their objects prior to 1900, and the inflated prices created by Morgan and Walters in the early twentieth century may have acted as a further deterrent. When the Museum of Fine Arts

began to purchase medieval art, textiles or works of stone and wood were chosen almost exclusively. Before 1940, the collection included only one other medieval Limoges enamel, a thirteenth-century pyx donated by Horatio Greenough Curtis (BMFA 15.322).

Alfred Greenough, the donor of this enamel, has previously been identified as the brother of sculptor Horatio Greenough, but he was, in fact, Horatio's nephew who had died the year before this enamel was given to the museum.[1] A graduate of Harvard (Class of 1865), Greenough was accepted as a student at the Ecole des Beaux-Arts in Paris in 1868, where he studied architecture. He remained in Europe for thirteen years before briefly returning to Boston in 1881. The following year, Greenough traveled to Asia, where he died in Rangoon in 1884.

At the time this enamel was given to the museum, the estate of Alfred Greenough also donated a Spanish silver crozier head attributed to the late twelfth century (BMFA 85.232). The Museum of Fine Arts received additional works from the Greenough Collection through a bequest from Charles H. Parker, the executor of the estate, in 1908.[2]

K McC

Literature: H. Swarzenski & N. Netzer, *Catalogue of Medieval Objects in the Museum of Fine Arts, Boston: Enamels and Glass,* Boston, 1986, 84, no. 25.

1. *Sixth Report of the Secretary of the Class of 1865, of Harvard College* (New York, 1885) , 20–25. See also *Letters of Horatio Greenough to his Brother, Henry Greenough,* ed. F. B. Greenough (Boston, 1887), 247–49. In addition to this enamel, other works received from the estate of Alfred Greenough included 58 textiles and embroideries, 152 pieces of ironwork and other metals, and 106 plaster casts. See *Boston Museum of Fine Arts Annual Report* 10 (1885): 14.
2. The collection was described as 317 objects consisting of "textiles, tiles, wood–carvings, Egyptian & Greek bronze statuettes, terra cottas, vases etc." *Boston Museum of Fine Arts Annual Report* 33 (1908): 93. An Italian ivory relief from the workshop of the Embriachi (BMFA 08.364) was the only other identifiably medieval object.

*A*lthough fragmentary and visibly worn, this section of a marble impost block displays the rich and elegant execution typical of stone sculpture produced in the Mediterranean basin in the years around 1200. It is carved with a lion's head with swags of foliage emerging from its mouth, a motif often found in architectural decoration (e.g. on cornices, capitals, and impost blocks) throughout the twelfth and thirteenth centuries. The fluid lines and the visible use of the drill for highlights relate this piece to sculpture in southern Italy (the ciborium in Barletta Cathedral) and the Latin Kingdom of Jerusalem (works of the Temple Area Workshop) of the late twelfth and early thirteenth centuries. In spite of its small size and fragmentary nature, this lion's head is worthy of comparison with the best examples from these centers.

The earliest medieval sculpture to enter the collection of the Museum of Fine Arts, this impost block has been attributed to southern Italy. Archival research, however, has revealed that it was given to the museum by Michel Farah, an Arab dealer of antiquities from Lebanon, and was first identified as the fragment of a marble capital from Tyre.[1] A sculpted lion's head bearing a striking resemblance to this work was sold at Parke-Bernet to a private collector in 1967. That head was also found in Lebanon and may have originally been a part of this impost block.[2]

Crusader art, particularly sculpture and architecture, flourished in the Latin Kingdom in Jerusalem in the late twelfth and early thirteenth centuries and was influenced by the most advanced artistic trends in western Europe. The movement of artisans between Europe and the Middle East during the Crusades also ensured that developments in Crusader sculpture made their way into Western art, especially in Italy. This situation explains the mis-attribution of the impost block as a product of southern Italy rather than as an example of Crusader sculpture from the eastern Mediterranean.

The Museum of Fine Arts bought forty-three pieces of Syro-Palestinian glass from Farah in 1892, and it is very likely that this sculpture was given in appreciation for recent purchases and in anticipation of future business, an occasional practice among dealers. Three decades later, for example, George Grey Barnard would give the museum a twelfth-century capital from St.-Michel de Cuxa (BMFA 1924.156) at the same time he was offering his

Cloisters collection for sale.

Few pieces of medieval sculpture entered public collections in the United States before 1900 since plaster casts were used extensively to represent this facet of the stone mason's craft in museums and art schools. The cost of sculpture, in general, was also considered prohibitive by the Museum of Fine Arts, whose monetary bequests did not approach the levels of the Metropolitan Museum of Art. "As a rule, original work is beyond our means, Sculpture of the best periods is almost absolutely out of our reach."[3] Prior to the purchases of the Western Art Visiting Committee (Other Collections) in 1912, the Boston Museum of Fine Arts received only one other example of medieval monumental sculpture, a fifteenth-century abbess's tomb slab from Naples donated by Edward W. Forbes (BMFA 07.505).

K McC

Literature: W. Cahn and L. Seidel, *Romanesque Sculpture in American Collections*, vol. 1, New York, 1979, 109, no. 10; H. Buschhausen, *Die süditalienische Bauplastik im Königreich Jerusalem von König Wilhelm II. bis Kaiser Friedrich II.*, Vienna, 1978, no. 375.

1. *Boston Museum of Fine Arts Annual Report* 17 (1892): 45. The correspondence of Michel Farah and his brother, Alexandre, with Charles G. Loring is kept in the file of 1893, Archives, Museum of Fine Arts, Boston. Previously, the donor has been listed incorrectly as Michael Farah.
2. Object file, Peter Marks to Hanns Swarzenski, April 16, 1971, Department of European Decorative Arts, Museum of Fine Arts, Boston.
3. "Special Report on the Increase of the Collection," *Boston Museum of Fine Arts Annual Report* 8 (1883): 10.

15. Fragment of Impost Block with Lion's Head

Eastern Mediterrean, Tyre?, c. 1200
Marble, 18.5 x 25.5 x 10.1 cm
Museum of Fine Arts, Boston
Gift of Michel Farah
93.9

15

16. Key

Germany, 13th? century
Iron, 12 x 5.2 x .47 cm
The Metropolitan Museum of Art,
Gift of Henry Marquand, 1887
87.11.673

17. Key

Germany, 13th? century
Iron, 25.4 x 13 x 1.3 cm
The Metropolitan Museum of Art,
Gift of Henry Marquand, 1887
87.11.680

Late medieval locks and keys, from the fifteenth and sixteenth centuries, are decorated with a profusion of Gothic ornament. Earlier products of the locksmith's workshop, such as these two keys, are much simpler.[1] Both of these keys have heads of flattened diamond shape with small loops on each corner. The shafts are unadorned. On the smaller key, the notches cut into the key plate (the bit) have an overall zigzag pattern. The bit of the larger key is more complex, with four trefoils sprouting from a long central notch.

Key types can be roughly dated by comparison to representations of St. Peter, who is usually shown holding one or more keys. In this context, simple square-headed keys can be seen at least as early as the Portico de la Gloria of Santiago de Compostela (1188) and at least as late as the early fourteenth century.[2] A key with a head very like these two can be seen in a mid-thirteenth-century image of St. Peter on a large wooden tabernacle, now in Oslo.[3] In the fourteenth century many keys had quatrefoil or rosette-shaped heads. An example of the latter type can be seen held by the St. Peter on the knop of the Sigmaringen Chalice (Cat. 41). The large number of locks and keys that survive from the later Middle Ages may reflect the increased quantity of personal goods produced to meet the demands of an increasingly prosperous society. The smaller key may have locked a chest or casket, which was the primary type of medieval furniture. The larger key is more likely to have been for a door.

Henry Gurdon Marquand (1819–1902), donor of these keys, was descended from an old New York family, but he made his personal fortune in the railway and banking businesses. He was never among the very rich, even compared to the more modest fortunes of the mid-nineteenth century, but he devoted a great deal of his income to art. Marquand was in many respects a typical art collector of his day. His home and his private art collection were similar to what could be found in many wealthy homes of the time.[4] His personal art collection included many paintings, particularly of the salon type, and a wide variety of decorative arts objects, especially porcelains. Among all of these objects there were only a few medieval pieces: two Limoges enamels (a lavabo and a large cross), a fourteenth-century French seal ring, and a Byzantine triptych.[5] But Marquand's collecting also had a strong public side. He was deeply involved in the creation and early management of the Metropolitan Museum of Art, serving on the Executive Committee from the beginning, and becoming the museum's second president (1889–1902). Many of his collecting activities were directed towards the enhancement of the museum's collections, particularly to filling what he saw as gaps. The types of objects Marquand brought to the Metropolitan are representative of the holdings of nineteenth-century American art museums in general, which usually consisted of second-rate Old Master and salon paintings, reproductions in plaster, metal, and other media, and objects representative of the industrial arts: textiles, laces, utilitarian ironwork, etc. Marquand's donations of paintings are not relevant here, but his belief in the value of facsimiles led to some of the Metropolitan's earliest acquisitions of "medieval" art, in the form of reproductions and models (Cat. 26, 29).

Marquand also made substantial contributions to the minor arts collections, donating a variety of objects. Like many other persons involved in the founding of American art museums, Marquand looked to the South Kensington Museum in London as a model. Created in the aftermath of the Crystal Palace exhibition of 1851, South Kensington emphasized the minor and decorative arts, hoping that the presence of fine exemplars from the past would improve the quality of contemporary industrial arts. The refinement of taste that these objects were intended to encourage would also aid in the general uplifting and enlightenment of the populace. Pursuant to these objectives, the Metropolitan from its inception placed great emphasis on the importance of industrial arts in its collections. This emphasis on the applied arts was, perhaps, also a result of the influence of the Arts and Crafts Movement. Among Marquand's donations in this area was a "valuable collection of ancient ironwork, chiefly wrought iron of Nuremberg, comprising upwards of three hundred pieces."[6] This collection was a varied assortment of locks, keys, hinges, handles, and decorative mounts. It was almost entirely late Gothic, of the fifteenth and sixteenth centuries. Although the late pieces were elaborately worked, such as the two fifteenth-century hinges visible in the photograph (MMA 87.11.688-689), the early pieces, such as these two keys, were much simpler.

Marquand also acquired a great quantity of ironwork from later centuries. The photograph for this entry illustrates a sampling of his entire ironwork collection, including the two keys. The presence of labels indicates that this may be an image from an old installation at the Metropolitan. It is not clear if Marquand bought his iron collections *en bloc* and presented them to the museum, or if he gradually acquired them over a period of years. Marquand was not the only nineteenth-century American to value old ironwork. Denman W. Ross also collected decorative iron, for the Boston Museum of Fine Arts, some of it Venetian Gothic. In the context of this exhibition, the significance of these pieces lies not in their aesthetic qualities, but rather in their representation of the usually modest nature of private and public medieval acquisitions in the nineteenth century and the importance that American museums placed on having models for contemporary practitioners of the industrial arts to follow. This high valuation of such relatively modest objects continued into the early twentieth century, even after the Metropolitan became wealthy with the arrival of the $5 million Rogers Bequest (unrestricted funds, available by 1904). One would think that three hundred medieval locks and keys would have been sufficient, but in 1910 the museum purchased at least one hundred more.[7]

A R

16, 17

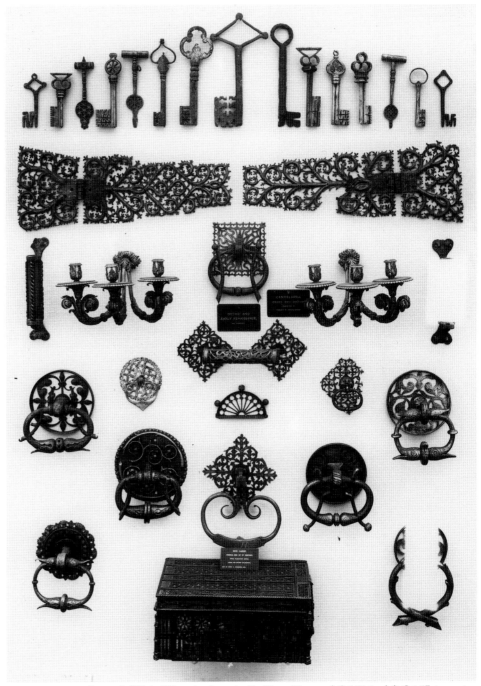

Ironwork (13th to 18th century) acquired by Henry Marquand; Cat. 16: top left; Cat. 17: top center.

Literature: Unpublished.

1. For related pieces, see H. d'Allemagne, *Decorative Antique Ironwork* (Paris, 1924; New York, 1968); and E. Frank, *Old French Ironwork* (Cambridge, Mass., 1950).
2. For the latter, see *Age of Chivalry, Art in Plantagenet England* (London, 1987), no. 560.
3. Ibid., no. 311. Similar key heads also appear in stained glass images as late as the fifteenth century. See *Corpus Vitrearum Checklist: Stained Glass before 1700 in American Collections,* vol. 1 (Washington, D.C., 1985), 42, 118.
4. See the stylish interiors in *Artistic Houses, Being a Series of Interior Views of a Number of the Most Beautiful and Celebrated Homes in the United States, with a Description of the Art Treasures Contained Therein* (New York, 1883–84).
5. From the sale catalogue, *The Henry G. Marquand Collection* (New York, 1903), nos. 1057, 1062, 1063, 1102.
6. *Annual Report of the Trustees* 20 (1889): 446.
7. MMA10.100.39–195; this sequence includes some Roman/Frankish pieces.

18. *Franc à Cheval of John II (1350–64)*

France, 1360–1364
Gold, 3.91 gm, 2.9 cm diameter
The Metropolitan Museum of Art,
Bequest of Joseph H. Durkee, 1899
99.35.110

Color plate (p. 6)

Most early medieval coinage was crude and static; the designs and images were simple and schematic and went unchanged for long periods, especially in France, where some coin types were used for centuries. By the late thirteenth century, a measure of naturalism and artistry had returned to western European coinage. In France, Philip IV (1285–1314) successfully reintroduced gold coinage after a lapse of over four hundred years. The quality and variety of issues increased greatly thereafter, and numerous complex and attractive types were produced.

Among the issues of John II (Jean le Bon, "the Good") was the *franc à cheval*. This coin type gets its name from the knight (chevalier) on its obverse. It was issued in large quantities to ransom King John, who had been captured by the English in the course of the Hundred Years War.[1] The franc à cheval marked the resumption of sound coinage after the Treaty of Brétigny between the two countries. It was unusual for a king to be represented mounted and in battle armor on coins; normally he was shown in regal state. The design may have been intended to symbolize forcefully John's return to freedom and to the head of his troops. The word "franc" in the name of the issue is not a reference to a unit of French currency; the latter did not develop until many centuries later. Franc here refers to France and the French people, earlier known as the Franks. The word literally means "free," and may have been a punning allusion to King John's release from captivity and his desire for a France freed of the English.

The mounted rider motif comes from seal types used by kings and nobles since the early twelfth century. King John is shown charging into battle, sword upraised. Both the king and his mount are partially armored. One can see the metal plate (*chanfron*) protecting the horse's head, indicated by the deep cut around its eye, and the spur on the king's heel. The king's helmet is capped by a crown. The break between the beginning and the end of the inscription around the perimeter is marked by a fleur-de-lis, which cleverly also forms the apex of the crown. Additional fleurs-de-lis, symbols of French royalty since the thirteenth century, cover the surcoat of the king and the costume of his mount.

The reverse of the coin displays a tri-lobed short cross with quatrefoil center and foliate ends, all surrounded by a large quatrefoil with tiny trefoils in each spandrel outside of the quatrefoil. The cusps of the quatrefoil terminate in fleurons, which connect with the fleurons at the terminals of the cross. This elaborate Gothic design developed from the very simple crosses displayed on earlier coinage.[2] The inscription on the obverse is ✠ IOHANNES : DEI : GRACIA : FRANCORVM : REX (John, by the grace of God, King of the French). On the reverse is ✠ XP[I]C[TOC] ✠ VINCIT S XP[I]C[TOC] ✠ REGNAT ✠ XP[I]C[TOC] ✠ IMPERAT (Christ conquers, Christ rules, Christ commands). This motto was the battle cry used by the first crusaders, and it appeared frequently on French royal coinage. It is especially appropriate here coupled with the charging warrior king on the other side.

The record of objects donated to American art museums before 1900 appears to confirm the impression that most of the few Americans who acquired medieval art during the nineteenth century acquired only a small number of objects, perhaps even just one or two. The objects were generally small, of middling quality, and often only marginally objects of fine art. They were, perhaps, the offhand souvenir of a trip to Europe, or a peripheral part of some larger collection not focused on medieval art. American art museums of the time were frequently the recipient of such modest odds and ends, the flotsam and jetsam of collectors. This was, perhaps, a carryover from early American museums, which included curiosities and objects of natural history as well as art.

Not a great deal is known about the donor, Joseph H. Durkee (c.1863–1898), a Wall Street broker who traveled back and forth between New York and Paris. The latter city was described as having been his home for six or eight years at the time of his death. Durkee graduated from Columbia University (c.1884) and also had strong military connections. He died while still a young man in a disaster at sea when the French liner, Bourgogne, sank.[3] His relatively modest estate of a quarter-million dollars included a bequest of coins to the Metropolitan valued at $25,000.[4] Durkee's coin collection was considerable, "about 8000 ancient coins, Roman, Arabic, East Indian, and Chinese, in gold, silver, copper, and other materials," but it included only a few medieval pieces.[5] Medieval coins were clearly not the primary focus of Durkee's interest; their presence in his collection is another instance of the somewhat incidental and

98

small-scale nature of medieval acquisitions by Americans in the nineteenth century. It is worth noting that Durkee, like most of the major American collectors of medieval art, both before and after him, spent a great deal of his time in Europe.

Knights in armor were, and still are, a conspicuous part of the popular image of the Middle Ages. Armor was present in private collections and American museums, sometimes in abundance, but very little of it was truly medieval. Like tapestries, armor is associated with the medieval period, but, also like tapestries, most of what survives dates from the fifteenth century or later and belongs more to the Renaissance than to the Gothic world. The popular image of the medieval knight envisions him and his horse covered with plate armor, that is, large contoured sheets, or plates, of polished metal. Partial plate armor, covering only the knees and lower legs, existed in the thirteenth century. On this coin King John can be seen wearing at least this much armor; the knee piece (*poleyn*) is clearly visible. Plate armor for the upper body was first made about the mid-fourteenth century, and total-body plate armor (referred to as *cap-à-pie*, or head-to-foot, armor) developed in the early fifteenth century. Before plate armor, medieval armor consisted chiefly of chain mail and heavy fabric or leather garments, along with metal helmets and shields made of wood and leather. Very little armor of any type from before 1450 has survived. Secular objects, in general, do not survive in quantity from the Middle Ages. The image of the medieval knight in shining (plate) armor is largely a misconception. Neither Roland nor Richard the Lionhearted sallied forth gleaming in the sun.

A R

Literature: J. Lafaurie, *Les Monnaies des Rois de France*, Paris, 1951, vol. 1, no. 297, pl. 13; *The Secular Spirit, Life and Art at the End of the Middle Ages*, New York, 1975, 133, no. 145, color pl. 6; *Les Fastes du gothique: le siècle de Charles V*, Paris, 1981, 413–14, no. 356.

1. The ordinance creating the franc à cheval is dated Dec. 5, 1360.
2. For a large color image of a similar reverse (of an écu d'or of Philip VI, c. 1337), see G. Hoberman, *The Art of Coins, and Their Photography* (New York, 1981), 182.
3. *New York Times* and *New York Tribune* for July 7, 1898, 1.
4. These figures were given in the notices of the will in the *New York Times*, July 29, 1898, 12:6, and *New York Tribune*, July 29, 1898, 6:6.
5. W. Howe, *History of the Metropolitan Museum of Art* (New York, 1913), 270. There were at least five western medieval coins in Durkee's collection: two eleventh-century English and three fourteenth-century French (MMA 99.35.107–111).

18

Obverse, John II on horseback.

18

Reverse, decorated short cross.

19. Cast Reproduction, the Virgin and Child from Notre Dame, Paris

France, Palais du Trocadéro?, late 19th–early 20th century
Plaster of Paris, 179 x 50.8 x 37.4 cm (From limestone original, France, Paris, c. 1250)
Glencairn Museum, Academy of the New Church, Bryn Athyn
08.SP.423

The original statue from which this cast was taken is located on the north transept trumeau of Notre Dame in Paris. Perhaps the most famous of all Gothic cathedrals, Notre Dame was begun in 1163, and its construction continued well into the thirteenth century. The exterior of the church was extensively decorated with sculpture, and in addition to the three portals of the west facade, the entrances to the south and north transepts each had a monumental sculpted doorway.

The arms of the transepts were extended in the second quarter of the thirteenth century, and new facades were added under the direction of Jean de Chelles, beginning about 1250. The north transept portal led into an area reserved for the private use of the cathedral's canons and is known as the *Porte du cloître*. Above the doorway, there is a tympanum divided into three registers with scenes from the Infancy of Christ and the legend of Theophilus. The jamb figures, no longer in place, consisted of statues of the Three Magi on the right and of the Three Theological Virtues on the left. The statue of the Virgin holding the Christ Child, from which this cast was taken, occupies the trumeau.

By the end of the seventeenth century, the effects of weathering on the sculpture of Notre Dame were already of concern, but no action was taken. Man-made destruction followed, reaching a peak during the French Revolution when the cathedral, a symbol of the detested old order, was subject to periodic attacks by the citizenry. Much of the statuary, already in fragmentary condition, was also removed and dispersed at that time. Only the trumeau figures of the Virgin from the north transept portal and from the *Porte de la Vierge* on the west facade survived the Revolution relatively intact.

Preservation of Notre Dame became a "cause célèbre" of the Romantic movement in France in the nineteenth century. Victor Hugo used the cathedral as the backdrop of his novel, *Notre Dame of Paris, or the Bell-Ringer of Paris*, published in 1831, and compared it to "a vast symphony in stone."[1] When the Monuments Historiques de France established a committee to oversee the restoration of Notre Dame in 1842, Hugo was appointed a member. The following year, the committee approved the plans for stabilizing the structure presented by Lassus and Viollet-le-Duc, but efforts soon turned from consolidation to full-scale restoration of both the architecture and sculpture. Attempts to return the cathedral to its "pristine" condition were so complete that the trumeau figure of the Virgin and Child from the Porte du cloître became the only large–scale statuary still preserved in its original position on the exterior of Notre Dame.

This reproduction of the Virgin and Child from the north transept portal seems to have been a quintessential exemplar of French Gothic figural sculpture in the late nineteenth and early twentieth centuries. An engraving of the Porte du cloître Virgin and Child appeared in Charles Herbert Moore's *Development and Character of Gothic Architecture* (1890). It is not surprising, therefore, that Moore, as newly appointed curator of the Fogg Art Museum, ordered a cast for the collection in 1895. The Slater Memorial Museum (affiliated with the Norwich Academy of Art in Norwich, Connecticut) also acquired a reproduction of this Virgin and Child for the use of its students prior to 1905. In both cases, this reproduction was only one of a few medieval casts to be included in the institutions' collections.

This replica of the Porte du cloître Virgin comes from the private collection of Raymond Pitcairn, who acquired plaster casts as well as stained glass and medieval sculpture to serve as models for the artisans constructing the Church of the New Jerusalem in Bryn Athyn, Pennsylvania. Pitcairn primarily selected French works from twelfth and thirteenth centuries, and of the approximately twenty surviving casts, most represent examples of early Gothic sculpture. Notre Dame was one of his favorite cathedrals, however, and this is undoubtedly one of the reasons why he chose the cast of the Porte du cloître Virgin as an exemplar of High Gothic sculpture.

In 1922, Pitcairn traveled to Europe, where he visited the Palais du Trocadéro in Paris, one of the continent's leading suppliers of medieval French reproductions. Many of the casts in his collection retain labels from the Trocadéro, and it is likely that they were acquired as a result of this trip.

By 1919, however, this Virgin and Child from Notre Dame had already begun to lose its primacy in relation to other sculpture from the cathedral within the academic community. In that year, Charles Morey published "Recommendations for Romanesque and Gothic Reproductions for the College Museum" under the auspices of the College Art Association, and the Porte du cloître Virgin was not included. Now the exemplars

of Gothic sculpture from Notre Dame were the tympanum from the Porte de la Vierge, the Virgin in the choir, and a panel from the choir screen.

K McC

Literature: Unpublished.

1. Known in America as *The Hunchback of Notre Dame*.

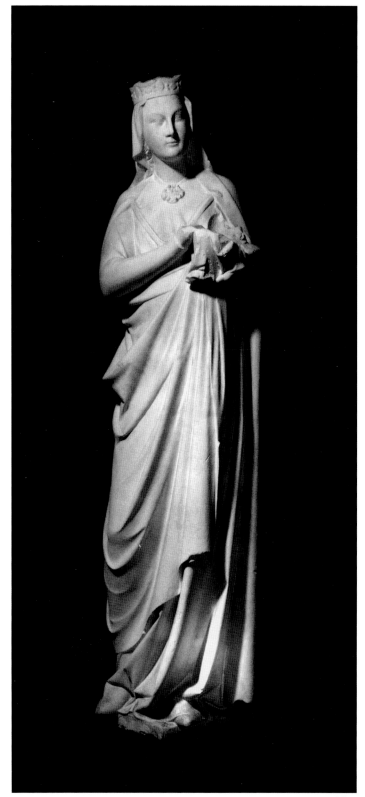

19

22. Situla, the Virgin and Child with Evangelists

(From ivory original, Ottonian, Milan, c. 980, in Milan Cathedral Treasury, Italy)
20 x 13 cm diameter

23. Plaque, the Offering of the Magi

(From walrus ivory original, German, Cologne, c. 1135, in Victoria & Albert Museum, London, inv. 145-1866)
22 x 20.4 x 3 cm

24. Plaque, the Ascension of Christ

(From walrus ivory original, German, Cologne, c. 1135, in Victoria & Albert Museum, London, inv. 378-1871)
21.5 x 20.3 x 3.2 cm

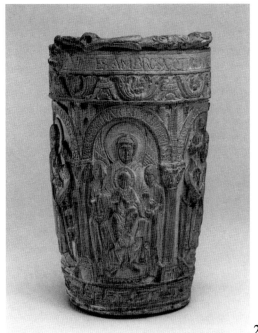

Situlas, buckets for holy water, carved in ivory are very rare. Only four are known to exist, all dating to around 1000. The inscription on the Milan Situla indicates that it was ordered by the archbishop of Milan, Gotfredus, in preparation for the arrival of the emperor Otto II. The central image is, again, the Virgin and Child enthroned under an arcade, here flanked by angels. The four other figures are the Evangelists, shown writing their Gospels and accompanied by their symbolic beasts. The change in style from the Carolingian to the Ottonian can be seen in the heavier, more rounded figures, and the simpler and less agitated drapery folds. While most ivories reproduced as casts were flat plaques, small three-dimensional objects, such as statuettes and this situla were also replicated. The metal handle of the situla has also been replicated.

22

The long attenuated figures, dance-like poses, and pinhole drapery borders indicate that these two reliefs are Romanesque. Classicizing borders are still in evidence. These large square plaques come from a series that probably formed part of an altar frontal. The plaques were made of several pieces of walrus ivory fitted together; the curved breaks are clearly visible. The two scenes represented come from the beginning and the end of the life of Christ. Though closely related, the two panels are rather different in conception. The Adoration of the Magi seems more informal, while the Ascension is highly ordered and symmetrical. Single medieval objects often became separated into their component parts in later centuries. These two plaques were acquired by the Victoria & Albert Museum in the nineteenth century. The American collector George Blumenthal acquired two more pieces from this group a half-century or more later (MMA 41.100.201, 41.100.202).

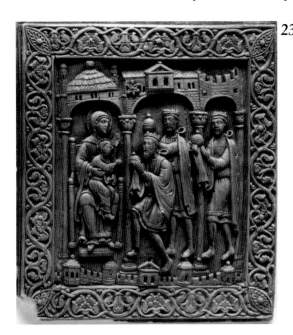

23

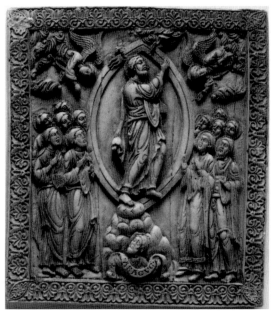

24

When ivory became much more available in Europe in the Gothic era, ivory carvings were mass-produced. The changing nature of religious devotion is reflected in the nature of these ivories. Although all of the preceding pieces discussed here were part of the furnishings of a church, many Gothic ivories were intended for private devotion. Diptychs and polyptychs were like miniature altarpieces. The two halves of a diptych usually represented the Virgin and Child on one leaf and the Crucifixion on the other, or scenes of the Passion, as here. Shown (from right to left and bottom to top) are the Betrayal of Christ by Judas, the Scourging of Christ, the Crucifixion, and the Deposition. This diptych is from the rose group, so-called because of the border of rosettes that separates the scenes on each leaf. The simple borders of rose group plaques are atypical of Gothic ivories. Most Gothic plaques, including the two in this exhibition, had elaborate architectural borders of Gothic arches (Cat. 37, 56). Earlier medieval ivories were and are relatively scarce in art collections. Gothic ivory diptychs and polyptychs formed the greater part of America and European collections of medieval ivories.

25a,b. Diptych, Scenes of the Passion

(From ivory original, French, first quarter of the 14th century, in Musée du Louvre, Paris, Molinier no. 49)
Each leaf 15.2 x 8.8 x 2 cm

25

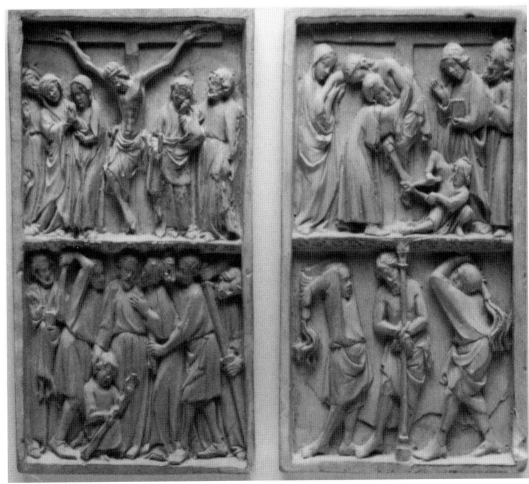

26. Electrotype Reproduction, Drinking Bowl (hanap)

Franchi & Son
England, c. 1873
Silver and gold on copper?,
5 x 20.5 cm diameter
(From silver, parcel gilt and enamel
original, French, c. 1330,
in Victoria & Albert Museum,
London, inv. 107-1865)
The Metropolitan Museum of Art,
Purchase, 1873
73.8.1

This bowl is a copy of an object from the Rouen-Gaillon Treasure, a large hoard of fourteenth-century French silver that surfaced in Europe at intervals during the second half of the nineteenth century.[1] The objects from this treasure are among the rare survivors of secular medieval craftsmanship in gold and silver, and they display some of the earliest known hallmarks. Almost all of the Gaillon bowls share the same profile and similar decorative motifs, including foliage and floral forms, pointed trefoils and quatrefoils, triangular patterns, and beaded borders. This particular bowl has in addition a Gothic arcade, which forms a six-pointed rosette. The designs are accentuated by parcel gilding and a roughened surface texture on a smooth silver background. The drinking bowl, or *hanap*, was the common drinking vessel of the Middle Ages. Although the standing cup, or goblet (*couppe*), did exist, it was reserved for important contexts. Most vessels for eating and drinking were made of wood; only very wealthy persons would have had quantities of silver and gold dishes.

After plaster casting, electrotyping was the most common method of replicating art objects. It was normally used for smaller pieces made of metal. Electrotyping is a process similar to electroplating and was developed by the same London company, Elkington's. In electroplating, the base metal object is placed in a chemical bath in which the plating metal is dissolved. An electrical current then causes the plating metal to be deposited on the object. In electrotyping, there is no base metal object, only a mold of the original. The same electro-chemical process is used to deposit a thin layer of the precious metal, followed by a heavy layer of the base metal on the inside of the mold, exactly recreating the original object. In this case, there are some slight differences between the original and the copy. The original has an enamel medallion in the center of the bowl, which is thought to be a restoration added before it was sold to the Victoria & Albert Museum in 1865. The under surface of the copy is rough and gilt and does not attempt to reproduce the smooth silver surface of the original. The unidentified heraldic device on the underside of the original is also not reproduced.

This particular reproduction is significant because it represents the first acquisition (and purchase) of a "medieval" object by an American museum. Although founded in 1870, the Metropolitan Museum of Art did not open its doors until 1872. Among the first purchases for the newly opened galleries was a collection of electrotype reproductions of pieces in the Victoria & Albert Museum (figure p.107). This group of facsimiles included two after medieval objects—the bowl shown here and a copy of a similar bowl also from the Gaillon Treasure (MMA 73.8.2 after V&A 106-1865). Unfortunately, these copies are probably not indicative of an early awareness of medieval art by the fledgling Metropolitan Museum. The actual pieces selected for purchase were chosen by George Wallis, the keeper of the Victoria & Albert's art collections. They are, however, indicative of a number of other things, including the degree to which early American art museums looked to the Victoria & Albert as a model, the emphasis placed on the minor arts, and the firm belief in the usefulness of reproductions.

This object and most of the other reproductions acquired by the Metropolitan were given accession numbers like actual art objects. The musuem continued to acquire electrotype reproductions of medieval objects until 1912, though not on the same scale as its acquisitions in plaster. Many of these electrotypes were copies of early Irish metalwork (Cat. 27).

A R

Literature: *Reproductions in Metal of Objects Selected from Museum and Private Collections in Russia, England, etc.*, New York, 1894.

1. Three pieces were acquired by the Cluny Museum in 1851, one in 1861 by the Louvre, eight by the Victoria & Albert Museum in 1865, and four by the Russian collector Basilewsky after 1874 (now in the Hermitage, St. Petersburg). They may have been found in Normandy; the provenance stories are suspect. See P. Williamson, *The Medieval Treasury: The Art of the Middle Ages in the Victoria & Albert Museum* (London, 1986), 210-11; and E. Taburet-Delahaye, *L'Orfèvrerie gothique au Musée de Cluny* (Paris, 1989), nos. 127-29.

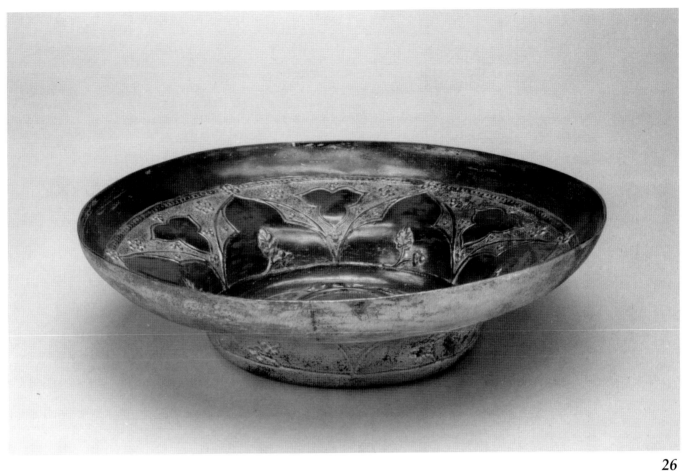

26

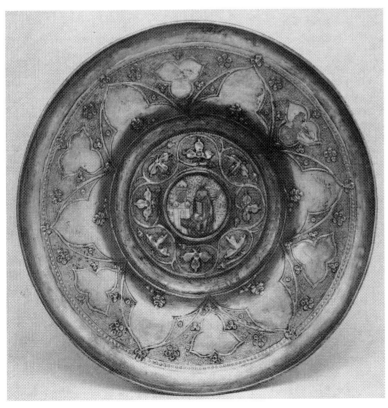

Drinking Bowl (hanap)
French, c. 1330
Silver, parcel gilt and enamel original
in Victoria & Albert Museum,
London, inv. 107-1865.

27. Electrotype Reproduction, Reliquary for St. Patrick's Bell

Edmund Johnson (1840s–1900)
Dublin, Ireland, c. 1891–1907
Silver and gold on base metal with
glass and enamel insets,
26.6 x 15.7 x 11.4 cm
(From silver and gold on bronze
with jewels and enamel original,
Irish, Armagh?, 1094–1105,
in National Museum of Ireland,
inv. R.4011)
The Metropolitan Museum of Art,
Rogers Fund, 1907
07.65.1

Color plate (p. 8)

28. Electrotype Reproduction, the Bell of the Will

Edmund Johnson (1840s–1900)
Dublin, Ireland, c. 1891–1907
Iron, 19.6 x 13.3 x 8.2 cm
(From iron plated with bronze original,
Irish?, 5th century or later, in National
Museum of Ireland, inv. R.4010)
The Metropolitan Museum of Art,
Rogers Fund, 1907
07.65.2

Color plate (p. 8)

St. Patrick (385?-461?), the patron saint of Ireland, is remembered for having popularized Christianity in Ireland (and for reputedly driving out the snakes). As with many other medieval saints, objects associated with him were treasured as sacred relics. Bells and croziers were particularly revered in Irish Christianity. Tradition considers the original bell, from which this replica was made, to have been St. Patrick's *Bell of the Will,* the same as that which St. Columba removed from Patrick's tomb in the year 552.[1] The bell itself is of no great aesthetic consequence—it is an ordinary cow bell of the time. The veneration of relics prompted the creation of its jeweled enclosure, made around the year 1100 by order of the High King of Ireland.

The reliquary made to house the bell is a superlative example of the latter period of Irish metalworking, showing the influence of Norse designs, the result of the Viking invasions of the previous centuries. It echoes the form of the bell, but simplifies and monumentalizes it, at the same time embellishing the simple form with intricate patterns and cabochons. The construction of the reliquary is as complex as its decorative designs, utilizing a number of metalworking techniques.[2] It is basically a box of bronze plates covered with gilt and silvered interlace panels set into silvered or gilt frames. Most of the stones set into the front were added later. On the original reliquary, many of these have been lost, along with some of the interlace inlays. The patterns are zoomorphic: here and there a tiny head, sometimes with inlaid eyes, can be seen. The crest is partially formed of two animal heads back-to-back. The snouts hang free as projecting flanges, and the eyes are formed from teardrop enamel inlays. On the back of the crest under the animal heads, two birds can be seen facing each other. The back panel of silver-plated crosses over a gilt bronze plate is bordered with a lengthy inscription in Irish, which translated reads: "Pray for Domnall Ó Lachlaind who caused this bell to be made, and for Domnall successor of Patrick in whose house it was made, and for Cathalán Ó Máelchalland steward of the bell, and for Cúduilig Ó Inmainen and his sons who enriched it."[3] Domnall Ó Lachlaind was the High King (Árd-rí) of Ireland from 1094 to 1121, and Domnall [Mac Amhalgadha] was the abbot of the Monastery of Armagh from 1094–1105. The reliquary was probably made at Armagh, which was founded by St. Patrick and considered the center of the Irish church.

Interest in medieval Irish art greatly accelerated after the discovery of the fabulous eighth-century "Tara" brooch in 1850. Acquired by a jewelry company, it was exhibited at the London Crystal Palace exhibition in 1851 and several other places in the following years. Thousands of copies of varying degrees of quality were made for popular consumption and for museum and fair exhibition. Queen Victoria herself purchased two copies. Many other examples of Irish metalwork were also duplicated; this was part of the vast production of art replicas in the nineteenth and early twentieth centuries. Irish decorative forms were also imitated in the contemporary arts, such as the building decorations of Louis Sullivan and luxury items produced by Tiffany's.

The two replicas shown here were created by the firm of Edmund Johnson, a Dublin-based jeweler. Johnson first became involved with Irish antiquities in 1869 when he was commissioned to restore the Ardagh Chalice, a masterpiece of medieval Irish art discovered in a potato field the previous year. His work on the chalice led to further similar commissions and to Johnson's production of a large line of replicas, which his business sold to museums and individuals. Although Johnson sought to make his replicas exactly like the originals in size and construction techniques, there are some significant differences between these originals and their copies. Most noticeably, the copy of the reliquary has much restoration. All of the missing and damaged areas have been restored, and all of the stones have been replaced. This is probably partly an expression of the Victorian penchant for tidiness in art and architecture. Johnson sought to give:

> . . . an exact idea of the magnificence and splendour [the original objects] presented to the eye when in actual use in all their beautiful contrasts of gold, silver, and enamels. . . . In nearly every case some slight restoration was necessary to clear the dirt of ages from their fine traceries and thus they found their way into my hands and those of my ancestors, who preserved exact moulds of these art treasures which cannot now be touched in any of the various institutions in which these collections are preserved.[4]

Johnson restored missing interlace plaque inlays from the surviving panels and also the battered and incomplete framing elements. His work both adds and detracts from the original. Showing the surfaces intact greatly aids envisioning the original appearance, but Johnson's method of construction detracts from its delicacy and intricacy. On the copy, the interlace inlays are integral to the body of

the replica, whereas on the original some of the interlaces are physically separate from the base plates, and thus appear greatly undercut. The pattern of plating in precious metals is also different. The surfaces of the original are sometimes gold, sometimes silver—for example the framework holding the front panels is silver to contrast with the gilt interlace inlays. On this copy, the overall surface metal appears to be silver, with few contrasting areas of gold. Another copy of this bell, produced by Johnson for the World's Columbian Exposition (Chicago world's fair) of 1893, has an overall gold surface. The Chicago copy also has a more colorful appearance, the glass insets being variously red, blue, green, amber, and white, some faceted, some cabochon (smooth). On the New York copy, all of the stones are red or white, and none are faceted. The Chicago version, intended as a "display model" for the fair, may have been more lavishly constructed. The New York piece may have been manufactured after Johnson's death in 1900. The bell itself is a rather lowly object. That Johnson bothered to reproduce it at all is perhaps an indication of the degree of importance placed on the industrial arts at the time. The replica of the bell does not seem to be an exact copy made from a cast of the original. The overall shape seems slightly different and somewhat neater, not precisely reproducing the folds of the metal sheets from which the original was made.

Johnson's replicas were exhibited at the Chicago world's fair of 1893, both with British manufactures and in the Irish Villages on the Midway, the amusement section of the fair. Almost two hundred different pieces were shown. Other "medievaliana" was also present. The British manufactures section included a forty-foot model of Windsor Castle, and a full-scale replica of an Irish stone cross. The Irish Villages (there were two of them) included copies of medieval castles and other buildings, another Irish cross, copies of illuminated manuscripts, and photographs of medieval Irish monuments, as well as Johnson's replicas. These things would have been seen at the fair by large numbers of people, many of whom may not otherwise have entered art galleries. All of the souvenir books of the fair seem to have included pictures of the Irish Villages, and some of them specifically mentioned the metalwork reproductions. Hubert Bancroft's large *Book of the Fair* discussed Johnson's pieces twice, specifically mentioning and illustrating the latter's reproductions of the

bell and the bell reliquary. After the fair, the replicas were displayed at the Columbian Museum, later the Field Museum of Chicago.[5] Johnson's copies, along with contemporary work based on medieval Irish pieces, were also sold at Tiffany's in New York.

These replicas and their companions are further evidence of the importance placed on copies well into the twentieth century. When the purchasing power of the Metropolitan Museum of Art was increased dramatically by the Rogers Bequest early in the century, the Department of Decorative Arts initially used the funds to buy more reproductions. The reliquary and the bell are only two of many replicas of medieval metalwork that were purchased between 1907 and 1912. Further evidence of the status of reproductions at the time is indicated by which accessions the Metropolitan chose to publish in its *Bulletin*. In 1908, the Metropolitan purchased a fine Romanesque column statue (MMA 08.175.9), and in the following year a large Italian Romanesque altar canopy, or ciborium, was bought. Neither of these major acquisitions were noticed by the *Bulletin*. However, two large reproductions acquired in 1908, a plaster cast of an Irish cross and a copy of the "Eleanor Grille," a piece of thirteenth-century ironwork, both received illustrated feature articles. Although reproductions fell into disfavor at about this time at the Boston Museum of Fine Arts, they continued to be purchased and displayed in quantity in New York through the 1920s. Only in the following decade do acquisitions of replicas seem to fall off, and the galleries of reproductions begin to close to make way for the expanding collections of originals.

A R

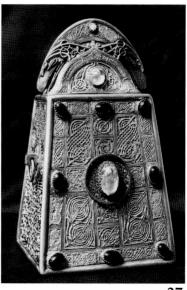

27

28

Literature: E. Johnson, *Description and History of Irish Antique Metal Work, Facsimile Reproductions of Which Have Been Specially Manufactured for Exhibition at Chicago*, Dublin, 1893; H. Bancroft, *The Book of the Fair: An Historical and Descriptive Presentation of . . . the Columbian Exposition at Chicago in 1893*, Chicago, 1893, 182, 837–38; *Imagining an Irish Past, the Celtic Revival 1840-1940*, ed. T. J. Edelstein, Chicago, 1992.

1. *Annals of Ulster*, year 552. See *Treasures of Irish Art* (New York, 1977), 143, no. 45.
2. For a thorough description, see *Treasures of Irish Art*, 213–14.
3. Quoted in F. Henry, *Irish Art in the Romanesque Period* (Ithaca, N.Y., 1970), 94–95.
4. E. Johnson, *Description and History of Irish Antique Metal Work Facsimile Reproductions* (Dublin, 1893), 7.
5. They are now at the Smart Museum of Art, University of Chicago.

29. Architectural Model, the Portal of St.-Trophîme, Arles

Adolphe Jolly
France, Paris, c. 1890
Plaster with polychromy,
 76.2 x 76.2 x 45.7 cm (1-20 scale)
(After stone structure, Arles, France,
 c. 1160–1180)
The Metropolitan Museum of Art,
Levi H. Willard Cast Fund, 1890
90.35.4

Color plate (p. 8)

The church of St.-Trophîme at Arles is one of the more important monuments of Romanesque art in Provence, near the French Mediterranean coast.[1] Sculpture and architecture in this region were considerably influenced by the remains of Roman antiquity. This influence is especially noticeable in the major monument of Provençal Romanesque, the facade of the church of St.-Gilles-du-Gard. The portal of nearby St.-Trophîme is a smaller and simpler version of St.-Gilles, after which it was modeled. This is most evident in the sculpture, much of which closely corresponds to that of St.-Gilles. The execution is considered uninspired in comparison to that of St.-Gilles, although the architecture is more coherently organized. While the portal is heavily decorated, the sculpture seems subordinated to the architecture, often becoming one with the architectural elements. This is especially noticeable in the main frieze where the rows of figures blur into a decorative pattern.

The decorations of medieval church portals were designed to instruct the illiterate faithful as they entered the church. A common theme, as here, was the Last Judgment. In the central image above the doors, Christ sits in Judgment, holding the Law on his knee, and raising his right hand in blessing. As described in the Apocalypse, the winged symbols of the four Evangelists surround him, each grasping one of the four Gospels. Three of these Gospels are bound codices like the Law held by Christ, but the eagle of St. John holds its Gospel in the form of a scroll. Two rows of angels fill the archivolts. Below Christ on the lintel sit the twelve Apostles. The friezes on either side represent the blessed and the dammed. The blessed, shown clothed, line up on Christ's right side. At the front of the line, near the doorway, an angel presents a soul (shown as a small person) to be judged. On the opposite side of the doorway, the Archangel Michael, sword in hand, prevents sinners from entering the Gates of Paradise, shown as a narrow doorway. The frieze on this side shows the dammed, chained, naked, and up to their knees in flames. The large haloed figures between the columns represent several of the Apostles. St. Trophîme himself is shown among them wearing bishops's robes and holding a crozier. Little angels place a crown on his head. Directly above these figures, at the same level as the capitals and running behind them, is a second frieze with scenes from the early life of Christ. The capital bases show animals attacking each other and

humans, as well as scenes from the Old Testament.

The facsimiles used by art museums were usually one-to-one copies directly cast or otherwise precisely duplicated, like tomb rubbings, wall paintings, and mosaics. The reproduction of full-size architectural ensembles was limited for obvious reasons of size, cost, and space, though a number of museums did have casts of enormous medieval facades, such as the triple portal of the main facade of Santiago de Compostela in the Victoria & Albert Museum in London, and the lower facade of St.-Gilles-du-Gard at the Carnegie Museum in Pittsburgh.[2] Instead of casts, architecture was sometimes represented by scale models. These could be key portions of buildings, such as this portal, or the entire structure.

The Metropolitan Museum of Art, which had the largest collection of casts in the United States, also had the largest collection of models. These included everything from an Egyptian mastaba tomb, to the Parthenon, to an Indian temple. Several of these models were of medieval structures, including the hall of Penshurst Castle, the narthex of Hagia Sophia, the facade of the Butcher's Guild at Hildesheim, and the entire city of Nuremberg. The most spectacular medieval model was that of the Cathedral of Notre Dame, an enormous structure with towers taller than the height of a man. Every architectural detail was meticulously reproduced. Even this more modest model of St.-Trophîme is remarkable for its intricacy and attention to detail. The model attempts to reproduce the original appearance of the portal, restoring worn and lost details. Naturalistic color is used to bring this little monument to life. A small figure of a priest or monk indicates the scale and context of the building.

Most of the Metropolitan's architectural models were acquired in the 1890s when the museum was creating its cast collection. At least some of these were unique constructions commissioned by the museum. St.-Trophime and Notre Dame were both made to the same scale (1–20) by a Parisian, Adolph Jolly, whose name can be seen on the base of the St.-Trophime model. Models were highly valued as educational tools, though eventually they came to be regarded as primarily useful for children. Though rarely created for art museum use today, they have not lost their value. They allow the viewer to gain an understanding of the organic three-dimensionality of the original

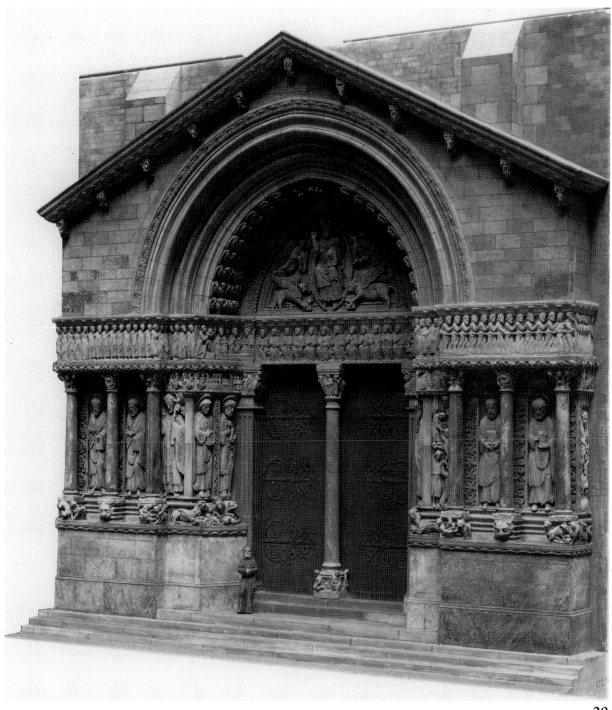

that cannot be achieved through photographs. In the case of vanished or ruinous monuments they also provide some sense of the original appearance.

A R

Literature: Metropolitan Museum of Art, *Catalogue of the Collection of Casts, with Supplement*, 2nd ed., New York, 1910, no. 1443; "Models as Teaching Material," *Bulletin of the Metropolitan Museum of Art* 10 (1915): 186–87, 189.

1. A discussion of St.-Trophîme and related monuments can be found in W. S. Stoddard, *The Façade of Saint-Gilles-du-Gard, Its Influence on French Sculpture* (Middletown, Conn., 1973).
2. Both of these portals are still on display in the cast halls of the respective museums.

2

1900-1920:
The Age of the Great Collectors

1900-1920:
Overview of the Period

Thanks in part to Ruskin and his American friends and followers, by the turn of the century, there had been a gradual change of attitude towards the Middle Ages among the educated élite. No longer leery of the art of the Middle Ages and more sure of themselves and of their taste in art, many well-to-do Americans were now ready to take the next step and begin to collect medieval art in a serious fashion. The years between 1900 and 1920 saw the development of three of the largest collections of medieval art yet assembled in the United States, put together by three individual collectors: J.P. Morgan, Henry Walters, and George Grey Barnard. Of the three, Morgan and Walters had most in common. Both had inherited large fortunes and important business enterprises from their fathers, which they continued to manage throughout their lives. They both became major collectors only after their fathers' deaths, and they both spent enormous sums of money on their collections, acquiring a wide range of works of art with the intention of leaving them to a museum where they would benefit the general public. Although their collecting habits differed—Morgan often buying entire collections sight unseen and Walters preferring to purchase single objects—both apparently had a special fondness for medieval art, perhaps born of early years in France, and both collections contained a disproportionate representation of the sumptuary arts.

After Morgan's death, the Metropolitan Museum of Art's loan show of his collection in 1914 made it available to the public. It would be nearly two decades before the bulk of Henry Walters's collection was put on display at the Walters Art Gallery. Consequently, it is safe to say that Morgan's medieval collection, much larger than Walters's and on view so much earlier, had by far the more formative impact on the art world and on the museum-going public. The impact of the Morgan collection was rivaled by that of George Grey Barnard. Barnard was not an industrialist but a sculptor, and his collecting activity focused on the products of his medieval counterparts. His Cloisters,

with its emphasis on the monumental art of the Middle Ages, was, like the Morgan loan show, extremely influential in the museum world. Its opening in 1914, nearly concurrent with the Morgan exhibition, meant that almost overnight, the New York museum-goer gained access to two large collections encompassing the full gamut of medieval art, from intricately carved ivory plaques to entire architectural ensembles. Newspaper coverage and entrance figures indicate that in both cases the public reaction to the exhibitions was positive, although it is difficult to say for sure whether the public was more attracted by the art or the notoriety of the collectors.

It is likely that by this time the more positive attitude to medieval art, which had permeated academia and élite society, had trickled down to the average man-in-the-streets. Certainly the Arts and Crafts movement, with its avowed admiration of medieval craftsmanship, was widespread in the United States between 1900 and 1920, complete with numerous local societies and national publications. In addition, it is tempting to postulate that the Armory Show of 1913, by exhibiting more "difficult," nonrepresentational art of the European avant-garde, had, to an extent, prepared the way for a greater understanding of the more primitive aspects of medieval art. Written contemporary evidence of this has not, however, come to light. If there was any relation between the new fashion for abstraction in modern art and a heightened appreciation of the abstract qualities of medieval art, it was probably on a subconscious level. In any case, in 1914 the Morgan loan show and Barnard's Cloisters placed before the New York public a wider range of medieval art than had ever been previously available to it. A similar event had occurred in 1853, when Thomas Jefferson Bryan opened his Gallery of Christian Art, with its Italian "primitives." In 1853, the New York public had not been ready for medieval art; in 1914, for a variety of reasons, it was.

J.P. Morgan and the Middle Ages

R. Aaron Rottner

ohn Pierpont Morgan (1837–1913) is a conspicuous figure in the annals of art collecting, not only for the size and importance of his collections, but also for the manner in which he acquired and disposed of them (Fig. 1). In the scant dozen years between 1900 and his death, he accumulated, with dramatic rapidity, an enormous variety of objects. He purchased the life's work of a connoisseur in an instant and acquired singular objects of considerable renown, aesthetic worth, and expense. He made magnanimous presentations of objects or entire collections to leading museums in Europe and America, and occasionally he even restored to their "rightful owners" objects he had bought (under what turned out to be cloudy circumstances), garnering much press coverage in the process, though this was surely not his intention. Such grand gestures were perhaps fitting for a man who was held by many to be the uncrowned king of America, a massive and commanding figure whose eyes were said to resemble the head lamps of a locomotive.[1]

Considering the extent of Morgan's collections, it is not surprising that he should have been one of the most important American collectors of medieval art, but that Morgan had a specific, focused interest in medieval art seems unlikely. His methods and purposes, to the extent that they can be determined, were too broad and too grand to be limited to any one area of artistic production. That he had a real interest in at least certain kinds and certain aspects of art, some of which was medieval, seems equally undeniable, however. Morgan's medieval acquisitions are important not only for their intrinsic aesthetic value and sheer bulk, but also for the preeminent and pivotal role they played in the development of Americans' taste for medieval art; only George Grey Barnard was as influential. Both scholars and museum personnel on the one hand, and the general public on the other, were affected by the Morgan objects. The great influence of his collections was a result of their size and quality, combined with their temporal primacy and the Morgan name.

Morgan's medieval collections included literally hundreds and hundreds of objects, representing almost every type of surviving artistic medium: monumental sculpture in stone and wood; enamels of many varieties; works in bronze, copper, silver, and gold; tapestries; ivory plaques and statuettes; caskets, reliquaries, and all sorts of church furnishings; illuminated manuscripts; furniture; even some architectural fragments and stained glass—only wall painting and arms and armor were not present. In a collection so large, a certain amount of dross is inevitable, but the general level of quality was quite high, especially consider-

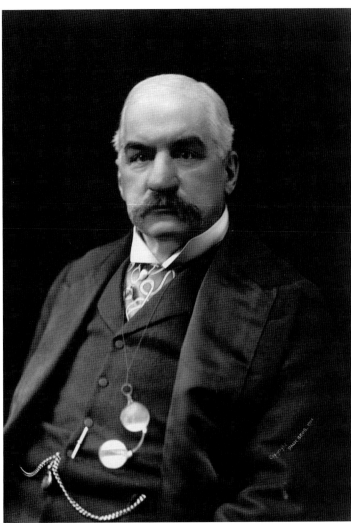

Fig. 1. J. Pierpont Morgan in 1902.
(Courtesy of the Archives, The Pierpont Morgan Library, New York)

ing what was in most other collections at the time. Morgan's collections were also the first large ensembles of medieval art seen in this country. Prior to their arrival, there were literally only a handful of pieces, many of them of questionable authenticity, in American art museums, and most of them were of rather modest artistic worth. Several museums did have significant, even considerable, quantities of facsimiles: plaster casts of everything from minuscule ivory plaques to gargantuan church facades, copies of precious metalwork, elaborate architectural models, and so forth. The importance of reproductions in educating the public's eye should not be minimized, but J.P. Morgan's collections would present authentic medieval art

to the museum goer, and also help shift museum policy away from facsimiles and towards the "real thing." Finally, Morgan's collections would not have been as influential as they were if they had not belonged to J.P. Morgan. His personal fame and notoriety probably attracted many people more than the objects themselves.

Any attempt at understanding why and how Morgan collected as he did is made difficult by the man himself. Pierpont Morgan was generally a man of few words. An anecdote about his early career claims he was released from a board of directors because he said so little.[2] He was one of the "silent men," as a biographer of the art dealer Joseph Duveen described certain collectors.[3] He hated reporters and refused interviews, discouraged biographies of himself, and destroyed many of his personal papers. In 1911, for example, Morgan burned more than thirty years of correspondence that he had sent to his father. To a large degree, his motivations and tastes can be determined only indirectly.

John Pierpont Morgan was the most influential figure in American finance in the two decades straddling 1900. Put another way, at the height of the Gilded Age when money and money-making dominated the culture, Morgan was the king of money. In the age of the great robber barons, of vast pre-income tax fortunes, and equally vast and conspicuous consumption, Morgan stood out. His name had become a household word by the first decade of this century. His father, Junius Spencer Morgan, directed the most important American banking house in Europe, a London-based firm specializing in American securities, which maintained close connections with American financiers. Junius helped his son establish himself in banking in New York City. "Young Morgan," as he was initially known, eventually became the head of his father's American branch, and consequently was constantly traveling back and forth between Europe and America. He first became well-known in financial circles though his reorganizations of American railroads in the 1870s, 1880s, and 1890s. After successfully thwarting Jay Gould, the most notorious of the robber barons, in his ruinous manipulations of railways lines (1869), Morgan was called upon by the stockholders and directors of numerous railroads in the next twenty-five years to save their businesses. (Explosive expansion and cutthroat competition had led many railways to near bankruptcy.) In the process of reorganization, or "Morganization" as it came to be called, Morgan came to dominate most of the railways in America, a position he held until the turn of the century. Success with the railroads and his position as a dealer in federal securities

made him a leader in the financial community. In 1895, Morgan averted a run on the federal gold reserves—and the ensuing financial disaster—by lending the U.S. government over $60 million, an extremely large sum at the time. In 1901, he engineered the creation of U.S. Steel, the first billion-dollar corporation, and he was also responsible for mergers that created General Electric (1891) and International Harvester (1902). The Panic of 1907 was also stopped through his leadership. For the second time, Morgan, almost single-handedly it seemed, was to avert economic disaster in America. This is something like saying he prevented the Depression—twice.

Morgan's loan to the federal government was highly publicized, and Morgan was heavily criticized for profiting handsomely on the government's distress, which indeed, he did. He also charged heavy fees for "Morganizing" the railroads. Morgan was very good at what he did, and he felt it was his due to be amply compensated for his efforts. The U.S. Steel merger and the 1907 Panic also received much press. It was all of these events combined and the attendant publicity that made Morgan famous. He became the symbol of Wall Street and the "Money Trust," a supposedly monolithic conglomerate that controlled many of the nation's major financial institutions, and through them, many corporations. Morgan was, indeed, influential. His habit of putting "his" men on the boards of the companies he became involved with created a network of interlocking directorates that he dominated more by his personality that by any direct control. But an increasing antagonism to the power, both real and imagined, of the "Money Trust" led to the congressional Pujo Committee investigations, beginning in 1912, with Morgan a primary target. The Pujo hearings were going on while Morgan was transferring his vast art collections from Europe to America. Morgan himself testified in December of 1912, and three months later he died. The Morgan Loan Exhibition of 1914–1916 followed close on the heels of the Pujo hearings. Earlier, when Morgan's Hoentschel Collection of Gothic art opened at the Metropolitan in 1908, the 1907 Panic was a fresh memory. Morgan's notoriety with the general public coupled with the inherent spectacular nature of his vast art collection made the people take notice when his possessions were put on display.

Morgan's career as an art collector stems from his dual American and European background. As the bases of his business operations were in both New York City and London, so the impetus and direction of his collecting came from both his American and European experiences. Without either one of them, he probably would not have

become the great collector that he did. From America came the aggressive entrepreneurial drive that created his financial empire and whose tactics he later applied to the acquisition of art. From his New England upbringing—he was born in Hartford, Connecticut—came a sense of public duty, and a patriotism and filial piety that impelled him to patronize the institutions of his country, especially those of his home towns. From Europe came a broader education and a direct exposure to the treasures and antiquities of the old world and an intellectual climate more favorable to the appreciation of art.

Morgan was different from most of the other tycoons of the gilded age, in that he was born into wealth and culture, and he was as equally at home in Europe as he was in America. The Morgan family could trace its presence in America back to the seventeenth century, but it was J.P.'s grandfather, Joseph Morgan III (1780–1847), who established the family fortune. Joseph became quite wealthy by early nineteenth-century American standards, and his son, Junius Morgan (1813–1890), was even more prosperous. The business connections of Junius led him to take over the management of a London-based American banking house in the 1850s. From that time to the end of his life, Junius lived continuously in England. His wealth and European connections enabled him to have his son John Pierpont Morgan complete his education in Europe—two years in a private academy and two years at the University of Göttingen in Germany (at that time the Kingdom of Hannover).[4] In Europe, J.P. Morgan learned French, German, Latin, and later Italian, and his courses included European history and French literature. He also had numerous opportunities for travel. As early as 1853, when he was sixteen, he toured Britain and the Continent with his family. In Britain he saw Stratford-on-Avon, Warwick and Windsor Castles, Oxford, the recently opened Crystal Palace (where he may have seen Augustus Pugin's Medieval Court), Walter Scott's home, Abbotsford, and nearby Melrose Abbey. The continental itinerary included Brussels, Cologne, Berlin, Dresden, Frankfurt, Strasbourg, and Paris, many of which were sites of famous medieval churches. After completing his university education, Morgan toured Europe again, visiting Cologne, Antwerp, Brussels, Paris, and Vienna. Although he returned to New York in 1857, and maintained his primary residence there for the rest of his life, his connections with Europe remained strong. J.P. Morgan's father, Junius, continued to reside in London, and, after the latter's death in 1890, J.P. Morgan's son, John Pierpont Morgan, Jr. (1867–1943), moved into the London residence and carried on the management of the London end of the business as his grandfather had done before him. Morgan Sr. returned

regularly to Europe at least once and sometimes twice a year, often for extended periods of six months or more. (He always went to visit his father, Junius, around the time of his own birthday in April for several weeks or more, and usually took extended excursions in the summer.) In addition to the London residences, Morgan had homes or apartments in Paris and Rome. His European visits typically included stays in London and Paris, southern France, and Rome, with frequent side trips elsewhere. Although much business was conducted while in Europe, especially from London, he frequently took time out for sightseeing. By the end of the century, his European education and experiences were considerable.

What Morgan thought of the things he saw is largely unknown. All that can be said with certainty is that from an early age he seems to have had in interest in the historical. One of the books surviving from his childhood is *The Youth's Historical Gift, a Christmas, New Year, and Birthday Present containing familiar descriptions of civil, military, and naval events by the Old English chroniclers, Froissart, Monstrellet, and others, and also the history of Joan of Arc and her times* (New York, Appleton and Co., 1847). Appropriately enough, this was given to him on Christmas day 1847 by his maternal grandfather, John Pierpont (1785–1866).[5] A charging mounted knight is stamped in gold on the cover. The young Pierpont had only just begun his formal education in the autumn of 1846, when he was nine years old. Morgan also preserved his student (?) copy of *Parley's Book of History* (Boston, 1848), much of which deals with the medieval history of Britain.[6] Pencil underlining and so forth, primarily of rulers' names, indicate the book was well used. In 1852, Morgan created for himself a sort of gazetteer, which he labeled "Places in English History, written by Worcester" (probably taken from Joseph Worcester's *Elements of History Ancient and Modern*, 1845). His visit to Walter Scott's home, Abbotsford, in the summer of 1853 may have prompted him to see *The Talisman*, "played at the Boston Museum" later the same year.[7] One assumes this was a play based on the 1825 Scott novel set in the twelfth century. Among the books he recorded reading in the same year were *The Days of Bruce*, presumably about the fourteenth-century Scottish king, Robert the Bruce, and other titles listed also seem to be historical novels. We also know that he had a collection of autographs "worth at least $100" at least as early as 1856, when it was lost with some luggage.[8] We do not know whether he read the medieval historical novels of Scott as a youth, though it would hardly be unusual if he had. We do know by Morgan's own statement that the first autograph manuscript he acquired was that for *Guy Mannering*,

seurs in building his art collection. This has particular significance with respect to medieval art at the Metropolitan, for among those hired was the professionally trained Wilhelm Valentiner. Valentiner, arriving in 1907, was responsible for the Decorative Arts Department, which at that time included medieval art. It is not surprising that the museum's acquisitions of medieval art began to accelerate in quantity and quality shortly afterwards.

Morgan's importance as a collector of medieval art lies not in whatever specific interest he may or may not have had in the Middle Ages and its art, but in the impact his collections had on American scholars and museums, and on the American public. Because of U.S. import duties on art, most of Morgan's collection was kept in Europe, primarily in his London houses and on loan to the Victoria & Albert Museum (at that time called the South Kensington Museum). Occasionally he made donations or loans to the Metropolitan. The impact of Morgan's collection was felt through three exhibitions or gallery openings at the Metropolitan in 1908, 1910, and 1914. In 1906, Morgan acquired the first of two large art collections from Georges Hoentschel, a Parisian variously described as an architect, upholsterer, or decorator. Apparently, Hoentschel's business involved producing period interiors for his clients. In the process, he had acquired a large collection of French decorative art. The first Hoentschel Collection fell into two parts, one of eighteenth-century wall paneling and furniture decorations, the other of medieval sculpture and furniture. This entire collection was transferred to the Metropolitan in 1908. The eighteenth-century portion was given outright to the museum (and stored in the basement), and the medieval portion was placed on indefinite loan.[20] Whether Morgan's desire to retain possession of the medieval segment is any indication of a greater interest in that period of art is unclear. On July 1, 1908, the Hoentschel medieval collection opened to the public, put on display in the north end of the recently completed Great Hall.[21] This display, largely unnoticed at the time, was the first substantial and systematic presentation of original, monumental medieval art to the American public.[22] The entrance to the exhibit area was flanked by a series of Gothic double columns that were part of the collection. The rest of the collection was presented in chronological fashion, tracing the development of French sculpture from the Romanesque period to the Renaissance.[23] Most of the collection was late medieval, fifteenth- and early sixteenth-century, much of it was wood, and a significant portion was late Gothic furniture. There were, however, a small number of twelfth- to fourteenth-century pieces. The pieces most often singled out for discussion in the 1908 museum *Bulletin* articles

were, significantly, among the least medieval objects in the display: two late Gothic/early Renaissance sculpture groups that Morgan had acquired from the Château de Biron. These were near life-size depictions of a Pietà, and the Entombment. They were not actually part of the Hoentschel Collection but were purchased by Morgan in France at about the same time, and from the beginning were part of the installation. These groups were conspicuous because of their size, and the comparative realism of their very late medieval style probably made them more accessible to the general public. The fact that the contents of the 1908 installation were largely late Gothic sculpture and furniture probably made it as a whole more accessible to the public. The American public's first considerable taste of medieval art, therefore, was in a more palatable style.

The earlier pieces, however, did not go unnoticed. Apart from the Biron sculptures, the most commented-upon object was the oldest piece in the exhibition perhaps because it was so different from all of the other sculptures—a twelfth-century wooden Virgin and Child Enthroned from the Auvergne (MMA 16.32.194). The reviewer for the *Burlington Magazine*, William Rankin, who seems to have been an American student, considered it "by far the most important" object in the collection. The rigid and austere frontality of this Romanesque work was in sharp contrast to the more animated and comparatively naturalistic forms of the Gothic. *The New York Times* considered it "a wonderful piece, almost Chinese in its rigid architectural forms and the regular curves of the drapery. . . . Both faces are naive and winning in profile with singularly sweet mouths The group has only one rival in the museums of the world—a similar composition in the Louvre."[24]

Although the memory of Morgan's seemingly single-handed quelling of the 1907 financial panic was still fresh in people's minds, this 1908 display of the first Hoentschel Collection went largely unnoticed at the time, at least in published sources. It does not seem to have been much publicized by the museum. It would be interesting to know who made the decision to display these pieces and what their rationale was. Perhaps it was the newly appointed decorative arts curator, Wilhelm Valentiner. The nature of the initial reaction was mixed, if the contemporary articles in *The New York Times* are any indication. In the *Times* an intelligent and thoughtful full-column article (unillustrated) printed a few days after the opening, discussed several pieces in detail with some sense of appreciation. Two months later, however, an illustrated half-page feature in the Sunday *Times* (internal features suggest it was by a different author) ignored the actual objects almost entirely

and attempted to interpret them by discussing Baroque nativity scenes, such as Neapolitan crèches in European museums. The illustrations were also of these crèche, or Krippe, figures, not the Hoentschel pieces. The significance of this collection was realized only gradually, after being reinforced by Morgan's other medieval collections. Feature articles on the importance of the first Hoentschel Collection ran as late as 1915 and 1916, when Morgan's collecting activities as a whole were evaluated in light of the exhibition of his entire art collection.[25]

The size of the combined 1906 Hoentschel Collections was so great that the Metropolitan was prompted to build a new Wing of Decorative Arts to house them.[26] In March 1910 this wing was opened with considerable fanfare (Figs. 3 and 4). Eight thousand guests attended the private viewing preceding the public opening. Morgan himself was in Europe at the time. The art columnist for *The New York Times* called the exhibition, "taking it all in all, the most important ever held in the city."[27] The columnist was most impressed by the historical and national progression of the

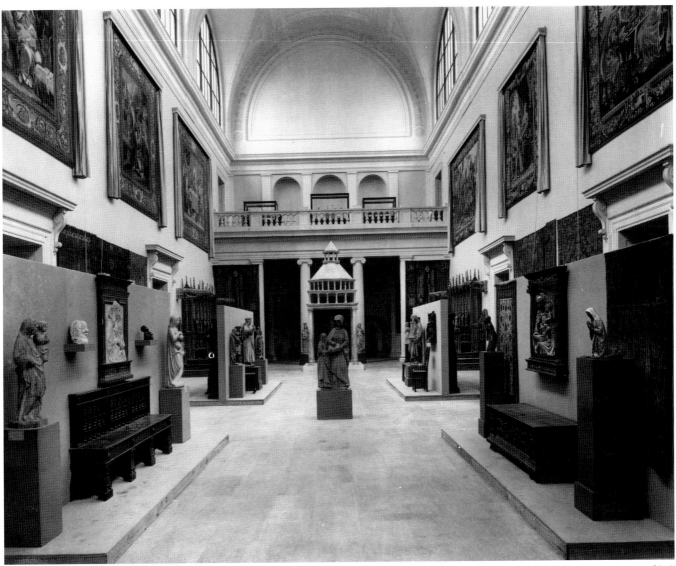

Fig. 3. Main Hall, Wing of Decorative Arts, Metropolitan Museum of Art, in 1910. (The Metropolitan Museum of Art)

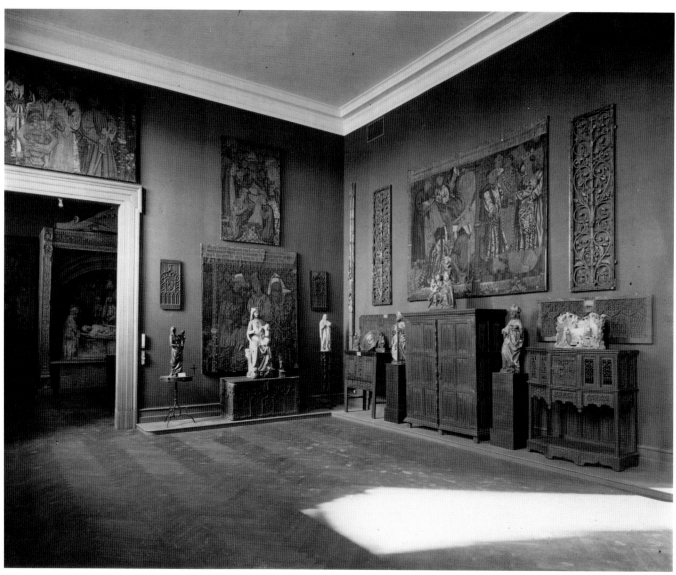
Fig. 4. Second Gothic Room, Wing of Decorative Arts, Metropolitan Museum of Art, in 1910. (The Metropolitan Museum of Art)

galleries and the attempt to create period environments in the rooms. It must be admitted that he devoted most of his ink to the eighteenth-century French portion, pointing out that the Gothic part had been fully noticed at the time of its [initial] exhibition. A full-page spread in the Picture Section of the *Times* two weeks later was also devoted to "The Hoentschel Collection, Gift of J. Pierpont Morgan," though here again, the primary emphasis was on the non-medieval portions.[28] Nevertheless, the considerable attention given to the new installation as a whole must have spilled over onto the medieval pieces, many of which were conspicuously displayed in the main hall of the new wing. The museum also included in the installation at least some of the few real medieval pieces it had acquired up to that time. A large Italian Romanesque altar canopy was axially placed at the end of the main hall, and at least two cases of small objects flanked the main entrance at the other end. In 1913, the Metropolitan published a catalogue of its medieval and Renaissance sculpture, extensively illustrated for the time. A large portion of the volume was taken up with the Hoentschel medieval pieces loaned by Morgan. It was considered of enough interest to the educated public to receive a very favorable review in the magazine, *The Nation*.[29]

Morgan's principal impact as a collector of medieval art came largely after his death, with the loan exhibition of his entire art collection—exclusive of manuscripts and a multitude of objects and collections already in the Metropolitan—held from 1914–1916 at the museum. The publicity for this exhibition began in effect several years before, and a considerable portion of it was devoted to his other medieval acquisitions. In 1909, American import duties on art were removed, partly through Morgan's efforts. Shortly after, inheritance taxes, or "death duties," on art were enacted into law in Britain. These two factors, coupled with Morgan's advanced age (he was well into his seventies), impelled the banker to transfer his European art collections, most of which were in England, en masse to New York City. This great exodus of art to America attracted enormous attention, both here and abroad.[30]

In the first decade of the twentieth century, J. Pierpont Morgan was one of the most famous men alive, both here and in Europe. He hobnobbed with presidents and kings. An empress made an *appointment* to see his private art collection in London.[31] He was thought to control the finances of America. He was constantly in the newspapers, usually on the front page. The degree of his renown is evident in the nature and extent of these articles. Even the most trivial matters concerning him made the news. In 1910, the front page of *The New York Times* reported "Fourteen Prize Turkeys Stolen from Cragston Estate of J.P. Morgan."[32] Part of the reason his art collections received so much attention in the press and in the galleries was because his name was attached to them. His art collections, given so much attention initially because of his already established renown, contributed in return to his notoriety by virtue of their size, expense, magnificence, and rate of acquisition. Many of the people who came to view the Morgan collections were probably drawn more by the desire to see the possessions of a wealthy man, than by a desire to look at art. It is perhaps significant that the eighteenth-century Fragonard panels from the "Room from Mr. Morgan's House in London Brought Here in its Entirety" was one of the most commented-on parts of the loan exhibition.[33]

Throughout 1912, Morgan shipped his art collection to America. Until then relatively little of it was in America, except for his library and what he had already given or lent to the Metropolitan. The transfer took over a year and was continually in the papers, often making the front page. The collection was so large that, unprecedented and at Morgan's expense, a U.S. Treasury official was sent to Europe to do the customs inspections, so that the delicate and priceless objects would not be disturbed again upon arrival. One of the shipments narrowly missed being sunk on the Titanic—this could only have added to the publicity. At approximately the same time he decided to transfer his art, he acquired another collection of medieval art from Georges Hoentschel through Seligmann. (Seligmann also supervised the transatlantic transfer as a whole.) This collection was entirely of medieval objects, mostly smaller pieces—enamels, metalwork, and ivories, minor arts objects, plaques, caskets, statuettes, little tabernacles—not monumental statuary. They were also earlier in date, primarily of the twelfth, thirteenth and fourteenth centuries, that is, more alien in style to the modern viewer than most of the previous Hoentschel Collection first shown in 1908. The purchase and transfer of this collection was closely followed in the New York press—even just the *rumor* of the sale was reported. Perhaps the exhibition of the previous Hoentschel Collection for several years in the Metropolitan had made the name known. The enamel collection as a whole was said to be of over five hundred pieces.[34] The collection was described numerous times, usually in glowing terms: ". . . gorgeous reliquaries, caskets, crosses and crosiers, thickly encrusted with jewel-like coloring. . . ."[35] Several pieces in the collection were repeatedly described, such as the reliquary chest that had once belonged to William Beckford of Fonthill fame (now MMA 17.190.514), and the Malmesbury Ciborium (then referred to as the

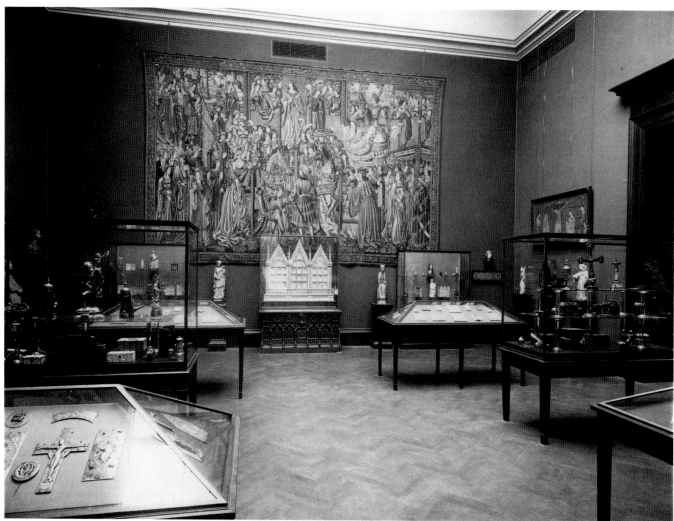

Fig. 5. Gallery 12, Gothic Period, Loan Exhibition of the J. Pierpont Morgan Collection, 1914. (The Metropolitan Museum of Art)

Braikenbridge), which is now in the Morgan Library. (It was never there in Morgan Sr.'s lifetime.) A group of Byzantine enamels (acquired by Hoentschel from S. Bardac) was also often described. A full-page spread in the Sunday *Times* of February 11, 1912, announced the collection's arrival in this country, with extensive descriptive text and large illustrations of eight pieces.[36] The rest of Morgan's collections were transported at the same time. These included medieval ivories and enamels on display at the Victoria & Albert Museum. The Victoria & Albert loan as a whole, which included many non-medieval objects, was said to fill thirty to forty display cases there.[37] The withdrawal, shipment, arrival, and anticipated exhibition of these pieces also received considerable press, and were, likewise, discussed

and illustrated in the papers, including the medieval art.[38]

The attention given the collections was no doubt heightened by the concurrent Pujo Committee investigations of the "Money Trust" in Washington, Morgan's testimony at those hearings (December 1912), and his death in Rome a few months later (March 31, 1913). His death notices occupied most of the first six pages of *The New York Times* the following day; his "$60,000,000 Art Collection," being one of the front-page headlines.[39] By this time, Morgan was as famous an art collector as a financier. The interest in the collection was heightened by the uncertainty regarding its fate. His will left its disposition entirely up to his son (the Metropolitan was not even mentioned), and, especially

after major parts of it were sold in 1915, there was considerable doubt about its ultimate fate, which caused much editorializing. Morgan had intended that his collection be loaned for exhibition at the Metropolitan, though he was less clear about its ultimate fate.[40] In February of 1914, an exhibition of the collection was opened to the public (Fig. 5). This was also the first time most American scholars and curators saw the collection; it had been in storage since its arrival in New York. The collection filled the entire upper floor of another new wing of the building (now occupied by the Far Eastern collections). Museum attendance records were broken.[41] In the approximately two years it was on display, from February 16, 1914, to May 28, 1916, over a million and a half people entered the museum. Of course, not necessarily everyone saw the two galleries of Morgan medieval objects in the loan exhibition, or the Hoentschel Collection in the Decorative Arts Wing, but certainly a great many people did. The opening of George Grey Barnard's popular medieval museum, the Cloisters, in New York in December 1914 probably had a synergistic effect; the interest in the medieval pieces in one collection probably heightened interest in the other, and vice versa.

Press reaction to the medieval objects in the Morgan Loan Exhibition was largely favorable. In a lengthy special article on the medieval enamels and ivories, *The New York Times* referred to:

> The noble group of early enamels. . . are not only rare and priceless works of art, but human documents of the highest value. . . . The figures. . . are treated as decorations without definition of feature or expression, yet theses narrow bodies. . . are more impressive in their passive dignity, even more pathetic and stirring to the soul than the tortured forms that were presently to take their place in religious art. . . . From the ivories one experiences, not quite so poignantly, a similar sequence of emotions. . . .These little French Virgins illustrate the lively spirit of the race from which they spring. The mirthful eyes and laughing mouths. . . . Nothing could be more reassuring as to the pleasure taken by Gothic France in its religion than such images of happy reality.

The writer admits, however, that the medieval galleries may fail to interest many of the visitors . . . "because the technical processes and the mental attitude of the artists are not matters of familiar knowledge."[42] Frank Jewett Mather, Jr., in *The Nation* discussed the enamels and ivories at length. Though his account is more descriptive than evaluative, he considered the Morgan medieval enamels superior to his collections of Baroque snuff boxes and watches. "In Gothic and earlier times it [enamel] had strength and carrying power…all [are] magnificent examples of sensitive craftsmanship and of wide design."[43] A writer in the *New Republic*, was not as sympathetic, although the objection seemed to be more to the unending display of objects, than to the objects themselves. Although the Byzantine and Limoges enamels were counted among the "great beauties" of the collection, it all was considered to be too much:

> This practice of unending accumulation, which displays everything and reveals nothing, is the direct result of a policy of mere acquisition The modern collector hoards what he usually has neither the time nor the space to house. On his death the museum, in the role of a benevolent Fafner, provides an appropriate cave in which successive Nibelungen hoards recovered from a disintegrating past are accumulated in exactly the piles in which they were originally heaped . . . Imagine, instead of these well-ordered salesrooms, an apse built into a wall, an altar beneath a stained glass window, the reliquaries, the lamps and the bishop's crook in their destined places, tapestries hiding the walls. Would there be need of a catalogue to remind us that craftsmanship is the precious bond that unites art to life, and that beauty achieves perfection by serving some other purpose than to display itself?[44]

The latter part of this description seems to presage the Cloisters museum of medieval art of George Grey Barnard, which was to open in December 1914. Although the author expresses some grudging appreciation for the treasures Morgan assembled, (s)he is already looking for something more from American museums and medieval art, which another American collector was soon to supply.

In 1916, the first Hoentschel Collection—the late Gothic sculpture continuously exhibited since 1908—was formally given to the Metropolitan by J.P. Morgan, Jr. In 1917, most of the medieval pieces in the loan exhibition were likewise given and were installed the following year.[45] Even today, after many decades of important medieval acquisitions, the Morgan Collection remains one of the largest and most important groups of objects in the Metropolitan, perhaps only equaled by the Cloisters collections of George Grey Barnard and John D. Rockefeller, Jr.

Morgan's collections also affected the museum and academic community. For the first time, a broad array of medieval objects were available to American scholars. Georg Swarzenski, writing in the preface to the catalogue for the major Boston exhibition, "Arts of the Middle Ages", traced American medieval collections back to Morgan. The changes can be seen at the Metropolitan and elsewhere. Before the Morgan acquisitions, large quantities of reproductions were still bought, such as the Irish metalwork objects (Cat. 27 and 28). This had almost entirely ceased by 1920. Before the Morgan acquisitions, Metropolitan purchases of medieval art were restrained, the $5 million Rogers Fund notwithstanding. In 1908 and 1909, for example, the museum purchased several modest Romanesque bronze censers, which they considered "valuable addition[s] to the

Museum's collection . . ."[46] Ten years later, after the Morgan acquisitions, they purchased another piece of Romanesque bronze work, but this time it was a superlative Mosan candlestick base with figures of prophets around the base. The difference in quality is probably a direct result of what the curators learned from the Morgan collection. Scholars trained at the Metropolitan sometimes went to art museums elsewhere in America. Wilhelm Valentiner, curator of decorative arts at the Metropolitan from 1907–1917, eventually became the director of the Detroit Institute of Arts, which developed a small but fine medieval collection.[47] The connections are even clearer with respect to the Cleveland Museum of Art. William Milliken, who served as an assistant curator of decorative arts from 1914–1917, when the Morgan collections were unpacked and exhibited, became a curator and then director of the Cleveland museum. Like the Morgan collection, the medieval collection he built for Cleveland is heavily concentrated in the minor arts. Many of the individual Cleveland pieces have close analogs among the Morgan objects. This taste for minor arts that Milliken appears to have developed from exposure to the Morgan collection may also be what led him to help bring the Guelph Treasure of medieval metalwork to America in 1930.

1. The locomotive observation was made by the photographer, Edward Steichen. See F. L. Allen, *The Great Pierpont Morgan* (New York, 1949), 163. There are numerous biographies of Morgan's business career, including L. Corey, *The House of Morgan, a Social Biography of the Masters of Money* (New York, 1930); and V. Carosso, *The Morgans, Private International Bankers, 1854-1913* (Cambridge, 1987). The primary personal biography remains that by his son-in-law H. L. Satterlee, *J. Pierpont Morgan, an Intimate Portrait* (New York, 1939).

2. J. K. Winkler, *Morgan the Magnificent, the Life of J. Pierpont Morgan (1837-1913)* (New York, 1930), 55.

3. S. N. Behrman, *Duveen* (New York, 1952; Boston, 1972), 184.

4. This and the following biographical information comes from Satterlee, *J. Pierpont Morgan*, especially chaps. 2 and 3.

5. Or perhaps 1846, the last digit is unclear. This book and *Parley's Book of History* are both preserved in the family archives of the Morgan Library, New York.

6. There was a long inscription by the youthful Morgan penciled in the end papers which might have provided some insights, but it has been almost completely erased, presumably by an older, more reticent Morgan.

7. Satterlee, *J. Pierpont Morgan*, 65. The "Boston Museum" referred to is not the present institution founded in 1870, but something more on the order of Barnum's museum. It is a place where popular theatrical entertainments were staged, and art and curiosities were displayed.

8. Satterlee, *J. Pierpont Morgan*, 88.

9. Ibid., 435.

10. Ibid., 124.

11. J. F. Sabin, *Catalogue of the Library of Mr. J. Pierpont Morgan* (New York, 1883).

12. Corey, *The House of Morgan*, 50.

13. He was a founding trustee, served as its treasurer from 1875 to 1890, and as first vice-president from 1903-1910.

14. Satterlee, *J. Pierpont Morgan*, 145.

15. E. Fowles, *Memories of Duveen Brothers* (New York, 1976), 26.

16. For the history of the Morgan Library's collections, see S. de Ricci, *Census of Medieval and Renaissance Manuscripts in the United States and Canada*, vol. 2 (New York, 1937), 1359–1636; F. Adams, *Introduction to the Pierpont Morgan Library* (New York, 1964); W. Voelkle, *Masterpieces of Medieval Painting: The Art of Illustration* (New York, 1980); and *In August Company: The Collections of the Pierpont Morgan Library* (New York, 1993).

17. Satterlee, *J. Pierpont Morgan*, 258.

18. C. Tomkins, *Merchants and Masterpieces: The Story of the Metropolitan Museum of Art*, rev. ed. (New York, 1970; New York, 1989), 98-99.

19. Robinson was assistant director from 1905-1910 and director from 1910-1931. Henry Kent joined the staff in 1904; he was eventually responsible for almost everything in the museum except the curatorial departments. Kent has been considered equal in power to the directors. See Tomkins, *Merchants and Masterpieces*, 118.

20. E. R[obinson], "The Hoentschel Collection," *Bulletin of the Metropolitan Museum of Art* 2 (June 1907): 98 .

21. W. V[alentiner], "The Hoentschel Collection," *Bulletin of the Metropolitan Museum of Art* 3 (July 1908): 129–33; and *Annual Report of the Trustees* 39 (1908): 22.

22. See *The New York Times*, July 8, 1908, 6:7; E. L. Cary, "Mr. J. Pierpont Morgan's Examples of Gothic Art at the Metropolitan Museum," *International Studio* 36 (Nov. 1908): xxx-xxxvi; and W. Rankin, "Current Notes," *Burlington Magazine* 14 (Oct. 1908): 61-62. The American public could have seen considerable quantities of plaster and metal reproductions of medieval art in several places, most notably at the Metropolitan itself.

23. "Gothic Art Shown at Metropolitan," *NYT*, July 8, 1908, 6:7.

24. Ibid.

25. "Hoentschel Gothic's Importance," *NYT*, Mar. 14, 1915, sec. 5, 22:1; and W. Harris, "Ecclesiastical Furniture," *Good Furniture* 6 (1916): 137–47.

26. This wing, named the Pierpont Morgan Wing after his death, now contains the collections of arms & armor and musical instruments.

27. "The Opening of the New Wing of the Metropolitan Museum," *NYT*, Mar. 13, 1910, sec. 6, 14:2. See also "Metropolitan Reception," *NYT*, Mar. 15, 1910, 5:3.

28. "Hoentschel Collection, Gift of J. Pierpont Morgan," *NYT*, Mar. 27, 1910, 1:5.

29. "Art," *Nation* 97 (Oct. 2, 1913): 319.

30. *The New York Times* ran over twenty articles on the transfer of Morgan's art collections in 1912.

31. "Morgan May Bring Art Treasures Here," *NYT*, May 22, 1910, sec. 3, 4:1.

32. *NYT*, Dec. 23, 1910, 1:6. Cragston was Morgan's country house in upstate New York.

33. "$50,000,000 Morgan Art Collection . . . ," *NYT*, Feb. 15, 1914, 14:1.

34. "Says Detectives Guard J.P. Morgan," *NYT*, Jan. 9, 1912, 3:4.

35. "More Morgan Art Treasures Arrive," *NYT*, Mar. 14, 1912, 11:3.

36. "J.P. Morgan to Bring Hoentschel Treasures Here," *NYT*, Feb 11, 1912, sec. 5, 13:1.

37. "Mr. Pierpont Morgan and South Kensington, Loan Collection Withdrawn," *London Times*, Jan. 26, 1912, 6:5.

38. See, for example, *NYT*, Feb. 25, 1912, 2:1.

39. "J. Pierpont Morgan Dead…," *NYT*, Apr. 1, 1913, 1:6; 2:1-6:1.

40. A preliminary exhibition of his Old Master paintings had already opened in Jan. 1913.

41. *NYT*, Feb. 23, 1914, 8:2; *NYT*, Mar. 10, 1914, 11:3; and *NYT*, Mar. 16, 1914, 3:2.

42. "Enamels in Morgan Collection…," *NYT*, Feb. 22, 1914, sec. 5, 11:1.

43. F. J. Mather, Jr., "The Morgan Loan Exhibition," *Nation* 98 (Feb. 26, 1914): 220–23.

44. "The Land of Sunday Afternoon," *New Republic* 1 (Nov. 21, 1914): 22–23.

45. Some of the medieval Limoges enamels that were sold ended up in Michael Freidsam's collection, which was given to the Metropolitan in 1931. A few pieces were retained by J. P. Morgan, Jr., and transferred to the Library, where they remain. The bronze angel reputedly from Ste. Chapelle remained at the Library until sold to the Frick Collection.

46. J. B[reck], "Principle Accessions," *Bulletin of the Metropolitan Museum of Art* 4 (Nov. 1909): 208-9.

47. Medieval art was included in the Department of Decorative Arts at the Metropolitan until 1933, when it was given its own department.

Henry Walters: Elusive Collector

Marshall Price

enry Walters (1848–1931) was a dynamic personality who loved to entertain lavishly for his friends, neither embarrassed nor shy about his wealth. But, he was also selfless and shared with those less fortunate than himself. His museum was founded not to flaunt his wealth, but to share with the public all of the wonderful objects he had acquired, to educate them, and to foster public interest in the arts (Fig. 1).[1] Walters felt strongly that a museum could enrich a city through cultural education. This notion is manifested in the collection he bequeathed to the city of Baltimore as The Walters Art Gallery.

To understand Henry Walters as a man, and more importantly, as a collector, we must first look at his father, William, for he is the one who most strongly fostered Henry's deep love and appreciation for art. William Walters (1819–1894) moved to Baltimore in the early nineteenth century from rural Pennsylvania. At twenty-one, he was a merchant dealing with trade between Baltimore and Pennsylvania. His business developed and grew, and he invested more and more in the shipping industry, most notably railroads. William Walters was apparently a natural born collector as ". . . the first five dollars he earned was spent on a picture, and that part of the first years profit was spent on the best pictures he could find."[2] William's collection consisted mostly of modern artists and Oriental porcelains, for which he had an affinity. He championed not only French academic artists and those of the Barbizon and Romantic schools, but also local Baltimore artists, W.H. Rinehart and A.J. Miller.[3]

An even more elusive character than his son, William was a shrewd businessman who eventually became the proprietor of a railroad dynasty. Setting an example for his son, he bought small bankrupt railroads and consolidated them until he owned one of the largest systems in the South. As a Southern sympathizer, he moved his family to Paris during the Civil War. Henry finished his primary education there.[4] It was in France that William met George Lucas, another American living in Paris. Lucas was a collector and personally knew many artists of the time. He played an invaluable role in shaping the taste of William (and later Henry) and provided considerable assistance to both Walters men in their pursuit of art. It was during this stay in Europe that William acquired a taste for Oriental porcelains. These were introduced by international exhibitions in London (1862), Paris (1867), and Vienna (1873).[5] The immense collection of these ceramic wares that William built up, perhaps more than anything else, brought notoriety to the collection.

Fig. 1. Thomas Corner, Portrait of Henry Walters.
(Courtesy of The Walters Art Gallery, Baltimore)

Upon the family's return from Europe, William expanded his enterprise while helping the reconstruction efforts in the South. He built two additions to the family house in 1873 and 1883 to hold the ever expanding collection. During the middle 1880s, he began to open the house and these additions to the public on Wednesdays in February, March, and April, and on Saturdays in April, plus on certain holidays. The admission was fifty cents, and all the proceeds went to charity.[6]

Very little is known about Henry Walters's early formal education. It may be presumed that he attended the lycée l'Institution Bonnefous, the inscription of which was found on a card in a book acquired by Walters in 1865, putting him around high school age.[7] While in Europe, William saw to it that Henry received a proper young gentleman's education, which cultivated a love, appreciation, and familiarity of art, especially French art. William apparently made the young Henry compose essays on art, which he surprisingly did not rebel against.[8]

The relationship between Henry and his father was strong, and Henry listened and observed intently when his father took him to museums in Paris or to an artist's studio. This was an important time for Henry as the young man's taste for art was developing, no doubt, under his father's scrutiny. The bond between the two was presumably strengthened by the sudden passing of Henry's mother due to pneumonia while the parents were in London.

When the family returned to America, Henry attended Loyola College in Baltimore, receiving a bachelor of arts degree in 1869. He then went on to Georgetown University and received his master's degree in 1871. This part of his education may have been dictated by his father because he then went on to complete a second bachelor's degree in 1873 in science at the Lawrence Scientific School at Harvard. It is possible that while at Lawrence, Walters may have attended the lectures of Charles Eliot Norton, especially considering his strong interest and previous education in art. Now that Henry had a solid background in both the arts and the sciences, he was ready to follow in his father's footsteps.

Henry spent the years 1873 through 1875 in France, reinforcing his knowledge and appreciation of art by visiting galleries and by collecting with his father.[9] Upon his return to the States in 1875, he plunged into the railroad industry as a member of the engineering corps of the Valley Railroad of Virginia.[10] He quickly worked his way up the business ladder to an administrative position. Through his father's connections, he soon joined the Atlantic Coast Line Co., the railroad his father had founded, as general manager and soon thereafter as vice president.

William Walters died in 1894, leaving his son not only a diverse art collection and a huge sum of money, but also a railway system worth over $100 million. Henry continued to expand the business in true robber baron fashion. As his father had done years earlier, Henry bought old bankrupt lines in the Carolinas, and by 1902 he had extended his business into Kentucky and Tennessee. By then he owned the largest railroad system in the South, stretching from Virginia to the Florida gulf.

It is difficult to establish a pattern for Henry Walters's early collecting habits. Initially, he apparently collected first editions and other fine examples of classic publications, no doubt to fill his gentleman's library.[11] This may have been encouraged by his father's early publishing ventures, some of the earliest having nothing to do with art but including other interests that were dear to him. For example, in 1868

William Walters published a paper on the Percheron horse, a draft breed he had seen in Europe. Later, there were publications on the Walters Collection. These publications eventually facilitated William's entrance into the Grolier Club (1893), America's oldest club devoted exclusively to the art of the book. Henry himself was admitted soon after his father's death (1894) in recognition of his participation in these undertakings.

Henry Walters was generous with his time with regard to cultural institutions. In 1905, he became a member of the Board of Trustees at the Metropolitan Museum of Art in New York, and in 1913 he became vice president, reportedly declining the presidency on more than one occasion. He was also a trustee on the board of the New York Public Library and the Fogg Museum Visiting Committee. Apart from these endeavors, however, he was an extremely private man who shied away from the public and the media. In 1910, when he succeeded John D. Rockefeller, Sr., on the steel board, an article in *The Wall Street Journal* identifying him as the richest man in the South was titled "Who is Henry Walters?" Although Walters was an extremely wealthy man, he was careful with his money and did not let it get the better of him. This is best expressed in an inscription in his hand on a flyleaf:

> Money is a very good thing if you have it—I can answer for that, because of what it does in advantages gained for social and literary cultivation of time, ease and tastes—But the getting of money (with few exceptions) does so dwarf and stultify the soul, that I always shrink from a community where it is the prevailing passion.[12]

By this time, business required that Walters live in New York. Baltimore's foremost collector in absentia, he returned once or twice a month to attend to business or to the art collection. He lived with his good friends Pembroke Jones and his wife Sarah Wharton Green Jones, whom he had met during his early railroad days in Wilmington, North Carolina. Walters eventually married Sarah at the age of seventy-three, after Pembroke's death.

Henry Walters did not start collecting until he was almost fifty years old. This remains unexplained, but it is possible he felt overshadowed by his father or unable to fill his shoes. Whatever the explanation, the earliest objects were acquired around 1897. These included Egyptian and Near Eastern objects and, quite possibly, manuscripts. It is possible that Walters met the art dealer Dikran Kelekian at the World's Fair of 1893 in Chicago. Kelekian came to the United States from Paris and opened a booth at the fair to expose the arts of the Near East to America.[13] This relationship lasted until Henry's death in 1931.

Kelekian supplied Walters with only a small percentage of his medieval objects, but Walters held Kelekian in high regard. At one time, Kelekian served as Turkey's emissary to Persia, and was given the title of Khan by the Shah of Persia. He had been a student of archaeology, immersing himself in its lore, but simultaneously remained close to modern painting. He was a cosmopolitan man, well versed in a wide variety of art. He eventually opened branches of his gallery in London, Cairo, and New York.[14] Along with Walters, Kelekian served men such as J.D. Rockefeller, Jr., and J.P. Morgan. Kelekian is responsible for some of the Walters's Byzantine, all of the Armenian, and most of the Islamic manuscripts.

Most of the French medieval manuscripts in the collection came from the dealer Léon Gruel.[15] Principally a book binder in Paris, he had a partner, Jean Englemann, who apparently dealt more with the exchange of rare manuscripts. Walters met Gruel in 1895 in Paris through George Lucas. This relationship lasted until Gruel's death in 1921, then continued with his son, who carried on the business. At first, Walters took Grolier Club publications to Gruel instead of having them done at the club's own bindery.[16] Eventually, Gruel became important in forming Henry's manuscript collection, as some 210 codices came from him. The majority of them are illuminated manuscripts, mostly of French origin. In all, the objects that came from Gruel comprise about fifteen percent of the Walters medieval collection.

Jacques Seligmann and his son Germain Seligman were also dealers to whom Henry Walters was loyal. Approximately twenty-five percent of the medieval collection came from the Seligmanns (Fig. 2). Their acquaintance began in 1902 when Henry bought a collection of porcelain and enamel from Seligmann. Seligmann was apparently interested, as was Walters, in the educational value of public museums. He was an important dealer to Morgan as well, and his contributions make up a large amount of both collections. In 1907, Jacques was recognized for his efforts and elected Fellow for Life at the Metropolitan Museum of Art. Unfortunately, he passed away in 1914, leaving son, Germain, to take over. Walters consoled Germain after his father's death, probably feeling sympathy as he, too, had lost a parent as a young man.

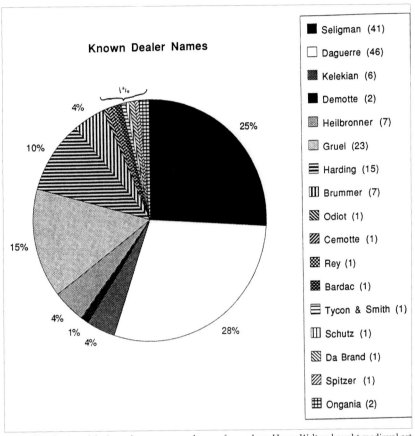

Fig. 2. Distribution of dealers whose names are known from whom Henry Walters bought medieval art.

Germain had always shown a genuine interest in Henry Walters's collection but had never seen it. It is in the younger Seligman's memoirs that we learn of the aging Walters's anecdotes. Walters brought Seligmann to Baltimore, and he was shocked by what he called "... a typical Victorian disregard for method, value, aesthetic merit, or period."[17] No doubt the collection looked much as it does in a pre-World War I photograph (Fig. 3). The only explanation Walters could give was that he had no time to unpack and catalogue the items. It is interesting to juxtapose this photograph against one taken of the gallery circa 1934 (Fig. 4). The dramatically different arrangement reflects the change in taste between the two eras.[18]

During this trip to Baltimore, Seligman became aware of some fakes in the collection but kept quiet for fear of offending Walters. Henry asked his opinion on these objects and Seligman tried to avoid commenting on them, but Walters persisted. Finally, he could avoid them no longer, and when he told Walters they were fakes, Walters

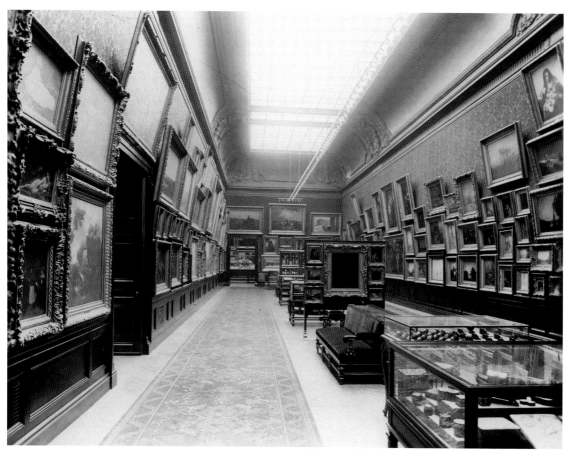

Fig. 3. The Walters Art
Gallery before
World War I.
(Courtesy of the
Walters Art Gallery,
Baltimore)

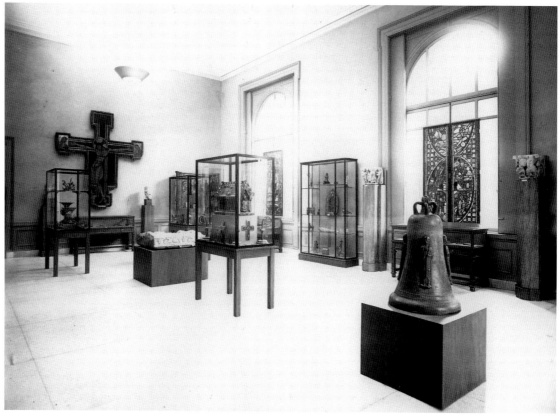

Fig. 4. The Walters Art
Gallery c. 1934.
(Courtesy of the
Walters Art Gallery,
Baltimore)

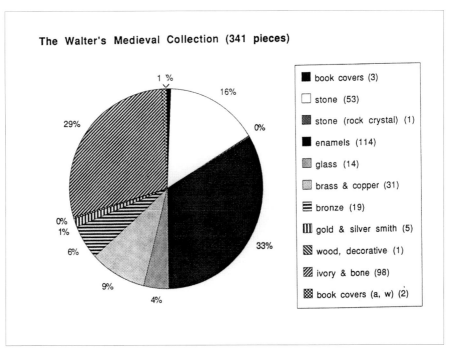

The Walter's Medieval Collection (341 pieces)

1 %

16%

29%

0%

0%
1%

6%

9%

4%

33%

- book covers (3)
- stone (53)
- stone (rock crystal) (1)
- enamels (114)
- glass (14)
- brass & copper (31)
- bronze (19)
- gold & silver smith (5)
- wood, decorative (1)
- ivory & bone (98)
- book covers (a, w) (2)

Fig. 5. Distribution by medium of medieval art in Henry Walters's collection.

replied, "My boy, that is just what I wanted to hear. I know they are fakes, but since they were bought by my father, they will remain here as long as I live. Meantime it gives me a good test of other peoples knowledge."[19] Seligman was also shocked to see crates piled on top of one another and inquired about a sculpture he had sold Walters a year earlier. Walters told him that it had not been unpacked, and Seligman again was astounded. Walters replied, "I probably won't live to see them all opened, but you can imagine the surprise of those who will unpack them after I am gone."[20]

Henry Walters never specialized in one field to the exclusion of others, and he apparently never abandoned a field once he became interested in it. A 1908 list of the collection includes Egyptian, classical, medieval, and modern objects. From this he apparently formed the nucleus of the medieval collection.[21] Walters was a prolific collector. Even during World War I his efforts never decreased as he spent $1 million a year on art until his death. He rarely bought entire collections, as Morgan often did. Instead, he approached objects one at a time. There were, however, three existing collections that he bought en bloc. In 1902, he acquired the Don Marcello Massarenti Collection, which included seven Roman sarcophagi and various other

Roman and Etruscan works. The collection was so large he needed to charter a whole ship just to transport it. He also purchased a collection of over one thousand fifteenth-century printed books in 1905 and a collection of Sèvres porcelain. These purchases were made with the notion they would form the nucleus of a larger collection.

Walters typified the Southern gentleman image with his portly figure and his white hair and goatee. His approach to art was much different than that of his father's—"he was more of a connoisseur and less of a patron."[22] He was also a generous contributor to charity, although his private nature often shrouds his contributions. Among these various alms to society, Walters helped establish the American Academy in Rome, to which Morgan also contributed. In a rare but precious quote from Walters about the academy, he explained its aims: ". . . we try to discover the best material in the country and then send those men to Rome, where they may achieve their highest for the elevation of American arts and letters."[23] Walters gave money to erect the main building of the Georgetown Preparatory School, and apparently he and Morgan gave money to save the economically faltering *Burlington Magazine*. During the war, Walters served the United States as director general of railroads and maintained the Passy military hospital near

Paris. Walters was an avid yachtsman and heavily supported the New York and Newport yacht clubs. In Baltimore, he erected a system of public baths, and at Johns Hopkins University he endowed the art department for medical illustrators.

According to Dorothy Kent Hill, an early curator of ancient art at the Walters Art Gallery, "If we were to choose one characteristic in the taste of Henry Walters, as directed toward all periods and subjects, it would be his feeling for the small object."[24] This is demonstrated by a breakdown of the Western medieval objects in his collection (Fig. 5). Henry Walters saw the worth of his collection far beyond its monetary value. He said, "I don't want anybody in later years to talk of my collecting in terms of money spent . . . that is my business. They'll have the works of art and their pedigrees."[25] This would be true, but unfortunately while brandishing the shears to remove the price of an object, he often removed the pedigree written on the back of the invoice, making the history of his collection often as elusive as the man himself.

1. I am very grateful to William Johnston, associate director of the Walters Art Gallery, for answering my questions on Henry Walters and providing me with information on him.
2. D. Sutton, "Connoisseur's Haven," *Apollo* 84 (December 1966): 422.
3. Some of the notable European artists William Walters patronized included Gérome, Meisonnier, Millet, Alma–Tadema, and Delacroix.
4. E. Burin, "Henry Walters," *American Book Collectors and Bibliographers,* ed. J. Rosenblum (Detroit, 1994), 297.
5. Sutton, "Connoisseur's Haven," 426.
6. D. K. Hill, "William T. Walters and Henry Walters," *Art in America* 32 (Oct. 1944): 178–79.
7. See E. Burin, "Henry Walters," 297.
8. Ibid.
9. Ibid.
10. For a more thorough account of Henry Walters's railroad ventures, see J. Ward, "Henry Walters," *Railroads in the Age of Regulation: Encyclopedia of American Business History and Biography,* ed. K. Bryant (New York, 1988).
11. Burin, "Henry Walters," 297.
12. Ibid., 299.
13. "Obituary of Dirkran Kelekian," *Art Digest* 25 (Feb. 15, 1951): 10.
14. Ibid.
15. Manuscripts, an important part of the Walters Collection, are generally outside the scope of this exhibition.
16. Burin, "Henry Walters," 301.
17. G. Seligman, *Merchants of Art: 1880-1960, Eighty Years of Professional Collecting* (New York, 1961), 132.
18. Three objects in the c. 1934 photo are in this exhibition, a testament to their importance in the context of the Walters Collection.
19. Seligman, *Merchants of Art*, 132.
20. Ibid., 133.
21. Hill, "William T. Walters and Henry Walters," 183.
22. Sutton, "Connoisseur's Haven," 427.
23. "Morgan to Develop the Roman Academy," *New York Times*, Feb. 3, 1917, 13.
24. Hill, "William T. Walters and Henry Walters," 185.
25. Seligman, *Merchants of Art*, 134.

George Grey Barnard: Artist/Collector/Dealer/Curator

Elizabeth Bradford Smith

ɔn his day, George Grey Barnard (1863–1938), was considered one of the most significant American sculptors of his generation (Fig. 1). He was also one of the greatest and most influential American collectors, creating the first museum in this country devoted exclusively to medieval art. During his life, Barnard's sculptures and his collections were the object of immense attention in the art world and in the popular press of both the United States and France. Although since his death his star may have waned to a certain degree, he has never been forgotten. The story of how Barnard turned his attentions from sculpting to collecting and eventually to the exhibition of medieval antiquities has been told a number of times, and it will suffice here to summarize his career before considering certain aspects of it in greater detail.[1]

Barnard's background and upbringing were unpretentious. Son of a Presbyterian minister, he was born in Bellefonte, Pennsylvania, and grew up in the Midwest. While still in his teens, he worked for a Chicago jeweler as an engraver and later joined the workshop of the sculptor David Richards, where he first carved in marble.[2] He went on to study sculpture at the Art Institute of Chicago, where he was inspired by plaster casts after Michelangelo and dreamed of studying in Europe.[3] In 1883, with the proceeds of his first commission, Barnard went to Paris and trained under the sculptor Pierre Jules Cavelier at the Ecole des Beaux-Arts.[4] Early recognition of his talents came after three and a half years of study in Paris, when American financier Alfred Corning Clark became his patron, and Barnard was able to set up a studio in Paris, working on commissions received through Clark.[5] In the Paris Salon of 1894, Barnard's six entries were applauded by the jury, of which the sculptor Rodin was a member, and won such wide acclaim that he was said to be "the most discussed man in Paris."[6] In 1894, Barnard returned to America, married, and settled down in New York where he taught at the Art Students League. Hoping to demonstrate to his students the "technique of direct carving" employed by Romanesque and Gothic masters, whose art he had most likely come to know and admire during his years in Paris, he was frustrated by the paucity of medieval models in this country.[7]

Opportunity for a return trip to France came in 1903. Barnard received a commission to execute for the state capitol of Pennsylvania at Harrisburg two groups of sculpture containing thirty-three heroic statues for the then-enormous sum of seven hundred thousand dollars.[8] The place to fulfill this unprecedented commission, Barnard decided, would be Paris. There, not only were his skills

Fig. 1. George Grey Barnard at work in his studio. (photographer unknown)

better appreciated, but also the artistic climate was more conducive to work. Skilled workshop assistants could be more easily had, and the Carrara marble he planned to use would be more accessible. Once embarked upon the Harrisburg commission, Barnard quickly consumed his original advance in the outlay for the studio, stone, supplies, and workshop assistants. By the time he was fully entrenched in the venture, the whole project was embroiled in a scandal involving graft and mismanagement within the state government. In 1906, funding dried up, the commission was suspended, and Barnard, already in debt and completely committed, was faced with financial ruin.[9] In addition, he now had a wife and family to support.

Some months before the Harrisburg scandal, Barnard had apparently begun working as a finder of medieval "antiquities" for Parisian art dealers, who had quickly recognized his potential as a shrewd and informed buyer with an eye for authenticity and a talent for bargaining. Ever resourceful, he now turned to this activity, which up to then had been only a profitable sideline, to help him out of his difficult financial situation and to enable him to continue working on his own sculpture. Instead of scouting for the Parisian dealers, he would become a dealer himself, and on a grand scale, comparable to that of his monumental statues for the capitol of Pennsylvania: he would buy entire architectural ensembles from the Middle Ages and sell them to Americans, for a great deal more than he had paid. Barnard's first and perhaps his most notable finds in his new role were four abbey cloisters—St.-Michel-de-Cuxa, St.-Guilhem-le-Désert, Trie-en-Bigorre and Bonnefont-en-Comminges—all from the south and southwest of France, which he located and bought in 1906 and

1907. Like the other cloisters, that of Cuxa was not conveniently *in situ* but was dispersed across the surrounding countryside. In the nearby town of Prades, a substantial section of it served as an arcade before the local bath house, and another section was an arbor for a local vintner.[10] In a small notebook, Barnard pasted the receipts for the Cuxa fragments as he made the rounds in Prades in January 1907, buying capitals, columns and bases, usually four or five at a time, from at least a dozen different sources. A typical receipt reads as follows: "Received from Mr. George Grey Barnard, artist-sculptor, the sum of four thousand francs, for 4 capitals (beasts) in red marble coming from St.-Michel de Cuxa—It being well understood that these capitals will immediately be replaced by simulated stone in poured cement. Prades, 19 January 1907" (Cat. 42).[11]

Although Barnard was not able to sell the cloisters immediately as he had hoped, he was saved from ruin and was

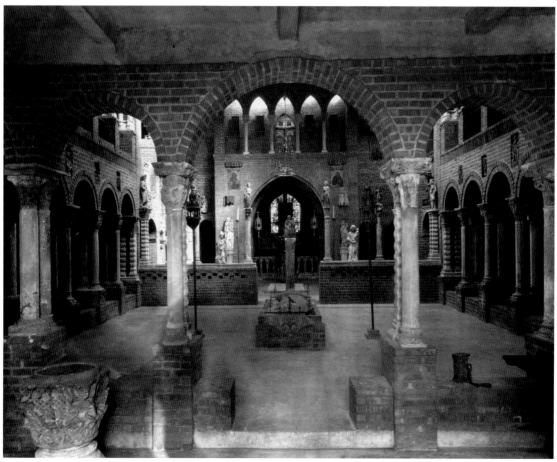

Fig. 2. Barnard's Cloisters, Washington Heights, general view of interior in 1926. (The Metropolitan Museum of Art)

134

able to resume work on the capitol project thanks to an anonymous group of New York businessmen who agreed to finance the project in order to salvage "an imperilled masterpiece." The group took care of expenses and gave Barnard a yearly allowance.[12] During the course of the next few years, as he completed the sculptures for Harrisburg, Barnard continued to buy examples of Romanesque and Gothic sculpture, often selling single works to dealers or collectors, and always hoping but never managing to sell the entire lot to an American museum. Some of Barnard's more colorful provenances may have been invented, some of his claims exaggerated, and certain of his contacts of dubious reputation.[13] Nevertheless, most of what he purchased in these years—over six hundred works of medieval art, according to J.L. Schrader—was authentic and of definite historic and artistic value.

On his return to the United States in 1911, the sculptures of Barnard's Pennsylvania State Capitol project were put into place and dedicated, but much to his chagrin the sale of his cloister collection still failed to materialize. Again, not to be undone, he started plans to build a "chapel" to house and exhibit the collection himself.[14] He designed, completed, and opened his Cloisters in Manhattan's Washington Heights on December 13, 1914, to a fanfare of publicity (Figs. 2 and 3).[15] The interior recalled a twelfth-century church—complete with nave, sanctuary, pulpit, altar, and gallery—and housed a pastiche of assorted medieval objects unrelated to one another except in time period. Columns and capitals from the Romanesque abbey of St.-Guilhem-le-Désert were arranged around the perimeter on the ground level (Cat. 43 and 44). In the center of the nave was the tomb effigy of Jean d'Alluye, a thirteenth-century chevalier who founded the Abbey of La Clarté after his return from a pilgrimage to the Holy Land in 1244. (Barnard claimed that the effigy was used face down as a bridge over a stream when he found it, but he actually bought it from the dealer, Georges Demotte.)[16] Gothic elements from the Trie and Bonnefont cloisters formed an arcade at the gallery level. Remnants of St.-Michel-de-Cuxa were reconstructed outside as an annex to the main building. Barnard, with his unerring flair for the dramatic and unusual, had ignored conventional museum methods of display in favor of a composite medieval setting, complete with museum guides dressed in monks' robes against a background of candlelight, incense, and medieval chant.[17]

The public was entranced, and so were the critics. *The New York Times* accorded glowing recommendations, complete with illustrations a week in advance of the opening. The

works of art were praised as "veritable treasures," but it was the setting Barnard had created for them that had the biggest impact: "arranged as only a scholar who also was an artist, and only an artist who also was a scholar, could arrange them. . . . Nothing so reviving and stimulating, so actively poetic has been accomplished in this age of renewed interest in ancient art."[18] Jerauld Dahler writing in the periodical *Architecture*, described the mystical effect the Cloisters had in "transport[ing] the visitor back to . . . visions of the Middle Ages," and creating a "feeling of reverence" that "every one in the [architectural] profession should know about and see."[19] Dahler was especially impressed by Barnard's direct and personal involvement with the building of the Cloisters, and he attributed its success as a building largely to this and to the fact that

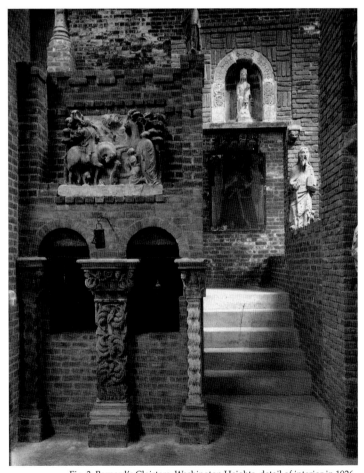

Fig. 3. Barnard's Cloisters, Washington Heights, detail of interior in 1926. (The Metropolitan Museum of Art)

Barnard was "not an Architect." He continues:

> For it is that very quality of seeking to become proficient, to
> be sophisticated, that exists in the profession today, that
> would destroy rather than produce such a work. When I first
> visited Mr. Barnard's cloister, I realized at once and more
> forcefully than ever before, not only how unimportant is aca-
> demic training, but also how stifling and limiting is apt to be
> its influence; and on the other hand, how all-important in cre-
> ative work is that which we call *feeling*. A total ignorance of
> academic rules has here permitted an unhampered freedom
> of personal expression which would be impossible to the
> school-trained individual. But on the other hand there was
> present here a thorough knowledge and a love for the art in
> which the builder worked, gained by constant association.
> No outside influence came between. That is why this build-
> ing is so beautiful to me and is always interesting,—because
> it is absolutely personal throughout, and an expression of the
> individual feeling of its author.[20]

Dahler's reaction to Barnard's Cloisters may seem exces-
sive—he himself refers to the "strange beauty of the ensem-
ble [that] brings one under its spell."[21] But Dahler was not
alone in this. In a sense, Barnard had, indeed, cast a spell;
he had made medieval art palatable for the masses.

Barnard's Cloisters became not only a popular outing for
the general public, but also a mecca for museum curators
and rich collectors alike. As can be expected, it had an
impact on both the collecting and the exhibition of
medieval art in the United States. Although it was not until
1925 that John D. Rockefeller, Jr., purchased Barnard's
Cloisters *in toto* for the Metropolitan Museum of Art, its
influence on the collecting strategies of American museums
was both immediate and longlived. One of the first
Americans to appreciate the monumental sculpture of the
Romanesque era and certainly the first to acquire it in great
quantity, Barnard set a fashion in collecting that flourished
continuously into the 1920s and 1930s, in private collections
and in university and public art museums.[22]

Similarly, the influence of Barnard's display techniques was
also quickly apparent, in spite of Dahler's gloomy predic-
tion to the contrary—"I suppose we shall continue to build
classic temples and halls to house Gothic exhibits . . . [with]
not one thing in relation to anything else, [to] fill glass . . .
cases to overflowing . . . and to crowd the wall."[23] Some
museums, such as those of Cleveland and Detroit, imedi-
ately adopted Barnard's concept of a skylit brick shell as a
setting for medieval sculpture, building garden courtyards
of brick. In a second wave, others installed medieval portals
surrounded by fake masonry walls (St. Louis in 1932); or
even bought and erected cloisters of their own (Toledo in
1933), in an attempt to recreate Barnard's technique of total-
ly immersing the museum goer in the Middle Ages. The
culmination of the trend occurred when in 1938 the
Metropolitan Museum of Art, again with funding from
Rockefeller, opened its own museum built to house
Barnard's collection. Called The Cloisters, it is in Fort Tryon
Park, not far from the site of Barnard's original Cloisters.

Barnard's massive exportation of medieval sculpture, espe-
cially of the Cuxa cloister, did not escape the notice of
French officialdom. He was repeatedly accused of
"Elginism," that is, of carrying away large amounts of
sculpture from their original site and even from their coun-
try of origin, just as Lord Elgin in the early nineteenth cen-
tury had removed the classical reliefs from the Parthenon.
In spite of the fact that Lord Elgin had been British and that
the Greek marbles were now in the British Museum,
"Elginism" was regarded by the French as "principally an
American illness." In fact, Barnard's "pillage" of French
monuments was a major factor in the French tightening of
controls in 1913 over the exporting of works of art that were
classified as historical monuments by the state, with consid-
erable repercussions on the international art market.[24]

Barnard was again to receive unwelcome attention from the
French press in 1927. At that time, after the sale of his first
collection, he once more began to buy medieval art in great
quantity, even purchasing the fragments of another cloister,
that of St.-Genis-des-Fontaines, from the southwest of
France. An article in *Le Quotidien*, January 30, 1927, bears
the headline, "Stone by Stone our Historical Monuments
are going to the United States," and asks that the artistic
patrimony of France be more strongly protected by law
from such "vandalism." The article goes on to report how
just such a law had recently been proposed in parliament
by Henri Auriol, deputy from the Haute-Garonne in the
southwest of France, the region from where Barnard had
taken most of his cloisters. In a letter to Barnard at this
time, the Paris dealer Paul Gouvert, from whom Barnard
had purchased the St.-Genis cloister and a number of other
works, advised him in light of this to sell the cloister "as
soon as possible and with a great deal of discretion" lest he
be obliged to send it back to France.[25] In an earlier letter,
Gouvert had already warned Barnard about the possible
effect of all the international publicity surrounding
Rockefeller's purchase of his collection: ". . . unfortunately,
thanks to these articles which assign an incalculable value
to the French works that America has in its possession, we
will soon find ourselves paralysed insofar as concerns the
export of these precious works, for a current of opinion is
forming here which will certainly vote a decree rigorously

forbidding all exports."[26] But this suspicious attitude to Barnard was not universal. Indeed after Barnard addressed the Institut de France on the subject of "Elginism" (at least as it applied to him), the French government soon came to appreciate what he had done on behalf of their nation's artistic heritage and made him a Chevalier of the Legion of Honor in 1928.[27]

Subsequently, due to what may be called benign neglect on the part of the authorities, Barnard was able to continue exporting medieval art from France throughout the succeeding years, as he built up his second collection. The primary purpose, according to Barnard, for the continuation of collecting and dealing, was not from any "desire to possess Gothic art," but for the "furthering of my monument" (The Rainbow Arch, Monument to Democracy).[28] Thus, Barnard's second collection, like the first, was but a means of financing the creation of his own art. Under Barnard's will, the proceeds from his second collection were to fund his last sculptural masterpiece, the hundred foot by sixty foot "Rainbow Arch," accompanied by large sculptural groups and a forty foot "Tree of Life," but this colossal epic

to memorialize the First World War was never executed for lack of funding and, perhaps, of public will.

In some ways, Barnard's second collection attempted to emulate the first, with its St.-Genis cloister, Romanesque portals, capitals, and other architectural elements, and even a thirteenth-century knight's tomb. The second collection differed from the first in having a greater proportion of freestanding sculpture and more works from the late Gothic and Renaissance periods. Barnard insisted that his second collection was equal in value to his first, saying, "This collection is incomparably greater as documents for study by the architects and sculptors than the Cloisters (the Cloisters are a poem), the great capitals unique, dynamic documents of the chisel, unsurpassed."[29] Nevertheless, as happened before, Barnard was unable to make the quick sale he was hoping for. This proved somewhat awkward, since the Metropolitan Museum of Art continued to house his first collection in the building Barnard had erected for it. Barnard, therefore, had nowhere to display his new collection of medieval art, and so most of it went into storage.

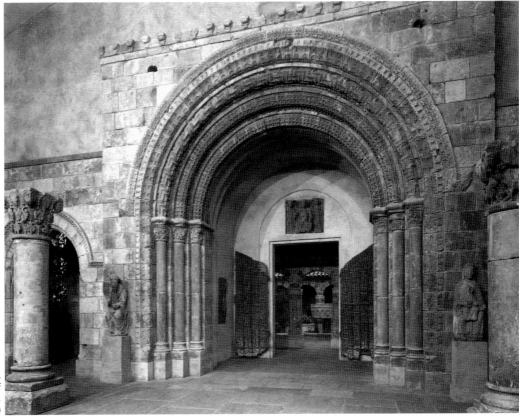

Fig. 4. Philadelphia Museum of Art, view of "The Display Collection of the Art of the Middle Ages" in 1931. (Philadelphia Museum of Art)

Barnard was in negotiations, however, with the Philadelphia Museum, whose new building had just been completed in 1928. Although they were not financially in a position to buy his entire second collection as Barnard hoped, they did buy from him that same year the St.-Genis cloister and also a Romanesque portal from St.-Laurent-l'Abbaye in Burgundy, thanks to a donation from Elizabeth Malcolm Bowman. In addition, they agreed to take on loan a number of capitals from his second collection. These they installed with the cloister, the portal, and the rest of the Philadelphia Museum's collection in the new Medieval Wing. Supplemented by numerous other "important loans" from a long list of museums, private collectors, and dealers, the Medieval Wing opened to the public in the spring of 1931 with a special exhibition entitled "The Display Collection of the Art of the Middle Ages" (Fig. 4).[30] Once more, as had by now occurred in a number of other museums, Barnard's Cloisters served as the inspiration for the arrangement, which centred around the St.-Genis quadrangle. Fiske Kimball, director of the Philadelphia Museum, placed his imprimatur on the Barnard method of display, with the following words:

> But suppose in this country, where there are no old Gothic churches for our public to pass daily, and where there is no Hotel Cluny to house our collections, we install the objects, uprooted, in neutral halls and galleries. What conception does the great public derive from them of their character as living embodiments in plastic form of the mighty organism of the Middle Ages, with its piety, its chivalry, and its romance? Clearly, architecture itself must here be called into the collections of the Museum—and, if it is not to violate every canon which governs them otherwise—the elements of architecture, like other works displayed, must be original and authentic, not copied.[31]

In the fifteen years since the opening of his Cloisters, Barnard's concept of an integrated period setting had become the established norm.

The Philadelphia Museum kept the objects lent by Barnard until 1936, when the Metropolitan Museum of Art removed the first collection from Barnard's Cloisters prior to installing them in their new home in Fort Tryon Park. Barnard once more took possession of his old skylit brick structure and once more he began to create there a pseudo-medieval environment for his collection. Now called L'Abbaye, Barnard's second museum opened in October 1937. Barnard died the following spring, less than a month before the scheduled opening of the Metropolitan's new museum, The Cloisters. The collection in the Abbaye, which closed on Barnard's death, remained there, intact. After several abortive attempts to dispose of it elsewhere, Barnard's heirs finally sold the greater part of the collection to the Philadelphia Museum of Art in 1945. The rest was sold at auction and dispersed.[32]

We may ask why Barnard chose to buy art of the Middle Ages rather than that of another era. Certainly one reason for this is that he lived for many years in France, where a tremendous amount of it was available to anyone who took the trouble to ferret it out. France, the richest and most highly populated country in Europe during the twelfth and thirteenth centuries, had erected literally thousands of churches during these years and had richly endowed them with sculptures, stained glass, tapestries and liturgical objects. The secularization of monasteries and the seizing of church property by the state as a result of the French Revolution had, in a sense, "liberated" a great many works of art belonging to the church. While some had entered private collections, many others, especially architectural elements of the Romanesque era, were accorded less value, and ended up as garden ornaments or were even put to utilitarian purposes on farms and in workshops. Such, for example, was the case with the Cuxa fragments. Thus, although the particulars of some of Barnard's stories may be exaggerated, it is no doubt true that a great deal of the art of the Middle Ages was undervalued both artistically and financially at the turn of the century and was fruit ripe for the taking by someone who could recognize its potential worth. Barnard, himself a sculptor of stone, seems to have had an instinctive appreciation for medieval sculpture.

In an undated list of objects in the Cloisters, Barnard explains that he collected medieval sculpture because of the particular texture of the limestone in which much of it was carved:

> My supreme object in making this collection was to give documents to the American sculptors and students that might teach them to use the chisel. The stone in France which was used for building its great cathedrals, and in fact all Gothic sculpture, is of a soft texture which prohibits an extreme finish and reveals in every touch of the sculptor's the manner in which he wrought his lights and shades and forms. Greek sculpture canot do this. Their ways are hidden partially owing to the fact that their medium, marble, demands extreme finish. It was my discovery of this fact that led to the awakening of interest in Gothic sculpture. . . .[33]

If we take Barnard at his word here, then it is perhaps to the even softer texture of the medium that we can attribute the fact that in his 1924 inventory of the Cloisters, Barnard lists a wooden torso of Christ from a Crucifix as "the greatest piece in my collection. The finest torso of Christ in the whole realm of French Romanesque Gothic [sic] sculpture," and describes a seated wooden Madonna, said to be from

St.-Denis, in the following words: "The statue of the Virgin and Child in wood . . . is the only one known of this important size with its original gold and polychrome. It constitutes, with the torso of Christ, 11th century, the two treasures of my collection, and two of the greatest treasures of French sculpture. Duveen estimated this at $50,000"[34]

It is difficult to know to what extent we can trust Barnard in the statements quoted above, as they were probably meant for the eyes of potential buyers. A letter written to his sister-in-law, Vivia Monroe, just after the completion of his assembly of the fragments of the cloister of St.-Michel-de-Cuxa, may be more revelatory of his personal sentiments: [underlining is Barnard's]

> Beloved Vivia—
> I am in the south of France where I have spent most of my time since Oct. Have just found & purchased a magificent thing.
> I want & should get $50,000 for it—my cloister=12th century—end of 11th perhaps oldest & most historical in France. Mr. Abbey loaned me the money—Edna's [Barnard's wife] $600 I turned into $1900 in 1 month—she has share with me in cloister—have 3 cloisters now—to sell. Let the Pittsburg Museum know all about it go & see Mr. Ogden & ask his advice about going to Mr. Carnegie to place it in New York—or elsewhere—He should pay $50,000 for it or more—with door $100,000—
> It's my 'pièce de resistance' worth any price—Have had $3000 already put on 2 single capitals & columns and there are sixty—but they are all not of equal value—
> If Chicago people don't move on the 1st cloister (I believe they will and are) then we will let them certainly buy this one—If NYork don't=or Pittsburg. I only wish I had some money to invest have a mine of chances but no funds—Yet I don't appreciate risking money of others—you will know how to copy museum letter to send elsewhere—I gave your address 251 W. 100th St. love to you all dear ones—I go from 6 AM to 12 PM. So must rest. Brother George. Jan 22, 1907 Prades=France.[35]

This letter shows Barnard's obvious love of the cloister he has just purchased, which he calls "a magnificent thing." It also demonstrates, in a single document, Barnard's strategy for the sale of the works he was acquiring and illustrates his optimism at this early stage, made all the more poignant by the fact that it would ultimately be nearly twenty years before his cloisters would be sold. During these years, Barnard struggled to stave off his creditors, whose many letters to him, alternately pleading and threatening, usually to no avail, suggest that over time he must have built up quite a thick hide. The offer of $3,000 for only two capitals, as mentioned in the letter to Vivia Monroe, gave Barnard the notion that if he were to calculate every capital at that price, the Cuxa cloister alone would be worth at least $50,000. It must have been the

hope of eventually realizing that sum that kept him going year after year.

It has been suggested that it was the possibility that J.P. Morgan would donate the cloisters to the Metropolitan Museum of Art, of which he was president of the board of trustees, that gave Barnard the impulse for his massive buying in 1906–1907.[36] Barnard's letter to Vivia Monroe, however, indicates he was not thinking only of New York, but also intended to put out feelers to Chicago and Pittsburgh at the same time, in a multi-pronged attack of the sort that would continue to be his preferred method of marketing for many years to come. Nevertheless, Barnard probably did have high hopes that Morgan would buy the cloisters for the Metropolitan, and he appears to have been stunned by the museum's suddenly going cold. Simpson's explanation of why the Metropolitan failed to follow through on its initial expression of interest—that the sale was squelched by the powerful dealer Joseph Duveen, who didn't like Barnard "horning in" on J.P. Morgan, Duveen's most valuable client—is the only explanation offered thus far, and it is a plausible one.[37]

In any case, as a result of his failure to make a quick sale of the Cuxa cloister, or indeed of any of his major architectural fragments, Barnard devised a plan to bring home the works of art in which he had invested so much of his time and other people's money. He would display them himself in the hope of finding a single buyer for the entire collection. In an attempt to understand how Barnard decided to present his collection in the way he did, one might first try to gain some notion of his general aesthetic principles, especially as regards sculpture. Evidence of his ideas in this regard can be found in a letter to his parents written during his first visit to Rome: [underlining is Barnard's]

> Rome Grand Hotel. Oct. 9, 1904. Beloved Mother and Father,
> Here Edna & I are in the old city where my road of 41 years has been leading me to. We arrived last night so have had but a bird's flight over things, St. Peter's I consider a monument of faults, a monument of what should not be done in architecture and sculptural decoration. Michael Angelo's dome is a harmony except the details outside on the top. The great architectural mass of construction in St. Peter's is fine, but they have overloaded it with shoddy frightful taste in colored marbles & bad statues. It reminds me of a fine statue covered with an extra dozen of legs hands & feet thinking to add to the form's greatness by giving it numerous feet & hands.
> Some of the smaller decorations of old mosaic like glistening dew in a sunshine. Michaelangelo Moses in marble is beautifully placed beneath a high window giving it the necessary shadows for the life & caracter [sic] he so sought for. The Moses—is—a—monument.
> Angelo beautiful (Pietà) Mother & Christ are badly placed high up where they cannot be seen & they had placed around

the group horrible little figures in bronze & marble of a caracter to utterly destroy the beauty in this sweet work. It is turned in[to] the too much decorated Roman catholic altar piece, the Italians cannot know the value of this single group or they would set it by itself, isolated & <u>open</u> to all—But then it is evident that ever since Angelo & Raphael stopped their work their followers have bent over backwards to cover or surround beautiful things with the <u>atrocious</u>. Rome is bewildering, no such poem as Florence gave me, 'an entity'—no Rome is such a mixture of 3 ages present (painfully), Renaissance & ancient Rome that one must face the 3 streams at once. However my heart is bound around the Sistine where Angelo's frescoes are & perhaps may be bound around Raphael's neither of these have I seen yet

but go to them tomorrow, I lost 2 models one left the country. . . . [rest of letter missing][38]

Barnard's letter to his parents, written when he was still completely involved in plans for his own sculptural endeavors, possibly before he began even to think of dealing in medieval art, shows him to be highly sensitive to the placement of sculpture—witness his dismay at seeing Michelangelo's *Pietà* surrounded by "horrid little figures in bronze" that "utterly destroy the beauty in this sweet

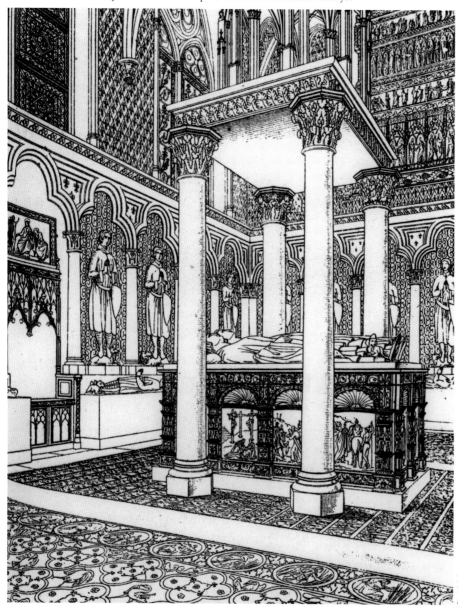

Fig. 5. Room of the 14th century in Alexandre Lenoir's Musée des Monuments Français, Paris, after Biet.

140

work." It also reveals Barnard's preference for the simpler "poem" of Renaissance Florence over Rome's "bewildering . . . mixture of 3 ages." This letter, then, helps us to understand why Barnard took such care in creating what was to him the perfect setting for the appreciation of his medieval fragments.

One source of inspiration both for Barnard's focus on medieval art and for the Cloisters as he built them might be the Ecole des Beaux-Arts itself, where Barnard went as a student in 1884 and with which he remained in contact over the next ten years as he lived and studied in Paris. Since 1816, the Ecole des Beaux-Arts had been housed in a complex of buildings, cloisters, and courtyards on the rue Bonaparte across the Seine from the Louvre.[39] The oldest part of this complex had originally been a monastery, the Couvent des Petits Augustins. Seized by the state in 1789, it then became the site of Alexandre Lenoir's famous Musée des Monuments Français. Here, in a monastic setting, Lenoir displayed the works of art, primarily medieval and Renaissance sculpture and architectural fragments, which he had allegedly saved from destruction (Fig. 5).[40] Although the Musée des Monuments Français was closed in 1816, when the site was given over to the Ecole, the original buildings and a number of Lenoir's fragments remained there as new buildings arose around them. These were still there, some of them prominent features of the architectural setting, when George Grey Barnard arrived as a student. Every day Barnard and his fellow students would have walked past—and sometimes even through—the medieval and Renaissance sculptures that filled the cloisters, courtyards, and chapels of the Ecole. These sculptures, in sympathetic yet not original surroundings, doubtless had over time a lasting impact on them all, Barnard among them.

In fact, the Ecole des Beaux-Arts, where Barnard spent a great deal of time at an impressionable age, may have provided Barnard with the overall concept for his Cloisters. Not only does his arrangement of the cloister fragments complete with tomb and other monumental sculptures recall Lenoir's, but more specifically, the placement at the Ecole des Beaux-Arts of the Renaissance Arch from the Château de Gaillon in front of the Neo-Renaissance Palais des Etudes is echoed in Barnard's positioning of the arch from a shrine near Villeneuve-lès-Avignon as a freestanding element in front of the entrance to his Cloisters. Moreover, Lenoir's museum and the fragments still in the Ecole des Beaux-Arts were beginning to attract a fair amount of attention in the French art world precisely during the years when Barnard was in residence—they were,

in fact, the subject of some debate among scholars and curators in the mid-1880s.[41] This increased awareness might easily have been communicated to the students of the Beaux-Arts. Thus, in terms of the collecting and display of works of art, Barnard's Cloisters can be seen to take direct inspiration from the Musée des Monuments Français and to evoke the shade of Alexandre Lenoir, the first great curator of medieval art. For Barnard, his Cloisters may in addition have recalled for him his youth at the Ecole des Beaux-Arts.

As for the interior arrangement of Barnard's Cloisters, a group of plates representing medievalizing set designs found among Barnard's papers provide intriguing parallels. Especially interesting are Eugène Morand's designs for Massenet's opera *Grisélidis*, and for *Oriande*[?], as presented in the section of "Peinture et sculpture décoratives" in the Salon of 1901.[42] Both of these use a combination of fragmented architectural elements—porticos, arcades, fountains, and sculpture—to create a scene evocative of the Romanesque era. Although there is no commentary by Barnard accompanying Morand's theatre designs, the fact that he kept them in a folder along with a group of photos including many of his favorite works of art (Michelangelo's *Moses* and *Pietà*, for example) suggests an additional source of inspiration for Barnard's Cloisters in the fictive world of theatre.

Ultimately, the fascinating thing about Barnard is that he was not a true collector, but a collector *malgré lui*. His collections were from the start amassed only in order to be sold. It was Barnard's failure to sell his assembled collection en bloc and his extraordinary tenacity in clinging to that as a goal that led to his creation of the Cloisters, where the ensemble could be displayed to advantage and perhaps attract a buyer for the collection as a whole. Ironically, one could say that the Cloisters was merely a glorified sales gallery, yet it established Barnard as a major medievalizing force within the American art community. There was something more at work here, however, than a desire to present his wares in the best possible setting. There was Barnard's sense of his own destiny, perhaps born of his early success in the Paris salons, a feeling that he was capable of great things. Barnard's own sculpture was executed on a colossal scale. His Cloisters, though not at all large, was by virtue of its wide-ranging and lasting influence on the American public and on American museums, a monumental creation.

1. The most complete accounts of Barnard's activity as a collector are: H. E. Dickson, "The Origin of 'The Cloisters,'" *Art Quarterly* (summer 1965): 252–74; and J. L. Schrader, "George Grey Barnard: The Cloisters and The Abbaye," *Bulletin of the Metropolitan Museum of Art* 37 (summer 1979).

2. H. E. Dickson, *George Grey Barnard, Centenary Exhibition* (University Park, Pa., 1964), 10–11.

3. J. W. McSpadden, *Famous Sculptors of America* (New York, 1925), 86.

4. Schrader, "George Grey Barnard," 10.

5. H. E. Dickson, "Barnard and Norway," *Art Bulletin* 44 (Mar. 1962): 55–59, esp. 55.

6. Dickson, *George Grey Barnard*, 6.

7. Dickson, "Origin of 'The Cloisters,'" 254.

8. M. S. Young, "George Grey Barnard and the Cloisters," *Apollo* 106 (Nov. 1977): 332–39, esp. 334.

9. Ibid., 334.

10. Dickson, "Origin of 'The Cloisters,'" 254–58.

11. "Reçu de Monsieur George Grey Barnard, artiste-sculpteur, la somme de quatre cents francs, pour 4 chapiteaux (bêtes) en marbre rouge provenant de St Michel de Cuxa—Etant bien entendu que ces chapiteaux seront immédiatement remplacés par de la pierre simulée en ciment coulé. Prades le 19 Janvier 1907." Barnard Archives, The Cloisters, The Metropolitan Museum of Art.

12. Dickson, "Origin of 'The Cloisters,'" 263.

13. Ibid., 255–56; Schrader, "George Grey Barnard," 12, and in captions throughout the article; and C. Simpson, *Artful Partners* (New York, 1986), 142–43.

14. Schrader, "George Grey Barnard," 23.

15. Dickson, "Origin of 'The Cloisters,'" 270.

16. Schrader, "George Grey Barnard," 24.

17. W. H. Forsyth, "Five Crucial People in the Building of the Cloisters," *The Cloisters: Studies in Honor of the Fiftieth Anniversary* (New York, 1992), 51–59, esp. 52.

18. Dec. 6, 1914.

19. J. Dahler, "George Grey Barnard's Cloister," *Architecture. The Professional Architectural Monthly* 33 (Mar. 1916): 51–57. esp. 57.

20. Ibid., 53–55.

21. Ibid., 57.

22. See Part III of this catalogue for an illustration of this point.

23. Dahler, "Barnard's Cloister," 57.

24. Dickson, "Origin of 'The Cloisters,'" 264–67; quotations are from an article in *Les Pierres de France*. Quoted in B. Weiss, "American Museums: Three Examples from the Cloisters to Michael Graves," *Lotus International* 35 (Feb. 1982): 100.

25. Paul Gouvert to Barnard, Jan. 31, 1927, Barnard Archives, The Cloisters, MMA.

26. Paul Gouvert to Barnard, Oct. 29, 1926, Barnard Archives, The Cloisters, MMA.

27. M. Weinberger, *The George Grey Barnard Collection* (New York, 1941), vii, xiv.

28. Barnard to John Gellatly, Dec. 7, 1927, Barnard Papers, Archives of American Art–Smithsonian Institution.

29. Barnard to Fiske Kimball, Dec. 12, 1927, Barnard Archives, The Cloisters, MMA.

30. F. H. Taylor, "Medieval Textiles and Romanesque Sculpture," *Pennsylvania Museum Bulletin* 23 (Apr. 1928): 17-21; "A Princely Gift. The Romanesque Section of the Museum," *Pennsylvania Museum Bulletin* 24 (Dec. 1928): 3–11; and "Handbook of the Display Collection of the Art of the Middle Ages," *Pennsylvania Museum Bulletin* 26 (Mar. 1931): 3–48.

31. F. Kimball, "Display Collection of the Art of the Middle Ages," *Pennsylvania Museum Bulletin* 26 (Apr. 1931): 3.

32. Schrader, "George Grey Barnard," 51–52.

33. Barnard Archives, The Cloisters, MMA.

34. Barnard Archives, The Cloisters, MMA.

35. Barnard Archives, The Cloisters, MMA.

36. Simpson, *Artful Partners*, 145.

37. Ibid.

38. Barnard Archives, The Cloisters, MMA.

39. R. Chafee, "The Teaching of Architecture at the Ecole des Beaux-Arts," *The Architecture of the Ecole des Beaux-Arts*, ed. A. Drexler (New York, 1977), 61–109, esp. 77–79.

40. For a recent discussion of Lenoir and his museum, see A. McClellan, *Inventing the Louvre: Art, Politics, and the Origins of the Modern Museum in Eighteenth-Century Paris* (Cambridge, 1994), 155–97.

41. L. Courajod, *Alexandre Lenoir: son journal et le Musée des Monuments Français*, 3 vols. (Paris, 1878-1887); and *Inventaire général des richesses d'art de la France, Archives du Musée des Monuments Français*, 3 vols. (Paris, 1883, 1886, 1897).

42. Barnard Archives, The Cloisters, MMA.

2

Catalogue Entries

30. Censer

Top: Germany, Lower Saxony, 12th century. Bottom: Italy, 13th? century
Bronze, 14 x 8.6 cm diameter
The Metropolitan Museum of Art,
Rogers Fund, 1910
10.18.4
Purchased from Sangiorgi

Like most of its medieval counterparts, this cast bronze censer consists of two hollow sections that, when joined, form a roughly spherical shape. Used as a receptacle for burning incense during the liturgy, it would be carried by a chain attached through holes around its perimeter and swung from side to side to disperse the scented smoke symbolizing the ascent of prayers to God. Although purchased together, the two halves of this censer are markedly different in design and may not originally have been part of the same object. The bottom half is a solid bowl with bands of foliate ornament. The pierced cover is cast in the form of miniature architecture, a reference to the Heavenly Jerusalem, or the City of God, and is decorated with gables, a tower, and arches inhabited by small figures of the Evangelists' symbols. The bowl has been compared to a similar one in the Schnütgen Museum in Cologne, part of a large group produced in Italy, using pattern molds "of goldsmith's quality," while the cover finds a parallel in the British Museum, attributable to a workshop active in Lower Saxony during the second half of the twelfth century.[1] Like the Glencairn Museum stained-glass panel included in the exhibition (Cat. 62), this object is a pastiche or composite work. A dealer may have taken two unrelated fragments and put them together to create a more salable whole.

This censer, and the crucifix and mirror case as well (Cat. 31 and 32), were purchased with monies from the Rogers Fund. In the nineteenth century, except for the casts and models, the medieval acquisitions of the Metropolitan Museum of Art came as donations. In the first years of the twentieth century, the museum entered a new era. The receipt of substantial monetary bequests (1901, 1908, 1909), the dynamic presidency of J.P. Morgan (1904-1913), and the hiring of professionally trained staff (starting in 1905) mark the beginning of the Metropolitan as a world-class institution. The nature of the medieval acquisitions reflects the impact of these events. In 1901, a New Jersey locomotive manufacturer, Jacob S. Rodgers, left approximately $5 million to the Metropolitan.[2] In 1908 and 1909, the Hewitt and Kennedy bequests added $1.5 and $2 million respectively to the endowments. Another $1 million arrived from the Leland estate in 1912. These enormous gifts opened up great possibilities.

At first, the Museum remained true to its nineteenth-century conceptions: the initial post-1903 medieval purchases were largely examples of the industrial/decorative arts and reproductions. The purchases from these years included Gothic chest fronts (1905), more keys (1906 and 1910), glass beakers (1906), candlesticks (1907), as well as the Irish metalwork reproductions (Cat. 27 and 28). American museums seem to have been unaware that major works of medieval art could be obtained. This censer is a sample of the kind of objects that were acquired instead. Several Romanesque bronze censers were purchased at about the same time.[3] They are modest pieces, not of outstanding art historical importance or strongly beautiful. To some degree, they continue the nineteenth-century pattern of acquiring minor odds and ends. But the quality of the objects is higher, there are more of them, the percentage of forgeries is lower, and perhaps most importantly, the museum itself is actively purchasing. The presence of medieval art is no longer left to chance; medieval objects are deliberately sought out.

A R

Literature: Unpublished.

1. Hiltrud Westermann-Angerhausen in a letter on file in the Medieval Department, Metropolitan Museum of Art.
2. The funds became available in 1903 and 1904 and were invested, generating over $200,000 in interest per year according to the *Annual Report of the Trustees* 35 (1904–1905): 14.
3. J. B[reck], "Examples of Romanesque Art," *Bulletin of the Metropolitan Museum of Art* 4 (Nov. 1909): 208–9. The two censers illustrated are 09.152.6 (left) and 09.152.4 (right).

30

On this simple Latin cross, a youthful Christ patiently endures the Crucifixion, his feet placed parallel to one another on a rectangular support (suppedaneum), and his arms outstretched, just slightly higher than his shoulders. Neither the upright triumphant Christ of the early Middle Ages, nor the tormented twisted Christ of the Gothic era, the Christ here is at a transitional stage in the gradual progression towards the suffering Christ of the later Middle Ages. His closed eyes, head bent to one side, slightly protruding belly, and slightly flexed knees combine to create the impression that he is no longer supporting his own weight and, thus, may be dead. A band above his head bears the inscription *IHC XPC*, an abbreviation of Christ's name in Greek.

This cast bronze corpus, or body of Christ, retains little of its original gilding and has suffered some damage. The thumb of Christ's left hand has been broken off, while his right shows signs of reworking. It is one of a relatively small group from Romanesque Germany that remain attached to a cross, in this case possibly of later manufacture. As is usual in this group, the corpus is secured by means of rivets through the hands, thus mirroring the way the body of Christ was nailed to the cross. The back of the cross is decorated with five medallions, one in the center containing the Agnus Dei (Lamb of God), while medallions with the symbols of the four Evangelists are placed at the ends of the cross.

Beginning in the late eleventh century, such crosses could be placed on the altar rather than simply near it, as had been the custom in the Carolingian and Ottonian periods. It is not certain whether this particular cross served originally as an altar cross or as a processional cross. All that can be said is that the projecting flange at the bottom would have been inserted into a support of some kind. It may have served interchangeably as both an altar cross and a processional cross, as some were known to do. Peter Bloch places this corpus within his group III C, the Trier Series, characterized by the loincloth knotting on Christ's right side with an overlapping fold on his left. He localizes the style of the figure to Westphalia/Lower Saxony, dating it to the second quarter of the twelfth century.

The improved quality of medieval acquisitions in the early twentieth century at the Metropolitan Museum was partly the result of more vigorous and professional leadership, both in the boardroom and the curatorial offices. In the nineteenth century, the Metropolitan's director and curators were all amateurs.[1] The first trained professionals were hired shortly after J.P. Morgan became president in 1904. The new director, Casper P. Clarke, had been head keeper of the Victoria & Albert Museum in London. The Victoria & Albert had consistently been a major influence on early American art museums since the latter were established in the second half of the nineteenth century, but J.P. Morgan may also have been specifically involved in hiring Clarke. London was Morgan's second home and the base of his European business operations, and a gallery of the Victoria & Albert was filled with objects Morgan had lent in 1901. The director of the Boston Museum of Fine Arts, Edward Robinson, was hired away from that institution at about the same time as Clarke (1905) to serve as the Metropolitan's assistant director. And in 1907, Wilhelm Valentiner, trained in German universities and museums, arrived to head the newly created Department of Decorative Arts. His department included, along with many other things, all European medieval art except for paintings by the Italian Primitives. It is probably to Valentiner (curator, 1907–1912) that the first flush of medieval purchases should be attributed, including this cross, which he discussed in the museum's bulletin. The cross and the censer (Cat. 30) are significant as being two of the earliest purchases of Romanesque art by an American museum. They were among the numerous Romanesque objects bought by the Metropolitan in the years 1908–1910.[2]

A R

Literature: W. R. V[alentiner], "Recent Accessions," *Bulletin of the Metropolitan Museum of Art* 5 (Sept. 1910): 214–15, fig. 2; J. Breck, *Catalogue of Romanesque, Gothic and Renaissance Sculpture*, New York, 1913, no. 281; P. Bloch, *Romanische Bronzekruzifixe (Bronzegeräte des Mittelalters, 5)*, Berlin, 1992, 173, 178.

1. There were just three curators: one for European painting, one for sculpture, and one for casts.
2. In addition to this cross and the censer (Cat. 30), at least fourteen other objects considered Romanesque were purchased from 1908 to 1910: a column statue (08.175.9), an altar canopy, now in the Romanesque chapel at the Cloisters (purchased in 1909), four censers (09.152.3-6), six stone reliefs (09.152.8-13), a stone portal (09.153), and a figural candlestick (10.134.5). It should also be noted that a major piece of Romanesque sculpture, a twelfth-century Auvergnat Virgin and Child, entered the museum as a loan object from J. P. Morgan in 1906. It was first exhibited 1908 and given to the museum in 1916.

31. Crucifix

Germany, Westphalia or Lower Saxony, second quarter 12th century
Bronze with traces of gilding,
27 x 16.8 x 3.1 cm
The Metropolitan Museum of Art, Rogers Fund, 1910
10.134.6 a, b
Purchased from Böhler, Munich

Color plate (p. 9)

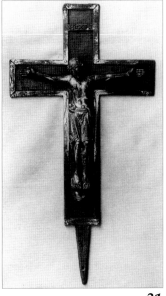

31

32. Mirror Case, the Siege of the Castle of Love

Europe, 19th century (in style of France, Paris, first half 14th century)
Ivory, 13 cm diameter x 1.3 cm
The Metropolitan Museum of Art, Rogers Fund, 1911
11.93.14
Ex. coll. E. Felix, Leipzig
Purchased from Silo Ichenhauser

Gothic mirror cases are among the relatively few types of purely secular objects that survive in quantity from the Middle Ages. A piece like this would have had a matching half carved on one side with a similar scene. One of the halves would have held the mirror—probably a polished metal disc. Personal objects, such as mirror cases, jewelry boxes, and combs were often decorated with secular subjects with few, if any, overt references to religion. Most of the subject matter was amorous in nature, and the Siege of the Castle of Love was a recurrent theme. The action is symbolic: the knights besiege the fortress of their ladies' hearts, so to speak, and attempt to conquer them. The ladies, meanwhile, shower their suitors with roses. Two trumpeters dressed as monks sit in trees on either side, and the winged god of love shoots his arrows from the top of the castle.

Forgery is an ever-present risk in the art market. As one might expect, when Americans began to buy medieval art in some quantity, fake objects began to appear more frequently among the early acquisitions of medieval art by American museums. Many of the "medieval" objects given to the Metropolitan in the nineteenth and early twentieth centuries are now considered spurious. When it was discussed by Joseph Breck in the 1911 *Bulletin*, this mirror case was considered authentic, although its similarity to one in the Victoria & Albert Museum was noted. By 1933, it was recorded as of "doubtful authenticity."[1] Today it is generally accepted as a forgery. The mirror case is in suspiciously perfect condition. While this is exceptional, it is not impossible. More revealing are details of style. The mirror case is not only similar to, but a very close copy of the one in the Victoria & Albert Museum.[2] The scene is almost exactly duplicated by the New York piece; the differences are subtle. The crenelations of the castle on the authentic ivory are slightly irregular. On the forgery they are precisely straight and uniform. This may reflect the nineteenth-century penchant for tidy design. For example, the reconstruction of medieval monuments, both on paper and in actuality, by the French architect and restorer Viollet-le-Duc, and the designs of Gothic Revival architects are more stylistically uniform, neat, and perfect than medieval buildings ever were. The handling of the trumpeters' pennants on the fake ivory is also more rigid than on the original. The copy has replaced the lions on the rim of its model with dragon-like creatures.

In the context of this exhibition, the way this object was used by the Metropolitan in its educational programs is more important than its authenticity. American art museums of the late nineteenth and early twentieth centuries considered the "enlightenment of the masses" a major part of their mission. Extensive programs were developed for children as well as adults. From 1916 to 1935, the Metropolitan published a *Children's Bulletin*—a juvenile counterpart to the main *Bulletin*. Whereas the *Bulletin*, which was designed not for scholars but for the general museum member, had brief accessible discussions of new acquisitions, museum events and museum philosophy, the *Children's Bulletin* took objects from the museum's collections and built stories around them.[3] These stories covered a wide variety of cultures and artifacts, including those of medieval Europe. Half of the issues published in 1917 and 1918 told stories of the Middle Ages. This was just at the time that J.P. Morgan's collections were formally transferred to the Metropolitan (1916 and 1917), and the Morgan Wing was reopened (1918). The first issue of 1917 told "The Story of Bertrand the Brave, A Boy of the Middle Ages," which took place in Paris c. 1175 and featured the Auvergnat Virgin and Child from Morgan's Hoentschel Collection (MMA 16.32.194).[4] The mirror case was the focal point of "The Story of the Gargoyle Told," in which a stone gargoyle installed in the Metropolitan's galleries comes to life "one very rainy afternoon when [the storyteller] was wandering aimlessly through the Museum"[5] The gargoyle is asked about the mirror case (on display nearby) and proceeds to tell the story of Jehan de Couilly, an apprentice ivory carver, how he came to create the mirror case, and how he gave it to the new child queen of France on her entry into Paris. In the process of telling the tale, information was revealed about the object, how it was made, what it meant, what it was used for, and so on. The object was placed in its cultural context in a clever and entertaining fashion without recourse to lecturing.[6]

A R

Literature: A. von Eye and P. E. Börner, *Die Kunstsammlung von Eugen Felix…*, Leipzig, 1880, 97, 99, pl. 24; *Catalogue des objets d'art et de haute curiosité composant la collection importante de Eugène Félix à Leipzig*, Cologne, 1886; J. B[reck], "Ivories," *Bulletin of the Metropolitan Museum of Art* 6 (Aug. 1911): 163–64; S. Sachs, *Fakes and Forgeries*, Minneapolis, 1973, no. 40.

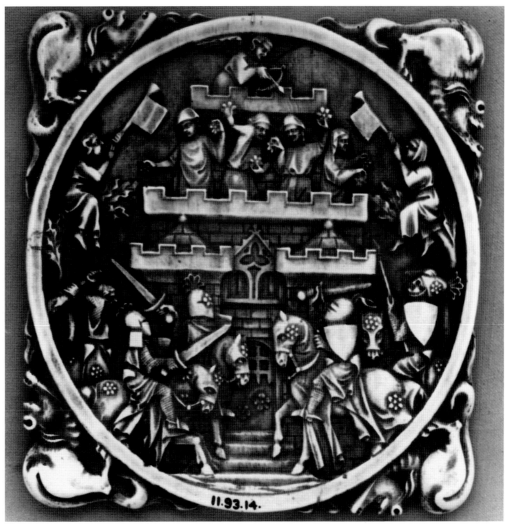

32

1. Notation dated May 15, 1933, in the files of the museum's Accessions and Catalog Department.

2. Inventory no. 9–1872. Another mirror case half in the V. & A. (no. 1617–1855) could be its counterpart. Interestingly, it was also copied before 1900. See M. H. Longhurst, *Catalogue of Carvings in Ivory*, vol. 2 (London, 1929), 48, 49, pl. 44.

3. Until 1925, all of these stories were written by Winifred E. Howe, who also wrote *A History of the Metropolitan Museum of Art* (New York, 1913).

4. *Children's Bulletin* 1 (Mar. 1917): 3–12. This Virgin and Child has been referred to elsewhere in this catalogue (see Cat. 27, 31, 33, and the Morgan essay). It appears to have been considered a very important piece in the museum's early collection of medieval art.

5. *Children's Bulletin* 1 (June 1917): 19–30. The gargoyle was probably one of two discussed in M. McI., "Gargoyles," *Bulletin of the Metropolitan Museum of Art* 1 (Dec. 1906): 165–66.

6. The names of real people and places were used frequently. Jehan de Couilly made ivory objects for King Charles VI and Queen Isabella of France and the Cathedral of Notre Dame is also featured prominently in the story. The gargoyle is described as being "perched high up on one of the square towers" from where he "had a fine chance to see what was happening," and Jehan presents his ivory to the queen when her procession stops in front of the church. The Metropolitan also had a very large plaster model of Notre Dame.

33. Relief Sculpture, Apostles in Prayer (Pentecost)

Master of the Hackendover Altarpiece
Flanders, Brabant, c. 1420–1425
Oak, 49.6 x 32.4 cm
The Metropolitan Museum of Art,
Gift of J. Pierpont Morgan, 1916
16.32.214
Ex. coll. J. Pierpont Morgan, Sr.,
New York; G. Hoentschel, Paris

Color plate (p. 10)

This sculpture, originally covered with polychromy and gilding, may represent the Apostles on the day of Pentecost. After the Resurrection, when they were all gathered together to celebrate the Jewish feast of Pentecost, tongues of flame descended over the heads of the Apostles, and they were filled with the Holy Spirit.[1] The flames may have been represented in paint on the surface behind the figures. St. Peter and the beardless St. John face each other in the front of the group. Between and behind them is the balding St. Paul. The Apostles are huddled together as if they were gathered around a flame, being warmed by the Holy Spirit, so to speak. Paul's praying hands even have a flame-like appearance, perhaps echoing the tongues of flames that once appeared over the Apostles' heads. The base is probably not original. This group would have been one of several scenes from the Life of Christ, grouped together on a retable, a large flat altarpiece in which frames enclose a series of related scenes.

This Apostle group is notable for the great simplicity and enveloping mass of its draperies. It has been assigned to the Master of the Hackendover Altarpiece, active c. 1400–1430, the leading sculptor in Brussels, who probably headed a large workshop. His early works are said to show the influence of André Beauneveu. His late works, among which the Pentecost is placed, are quite different. In his later works the heavy bodies, covered with sharp, hard-edged draperies with many horizontal "U"-shaped folds that characterize his earlier works, are replaced by more slender figures enveloped in very thick, soft draperies with strong vertical emphasis.[2] The Hackendover Master's distinctive interpretation of the Soft Style is so different from his earlier style that it hardly seems to be the work of the same artist. These late works also share a quiet gentle mood and a grouping together of the individual figural and background elements into a single mass. The draperies, characterized by long straight folds that terminate in soft angular breaks, have been compared to those in Robert Campin's paintings, such as the Dijon *Nativity*.[3] The long, quietly restrained folds of St. John's robes in the Metropolitan relief are particularly striking. The garments have a nearly abstract quality that is not merely decorative but deeply expressive like the faces and gestures of the Apostles themselves, helping to create the quiet gentle solemnity of the piece. The tendency toward simplification of drapery lines is carried even further in a slightly later work by the same master, St.

Peter in Penance (c. 1425–30, priv. coll.), in which the robe is reduced to a few long folds, and the rocky enclosure to simplified, almost crystalline forms.

As with much surviving medieval wood sculpture, the polished surface revealing the wood from which it was carved is probably the result of "cleaning" by dealers. Because of the dominance of Greco-Roman sculpture as an ideal in the artistic tradition of the nineteenth century, sculpture was expected to be completely monochromatic as all Greek sculpture was once thought to be. Dealers, and probably collectors as well, were less concerned with preserving as much of a piece as possible as with having an attractive object conforming to the aesthetic standards of the time. Partially preserved polychromy tends to look messy and obscures the "pure sculptural form" of the object. Many of these once brightly colored pieces were completely stripped to make them more salable.

This sculpture was part of the Hoentschel Collection of Gothic art, purchased by J.P. Morgan in 1906 and loaned to the Metropolitan shortly thereafter. For approximately two years (from July 1, 1908, to some time before March 14, 1910) the Hoentschel Collection of Gothic sculpture and furniture was on display, in chronological sequence, in the Great Hall of the museum, thus forming the first "exhibition" of medieval art in America. Many of the objects in the collection were, like this piece, cleaned and stripped fifteenth-century northern wood sculpture from retables. Technically, the display was not a special exhibition in the modern sense. There was no catalogue or checklist, it was little publicized, and it was not scheduled to come down a few months later. Nevertheless, it was the first large body of medieval works to be shown as a unit to the American public.[4] It remained on loan in the museum until it was formally donated ten years later, moving to the special Decorative Arts Wing in the years in between. The presentation of the statuary of the first Hoentschel Collection was a major milestone in increasing the quantity, quality, and visibility of medieval art in America.

A R

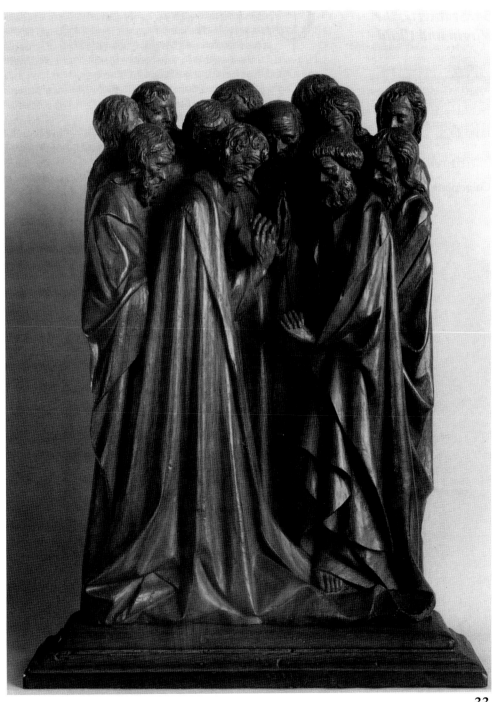

33

Literature: A. Pératé and G. Brière, *Collections Georges Hoentschel acquises par M. J. Pierpont Morgan et prêtées au Metropolitan museum de New-York, I, Moyen-âge et renaissance*, Paris, 1908, 14, pl. 3; J. Breck, *Catalogue of Romanesque, Gothic and Renaissance Sculpture*, New York, 1913, no. 277; Walters Art Gallery, Baltimore, *The International Style: The Arts in Europe around 1400*, Baltimore, 1962, no. 87, pl. 80; J. W. Steyaert et al, *Late Gothic Sculpture: The Burgundian Netherlands*, Ghent, 1994, 68–70.

1. This occurrence is described in Acts 2:1–13.
2. For an early work, see the Hakendover Altarpiece (no. 21) and for the late works, Peter in Penance (no. 23) and Christ in Gethsemane (fig. 12) in J.W. Steyaert et al., *Late Gothic Sculpture: The Burgundian Netherlands*, (Ghent, 1994).
3. Ibid., 71.
4. In 1903, Isabella Stewart Gardner had opened her house, Fenway Court, to the public on a limited basis. She was one of the first to acquire a significant number of medieval objects, but most were treated as part of the fabric or furnishings of the building and were subordinated to the overall aesthetic effect of the interior. See K. McClintock, "The Classroom and the Courtyard," in this catalogue.

36. Reliquary Châsse

France, Limoges,
first third 13th century
Champlevé enamel on copper gilt,
25.4 x 22.5 x 8.9 cm
The Metropolitan Museum of Art,
Gift of J. Pierpont Morgan, 1917
17.190.521
Ex. coll. J. Pierpont Morgan, Sr.,
New York; G. Hoentschel, Paris

Color plate (p. 12)

This enameled and copper-gilt *châsse* (reliquary casket) is in the form of a miniature sarcophagus supported by rectangular feet at each corner and topped with an openwork crest from which sprout three rounded finials. Such a casket would once have held the relics of one or more saints (no longer identifiable) and would have been intended as part of the liturgical accoutrements for an altar. Its decoration is composed primarily of *champlevé* (raised field) enamels, with blue and green as the predominant colors. Champlevé enameling is a technique in which the artisan carves a depression in the copper plate and then places in it colored ground glass, which will vitrify upon firing. Areas not intended for enameling are given incised designs (e.g., the standing saints on the short ends of the châsse) or receive attached figures, cast in copper and held on by little nails, like the eight figures of saints applied to the front of this casket.

During the late twelfth and thirteenth centuries, the city of Limoges in western France was a major center for the quasi-industrial production of works in enameled copper. Workshops in Limoges turned out large quantities of reliquaries, bookcovers, candlesticks, croziers, eucharistic doves (Cat. 39), and other liturgical objects, which found their way into church treasuries all over Europe. The popularity of Limoges enamels was at least partly based on two things. Their gilding and bright colors made them visually appealing, especially in the comparatively drab world of the Middle Ages, and the relative cheapness of their materials made them an affordable substitute for objects made of gold and jewels. Displayed in the dim interior of a church, with their shiny surfaces reflecting the flickering candlelight, objects of Limoges enamel would have presented a sumptuous appearance. Some seven hundred Limoges reliquary caskets exist today and make up approximately one tenth of the Limoges objects catalogued by the *Corpus des émaux méridionaux.*[1]

The decoration of this châsse is typical of Limoges work in the first third of the thirteenth century. The doll-like figures of saints on the front, some holding books, some with hands raised in prayer, stand under arcades against a striped ground studded with enamel rosettes. A similar program of decoration can be found on a number of Limoges caskets, one of the largest and most elaborate being the *Châsse de Saint Calmine* in the church of Mozac.[2] The single saint standing under an arch on each of the short sides of the casket is also a much-used formula in Limoges reliquaries. More visually arresting

is the bright geometric decoration on the rear face of the châsse, composed of a series of diamond-shaped lozenges enclosing four-petaled rosettes. This type of design can be compared with that on a châsse in the Musée de Cluny, Paris, and one in the church of St.-Junien.[3]

J.P. Morgan appears to have liked the glittery and the colorful. The first objects he is said to have collected were bits of stained glass fallen out of church windows, gathered while a student in Europe. He collected ancient and Renaissance jewelry and enamel work spanning a thousand years of European history. Enamel work and illuminated manuscripts are among the few types of medieval art objects to have survived with their colors intact. Significantly, Morgan collected both. Morgan also liked boxes. His large collections of watches, snuffboxes, and the locket-like miniatures point to a liking for small objects that could be opened and closed. His apparent delight in artistic little enclosures is documented in an anecdote told by a family friend, Bishop William Lawrence, that took place during one of Morgan's trips to Egypt. At one of the excavation sites, a Coptic bronze box was uncovered. Morgan removed the object himself. "His delight was that of a child who has happened upon an unexpected toy. He kept it in his hand or near him on his table or in his room throughout the trip, and insisted that [no one] would prevent his carrying it to New York."[4]

His special fondness for boxes, lockets, caskets, and other such enclosures, and his taste for the glittery and colorful are combined in the numerous enamel reliquary chests in his collections. At his London residence at Prince's Gate, there were "cabinets standing about with reliquaries, statuettes, and other figures."[5] One of the objects he singled out for placement in his study in the (Morgan) Library, was a reliquary casket of silver-gilt translucent enamel, the Lichtenthal altar tabernacle. Most of the medieval enamel Morgan acquired was Limoges work. Limoges enamels, because of their quasi-industrialized production, were often of middling or crude workmanship. Morgan's collection included some very fine examples of the type, such as the Beckford châsse (MMA 17.190.514), and some that were very crude, though even the poorer work still has a coarse richness. While Morgan may not have found the crude figures on the front of this châsse very appealing, he may well have delighted in the bright and carefully rendered patterns on its back.

A R

Front.

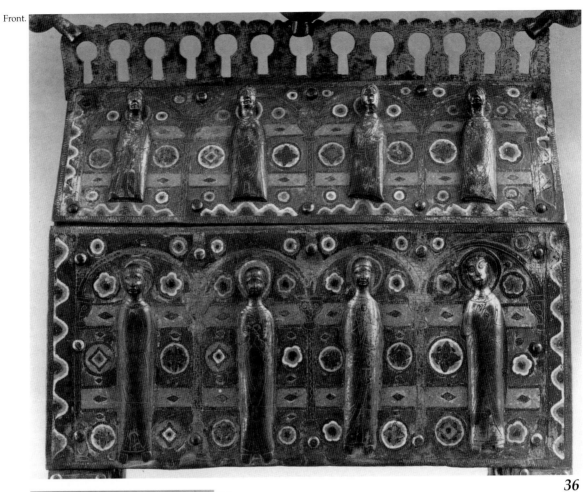

36

36

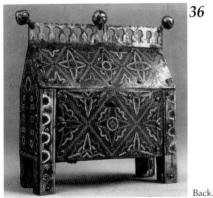

36

Back.

Side.

Literature: *Treasures from the Metropolitan: Catalogue of the Inaugural Exhibition of the Indianapolis Museum of Art*, ed. C. J. Weinhardt, Jr., Indianapolis, 1970, no. 103.

1. M.-M. Gauthier, *Emaux du moyen âge occidental* (Fribourg, 1972), 96.
2. M.-M. Gauthier, *Emaux limousins champlevés des xiie, xiiie et xive siècles* (Paris, 1950), pls. 38, 39.
3. Ibid., pls. 30, 37.
4. W. Lawrence, "Memoir of John Pierpont Morgan, written in the form of a letter to Herbert L. Satterlee, Boston 1914," 82–83, Morgan Family Archives, Pierpont Morgan Library, New York.
5. Ibid., 50–51. Quoted in F. H. Taylor, *Pierpont Morgan as Collector and Patron, 1837–1913* (New York, 1970), 21.

37. Book of Hours with Inset Plaque of Coronation of the Virgin

Ms: northeast France, Lille?,
c. 1275–1300, ff. 158
Plaque: ivory, northern Italy?,
14th century
Binding: morocco with gold
and silver mounts,
Léon Gruel, Paris, France,
late 19th–early 20th century
10.5 x 8.5 cm
The Walters Art Gallery,
Baltimore
MS W.39

The rich, dark brown morocco binding of this small Book of Hours bears in the center of the front cover an ivory plaque of the Coronation of the Virgin. The ivory is held in place by a twisted silver frame from which emerge little silver foliate clasps, imparting an extra element of opulence and refinement to the binding. The Coronation of the Virgin is set below a Gothic arcade with inset trefoils and crocketed pinnacles. Christ stretches his right arm forward to place a crown on Mary's head, while above them angels lean in from each side, vigorously swinging censers. Richard Randall localizes the manufacture of this ivory to northern Italy during the second half of the fourteenth century on the basis of comparison with two ivories known to be from that region. The hole at the top center of the ivory indicates that it originally served as a writing tablet.

This is one of the most interesting of the bindings created by the Parisian bookbinding and bookselling firm of Gruel for Henry Walters. Between their first transaction in 1895 and the death of Walters in 1931, Léon Gruel, and later his son Paul, sold Walters a great many medieval manuscripts, mostly French in origin.[1] Lillian Randall places at 210 the number of manuscripts bought by Walters from Gruel, and affirms that Walters was Gruel's most important client in the area of manuscripts.[2] Some of the manuscripts Gruel endowed with what could be called a simulated medieval *Prachteinband* (luxury binding), incorporating authentic medieval works of art in precious materials within a modern binding. Although a general survey of manuscript collecting is not included within the scope of this exhibition, there are certain instances where manuscripts are used to make a special point. The combination of a thirteenth-century French manuscript with a binding that incorporates a fourteenth-century North Italian ivory reflects two of Henry Walters's major interests: Gothic ivories and Gothic manuscripts. As such, it serves as a hinge between two aspects of his collecting, demonstrates visually the comparatively unusual conjunction of these interests in one person, and also reflects his housing of his manuscripts and his works of art in the same institution, as opposed to the way they were more often separated.

In addition, another important aspect of Henry Walters as a collector is evoked in this binding: his relation to the dealer Léon Gruel, who united the thirteenth-century manuscript and the fourteenth-century ivory in a modern binding. Neither the date nor the circumstances surrounding Henry Walters's purchase of the manuscript are known, *i.e.*, whether Walters bought the manuscript elsewhere and took it to Gruel for binding or whether Gruel sold it to him as a fait accompli. Although his first purchase of a medieval manuscript is not precisely dated, he did not acquire his first Gothic ivory until 1901 (the Virgin and Child statuette, Cat. 38), and his earliest recorded purchase of medieval art in other media did not occur until the following year. It is, therefore, tempting to imagine that Gruel's pastiches, such as the binding of this Book of Hours, might have served as an introduction into the field for Henry Walters, perhaps constituting his earliest purchases of medieval works of art, if not of medieval manuscripts, but there is no documentation to support such a view. The only one of Gruel's antiquarian bindings for which the date of purchase by Walters is known is W.47, incorporating a Limoges enamel plaque, bought in 1903. Nevertheless, the mere fact that Walters bought such composite creations suggests that he appreciated Gruel's presentation of the manuscripts in this way, and that he appreciated the bookcover *qua* object of art. It is, therefore in this way, as an object of art as well as a manuscript, that W.39 is presented in this exhibition.

Literature: S. de Ricci, *Census of Medieval and Renaissance Manuscripts in the United States and Canada*, New York, 1935, vol. 1, 781, no. 156; Walters Art Gallery, Baltimore, *Illuminated Books of the Middle Ages and Renaissance: An Exhibition Held at the Baltimore Museum of Art*, Baltimore, 1949, no. 56; *Time Sanctified: The Book of Hours in Medieval Art and Life*, ed. R. S. Wieck, New York, 1988, no. 3; L. M. C. Randall, *Medieval and Renaissance Manuscripts in the Walters Art Gallery*, vol. 1, Baltimore, 1989, no. 39; R. H. Randall, Jr., *The Golden Age of Ivory: Gothic Carvings in North American Collections*, New York, 1993, no. 212.

1. *The Diary of George A. Lucas: An American Art Agent in Paris, 1857-1909*, ed. L. M. C. Randall (Princeton, N.J., 1979). George Lucas had served as art agent for Henry Walters's father, William Walters, and continued in the same role for Henry, whom he had known as a boy. Lucas's account book records frequent meetings between Walters and Gruel during these years.
2. L. M. C. Randall, *Medieval and Renaissance Manuscripts in the Walters Art Gallery*, vol. 1 (Baltimore, 1989), xii.

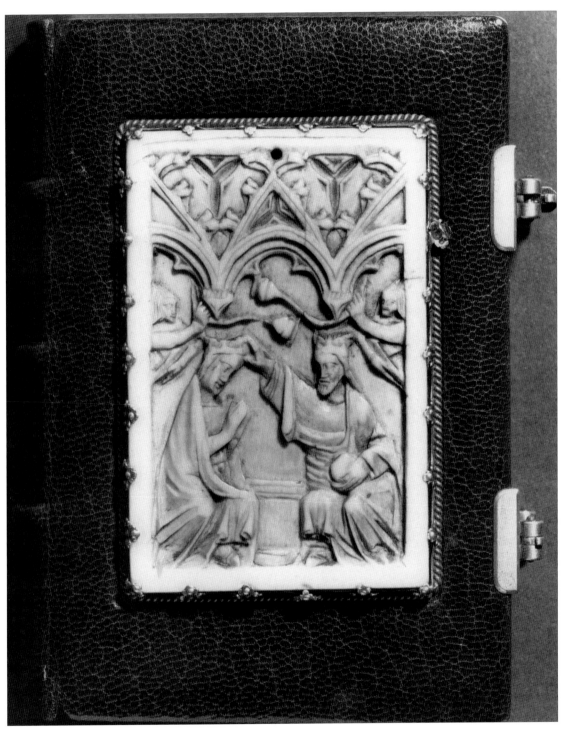

38. Eucharistic Dove

France, Limoges, early 13th century
Champlevé enamel on copper, 17.8 x
20.8 x 8.7 cm
The Walters Art Gallery, Baltimore
44.77
Ex. coll. G. Chalandon, Paris;
E. Chalandon, Lyon

Color plate (p. 13)

Doves such as this once hung above the altar in a church, where they served as receptacles for the host and also "... symbolized the participation of the holy ghost in the blessed sacrament."[1] This dove has a small compartment, covered by a hinged lid on its back, where the consecrated wafers were held. The wings are enameled with bands of light blue and green sweeping back toward the tail. The front of the wings are stylized feathers in enamel while feathers are mimicked by engraving on the underside, the head and the breast of the bird. Such doves, of which some three dozen survive today, were very popular throughout Western Europe in the first half of the thirteenth century, when they entered many church treasuries. According to Marie-Madeleine Gauthier, their popularity was due in part to the example set by the patronage of Limoges work by Pope Innocent III, and in part to the pope's declaration that objects in enameled copper could, like those in gold and silver, canonically be designated as repositories for the consecrated host between masses.[2] This dove is one of a few that remain attached to the original base, in the form of a paten, or plate, for the host. The dove has been ascribed to the oldest group of those surviving and dated to the early thirteenth century on the basis of comparison with a similar dove in Amiens (Musée de Picardie).[3]

Limoges enamels are important in the history

of collecting. As a result of the dispersal of the contents of many church treasuries in the wake of the French Revolution, many medieval liturgical objects of Limoges manufacture were placed on the art market, and were consequently among the first medieval objects to be actively collected in modern times. They were included in famous collections of the eighteenth and early nineteenth centuries in England and on the Continent, and they have continued to be highly coveted by both private collectors and public institutions well into the twentieth century. Limoges enamels were also the object of scholarly study as early as the eighteenth century, and by the second half of the nineteenth century Ernst Rupin was compiling a census of surviving examples.

Within Henry Walters's collection of medieval art, his 114 enamels make up the largest portion of works dating from the years 800 to 1400, and within these, thirteenth-century objects in champlevé figure prominently. Among his pieces are two eucharistic doves, neither of which have known dates of acquisition.[4] The provenance is known for this dove, however. Before being purchased by Henry Walters, it was in the collections of Emmanuel Chalandon in Lyon in 1877 and of his son, Georges Chalandon, in Paris in 1905.

M P

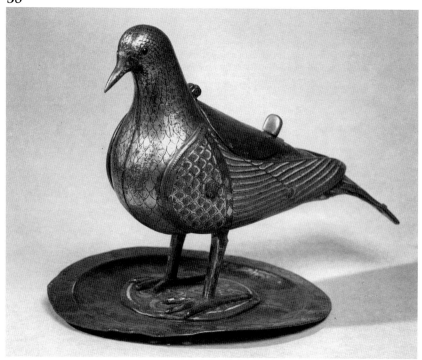

38

Literature: G. Migeon, "La collection de M. G. Chalandon," *Les Arts* 42 (1905): 17-29, esp. 20, 28-29; U. McCracken, *Liturgical Objects in the Walters Art Gallery*, Baltimore, 1967, no. 12 [mistakenly identified as WAG 44.3]; M.-M Gauthier, "Colombe limousine prise aux rêts d'un 'antiquaire' bénédictin à Saint-Germain-des-Prés, vers 1726," *Intuition und Kunstwissenschaft: Festschrift Hanns Swarzenski*, Berlin, 1973, 179, 186, n. 12.

1. U. McCracken, *Liturgical Objects in the Walters Art Gallery* (Baltimore, 1967), 23. For other examples of doves, see E. Rupin, *L'Oeuvre de Limoges* (Paris, 1890), 222-34; and M.-M Gauthier, "Colombe limousine prise aux rêts d'un 'antiquaire' bénédictin à Saint-Germain-des-Prés, vers 1726," *Intuition und Kunstwissenschaft: Festschrift Hanns Swarzenski* (Berlin, 1973), 171-90.
2. Gauthier, 182.
3. Ibid., 179.
4. The legs, base, and cover of the other dove (WAG 44.3) are replacements.

he Virgin holds the Christ Child high on her breast with her right hand as he gently places his hand on a flower held by her other hand. The folds of her robe and cloak are echoed gracefully in her hair and veil. These details emphasize the elongation of the figure and lend themselves to the delicate and precious nature of the work.

Often, ivory statuettes would possess a "sway" such as this one. This characteristic is due to the artist following the natural curve of the tusk from which it was carved. The back is strengthened by a piece of wood indicating that this was not meant to be seen in the round, rather, it was probably once part of a larger ensemble, such as an altarpiece or reliquary. The pigment and gilding that once adorned the Virgin and Child have since disappeared and only traces remain. This specific work is very similar to fourteenth-century ivory statuettes of the Virgin and Child from France.[1] A striking example of this similarity can be seen in a Virgin and Child statuette which dates from the second quarter of the fourteenth century from the Princeton University Museum.[2] This piece may be considered, by the fluent elongation of the Virgin's proportions, within the tradition of the "style monumental" running concurrent with the beginning of the fourteenth century.[3] As the emphasis in production shifted towards private sculptural commissions, the idea of the monumental was carried over into small devotional items, manifesting itself in objects such as this one. This scaling down of monuments allowed the artist greater precision of detail, which is inherent in the Virgin's drapery and veil.[4]

This ivory is important in the context of this exhibition for many reasons. It is the earliest ivory that Henry Walters is known to have acquired, purchased from the collection of M. Antocolsky in Paris, June 10, 1901 (lot 72). Therefore, it may be seen as a prelude to the now extensive collection of ivories at the Walters Art Gallery. It is significant that the first ivory Walters bought was a medieval piece. This piece also exemplifies the type of small precious object that he was seemingly so fond of.

MP

Literature: R. H. Randall, Jr., *Masterpieces of Ivory from the Walters Art Gallery*, New York, 1985, 202, no. 273.

1. D. Gaborit-Chopin, "Les Ivoires," *Les Fastes du gothique: le siècle de Charles V* (Paris, 1981), 167–69, 176–77.
2. See R. H. Randall, Jr., *The Golden Age of Ivory: Gothic Carvings in North American Collections* (New York, 1993), 40, no. 15.
3. Gaborit-Chopin, 176–77.
4. P. Williamson, *Medieval Ivory Carvings* (London, 1982), 18.

39. Statuette, the Virgin and Child

Germany, Rhenish, c. 1325–1350
Ivory, 17.8 x 5.3 cm
The Walters Art Gallery,
Baltimore
71.153
Ex. coll. Antocolsky, Paris

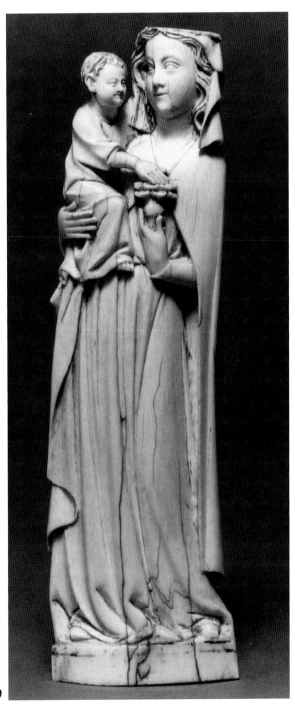

39

40. Candlestick, Samson and the Lion

Meuse Valley, 13th century
Bronze with traces of gilding,
40 x 21.2 x 13.6 cm
The Walters Art Gallery,
Baltimore
54.784
Purchased from A. Seligmann,
Rey & Co., New York
Ex. coll. J. Pierpont Morgan, Sr.,
New York; A. von Oppenheim,
Cologne

Color plate (p. 13)

This object probably represents Samson and the Lion, a popular Old Testament subject in the twelfth and thirteenth centuries, when it was interpreted as a prefiguration of Christ's triumph over the devil.[1] "Samson went down to Timnath and, when he reached the vineyards there a young lion came at him growling. The spirit of the lord suddenly seized him and, having no weapon in his hand, he tore the lion to pieces as if it were a kid" (Judges 14:5-6). The traces of gilding remaining on this object suggest it was originally made for use in a church. It would have stood on an altar, perhaps as one of a pair of candlesticks flanking a crucifix, thus physically expressing Samson's typological role as a prefiguration of Christ.

Samson, identifiable by his long hair, sits upright on the back of the lion with his left arm raised above his head in support of the mount for the candle. His tunic, pulled tight around his waist, falls upon his thigh, conforming to it and the lion's back. His right hand rests on the head of the lion suggesting, though not particularly narrating, a struggle. Samson's face is delicately portrayed, a quality that is enhanced by this reduction in detail of the features. The pose itself may derive from representations of Mithras and the sacrificial bull of late antiquity.[2] The lion stands stiffly, its head turned in a three-quarter pose. Its mouth is open, and it is baring its teeth in a menacing way. In opposition to the Samson figure, the lion is portrayed as a weighty creature indicating its strength. The double-edged eyes and flowing stylized mane are typical of other representations of the subject from this time, as in two French candlesticks from the end of the twelfth century in private collections in Paris.[3] The hatchings on the torso, back, and hindquarters of the lion suggest tendons and muscles, lending themselves to the nature of this animal, and again suggesting a struggle between man and beast. According to Otto von Falke, twelve late Romanesque candlesticks in the form of Samson and the lion survive today. Of the twelve, only five show man and beast in active opposition, while the others, like the Walters candlestick, show them in a peaceful pose with Samson more engaged in supporting the candlestick than in dominating the lion.

This work was most likely cast in one piece using the lost wax technique. This process entails forming a core of clay and applying layers of wax to form the basic shape. An outer mold was then built around the wax with "gates" and "vents." These would allow the molten metal to enter the mold and gases to escape. The mold was then fired and the wax melted away leaving a cavity within the mold ready for casting. The hatchings and other details were then engraved into the object. The inherent complexity of this work is a testament to the advanced nature of casting during the Middle Ages. Bronze metalwork such as this was popular for both domestic and liturgical use at that time, constituting a quasi-industrial art, with workshops producing objects for sale and shipment to distant clients. Von Falke considers the Walters candlestick to be the largest and one of the most important of a group of eight Samson candlesticks that he calls the Western Group, assigning them to workshops active in the Mosan region in the middle of the thirteenth century. He suggests a possible localization of the workshops in the town of Dinant, at that time just beginning to achieve renown as a center for the casting of vessels in bronze and brass.

The Samson candlestick, the only one of von Falkes's Western Group in the United States, was acquired by Henry Walters from A. Seligmann, Rey & Co. of New York in 1923, a year in which he purchased quite a few medieval objects, including one of stone, eight ivories, and this bronze piece. Interestingly, the Samson was once owned by J.P. Morgan, perhaps the greatest American collector of medieval objects.

M P

Literature: E. Molinier, *La Collection du baron A. Oppenheim, tableaux et objets d'art,* Paris, 1904, pl. 66; O. von Falke and E. Meyer, *Romanische Leuchter und Gefässe, Giesgefässe der Gotik (Bronzegeräte des Mittelalters,* 1), 2nd ed., Berlin, 1935; Berlin, 1983, 34-36, abb. 226; U. McCracken, *Liturgical Objects in the Walters Art Gallery,* Baltimore, 1967, 3, no. 2; Walters Art Gallery, Baltimore, *The Taste of Maryland: Art Collecting in Maryland 1800-1934,* Baltimore, 1984, 72, no. 148.

1. N. Netzer, *Medieval Objects in the Museum of Fine Arts, Boston: Metalwork* (Boston, 1991), 96.
2. G. Szabo, "Candlestick in the shape of Samson and the Lion," *Songs of Glory: Medieval Art from 900-1500* (Oklahoma City, Okla., 1985), 155.
3. See G. Swarzenski, "Samson Killing the Lion: A Mediaeval Bronze Group," *Boston Museum of Fine Arts Bulletin* 38 (June 1940): 73.

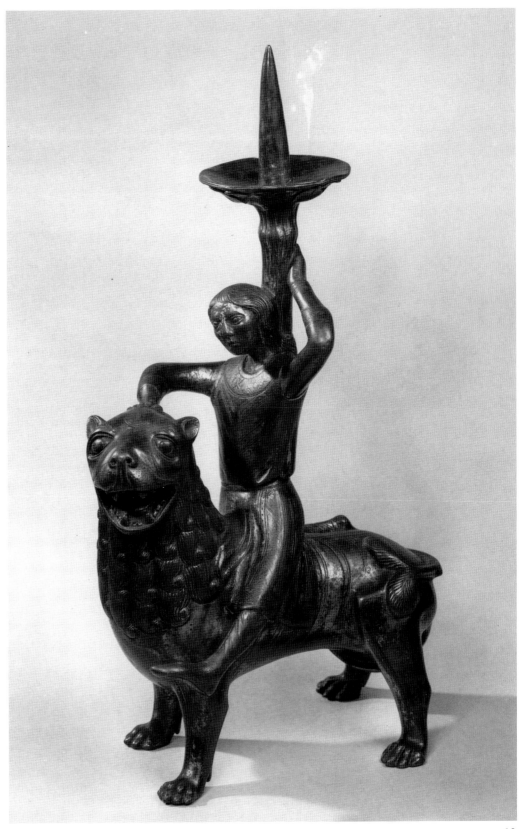

41. Chalice with Scenes from the Life of Christ

Germany, Rhenish, Constance, c. 1320
Silver gilt with basse-taille enamel, 20.5 cm high
The Walters Art Gallery, Baltimore
44.376
Ex. coll. Dukes of Hohenzollern-Sigmaringen, Sigmaringen

Color plates (p. 12)

This silver-gilt chalice is elaborately decorated with enamels showing scenes from the Life of Christ, and with pierced and engraved designs. The decoration begins on the stem just below the cup with a band of openwork quatrefoils on an enameled ground. This decoration is repeated below the knop where it rests above a less decorative band of cross-hatchings and punched dots. The top of the base is surrounded by alternating sculpted angels and rosettes. At the bottom of the base, interspersed between the elaborately colorful scenes, angels with polychromatic enameled wings echo the sculpted angels above.

The knop is decorated with six teardrop-shaped, enamel half-length figures of saints with rosettes and delicately engraved designs between them. The saints represented are Peter holding the key, John the Baptist with staff and flag, Andrew holding a cross and a book, Paul holding a sword, John the Evangelist with book in hand, and Bartholomew also holding a book and a knife. On the base are six teardrop-shaped enamels illustrating scenes from the Life of Christ, rendered in light blue, violet, green, and yellow against a deep blue ground. Like the portraits of saints above, the Christological scenes are framed by a fillet of red enamel. The first scene shows the Annunciation, as the angel Gabriel kneels before Mary to announce the coming of the Christ Child. The following scene is the Nativity, with a crowned Virgin Mary supporting the newborn Child in a stable as Joseph looks upon him with fondness and love. The next two scenes are the Mount of Olives and Christ Bearing the Cross. These are followed by the Crucifixion and the Resurrection. Thus, the decoration on the foot of the chalice, in representing the sacrifice of Christ's blood for the redemption of mankind, reinforces the function of the chalice in the Eucharistic rite, in which it serves as a vessel for the transubstantiation of wine into the blood of Christ.

The technique of translucent or basse-taille enameling used to decorate this chalice was developed in the late thirteenth century, possibly in Tuscany, and quickly became popular in courtly centers throughout Europe. In this technique, the design is first outlined in silver, and the desired details of the work are then engraved in low relief on the surface. Because the enamels are transparent after being fired, the depth of the relief is important. Subtle differences in the thickness of the enamel will result in the shading and modeling of light.

Katia Guth-Dreyfus traced the provenance of this chalice back to the Cathedral of Constance. In 1654 Franz Johann von Prassberg, Bishop of Constance, presented the chalice to the church of St. Theodul in Sachseln (Canton of Unterwalden) on the occasion of the beatification of the hermit Nicolas of Flüe. The bishop's arms are engraved on a small plaque set into the cavity of the foot of the chalice. In 1855, the chalice was bought by an antique dealer in Lucerne, from where it entered the collection of Duke Karl Anton von Hohenzollern at Sigmaringen Castle, and it has since been known as the Sigmaringen chalice. Sold at auction with the rest of the Hohenzollern collection in 1928, the chalice was purchased by Henry Walters the following year from A. Seligmann, Rey & Co.

The chalice was most likely produced in Constance itself, known as a major production center for translucent enamels. A close comparison for both the enamels and details of goldsmithwork can be made with the contemporary chalice of Wetting (Mehrerau Abbey, Austria), also attributed to Constance. (The difference in proportion between the two is the result of restoration to the Sigmaringen chalice, which made its cup steeper and added a ring to its stem.) The precious, mannered figures on the Sigmaringen chalice are typical of the painting style of Constance in the first third of the fourteenth century, visible in manuscript painting, stained glass, and even wall paintings. The design and draftsmanship on the chalice are of the highest quality. Each scene is a miniature work of art, with a carefully balanced composition. The rendering of the tiny figures, with their elegant large-fold drapery and finely formed and expressive features indicates that the shop that produced the chalice was capable of work that could compare favorably with the best produced in Paris or other major centers. In fact, the Sigmaringen chalice is today the earliest of the few surviving products of the basse-taille enamelers of Constance, and one of the most important.

The presence of John the Baptist in two places on the chalice, among the half-length portraits of saints on the knop and also, unusually, in the scene of the Crucifixion, has been taken as evidence that it was made for the monastery church of St. Johann in Constance, dedicated to the Baptist. It seems originally to have been part of a liturgical set, paired with a paten, or

plate, now in the Museum für Kunsthandwerk, Frankfurt. In 1535, during the Reformation, when the treasury of St. Johann was melted down, the chalice may have found a safe haven in the cathedral of Constance.

The importance of the Sigmaringen chalice within the context of this exhibition is due not only to the fine craftsmanship with which this piece was made, and its precious testimony to the craft of enameling as practiced in Constance during the fourteenth century, but also to the obvious attraction that objects in this medium held for Henry Walters. Between 1910 and his death in 1931, Walters acquired at least one enamel object each year, and enamels made up the largest portion of medieval works in the Walters Collection.

<div style="text-align:center">M P</div>

Literature: K. Guth-Dreyfus, *Transluzides Email in der erster hälfte des 14. Jahrhunderts am Ober-, Mittel- und Niederrhein* Basel, 1954, 20-27 [contains summary of earlier bibliography]; U. McCracken, *Liturgical Objects in the Walters Art Gallery*, Baltimore, 1967, no. 9; M.-M. Gauthier, *Emaux du moyen âge occidentale*, Fribourg, 1972, 269, 408; H. Lutkenhaus, *Sakrale Goldschmiedekunst des Historismus im Rheinland: Ein Beitrag zu Gestalt und Geschichte retrospectiver Stilphasen im 19. Jahrhundert*, Berlin, 1992, 82–83, abb. 51.

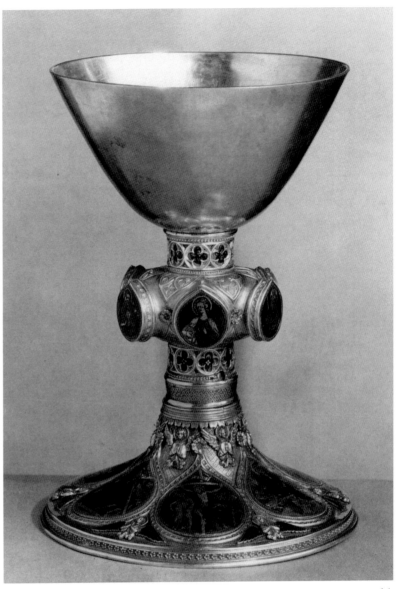

41

42. Capital with Winged Lions

France, Roussillon,
Abbey of St.-Michel-de-Cuxa?,
1125–1150
Marble, 37.4 x 50.2 x 33 cm
Glencairn Museum,
Academy of the New Church,
Bryn Athyn
09.SP.168
Ex. coll. G. G. Barnard, New York

The Benedictine abbey of St.-Michel-de-Cuxa was founded in 878–879, but it was not until the Romanesque period that it reached the apex of its importance as the religious and artistic center in the regions of southern France and northern Spain.[1] It was during the Romanesque period (c. 1130) that the cloister of the abbey was constructed. Sometime before 1906, George Grey Barnard purchased many elements of the Cuxa cloister and by 1914 he had reassembled them back in the United States, where they formed an integral part of his medieval sculpture collection, the original Cloisters in Washington Heights. Later, when the Metropolitan Museum of Art acquired his collection, the Cuxa cloister became one of the main focal points of their new museum, The Cloisters, which opened in 1938. The sculptural pieces that make up the Cuxa cloister were important during the Romanesque period, when their style influenced the workshops that produced architectural embellishments found in churches throughout the Roussillon region of France. They are also crucial to the history of medieval collections in this country, because they were such a major part of Barnard's first collection.

In a letter written to the dealer Jacques Seligmann in October of 1922, the American collector Raymond Pitcairn stated that he had recently purchased "several capitals which Mr. Barnard brought from the cloister of St.-Michel-de-Cuxa."[2] This particular capital was among those Pitcairn was referring to. Barnard sold this capital along with two others attributed to the Cuxa cloister when he began to experience financial difficulties in 1921. The fact that Barnard, the premiere collector of medieval architectural decoration in the United States, contacted Raymond Pitcairn to purchase his pieces attests to Pitcairn's reputation as a connoisseur and a ready buyer among other collectors of medieval art.

In the same letter to Seligmann, Pitcairn stated also that the capitals were "absolutely authenticated," and that they were "at one time [in] a bathing establishment in the south of France."[3] Although this capital was purchased from Barnard, it is questionable whether it is in fact one of the mysterious "bath house capitals" Barnard removed from a bath in Prades. The attribution to the abbey of St.-Michel-de-Cuxa is also questionable. While there are definite stylistic and iconographic affinities between this capital and pieces attributed to the abbey's cloister, there are also striking differences that may indicate this capital was

inspired by the very influential Cuxa workshop, but not actually a product of it. Faye Hirsch has pointed out that while the motif of the winged lion does occur at Cuxa, it is also seen in monuments throughout the Roussillon region that were influenced by the great abbey's atelier. The nearby church of Serrabonne, consecrated in 1151 at the height of Cuxa's influence, is among the structures of Roussillon that seems to have been influenced the most by the Cuxa workshop.[4] In fact, there are many general parallels that can be drawn between sculpture produced for Serrabonne and this capital. The strongly undercut abacus, decorated with small, delicately curving leaves is similar to the abacus of a tribune capital from Serrabonne, which also depicts standing lions. The strong use of the drill to give depth to the eyes, manes, and paws of the lions, and to the abacus and its leaves is a characteristic seen throughout the Serrabonne sculpture group, but rarely seen in capitals attributed to the Cuxa cloister.

This capital is not only representative of the type of sculpture that George Grey Barnard added to his collection, but it is also indicative of Raymond Pitcairn's taste as well. An overwhelming eighty percent of Pitcairn's sculpture collection can be traced to provenances in France, the country of origin of this capital. It is also dated to the twelfth century, the time period that Pitcairn seemed to prefer, since pieces from this century make up the largest percentage of his sculpture group. Pitcairn also preferred stone sculpture such as this piece, which has more architectural connections, to pieces made of wood, which are not directly associated with the structure of the buildings they furnish. This trend in his collection is again indicative of its purpose—to serve as models for the artists designing the sculpture that would eventually embellish Bryn Athyn Cathedral.

This piece also illustrates Raymond Pitcairn's particular fondness for capitals depicting fantastic beasts. Not only did Pitcairn collect several medieval pieces with fanciful beasts on them, (such as "Capital with Inverted Quadrupeds," Glencairn 09.SP.164), but also he had his artisans sculpt similar beast capitals to incorporate into the structure of Glencairn, the Romanesque style home he constructed in the early 1930s (Color Plate and Cat. 59). These "modern" beast capitals can be seen throughout Glencairn—in the Bell Tower, the Great Hall, and the cloister. This particular capital must have had a special appeal to Pitcairn,

who had his artists prepare an exact replica of it, a rare occurrence, since most of the sculpture made by Pitcairn's artisans was only loosely based on medieval prototypes. The replica was placed in a small porch on the front side of Glencairn where it remains today.

B L

Literature: J. Hayward, and W. Cahn, *Radiance and Reflection: Medieval Art from the Raymond Pitcairn Collection,* New York, 1982, 58–59, no. 6A; P. Williamson, *Catalogue of Romanesque Sculpture* [London], 1983, 21; *Songs of Glory: Medieval Art from 900–1500,* Oklahoma City, Okla., 1985, 78–79, no. 6.

1. *The Middle Ages: Treasures From the Cloisters and the Metropolitan Museum of Art* (New York, 1969), 84.
2. Raymond Pitcairn to Jacques Seligmann, Oct. 3, 1922, Glencairn Archives, The Glencairn Museum, Bryn Athyn, Pa. See the essay below, B. Lombardi, "Raymond Pitcairn and the Collecting of Medieval Stained Glass in America."
3. Ibid.
4. *The Middle Ages: Treasures from the Cloisters,* 84.

42

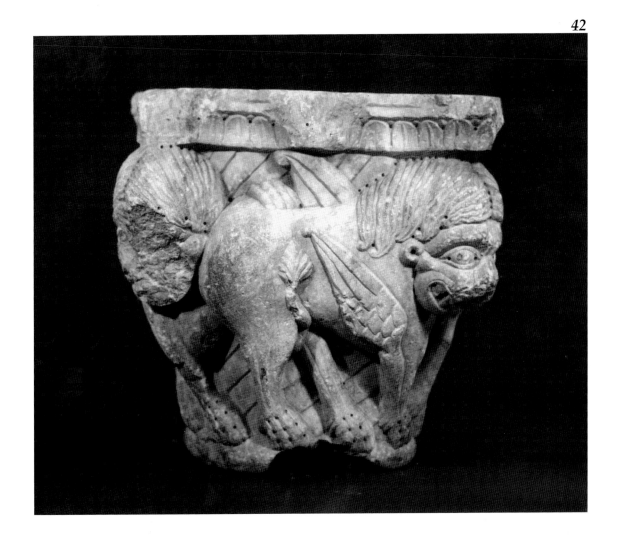

43. Engaged Corinthian Capital

France, Hérault, St.-Guilhem-le-Désert,
late 12th–early 13th century
Stone, 29.2 x 24.4 x 42 cm
The Metropolitan Museum of Art,
The Cloisters Collection, 1925
25.120.47
Purchased from Barnard with funds
donated by John D. Rockefeller, Jr.
Ex. coll. G. G. Barnard, New York;
Vernière, Aniane

Color plate (p. 14)

44. Engaged Corinthian Capital

France, Hérault, St.-Guilhem-le-Désert,
late 12th–early 13th century
Stone, 29.2 x 43 x 25.4 cm
The Metropolitan Museum of Art,
The Cloisters Collection, 1925
25.120.114
Purchased from Barnard with funds
donated by John D. Rockefeller, Jr.
Ex. coll. G. G. Barnard, New York;
Vernière, Aniane

Color plate (p. 14)

The Abbey of St.-Guilhem-Le-Désert

All of the pieces on loan from The Cloisters of the Metropolitan Museum of Art are from the Benedictine Abbey of St.-Guilhem-le-Désert, whose ruins are still extant in the wild and rocky Gellone Valley near Montpellier in the south of France. The abbey of St.-Guilhem, originally known as Gellone, was founded in 804 by Guilhem Duke of Acquitaine and Count of Toulouse. Duke Guilhem had distinguished himself as a knight under the command of Charlemagne in the campaigns against the Saracens in Spain in the eighth century. A devout Christian, in later life he founded his monastery and soon afterwards retired there, becoming a monk himself. He was awarded a relic of the True Cross for his church and died in the cloak of sanctity on May 28, 812. The monastery grew rapidly due to the presence of the relic of the Cross and through the fame of its founder, who had become famous as the hero of a "Chanson de Geste" or ballad devoted to tales of his heroic deeds.[1] By the twelfth century, it was one of the regular pilgrimage stops on the road to the shrine of Santiago de Compostela in northwestern Spain, and it was at this time that it came to be known as the monastery of St.-Guilhem, after its founder.[2]

The monastery church, built primarily in two campaigns in the second half of the eleventh century, still stands.[3] The nave and aisles, erected as part of the first campaign before 1075, are among the later and grander examples of the Premier Art Roman, or Southern First Romanesque. The interior of the nave is noted for the soaring height of its barrel vault and arches. Its beauty lies in the subtle interplay of spaces—the rhythmic sequence of the arches, the high windows and the contrast between the grey limestone walls and the golden brown tufa of the barrel vault. In a second campaign, begun almost immediately after completion of the first, the Romanesque transept, eastern apses and trapezoidal cloister were constructed. According to an entry in the cartulary of the monastery, referring to a *claustro novo* in 1205, it has been deduced that a second storey was added to the cloister galleries at that time.[4] It is from this upper arcade, no longer extant at St.-Guilhem, that the "ensemble of unsurpassed carved capitals and shafts" at The Cloisters originated.[5]

During the Middle Ages, the cloister of a monastic complex often became the focus of artistic innovation because of its function and location. Usually in the form of an enclosed quadrangle with an arcaded ambulatory surrounding a central garden, located south of the nave of the church and west of the transept, its four galleries served as a major link unifying the monastery church with the domestic buildings. Around it were grouped buildings for prayer, reading, eating, working, and sleeping.

43

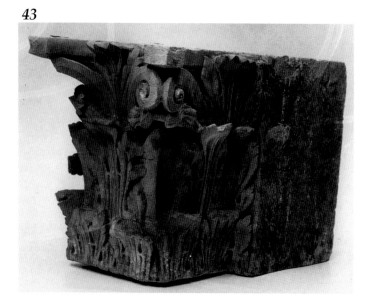

44

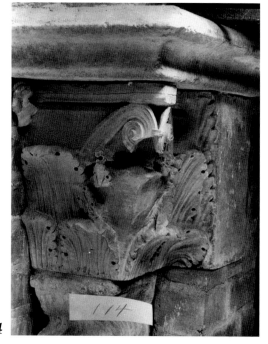

Its sheltered passages provided a quiet place for meditation, reading the breviary or observing canonical hours.

Cloister arcades were supported by columns, or often, as in the upper gallery of St.-Guilhem, by pairs of slender colonnettes topped by double capitals. Unlike the soaring church pillars, cloister columns were relatively short and their capitals clearly visible. These were often richly carved with biblical scenes, religious symbols, moral admonitions (personifications of virtues and vices) or simply with decorative designs. Most of the capitals from St.-Guilhem are medieval versions of the classical Corinthian capital, supreme examples of what Barnard described the "the patient Gothic chisel."[6] In spite of their distinctive style, the sculptures from St.-Guilhem were probably not carved by local sculptors. It was common practice in the Romanesque and Gothic eras for masons and sculptors to travel from one commission to another, often remaining within a single region but sometimes covering great distances. Stylistic affinities link the carving in this cloister to that visible in neighboring abbeys, expecially St.-Gilles-du-Gard and St.-Trophime in Arles, and by extension to the local remains of ancient Roman ruins, which provided the strongest source for the Romanesque style in Provence.[7]

The monastery of St.-Guilhem-le-Désert was sacked in 1569 by the Calvinists during the French Wars of Religion (1562–1598), but it was re-formed again in the seventeenth century under the congregation of St.-Maur. Plans

of the monastery drawn by the Maurist monk Robert Plouvier during this period (c. 1656) reveal a thriving complex of buildings. The upper cloister gallery is carefully indicated, with its rows of twin columns around the periphery clearly set out.[8] Seized by the state during the French Revolution, the monastery buildings were sold and subsequently used as a cotton mill, a tannery, and a quarry.

Pieces of the original sculptures were scavenged and dispersed among the peasants of the surrounding countryside. Some of the sculpture is now back at St.-Guilhem, some is in the Archeological Museum in nearby Montpellier, and some may still be hidden or unidentified.[9] Many of the sculptures from the second storey cloister of St.-Guilhem were collected and displayed before 1875 in the garden of Pierre-Yon Vernière in nearby Aniane, where the colonnettes, erected in single file, supported a grape arbor.[10] In March of 1906, George Grey Barnard bought the entire ensemble from Vernière through the Parisian dealer Louis Cornillon, who shared an interest in it with a colleague from nearby Carcassonne.[11]

In his 1925 inventory of his collection, Barnard enumerated the St.-Guilhem elements as follows:

> Cloister of St. Guilhem complete inside in place; the complete lot, including all material from St. Guilhem whether or not herein specified:
> 48 sculptured capitals
> 26 shafts
> 1 pilaster
> 35 bases
> 17 capping blocks (abaci)
> 10 coping slabs

45. Voussoir with Lion

France, Hérault, St.-Guilhem-le-Désert,
late 12th–early 13th century
Stone, 32.3 x 27.9 x 17.1 cm
The Metropolitan Museum of Art,
The Cloisters Collection, 1925
25.120.122
Purchased from Barnard with funds
donated by John D. Rockefeller, Jr.
Ex. coll. G. G. Barnard, New York;
Vernière, Aniane

46. Spandrel with Foliage Whorl Decoration

France, Hérault, St.-Guilhem-le-Désert,
late 12th–early 13th century
Stone, 33 x 103.5 x 10.8 cm
The Metropolitan Museum of Art,
The Cloisters Collection, 1925
25.120.129
Purchased from Barnard with funds
donated by John D. Rockefeller, Jr.
Ex. coll. G. G. Barnard, New York;
Vernière, Aniane

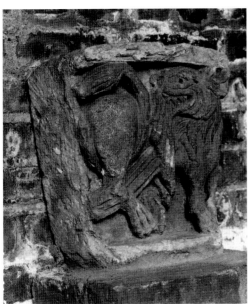

45

46

47. Archivolt Fragment with Elder of the Apocalypse

France, Parthenay?, 12th century
Sandstone, 28 x 18 x 15 cm
Philadelphia Museum of Art:
George Grey Barnard Collection
45-25-71 C
Ex. coll. G. G. Barnard, New York

48. Archivolt Fragment with Elders of the Apocalypse

France, Parthenay?, 12th century
Sandstone, 41 x 28 x 15 cm
Philadelphia Museum of Art:
George Grey Barnard Collection
45-25-71 D
Ex. coll. G. G. Barnard, New York

These figures can be identified as Elders of the Apocalypse, each wearing a crown and holding a lute, in accordance with the description in St. John's Book of Revelations:

And immediately I was in the spirit: and, behold, a throne was set in heaven, and one sat upon the throne
And round about the throne were four and twenty seats; and upon the seats I saw four and twenty elders sitting, clothed in white raiment; and they had on their heads crowns of gold. (Rev. IV:2, 4)
And when he had taken the book, the four beasts and four and twenty elders fell down before the Lamb, having every one of them harps, and golden vials full of odours, which are the prayers of saints. (Rev.V:8)

As was usual in the Romanesque period, these Apocalyptic Elders would have been part of the monumental decoration of a church facade intended to remind the faithful to heed the Commandments before it was too late. In many parts of France, such a composition would have been carved on a tympanum placed over the entrance. In western France, where the carved tympanum was a rarity, archivolts around the portal fulfilled this function. The shape of the blocks of stone on which these Elders are carved indicates that they would logically form part of the right side of an archivolt.

Barnard referred to these figures and to four others belonging to this series, also in the Philadelphia museum, as "musician kings,"

saying they came from Parthenay in western France.[1] Their similarity to the Apocalyptic Elders found on the cycle on the west front of Notre-Dame-de-la-Couldre in Parthenay led Weinberger to believe that they came from another church in the region, possibly inspired by Notre-Dame-de-la-Couldre. Scher suggested that they may have come from Parthenay itelf, from one of seven other twelfth-century churches destroyed or remodeled in subsequent centuries. The fragmentary nature and badly eroded surface of these sculptures makes a more precise attribution difficult.

Romanesque architectural fragments in Barnard's second collection consisted mostly of carved capitals. Although there were also two small portals from southwest France, these are decorated only with simple moldings. Within Barnard's second collection, the Elders stand alone as examples of historiated archivolts.

R D

Literature: M. Weinberger, *The George Grey Barnard Collection*, New York, 1941, no. 71 c and d; S. K. Scher, *The Renaissance of the Twelfth Century*, Providence, R.I., 1969, no. 21.

1. This is from a list made by Barnard of objects in his second collection, Barnard Archives, The Cloisters, The Metropolitan Museum of Art.

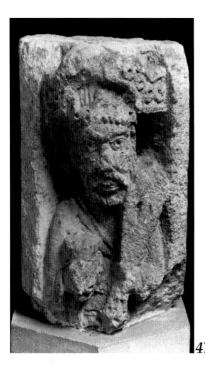

47

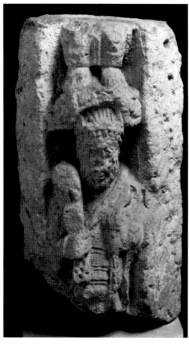

48

This statue is an intimate arrangement with the seated Virgin supporting the standing Christ Child on her knee with her left hand. In her right hand Mary holds a flower, probably a lily, symbol of her purity. The Child gently touches her chin with his right hand while holding a dove in his left. An expression of tenderness between Mother and Child typifies many such statues in the late thirteenth and fourteenth centuries. As Queen of Heaven, Mary wears a crown. Her gown is belted high, with the buckle clearly visible just under her bosom, and her mantle is fastened at the neck with a large elaborate clasp. The Christ Child wears a simple long tunic. Due to the widespread popularity of the cult of the Virgin Mary in the Gothic era, statues of the Madonna and Child were produced in great quantities in a variety of media and sizes, and taken together, form the largest group of medieval sculptures to survive to this day. This particular statue is of a size that would have been appropriate to place on an altar, most probably in a church, where it would have served as a devotional image.

During the Middle Ages, it was the practice to finish stone sculpture by coating the surface with a layer of gesso as a ground and then applying paint so as to impart a more lifelike quality to the figures. Few medieval statues retain their original polychromy, and it is likely that the paint visible on this figure is the result either of overpainting or restoration. There are some plaster repairs, and the back is partly rechiselled. The Child is darkened, indicating that it may have often been touched, most likely by the congregation of the church where it was originally located.

The exaggerated sway of the statue recalls that of many ivory Madonnas of the Gothic era where the cant to one side is the result of the curve of the tusk from which they are carved. Here, in a stone sculpture, such a sway seems unnecessary and unnatural. The tubular folds of the hem of the Virgin's mantle reflect the elegant, courtly style prevalent in the Ile-de-France in the early fourteenth century, as do the broad flat faces and small, neat features of both Mother and Child.

Within the exhibition, this statue serves as representative of the many examples of freestanding, non-architectural sculpture in both of the collections assembled by George Grey Barnard.

R D

Literature: M. Weinberger, *The George Grey Barnard Collection*, New York, 1941, no. 79.

49. Statue, Virgin and Child

France, Ile-de-France, c. 1320–1330
Limestone, 76 cm high
Philadelphia Museum of Art:
George Grey Barnard Collection
45-25-79
Ex. coll. G. G. Barnard, New York

Color plate (p. 14)

49

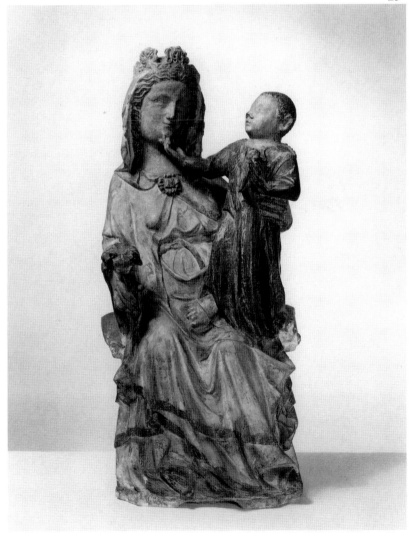

3

1920-1940:
THE Era of
Art Historians and Curators

1920–1940:
Overview of the Period

By the end of the First World War, the interest in medieval art that had begun at Harvard in the 1870s had percolated throughout the Ivy League colleges. At Princeton, as well as at Harvard, museums established primarily as teaching aids for the departments of art history began increasingly to collect original works of medieval art. Collecting patterns at these museums became more sophisticated, reflecting the interests of resident art historians and the advances in scholarship made by them. Arthur Kingsley Porter's association with the Fogg Museum at Harvard was an outstanding example of such a symbiotic relationship. The impact on Pittsburgh Plate Glass heir Raymond Pitcairn of Porter's publications dealing with medieval architecture and sculpture serves as an example of how in this period academia influenced the direction of private collecting as well. Concurrently, the effects of the Morgan loan show and George Grey Barnard's Cloisters began to be apparent in public museums. The interest in collecting medieval art rose sharply. Medieval departments were established, with curators trained in the history of art. Attempts were made to emulate Barnard's period approach to the exhibition of medieval art: portals, courtyards, and cloisters were erected in many museums.

The growth of medieval studies in the academic world and an increased professionalism in public museums helped to bring medieval art to the public in greater quantities and in a wider variety than before, while also teaching them how to look at it. Curators now began to organize special exhibitions of medieval art, the first to focus on art of a particular medium or era. Such were the Metropolitan Museum of Art's Tapestry Loan Show of 1928, or the Worcester Museum's exhibition of "The Dark Ages" in 1937. Perhaps the most widely seen exhibition of this period was the Guelph Treasure, an unparalleled collection of medieval liturgical objects from the House of Hanover in Germany. In 1930 and 1931, this exhibition traveled across the United States, drawing record crowds in each city where it stopped along the way. The Guelph traveling exhibition was in large part the result of the purchase of a number of the finest pieces of the treasure by the Cleveland Museum of Art. William M. Milliken, director of the museum, and formerly curator of medieval art in that institution, had worked at the Metropolitan Museum of Art when he was fresh out of Princeton. This had been at the time of the Morgan loan show, and Morgan's collection impressed Milliken a great deal. Milliken, in turn, would place his imprint on the medieval collection at Cleveland. In a sort of ripple effect, after the Cleveland purchases and the traveling exhibition, a number of other American museums acquired objects from the Guelph Treasure.

In the late 1930s, two other events took place that are representative of the growing importance of museum curators in the collecting and exhibiting of medieval art. In 1938, thanks to a large donation by John D. Rockefeller, Jr., the Metropolitan Museum of Art opened The Cloisters, an elaborate pseudo-monastery newly constructed in Fort Tryon Park. The Cloisters, which housed the George Grey Barnard collection, as well as numerous other works of medieval art, served as a permanent tribute to Barnard, presenting medieval art as he had done, in a medievalizing setting. Shortly afterward, in 1940, Georg Swarzenski organized the first comprehensive loan exhibition of medieval art to be shown in this country at the Boston Museum of Fine Arts. In a strictly modernist setting, the "Arts of the Middle Ages 1000–1400" brought together over three hundred works of medieval art from American public and private collections. Although the restriction to American collections was due to the terrible onslaught of World War II, which put a halt to transatlantic travel, it actually served to demonstrate to all that a first-rate exhibition could be created while drawing exclusively upon collections in the United States. This would not have been possible only a short time before; "Arts of the Middle Ages" showed that in 1940 medieval art in America had come of age.

Academic Collecting at Harvard

Kathryn McClintock

Harvard University in Cambridge, Massachusetts, established the first American department of art history in 1874, but it did not have a formal art museum until 1895. The presence of the Museum of Fine Arts in nearby Boston (founded in 1870) undoubtedly played a role, for even after the university received a bequest for the construction and maintenance of an art museum in 1891, there was concern "that in a city the size of greater Boston there was room for only one museum."[1]

The method of teaching the fine arts under Charles Eliot Norton and Charles Herbert Moore, who both followed the practices of John Ruskin, was also a significant factor. Norton taught art history from a social and moral perspective and, with the notable exception of St. Mark's, did not generally emphasize the analysis of individual works. When teaching his course on Florentine art, for example, Norton lectured three months before discussing a specific painting (Fra Filippo Lippi's *Coronation of the Virgin*). Moore, on the other hand, encouraged his students to learn about art by imitating the technique of Ruskin as they made copies of his drawings or of Moore's copies after Ruskin. Moore trained the eye to see in the Ruskinian manner, while Norton's approach was fundamentally literary.[2] In both cases, the study of artworks as objects in their own right was not of primary concern, and the need for a museum to house paintings and sculpture (either reproductions or originals) for the use of the students lacked both urgency and funding.

The situation changed in 1891, however, when Harvard University received a bequest of $220,000 for an art museum from Mrs. William Hays Fogg of New York. The building was first conceived primarily as a memorial to the donor's husband (with a small gallery for the display of Mr. and Mrs. Fogg's collection of paintings and curios) and only secondarily as a museum for the use of the Department of Fine Arts. Norton, however, successfully argued that any building constructed under such conditions could not "be satisfactory as a University Museum of Fine Arts," and by the time the museum opened, it was seen as "a well-fitted art laboratory, for the study and comparison of facts relating to art and artists."[3] The permanent collection was to consist largely of plaster casts, photographs, and other reproductions of the greatest examples of European art, while donations from the alumni and friends of Harvard were considered the most likely sources for original works of art.

Charles Herbert Moore, Norton's colleague in the Fine Arts Department, was appointed the museum's first curator

when the Fogg Art Museum opened to the public in 1895. Named director the following year, Moore remained at the Fogg Art Museum until his resignation in 1909. The early years of his administration were concerned with building the museum's collection, and he began by purchasing casts from various European sources.[4] Examples of Greek and Renaissance sculpture predominated, although his orders for reproductions included a sampling of Assyrian, Egyptian, and medieval sculpture as well.

Two casts of reliefs from Nicola Pisano's pulpit in the Baptistery of Pisa were requested from the Berlin Museum, but because these were unavailable, Moore accepted two casts from the pulpit in Siena in their place. Apparently, there was little concern for duplicating reproductions already available at the Boston Museum of Fine Arts because it had a complete cast of the pulpit from Siena in addition to a relief panel of the Nativity from the pulpit at Pisa. Moore even specifically requested a replica of the *Venus de Milo* "to be like the one at the Boston Museum of Fine Arts" from P.P. Caproni & Brothers.

Moore also had difficulty securing the reproductions of medieval French sculpture that he ordered from the Palais du Trocadéro in Paris. Of the items requested, only two could be supplied: the statue of the Virgin and Child from the trumeau of the north portal at Notre Dame of Paris (Cat. 19) and the retable from the church of St.-Germer-de-Fly.[5] The collection of plaster casts remained small due to limitations of space, and after the initial purchases of 1895, only three non-medieval items were bought. Funds to build the collection were subsequently directed toward the more space-efficient and cost-effective acquisition of photographs of paintings and architecture.[6]

The Fogg Art Museum received its first significant loans of original works from Edward Waldo Forbes (Harvard, Class of 1895), who provided the museum with several Italian panel paintings and classical sculptures in 1899.[7] Forbes continued to place similar works on indefinite loan at the museum and became known as the museum's "most constant benefactor."[8] When Moore resigned as director of the museum, Forbes was appointed to that position and started to build a permanent collection of Italian Primitives through the purchase of the *Madonna and Child with Angels* "by an early Italian master" (FAM 1909.32).[9] He also mounted a loan exhibition of Italian Primitives during the first year of his directorship and provided works from his own collection for extended loans. By 1911, Forbes was proud to announce that there were about thirty-five early Italian paintings on view at the Fogg Art Museum.[10]

Forbes was joined in his efforts by Paul Joseph Sachs (Harvard, Class of 1900), appointed assistant director at the museum in 1915. Both men had been inspired by Charles Eliot Norton as undergraduates and were collectors of art, which they placed at the disposal of the museum.[11] Forbes and Sachs also came from prominent and wealthy families and often received support from their relatives for the benefit of the museum. Forbes's aunt, Mrs. Edward M. Cary, gave over $20,000 for the purchase of paintings, while the Sachs family, particularly Paul's younger brother Arthur (Harvard, Class of 1901), contributed not only works of art, but also donated substantial amounts of money in support of the museum and Department of Fine Arts.

Much of the early expenditure for original works of art was directed toward the purchase of the Italian Primitives, and the first gift of the Society of the Friends of the Fogg Museum (founded in 1913) was a diptych of the *Annunciation* by the Sienese painter, Andrea Vanni (Fig. 1).[12] When asked why the Fogg was devoting itself primarily to the acquisition of early Italian painting, Forbes replied:

> . . . it is not desirable to try to do just what the Museum of Fine Arts in Boston is doing; namely to have large and comprehensive collections in all fields of art. It is better for a small museum to specialize. . . .The importance of early Italian painting in the history of art is fundamental. The paintings are not as is so often supposed, merely curious and interesting historically. They are really beautiful, even though they sometimes need study before the beauty is perceived.[13]

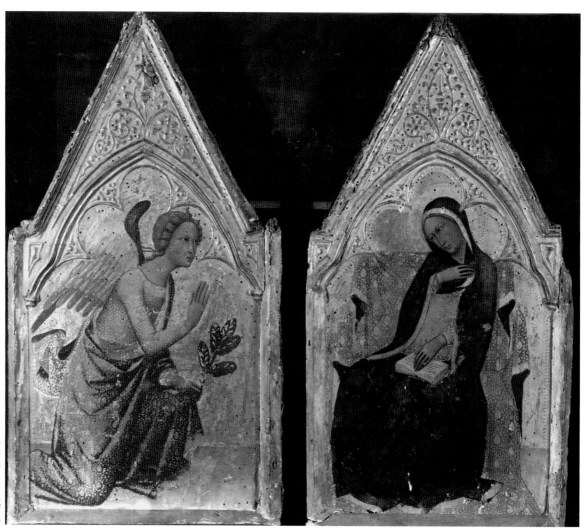

Fig. 1. Andrea Vanni,
The Annunciation
(diptych),
late 14th-15th ceturies.
Tempera on panel.
(Fogg Art Museum,
Gift of
The Friends of the Fogg)

There were also economic considerations, for "in spite of the increasing difficulty of collecting masterpieces, it is still easier to get a good deal of beauty for a small amount of money in the Italian school than in most other schools . . . and the second-rate Italians which occasionally can be purchased are much better than other second-rate masters, and, indeed, better than most other first-rate masters."[14] But primarily, these paintings occupied a significant place in the curriculum that had been established by Charles Eliot Norton and which continued to be offered. "For the teaching of the history of art in the West the collection of Italian paintings in the Fogg Art Museum has formed the backbone of the original material indispensable for the needs of the Fine Arts Department."[15]

The purchase of original works of art to supplement the courses offered at Harvard reflected an expanded role for the Department of Fine Arts not only within its own community, but also within American society at large. With the rapid growth of public art institutions in the United States, there was a need for "the training not only of well-informed laymen and of competent teachers [as in the days of Charles Eliot Norton], but also of a group of scholars prepared to play their part in the direction of municipal museums throughout the country."[16] Reproductions alone were no longer sufficient as more and more original art passed from private hands into public collections. Charles Eliot Norton had inspired many in the first generation of gifted amateurs, who had built the early collections of American museums; it was now the responsibility of Paul Sachs, who established the first course on museum administration at Harvard University in 1921, to train experts in the handling and management of priceless objects for future generations. "The Fogg Art Museum is in fact, not only the laboratory, but the treasure house as well of an increasingly important fine arts department."[17]

More and more, early Italian panel paintings had become part of the collections of American public institutions after the turn of the century. Forbes had concluded that the appreciation of the Italian Primitives was a logical progression for art collectors in America, who had initially started with an interest in the Barbizon School, then moved backwards to English eighteenth-century painting, the Dutch seventeenth-century masters, and Flemish and Italian sixteenth-century painting. It was then a small step to an exploration of the more remote areas of fifteenth-century panel painting, and if one were persistent, to the Italian Primitives of the thirteenth and fourteenth centuries.[18]

Recognition of the aesthetic qualities of Sienese painting, in

particular, was also related to contemporary developments in art. "With the turn to the appreciation of non-representational art in the early years of the twentieth century, the exquisitely abstract and deeply religious pictures of Siena were among the first to be discovered by modern connoisseurs."[19] It is noteworthy, however, that this appreciation did not often translate into the acquisition of both early Italian painting and contemporary art by the same collector.

The demand for panel paintings became so great in the early twentieth century that Arthur Kingsley Porter, with some degree of concern, wrote:

> Characteristic of this America of ours are the waves of fashion that sweep through the country. There is danger in this jerky, intense way of doing things, even when the excitement is directed towards some object in itself entirely laudable. It is therefore with some mixed feelings that we must regard the rise in the field of art of a distinct fad for Italian primitives. We may concede that the present popularity of the Giotteschi in many ways gives cause for optimism. It is impossible not to feel that a taste for Giotto, if sincere, represents an immeasurable intellectual and artistic advance over the taste for Barbison [sic] and Fragonard, which it supplants. Yet American fads have a way of blighting and befouling all that they touch. The swarm of locusts flies away leaving the verdure sere, the flowers deprived of their freshness.[20]

This represents a tremendous shift in appreciation from the days when Charles Eliot Norton was not able to interest Harvard in the purchase of the Jarves Collection, which Yale University acquired by default in 1871.[21]

Forbes took great pride in the collection of Italian paintings he was building at the Fogg Art Museum. Around 1915, he asked Osvald Sirén, who at the time was preparing a catalogue of the Jarves collection, "'Well, How is the Fogg Museum Collection coming along? Has it got ahead of the Yale Collection?' He looked at me seriously and said, 'It never will.'"[22] Despite the rebuff, Forbes remained undeterred and continued to purchase Italian Primitives. In 1919, the Fogg Art Museum published its own catalogue of Italian paintings, which consisted of fifty-one examples of early Italian and Renaissance works; the Jarves Collection at Yale had 119.

Although Italian paintings dominated the early patterns of institutional collecting at the Fogg, the appointment of Arthur Kingsley Porter (Yale, Class of 1904) as a research professor at Harvard changed the direction of acquisitions. He had studied architecture at Columbia University and written three classic works on medieval art before he began teaching at Yale University: *Medieval Architecture, Its Origins and Development* (1909), *The Construction of Lombard*

and *Gothic Vaults* (1911), and *Lombard Architecture* (1915). Through his writings and extensive research in the field, Porter developed an international reputation as a medieval archaeologist, and in 1920, Harvard invited him to join the faculty of the Department of Fine Arts.

He was already working on his monumental investigation of the Romanesque sculpture of the pilgrimage roads (published in 1923) when he received the offer from Harvard. He had spent extended periods of time in Europe since 1904 studying and photographing medieval monuments and developed a particular interest in the origins of Romanesque sculpture, at that time a relatively neglected area. Earlier research on the subject had often been guided by regional jealousies over precedence, but Porter approached the field with a fresh eye and far-reaching grasp, unencumbered by the local prejudices of many European scholars. In his search for the sources of medieval sculpture, his studies led him from Italy and France to Spain, and ultimately, to Ireland. His interest in Spanish Romanesque art, in particular, would have a significant impact on the patterns of collecting medieval art in the 1920s.[23]

Prior to Porter's affiliation with Harvard, American interest in Romanesque sculpture was very limited, and a preference for Italian examples had predominated. Isabella Stewart Gardner had incorporated Italian Romanesque sculpture into Fenway Court as part of the Ruskinian Venetian aesthetic. The earliest purchases of medieval sculpture by the Metropolitan Museum of Art in New York had also been Italian Romanesque, perhaps influenced to some degree by the increased acceptance of Italian Primitive painting at the same time. The presence of German scholar, Wilhelm R. Valentiner, as a curator at the Metropolitan, should also not be overlooked. George Grey Barnard's inability to find a buyer for his cloisters before 1925, on the other hand, indicates that America was not yet generally appreciative of the Romanesque sculptural aesthetic prior to Porter's pioneering scholarship.

The situation would change dramatically in 1920 when Porter accepted the position of research professor at Harvard. The Fogg Art Museum's first permanent acquisition of medieval sculpture (a twelfth-century French head from St.-Denis, FAM 1920.30) occurred in the same year he joined the faculty, and although he did not assume full teaching responsibilities until 1925, Porter provided invaluable advice and counsel in building the museum's medieval collection. He also, at times, acted as donor when museum funds were not available, and because he and his wife had independent means of support, often used his salary for works of art. Although he would not personally affect a generation of undergraduates in the same way that Charles Eliot Norton had, Porter would profoundly influence the direction of medieval studies and acquisition in America.

Porter's appointment at Harvard was fortuitous because Forbes and Sachs had recently seen the collection of medieval sculpture being offered by the Parisian art dealer, Georges Demotte, and needed Porter's evaluation. His response was most positive:

> For my part, I feel more strongly than ever that this is an opportunity which the Fogg Museum should strain every nerve not to miss. . . . No other museum in the world possesses such representation, nor does it seem conceivable that either the Fogg Museum or any one else will ever in the future have another chance to acquire such a showing. . . . On the whole it seems to me that the Demotte collection gives a more representative view of French medieval sculpture than any other in existence, excepting the Louvre.[24]

The collection included statues of the Virgin in various materials from the twelfth through the fourteenth centuries, a fragment from the tympanum at Laon Cathedral, and a fifteenth-century head from Strasbourg Cathedral, but Porter was particularly enthusiastic about the Romanesque offerings: twelve capitals from Moutier-St.-Jean, a statue from Moissac, sculpture from St.-Bertrand-de-Comminges, and six capitals from St.-Pons.

Although concerns arose over the legality of removing the sculpture from France and over the ability to pay for the complete collection (the asking price was $90,000), Porter initially remained committed to acquiring the collection in its entirety. Porter's confidence began to waver, however, as he encountered increasingly numerous reports concerning Demotte's penchant for fabricating provenances. Demotte also proved to be less than forthright about two statues, said to be from Beauvais, which Porter had bought for his own collection, but Porter still felt compelled to recommend several purchases:

> I feel very strongly that it would be a great misfortune to miss the pieces <u>with authenticated histories</u>, such as the Moutier-Saint-Jean and St. Pons capitals. Even if it should be necessary to give up the collection as a whole, I earnestly hope that it may be possible to pull these chestnuts out of the fire.[25]

In 1922, the Fogg Art Museum acquired the entire set of capitals from Moutier-St.-Jean (Fig. 2) and five of the six capitals from St.-Pons (Cat. 50), giving one of the latter group to the Metropolitan Museum of Art (MMA 1922.37.2). The sixth capital from St.-Pons was bought by the Boston Museum of Fine Arts (BMFA 22.53).

Although the purchase of the Demotte Collection had occupied much of Porter's energy, he also advised the Fogg Art Museum on the acquisition of stained glass from the sale of the Henry C. Lawrence Collection in 1921. The museum hoped to raise ten or fifteen thousand dollars expressly for this auction, but the bidding so exceeded expectations that the museum was unable to buy any stained glass from the Lawrence Collection:

> The prices seem to me to have been absolutely absurd. When one thinks of spending 2,000,000 lire for the [stained-glass panel of a] king [Glencairn 03.SG.229], and of what one could buy for that sum, it seems as though America must have been stark mad. Pitcairn must have lost his temper and his judgment; he probably had made up his mind to have that piece at any price as he wants models to copy for his experiments at Bryn Athyn It is an absolutely lovely thing, and an important example for the Fogg to have acquired, but I should never have been in favour of paying more than $10,000 for it. The other prices strike me as equally unreasonable.[26]

The museum's desire to own an outstanding piece of medieval stained glass persisted, however, and in 1924, Porter donated a thirteenth-century medallion, said to be from Canterbury, to the collection (FAM 1924.106). Paul Sachs was ecstatic:

> Now that the wonderful window has actually become one of the prize possessions of the Fogg Museum I simply cannot resist the temptation to again express my profound appreciation and gratitude. I think we have all hoped that we might have a truly splendid example of medieval glass, and we have been particularly anxious to acquire this very window, and now through your unfailing generosity it is actually ours. I look upon its acquisition as one of the very great events in the history of the Museum, and I therefore send you this word of affectionate gratitude.[27]

The following year, Sachs himself donated two fragments of thirteenth-century blue glass from Chartres Cathedral (FAM 1925.14.1-2).

Although they depended greatly on Porter for recommendations concerning possible acquisitions, Forbes and Sachs continued to look for medieval objects on their frequent trips to Europe. In 1923, for example, they considered buying an enamel reliquary from a widow in Paris. They finally decided against the purchase, however, because neither was especially knowledgeable about medieval metalwork, and they did not want to risk buying a forgery.[28]

Instead, loans from out-of-town collectors were employed to acquaint the students of Harvard and the university community with medieval minor arts. These loans were facilitated by the close ties Paul Sachs had to the art community in New York. John Pierpont Morgan, Jr. (Harvard, Class of 1889) often lent illuminated manuscripts, while

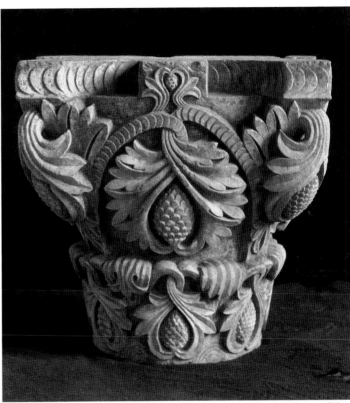

Fig. 2. Capital, Moutier-St.-Jean, c. 1125. Limestone. (Fogg Art Museum, Gift of The Friends of the Fogg Museum)

other New Yorkers, such as Mr. and Mrs. George Blumenthal, Arthur Sachs, and Jesse I. Straus (Harvard, Class of 1893), occasionally loaned medieval metalwork.[29] Raymond Pitcairn of Bryn Athyn, Pennsylvania, also provided Byzantine and Spanish ivories for a special exhibition at the opening of the museum's new building in 1927. With access to the resources of these collectors of the minor arts, the museum does not seem to have deemed it necessary to acquire its own examples for the permanent collection until the Guelph Treasure was offered for sale in 1931.

Throughout the 1920s and 1930s, the main focus of medieval acquisition at the Fogg Art Museum remained Romanesque sculpture, although the museum continued to purchase early Italian panel paintings. After Porter's arrival, Sachs supported the interests of his colleague by donating several works of Romanesque sculpture to the museum, including a twelfth-century historiated capital from Avignon (Cat. 51) and a foliate capital from Moutier-St.-Jean (FAM 1925.9.1). He also arranged for the purchase of a waterspout found near Avallon with funds from the Friends of the Fogg Art Museum (FAM 1925.9.2).[30]

Porter himself also gave a number of Romanesque sculptures to the museum and was instrumental in securing high-quality examples of twelfth-century French sculpture for the museum, such as the previously mentioned capitals from St.-Pons-de-Thomières (FAM 1922.64-67). Porter's attention was increasing drawn to Spain, however, first with the writing of *Romanesque Sculpture of the Pilgrimage Roads* (1923) and then, *Spanish Romanesque Sculpture* (1928). This is reflected in the purchases of an eleventh-century wooden statue of the Virgin Annunciate (FAM 1925.11) and of two twelfth-century Spanish capitals from Palencia (FAM 1926.4.1-2) through the Friends of the Fogg, as well as Porter's donation of a sarcophagus lid from Sahagún (Fig. 3).[31]

Fig. 3. Lid of sarcophagus of Alfonso Ansúrez, Spain, Sahagún, 1093. Marble. (Arthur Kingsley Porter, *La Escultura románica en España,* vol. 1, Florence, 1928, pl. 44; photograph by author)

Although it was becoming increasingly difficult to remove antiquities from France, Spain still offered opportunities for the acquisition of first-rate examples of medieval art, and Porter took full advantage of the situation. He not only found objects for the museum, but he also continued to build his personal collection:

> I bought two colonnettes from Sahagún [FAM 1962.308.1-2] which ought to be arriving at Elmwood about now. They supported the altar in the abbey, and were seen by Morales in the cloister in the XVI century. Gómez-Moreno publishes them in his forth-coming book on Léon, and says they are among the finest things of the XIII century in Spain, or words to that effect. He is quite bitter about the exploitation of Spanish antiquities that is going on, and I dread telling him these colonnettes are in Cambridge. I bought these from a dealer in Madrid, however, so I don't see what else he can expect.[32]

One of Porter's students, John Nicholas Brown (Harvard, Class of 1922) of Providence, Rhode Island, was also enlisted in the effort to provide the museum with examples of Romanesque art. Described in 1917 as the "richest boy in the world," Brown began his career as a patron of the Fogg Art Museum in 1923, lending an Italian Romanesque painting of the Virgin and Child which Paul Sachs had recommended to him (FAM 1969.151).[33] A year earlier, Brown had made his first trip to Spain and was to become an avid collector of Spanish art. One of the masterpieces of his collection was a signed painting by El Greco, and he also owned several Spanish Primitives.

Brown considered the medieval monastery of Silos to be "the shadow of the celestial paradise on earth," reflecting his fondness for the Spanish Romanesque, which was no doubt nurtured by Porter.[34] Among the objects in his collection, he possessed a twelfth-century Spanish ivory from Léon and a stone relief, which were both lent to the Fogg. The latter sculpture was discussed in the following letter:

> Mr. Arthur Byne of Madrid brought to my attention that Christ in Majesty from Santa Mater [crossed out and added Marta] de Tera was for sale. Professor Porter felt unable to buy it at the time and suggested to Mr. Byne that I be given the opportunity.
>
> Rather strangely enough Professor Porter had asked Charles Niver and me to look at this sculpture in 1922 on my first trip to Spain. We took some pains in finding the church, which is not far from Benavente, and in photographing it, rather badly I fear. It is an eleventh century work of great importance in the study of Spanish Romanesque sculpture.
>
> Believing that the Fogg would like to have this piece of sculpture on indefinite loan I told Mr. Bye to send it to the Fogg.[35]

Porter's interests and expertise also had an impact on the Boston Museum of Fine Arts, which began to collect twelfth-century Spanish art during his tenure at Harvard. His influence is explicit in the Museum of Fine Arts' acquisition of the portal from San Miguel de Uncastillo (BMFA 28.32):

Edward Forbes telephoned me the other day that Sachs and Porter strongly recommend our getting the [Romanesque portal] now in Barcelona. This seemed to be contradictory to Kingsley Porter's first report so I got a message through to him to write me. His letter however is as academic as usual and perhaps you remember that he showed none of his present enthusiasm at the time for the Catalonian fresco [BMFA 21.1285]. He writes however: 'On the other hand, it is an absolutely authentic example of Spanish Romanesque suclpture [sic], of very considerable interest. I know of no Spanish Romanesque portal as interesting in any museum in this country, except possibly that of Frias in the Metropolitan at New York.'[36]

The success of the Boston Museum of Fine Arts in purchasing a Spanish Romanesque portal undoubtedly mitigated some of the frustration Porter experienced over the failure of a similar transaction in 1926. As an agent of the Fogg, Porter had negotiated for the purchase of a sculpted portal from Carraceda, and a deposit had been accepted:

> The sale was practically assured when we left for Paris; a few weeks later Demotte, the antiquarian of Paris, made a trip through Spain, looking for Romanesque material. He was taken to Carraceda and offered to purchase the entire ruin, church, portal, chapter house, and what remains of the cloister. As this proposal was naturally more to the taste of the Bishop of Astorga and his colleagues, our offer for the portal only was thrust aside (though the details for sale had already been arranged).[37]

Porter could take solace only in the fact that Demotte was having great difficulty in exporting the sculpture because of a recent change in Spanish law.

A greater disappointment surrounded Porter's proposed acquisition of a Spanish Romanesque ivory plaque from the San Millán de la Cogolla reliquary (Fig. 4). Porter saw the ivory in 1928 and placed a deposit on it "which not only took all available cash but necessitated going into principal, the first time I have ever done such a thing."[38] Additional financial support from the museum was not immediately forthcoming, however, and the situation was further complicated by the impending sale of the Guelph Treasure:

> Thank you for telling me about the Welfenschatz. The objects are certainly of quite first importance and all the more desirable because of their history. They will no doubt create a great stir among museums, collectors, and dealers. However I am not sure there is any one of which I personally should prefer to the San Millán ivory that we couldn't find $6,000 to pay for.[39]

The chance to own a piece of the Guelph Treasure proved too significant to ignore, however, and the museum purchased a twelfth-century Sicilian pyx/reliquary from the treasure (FAM 1931.52). The same year, the Fogg also bought a "fourteenth-century" French Gothic plaque (FAM 1931.33), but medieval minor arts remained an area virtually unexplored by the permanent collection, either through gift or purchase.

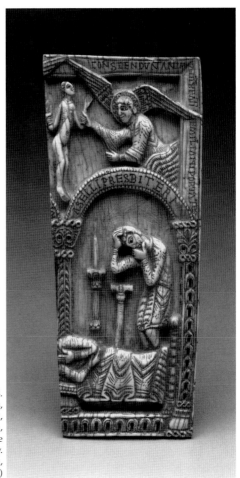

Fig. 4.
Death of Saint Aemilianus,
Spain,
Saint Millán de la Cogolla,
c. 1070. Ivory plaque
from a reliquary.
(Museum of Fine Arts, Boston,
Anna Mitchell Richards Fund)

Porter still had hopes that the Fogg Art Museum would eventually acquire the Spanish ivory, and in 1933 he received encouraging words from Forbes:

> You will remember that you and Paul and I have talked for years of the possibility of purchasing the San Millán ivory. I have felt badly that Paul and I have never succeeded in backing you up by buying this to help your Mediaeval Department, but I have now spoken to Paul about it and we are prepared to make a serious effort to get it.[40]

The asking price had substantially increased, however, and Forbes was understandably unwilling to meet the demands of the dealer:

> Seligmann sent me the photograph of the ivory we want, but he brought the bad news that the dealer had raised the price to $20,000, partly on account of our depreciated currency and partly on the general principal of robbery. I am writing back that it is wholly out of the question for us to consider paying any such price, and I think we had better leave it in the dealer's hands until he cools off and is willing to talk sense. I still hope that we shall buy it.[41]

In 1936, the San Millán ivory was purchased by the Museum of Fine Arts (BMFA 36.626), undoubtedly with the encouragement of Sachs and Forbes, who had long-standing ties with that institution, and also with the knowledge that it had been greatly prized by Porter.

After Porter's untimely death in 1933, the Fogg Art Museum continued to expand its collection of medieval sculpture. A thirteenth-century Spanish funerary monument was purchased by the museum in memory of Porter (FAM 1936.11), and other objects acquired at this time included an Italian Romanesque cassone panel (Cat. 52) and a twelfth-century sculpted head from Parthenay (FAM 1937.39). When the Brummer Collection was offered for sale in 1949, the Fogg also bought over one hundred pieces of medieval sculpture and greatly expanded its holdings of Gothic art. Porter's legacy to the Fogg Art Museum was further enhanced by several gifts from his widow, Lucy Bryant Porter, in 1957, and when she died five years later, the remainder of Porter's collection was donated to the museum.

The medieval collection of the Fogg Art Museum is a paradigm of specialization and reflects the concerted efforts of three men (Edward W. Forbes, Paul J. Sachs, and Arthur Kingsley Porter) to provide the best examples of original art for the training of the university's students as scholars and as museum administrators. Special emphasis was placed on acquiring objects closely related to the courses offered, and because the study of Italian painting had been of great importance since the days of Charles Eliot Norton, some of the museum's earliest acquisitions were Italian Primitives under the guidance of Forbes (later assisted by Sachs).

When Porter joined the faculty, the museum continued to collect early Italian painting, but also directed a significant portion of its resources towards the acquisition of Romanesque sculpture, Porter's area of expertise. The Fogg Art Museum always kept in mind the needs of its faculty, but also remained open to acquiring works of outstanding quality and historical significance and, thus, created one of the most important collections of medieval art in the United States.

1. Edward W. Forbes, "History of the Fogg Museum of Art," vol. 1, 5th rev., [1953], 88, Harvard University Art Museums Archives.
2. See J. A. Fasanelli, "Charles Eliot Norton and His Guides: A Study of His Sources," *Journal of Aesthetics and Art Criticism* 26 (winter 1967): 251–58.
3. Reprinted from *Harvard Graduates' Magazine*, Mar. 1895. Norton's comments are found in the Charles Eliot Norton Obituary file, Charles Eliot Norton to Edward W. Hooper, Mar. 3, 1893, Harvard University Art Museums Archives.
4. Charles Herbert Moore's ledger, Apr. 16-23, 1895, 1-21, Harvard University Art Museums Archives. Information concerning the acquisition of casts is taken from this source.
5. The unavailable casts were: a pier relief from St.-Trophîme, Arles; statues of a king and queen from Notre Dame, Corbeil; reliefs of the labor of the months from the *Porte de la Vierge*, Notre Dame of Paris; the relief of the *Resurrection of the Virgin*, Senlis Cathedral; heads of statues from the tympanum of the Porte de la Vierge, Notre Dame of Paris; and the head of a apostle from the Hospital of the church of St.-Jacques, Paris. Three of the casts corresponded to illustrations for his book, *Development and Character of Gothic Architecture*, published in 1890: the relief from St.-Trophîme (fig. 168), the *Resurrection of the Virgin* from Senlis (fig. 171), and the Virgin and Child from the north portal of Notre Dame (fig. 173).
6. Plaster casts played a much more significant role for the Germanic Museum of Harvard (now the Busch-Reisinger Museum), dedicated to German sculpture of the Middle Ages and Renaissance. In 1903, the museum received a representative collection of medieval casts through the auspices of the Emperor. The plastic arts of the thirteenth century were particularly well-represented and included reproductions of the Golden Gate and rood screen from Freiberg Cathedral, a series of statues from Naumburg, and the Death of the Virgin relief as well as the figures of Ecclesia and Synagoga from Strasbourg. See K. Francke, "Emperor William's Gifts to Harvard University," *International Studio* 36 (Nov. 1908): 13–18.
7. *Fogg Art Museum Annual Report* (1899–1900): 284. It had been Forbes's intention to pursue a career in teaching and had studied English literature toward that end. He had also taken courses with Charles Eliot Norton and received advice from his son, Richard Norton, regarding the availability of paintings for purchase when both were in Rome. Forbes began to acquire a few Italian paintings and planned to lend them to the Boston Museum of Fine Arts as he had no house in which to keep them. It was Richard Norton who suggested that the Fogg Art Museum would be better served by the loans and who also provided assistance in the acquisition of several classical works. Forbes, "History of the Fogg," 14-22, Harvard University Art Museums Archives.
8. *Fogg Art Museum Annual Report* (1903–1904): 1. Forbes was also a trustee of the Boston Museum of Fine Arts and donated Gandharan sculpture and Tibetan painting to that institution in 1907 as well as a fifteenth-century tomb relief from Naples (BMFA 07.505).
9. *Fogg Art Museum Annual Report* (1909-1910): 1. The panel is now considered the work of Apollonio di Giovanni and Marco del Buono, produced around 1450. See E. P. Bowron, *European Paintings Before 1900 in the Fogg Art Museum* (Cambridge, Mass., 1990), 98, fig. 564.
10. E. W. Forbes, "The Fogg Art Museum," *Harvard Alumni Bulletin* 14 (Oct. 25, 1911): 54. Two years later, the Boston Museum of Fine Arts published an article on the Fogg's Italian panel paintings. See E. W. F[orbes], "Primitive Pictures Recently Acquired by the Fogg Museum," *Boston Museum of Fine Arts Bulletin* 11 (Aug. 1913): 35-39.
11. After graduation, Sachs had entered the family partnership of Goldman, Sachs & Co. in New York where he worked in investment banking for fifteen years. Although primarily a collector of Old Master drawings and prints, Sachs owned several early Italian paintings which he lent and eventually donated to the Fogg Art Museum. His collection also included a few examples of French Gothic sculpture which were exhibited at the museum's new building after it opened in 1927. When Sachs died in 1965, his collection was given to the Fogg. See *Memorial Exhibition: Works of Art from the Collection of Paul J. Sachs* (Cambridge, Mass., 1965).
12. FAM 1914.9a&b. See Bowron, *European Paintings Before 1900*, 132, fig. 531.
13. E. W. Forbes, "Recent Gifts to the Fogg Art Museum and What They Signify," *Harvard Alumni Bulletin* 19 (Jan. 25, 1917): 329.
14. Forbes, "The Fogg Art Museum," 56.

15. B. Rowland, Jr., "The Early Italian Paintings," *Fogg Art Museum Bulletin* 5 (summer 1936): 44.

16. P. J. Sachs, "Fogg Art Museum," *The Harvard Graduates' Magazine* 24 (Mar. 1916): 424.

17. Ibid., 421.

18. Forbes, "Recent Gifts to the Fogg," 329–30.

19. Rowland, "The Early Italian Paintings," 44.

20. A. K. Porter, "The Art of Giotto," *Beyond Architecture* (Boston, 1918), 120–21.

21. The Boston Athenaeum made an attempt to acquire the collection by sponsoring a subscription, but interest was lacking, and the drive was cancelled. Charles Callahan Perkins, honorary director of the Boston Museum of Fine Arts and a leading figure in the art education movement, was also opposed to the acquisition which certainly affected the outcome.

22. Forbes, "History of the Fogg," 37, Harvard University Art Museums Archives.

23 The appreciation of Romanesque, given impetus by Porter, was also promoted by other scholars at this time, such as Wilhelm Neuss, Charles Rufus Morey at Princeton, and W. W. S. Cook. Moreover, it has been pointed out that as modern art criticism expanded the accepted canon of art, pre-Romanesque and Romanesque works came under increased scrutiny. See M. H. Caviness, "Broadening the Definitions of Art: The Reception of Medieval Works in the Context of Post-Impressionist Movements," *Hermeneutics and Medieval Culture*, eds. P. J. Gallacher and H. Damico (Albany, N.Y., 1989), 259–82.

24. Paul J. Sachs files, Arthur Kingsley Porter to Edward W. Forbes, Oct. 2, 1920, Harvard University Art Museums Archives.

25. Paul J. Sachs files, Arthur Kingsley Porter to Edward W. Forbes, July 11, 1921, Harvard University Art Museums Archives.

26. Paul J. Sachs files, Arthur Kingsley Porter to Paul J. Sachs, Feb. 23, 1921, Harvard University Art Museums Archives. Porter was in Italy at the time this letter was written which probably explains why the sale price of the king from the Tree of Jesse window at Soissons Cathedral is mentioned in lire.

27. Paul J. Sachs files, Paul J. Sachs to Arthur Kingsley Porter, Nov. 6, 1924, Harvard University Art Museums Archives.

28. Forbes, "History of the Fogg," 252, Harvard University Art Museums Archives.

29. While the Metropolitan Museum of Art would come into possession of the items loaned by the Blumenthals and Arthur Sachs, the Fogg eventually received the Limoges reliquary as a gift from Straus (FAM 1957.216).

30. The authenticity of the waterspout has come under question, but a comparison of the stone with the other sculpture from Moutier-St.-Jean indicates "all carved from the same source," per a report issued by the Brookhaven National Laboratory in 1982. Two "eleventh-century" stone heads, said to be from Vézelay, were also acquired from Jean Peslier at the time, but have since been retired (FAM 1925.9.3-4).

31. Formerly FAM 1926.20. As one of the earliest dated examples of medieval tomb sculpture in Europe, this sarcophagus lid was considered particularly valuable by the Spanish government, which successfully negotiated for its return in 1933. In exchange, the Fogg Art Museum received a double capital and abacus from Palencia (FAM 1933.99a&b) and an altar support from Santiago de Compostela (FAM 1933.100). For the sarcophagus lid, see *The Art of Medieval Spain A.D. 500-1200* (New York, 1993), 234–35, no. 107. It is now in the Museo Arqueológico Nacional, Madrid (1932/115).

32. Edward W. Forbes files, Arthur Kingsley Porter to Edward W. Forbes, Dec. 29, 1925, Harvard University Art Museums Archives.

33. *New York Times*, Feb. 17, 1917, 18:2. Brown inherited substantial estates from his father and uncle (who both died prior to his birth) as well as half of the $25 million trust established in 1874 by his grandfather, John Carter Brown. He remained actively involved in the family's manufacturing operations and was director of the Providence National Bank. John Nicholas Brown was also a trustee of Brown University (founded by an ancestor) and of the Rhode Island School of Design as well as a treasurer of the Mediaeval Academy of America.

34. John Nicholas Brown Collector file, John Nicholas Brown to Paul J. Sachs, Oct. 30, 1925, Harvard University Art Museums Archives.

35. John Nicholas Brown Collector file, John Nicholas Brown to Paul Sachs, Nov. 27, 1928, Harvard University Art Museums Archives.

36. Denman Waldo Ross files, [Edward J. Holmes] to Denman W. Ross, Oct. 5, 1927, Archives, Museum of Fine Arts, Boston.

37. Paul J. Sachs files, Arthur Kingsley Porter to Edward W. Forbes, Nov. 18, 1926, Harvard University Art Museums Archives.

38. Paul J. Sachs files, Arthur Kingsley Porter to Paul J. Sachs, June 1, 1928, Harvard University Art Museums Archives.

39. Edward W. Forbes files, Arthur Kingsley Porter to Edward W. Forbes, Dec. 9, 1930, Harvard University Art Museums Archives.

40. Edward W. Forbes files, Edward W. Forbes to Arthur Kingsley Porter, June 20, 1933, Harvard University Art Museums Archives.

41. Edward W. Forbes files, Edward W. Forbes to Lucy Bryant Porter, Feb. 19, 1934, Harvard University Art Museums Archives.

Academic Collecting at Princeton

Sarah Andrews

Medieval art history found one of its first footholds in the United States in the art history department at Princeton University. Long before eminent medieval scholars, such as Arthur Frothingham and Charles Rufus Morey, emerged at Princeton around the turn of the century, the first course on the fine arts at the College of New Jersey (later Princeton University) was taught in 1832 by Joseph Henry, who is better known for his later tenure as the first secretary of the Smithsonian Institution. This course on architecture had a modicum of medieval content, touching upon various styles ranging from the Egyptian to the Gothic. Through this course and others, Henry and his successor, Albert B. Dod, sought to provide a sense of the historical development of the various types of architecture.[1]

Medieval architecture was again part of the curriculum later in the nineteenth century when plans for the department were beginning to take shape. The first instructor in art history at Princeton was Allan Marquand, who began teaching art history in the fall of 1882, having had no formal training in the field. Marquand had had a very successful undergraduate career at the college and, after receiving his master's degree in theology from Princeton Theological Seminary and his doctorate in philosophy at Johns Hopkins University, returned to the college in 1881 as an instructor. Although Marquand was originally an instructor in logic, President James McCosh found his teaching of that subject to be "unorthodox and un-Calvinistic" and the Board of Trustees authorized McCosh to invite him to begin the instruction of art history instead.[2] The first course Marquand taught was on, as he put it, "the development of Christian architecture. It was a new field for me, but I put up a good bluff and stumbled along lecturing on Early Christian and Byzantine architecture as if I understood it well, and as if I knew beforehand all there was to follow in the unexplored fields of Romanesque and Gothic."[3] Marquand was largely self-taught in the study of art history, as were many of those who would join him in the early years of the department.

It was during this period that the first real push for a program in the fine arts at the College of New Jersey arose, led by its eleventh president, James McCosh (1868–1888). McCosh pressed the board of trustees to found a school or department devoted to the study of the arts, but the board apparently wanted to see some funding first, because in 1883 McCosh reported to them that he had raised $65,000 for his cause. Sixty thousand dollars came from the estate of Frederic Marquand and were administered by his brother, Henry Marquand, best known as a founder and later

president of the Metropolitan Museum of Art (1889–1902), and also the father of Allan Marquand.

Once there was an instructor in the discipline, the pressure to found an art history department became even greater. William Cowper Prime, who had recently pledged his collection of porcelain and pottery to the college, and General George McClellan, governor of New Jersey, put together a pamphlet, *The Establishment of a Department of Art Instruction,* for the purpose of fund-raising. Although it was originally produced to serve a mundane purpose, this brochure also gives a surprisingly insightful look into the attitude of these two men toward the study of art history, the essence of which also appears later in the department they helped to create. They saw works of art as imbued with cultural meaning: patronized by the people of a particular culture for a specific reason and indicative of the culture in which they were produced. Art was "the only trustworthy record of—not alone the history—but of the tastes, the mental character, and the manners and customs of various peoples in various ages." They also proposed a museum as a necessity for the study of actual art objects, going on to propose the dimensions of the building (which was also to provide space for lectures and classes), and adding, "All architectural ornamentation may well be left to the future, when the facade may be erected by any son or friend of Princeton, who should desire to place there a permanent monument of modern art. For the present, solidity and convenience should alone be considered." At Princeton, the practical concerns about the museum building and the display of objects for purposes of study outweighed the popular idea of the museum as something for the elite that "requires special mental abilities and tastes."[4] With this philosophy in place behind it, the "School of Art" at the College of New Jersey was founded on June 18, 1883.

Marquand's most noted field of study was with the works of the Della Robbias, and although his prime interest continued to be the art of the Renaissance, the content of his first course indicates the respect afforded medieval arcitecture from the very beginning of the department. Without Marquand the department might never have gotten off the ground, because most of its early operating expenses were covered out of Marquand's own pocket and his uncle's estate. For many years the department's purchases of books and equipment were paid for by him, as were the Marquand Professorship and the establishment of the *Princeton Monographs in Art and Archaeology.* Marquand retired from his paid position in 1910 to allow another member to be added to the faculty. He continued his previous duties without pay until 1922, when his final mono-

graphs on the Della Robbias were published. He died in 1924.

Arthur Frothingham, editor of the *Journal of Archaeology*, joined Marquand in the department from Johns Hopkins University in 1886. The first medieval scholar at Princeton, he began teaching in various fields, including ancient and Renaissance painting and the history of Christian architecture. In 1888, he taught what appears to be the first specifically medieval course in the department, "Subjects and Symbols in Early Christian and Mediaeval Art," setting the precedent for a field that would soon become prominent at Princeton. He also offered a course on medieval industrial art utilizing plaster casts of medieval ivories from the Arundel Society, which Marquand had purchased for the museum.

After Marquand published his first study on the Della Robbias in 1890, it appears that he became somewhat covetous of the field of Renaissance art, and as a result Frothingham taught only one more term on the Renaissance, focusing exclusively on medieval topics thereafter. The climactic break between Marquand and Frothingham came in 1896, possibly ignited by a course Frothingham gave on the art of Italy during the Middle Ages. Marquand may have seen this as stepping too close to his territory, and in accordance with his prerogative as the administrator of his uncle's bequest, which paid all departmental expenses, he cut off Frothingham's salary. Frothingham continued to lecture without pay until the president earmarked some funds from the rental of dormitory rooms. His teaching was restricted to Early Christian, Byzantine, Romanesque, and Gothic art and all of his courses had to be approved by the trustees. Though he remained with the department only a few more years, he did teach the first full-year course on early medieval art in 1903–1904. He left in 1905.

In 1906, the department saw the arrival of Charles Rufus Morey, who would become one of the most renowned scholars of the history of medieval art. In keeping with the cultural-historical philosophy of the department as it was first presented in the Prime-McClellan pamphlet, Morey offered a seminar on early Christian art during his second year at Princeton. He discussed the way Christianity changed the face of the existing Roman tradition and how Christian art reflected the development of the Church. Morey, perhaps more than anyone else at Princeton, led the department toward the study of art as a product of the historical context in which it was produced. In 1913, Morey began a course on the history of manuscript illumination.

His contributions continued with the establishment of the Princeton Index of Christian Art in 1917, the Princeton Series on Illuminated Manuscripts of the Middle Ages, and his later textbooks, *Early Christian Art* and *Medieval Art*.

The list of possible topics for an honors thesis for the courses presented by Morey reveals his view of the importance of contact with actual medieval objects. These included "Mediaeval Monuments in the Princeton Art Museum" and "Mediaeval Monuments in the Metropolitan Museum of Art," demonstrating Princeton's commitment to the ideal method of studying art—firsthand exposure to the objects.[5] This also suggests that many of the pieces in the museum were acquired specifically for students to study, an assumption that is bolstered when one notes the virtual inseparability of the museum from the Department of Art and Archaeology and its professors.

Morey's prominence in the field of medieval art made him the obvious choice when the College Art Association made recommendations to college museums regarding the purchase of plaster casts of medieval works for their collections. Plaster casts had been used by American art museums to make the major monuments of art, medieval or otherwise, available to the public, throughout the nineteenth century. By the time Morey formulated his recommendations in 1919, however, most of the larger public museums were moving away from the use of plaster casts in favor of original objects. The museum at Princeton, although it had earlier employed casts for teaching, had also emphasized the collecting of genuine objects from its inception. Morey himself commented on the limitations of the plaster medium—it really works only for monumental art, and then less so for medieval monuments than other, broader styles of art, and he comments that his lists should not be considered a complete curriculum for medieval art.[6] It seems ironic that Morey, a pioneer in the field of medieval art and associated with a museum that collected genuine artifacts from its earliest years, should be promoting the purchase of plaster casts at such a late date.

Morey's contributions to the early study of medieval art in the United States were countless. While previously "medieval" art at American universities had appeared mainly in the Neo-Gothic buildings found on many campuses, Morey and his counterpart at Harvard, Arthur Kingsley Porter, rebelled against this corruption of medieval forms, focusing instead upon the study and understanding of genuine medieval artifacts. Francis Henry Taylor, a former student of Morey and director emeritus of the Metropolitan Museum of Art, wrote of the

relationship between these two men: "It was, in fact, from the delicate and perfect balance of this equation of totally opposite temperaments that the study of mediaeval art achieved the proportions that it has in the universities and museums of this country."[7] Morey was concerned more with the historical circumstances surrounding an object and Porter more with the object itself, and the divergence between these two approaches seemed to have provided sufficient launching points for the in-depth study of medieval art on the same level as that of the antique and the Renaissance.

Another prominent medievalist joined the Princeton department in 1921, Albert M. Friend, Jr., who was a significant contributor to the series on medieval manuscripts initiated by Morey. Nearly his entire art collection was left to the museum upon his death, and according to George H. Forsyth, Jr., "The collection of rare books, Byzantine coins, drawings for stage sets, and other works of art which he assembled over the years were a tribute to his catholic tastes and also to his keen eye for a bargain; for he had no independent means."[8] These objects had often been used by Friend as visual aids to instruction, giving his students firsthand experience with original works of medieval art.

During the time of the department's development, various changes in housing occurred. The first courses offered in art history had been taught in the recently constructed Dickinson Hall. When the department began to expand, ground was broken for the combination museum-classroom building proposed in the original fund-raising brochure, the center section of which was used as early as 1888.[9] One can assume that there were a number of objects on display in the museum from the time it opened. Perhaps the alabaster Coronation of the Virgin included in this exhibition was among them, for it had been acquired by Marquand in 1887 (Cat. 54). Allan Marquand, in addition to his duties as a professor and head of the Department of Art and Archaeology, served as director of the museum until his retirement in 1922. As the department grew during the first two decades of the twentieth century, space in the museum became more and more cramped. As Frank Jewett Mather, Jr., who became director of the museum after Marquand's retirement, put it, "The exhibits tended to disappear. We set up blackboards before show-cases and shoved the movable cases into corners to make room for chairs."[10] The museum, thus, played an integral part in the education of a student in art history at Princeton—it was inescapable. When the department could no longer tolerate the crowded conditions, McCormick

Hall was built in 1923 to house the Department of Art and Archaeology, and the museum could then return to its primary focus—the housing and care of art objects.

From the outset, the Art Museum at Princeton had representative medieval objects. By 1890 there were casts of medieval sculpture, purchased with funds given by the Class of 1881, along with the Arundel ivory reproductions used by Arthur Frothingham in teaching medieval industrial art. In an article in *Princeton Alumni Weekly*, Mather wrote of the "Four Objects of First Importance," three of which were medieval—a Gothic sculpture of a female saint, a thirteenth-century French stained-glass window, and a Romanesque processional cross (Cat. 55).[11] Thus, by this time, medieval art was beginning to be recognized as some of the best the museum had to offer, perhaps influenced by the forward-thinking nature of the academic environment.

Among the most important contributions of the Department of Art and Archaeology at Princeton to the early study and collecting of medieval art in America was the goal of building a collection largely for study by students of art and art history. The Princeton method of studying art as a product of its historical context ensured that medieval art would be studied as seriously as the art of any other period. This also helped produce one of the most important medieval art historians of the early twentieth century, Charles Rufus Morey. In a similar manner to the historical approach taken by the founders of the Department of Art and Archaeology at Princeton, who studied works of art for a better understanding of the cultures in which they were created, the current exhibition examines some of the same works of art for a better understanding of the society in which they were collected.

1. M. A. Lavin, *The Eye of the Tiger: The Founding and Development of the Department of Art and Archaeology, 1883-1925* (Princeton, N.J., 1983), 7.
2. Ibid., 8–9.
3. *Dedication of McCormick Hall* (Princeton, N.J., 1923), 7. Quoted in Lavin, *Eye of the Tiger*, 9.
4. W. C. Prime and G. McClellan, *Suggestions on the Establishment of Art Instruction in the College of New Jersey* (Trenton, N.J., 1882), 4–5, 10–11. Quoted in Lavin, *Eye of the Tiger*, 10.
5. Lavin, *Eye of the Tiger*, 22.
6. C. R. Morey, "Reproductions of Romanesque and Gothic Art for the College Museum and Art Gallery," *Art Bulletin* 2 (Sept. 1919): 53–57.
7. F. H. Taylor, "Charles Rufus Morey 1877–1955," *College Art Journal* 15 (winter 1955): 141.
8. G. H. Forsyth, Jr., "Albert M. Friend, Jr. 1894-1956," *College Art Journal* 16 (summer 1956): 340–41.
9. Lavin, *Eye of the Tiger*, 14-15.
10. F. J. Mather, Jr., "An Art Museum at Princeton," *Princeton Alumni Weekly* 25, no. 18 (1925): 417.
11. Mather, "An Art Museum," 417-19.

Raymond Pitcairn and the Collecting
of Medieval Stained Glass in America

Beth Lombardi

In 1885, a man was born who would eventually change the face of the stained glass collecting world. This man was Raymond Pitcairn, son of John Pitcairn, the multimillionaire owner and founder of the Pittsburgh Plate Glass Company. The wealth of Raymond's family allowed him the luxury of countless trips to Europe with his mother, who passed her love of the art and architecture of the Western world on to her son. During his many sojourns to Europe, the young Raymond developed a great appreciation for the medieval churches there. His early exposure to these great monuments of the past would prove to be a seminal influence on him. Raymond, like his father before him, was a deeply religious man. He had been raised as a member of the New Church, which was founded on the theological teachings and revelations of Emanuel Swedenborg. In the 1890s, Raymond's father purchased some land northeast of Philadelphia to establish a community for the Swedenborgians. In addition to pur-

chasing over seven hundred acres for the community, which would come to be known as Bryn Athyn, John Pitcairn also set up an endowment that provided the financial help necessary to establish the Academy of the New Church and to construct a cathedral. The construction of this cathedral was to become Raymond Pitcairn's greatest inspiration (Fig. 1).

In 1912, the building of the cathedral at Bryn Athyn began.[1] Originally it was to be designed by the Boston architectural firm of Cram and Ferguson. Pitcairn soon realized that he and the chief architect, Ralph Adams Cram, had differing opinions regarding how the actual design process should be carried out. Cram preferred to do the principle design work in Boston and visit the site at Bryn Athyn only occasionally to check on the progress of the building.

But Pitcairn had been studying the writings of Arthur

Fig. 1. Raymond and Nathan Pitcairn with Bryn Athyn Cathedral in the background. (Courtesy, The Glencairn Museum)

Raymond Pitcairn began this great collection in order to create a cathedral with stained glass as luminous and inspiring as any Gothic masterpiece and with sculpture in stone whose ornament and figures captured the imaginations of all who entered his church. Raymond Pitcairn did much more than orchestrate the creation of a cathedral magnificent enough to rival its medieval precedents; he changed the way in which medieval art, stained glass in particular, was appreciated and collected.

1. For Bryn Athyn Cathedral and the art works associated with it, see: R. Pitcairn, "Christian Art and Architecture for the New Church," *New Church Life* (Oct. 1920): 611-24; E. B. Glenn, *Bryn Athyn Cathedral, the Building of a Church* (Bryn Athyn, Pa., 1971); A.C. Gunther, *Opportunity, Challenge, and Privilege* (n.p., 1973); J. Hayward and W. Cahn, *Radiance and Reflection: Medieval Art from the Raymond Pitcairn Collection* (New York, 1982); and M. Pryke, *A Quest for Perfection: The Story of the Making of the Stained-glass Windows in the Bryn Athyn Cathedral and Glencairn* (Bryn Athyn, Pa., 1990).
2. Hayward and Cahn, *Radiance and Reflection*, 33-38.
3. Pryke, *A Quest for Perfection*, 20-21.
4. Hayward and Cahn, *Radiance and Reflection*, 229.
5. *Collection of a Well Known Connoisseur, A Noteworthy Gathering of Gothic and Other Ancient Art Collected by the Late Mr. Henry C. Lawrence of New York* (New York, 1921).
6. Raymond Pitcairn to Winifred Hyatt, Jan. 24, 1921, Glencairn Archives, The Glencairn Museum, Bryn Athyn, Pa.
7. T. E. Norton, *100 Years of Collecting in North America: the Story of Sotheby Parke-Bernet* (New York, 1984), 221.
8. W. Towner, *The Elegant Auctioneers* (New York, 1970), 320-24.
9. Norton, *100 Years of Collecting in North America*, 221.
10. *Corpus Vitrearum Checklist: Stained Glass Before 1700 in American Collections* vol. 2 (Washington, D.C., 1987), 102-47.
11. See E. B. Glenn, *Glencairn: The Story of a Home* (Bryn Athyn, Pa., 1990).

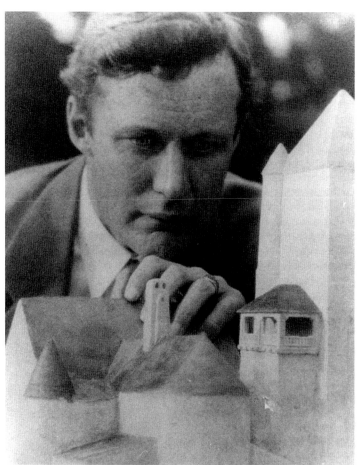

Fig. 2. Raymond Pitcairn with a model of Glencairn. (Courtesy, The Glencairn Museum)

element of the new cathedral should approximate medieval prototypes as closely as possible.

The building of the Cathedral of the Church of the New Jerusalem sparked in him an interest in Gothic and Romanesque stained glass and sculpture that would last a lifetime. Even after taking seven years to complete the cathedral, Pitcairn had not tired of building in the medieval style. In the early 1920s, he decided that he needed a "little castle" to house his collection of art, and thus, began building Glencairn, his Romanesque style home (Fig. 2).[11] Today Glencairn serves as a museum to house the artifacts collected by Pitcairn, and from its hilltop perch it overlooks the majestic cathedral that inspired the great collection housed within its thick stone walls. (Color plate p. 16).

Public Museums in the East:
The Case of Boston

Kathryn McClintock

The medieval collection at the Boston Museum of Fine Arts developed in a markedly different fashion from the collection at the Metropolitan Museum of Art in New York after the turn of the century.[1] The Metropolitan received a multimillion-dollar bequest from Jacob Rogers in 1901 that was used to increase that museum's holdings of medieval art, while the financial situation at the Museum of Fine Arts was strained due to the cost of the new building on Huntington Avenue, which opened in 1909. The directorship at the Metropolitan under J.P. Morgan had also weakened the power of the board of trustees, and decisions concerning acquisitions were increasingly the reponsibility of professionally trained curators. At Boston, on the other hand, the trustees remained strong, and purchases of objects from the Middle Ages often reflected consensus rather than the predilections or expertise of a single individual. Moreover, the Museum of Fine Arts did not have a specialist in medieval art on staff until 1939, a weakness acknowledged as early as 1919.[2] These conditions, however, did not prevent the museum from making a number of astute acquisitions between 1920 and 1940, particularly in the areas of monumental painting and sculpture.

Prior to World War I, the Boston Museum of Fine Arts already possessed an established collection of textiles, and one of its earliest purchases had been a sixteenth–century Flemish tapestry of the *Destruction of the Egyptians in the Red Sea* in 1895 (BMFA 95.1). Denman Waldo Ross enhanced the textile collection through gifts, which included medieval Italian embroideries, beginning in 1890, and after his election to the board of trustees five years later, his donations increased dramatically.[3] The collection of medieval fabrics, especially late Gothic tapestries, continued to grow through gifts and loans; many were displayed in the Tapestry Gallery that opened in 1915 and was arranged in the manner of a great baronial hall. By the end of the 1920s, medieval silks and brocades were also being added to the collection through purchase.

The museum also had a representative sampling of Italian Primitives at an early date, having first received a panel of the *Nativity*, first attributed to the School of Giotto, from the Boston Athenaeum in 1876.[4] Six years later, Martin Brimmer, the museum's president, donated a fourteenth–century Sienese altarpiece of the *Dormition and Assumption of the Virgin*.[5] Occasional gifts of early Italian panels followed thereafter, but the construction of the Evans wing of painting galleries (opened in 1915) seems to have inspired a flurry of beneficence on the part of Mrs. Walter Scott Fitz. An active donor and mother of trustee

and future director (and president), Edward Jackson Holmes, Mrs. Fitz gave an octagonal panel of the *Madonna and Child* by Fra Angelico in 1914, hailed by Denman Ross as a quintessential representation of the spirit of the Middle Ages (BMFA 14.416):

> It is particularly interesting that we should have in our Museum a picture in which the period of the Middle Ages is so beautifully summed up for us,—its Theology, its religious fervor, its vision of things unseen, its love of Order, its sense of Beauty, its unsurpassed craftsmanship. It is just such pictures as this that we want in our Museum,—pictures marking great moments in the History of Art. Many pictures are not needed, only a few of the best, the most significant and the most beautiful. A small collection of masterpieces is infinitely more instructive than a mile of paintings which stand, indiscriminately, for everybody and everything.[6]

A year later Mrs. Fitz provided four thousand dollars for the purchase of three Italian Primitives that were immediately installed in the new galleries; she also contributed additional early Italian panels in 1916.[7] Her gifts significantly increased the museum's holdings of medieval paintings and seems to have forestalled the need of the museum to direct its limited resources towards purchases in this important area. Instead, when the museum began to acquire medieval art in quantity, it purchased stone sculpture to fill the gap left by the retirement of the museum's collection of plaster casts.

J. Randolph Coolidge, Jr., temporary director of the museum, decried the lack of both medieval and modern sculpture in 1906:

> In sculpture, Mediaeval and Modern, the possessions of the Museum are lamentably few, and many of them of indifferent quality. The Museum needs enrichment in sculpture regardless of origin. Considering the increasing popularity of monumental sculpture, and the position of American sculptors to-day compared with those of any other country it is strange that the Museum, rich in ancient sculpture, should be truly poor in examples of sculpture of the past 1800 years.[8]

The situation was remedied to some extent by the establishment of the Department of Western Art (Other Collections) and its attendant Visiting Committee in 1906, chaired by the director's cousin, J. Templeman Coolidge, Jr. The Visiting Committees promoted the best interests of the museum and provided assistance to their respective departments; this seems to have been translated, in part, into raising funds for the acquisition of works of art. The Western Art Visiting Committee directed a significant proportion of its earliest resources toward the purchase of Gothic sculpture, and provided funds for two thirteenth-century French columns with capitals, a thirteenth-century Mosan wooden statue of the Virgin and Child, and a fifteenth-century French statue of the Virgin and Child (BMFA 12.1171–1174).[9]

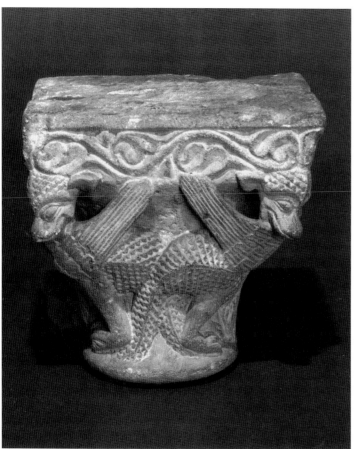

Fig. 1. Capital, French, 13th century. Stone. (Courtesy, Museum of Fine Arts, Boston)

made comparable purchases less likely in the future:

> The opportunities of the last fifty years have enabled us to secure collections of permanent value, and similar opportunities cannot recur to the same extent. The two great sources on which museums have drawn, private collections and excavation, are becoming exhausted. High prices paid for works of art in recent years are fundamentally based on the gradually lessening supply coming into the market. The duty of the Museum to future generations means first, that the great art of the past must be preserved; not that it must be preserved unseen, but that it must be exhibited with primary consideration of its safety. It means, secondly, that additions to the collections should be made not so much for present effect on our public today as for an enduring effect—today and during generations to come. In other words, the limited funds at our disposal should be spent for objects which we believe to be of the finest quality, and therefore of the most lasting value.[11]

This emphasis on selective acquisition is clearly evident in the purchases of art from the Middle Ages by the Museum of Fine Arts over the next two decades.

The museum's interest in medieval sculpture may have encouraged George Grey Barnard to consider the Boston Museum of Fine Arts a potential buyer for a portion of his collection in 1918:

> I have decided to offer at a strictly private sale, the gothic collection bought by me from the "Demotte collection" in Paris. This collection of some ninety Saints, Virgins, bas reliefs and other sculptures in stone and wood, was selected by me from four hundred and sixty objects of the "Demotte collection" sold because of the extreme war pressure in France.
> I have carefully divided the ninety objects in groups of eight to twelve pieces in each group. These groups will not be broken. . . .
> The price of each group is $20,000. This collection forms no part of my permanent cloister collection. I regret that it cannot.[12]

J. Templeman Coolidge, Jr., also made donations as an individual, and his private gifts were similar to those funded by the Visiting Committee. He gave two late Gothic, freestanding sculptures of St. Catherine (BMFA 17.329 & 17.348), as well as several pieces of thirteenth-century French architectural sculpture, including a capital from Toulouse (Fig. 1).[10] The efforts of the Boston Museum of Fine Arts to build a collection of medieval sculpture were also supported by loans and gifts from other patrons, and a preference for French Gothic work is apparent in both the purchases and gifts of this period. In 1918, the museum opened the Gothic Room for the display of these newly acquired works.

The availability of such a quantity of French medieval sculpture was partly the result of the damage and economic conditions created by World War I. The museum's director, however, acknowledged that rising prices and shrinking supplies of museum-quality art, in general,

The Boston Museum of Fine Arts did not avail itself of this opportunity, but instead purchased a fourteenth-century monumental statue of the Virgin and Child directly from Demotte (BMFA 19.37). Barnard remained hopeful that he might interest the trustees in some of his collection, however, and continued to present the museum with various options. In 1924, he offered a portion of the cloisters of St.-Michel-de-Cuxa for sale and went so far as to donate a foliate capital from Cuxa to the museum (BMFA 24.156). The museum chose not to purchase the other sculpture from Cuxa, but did acquire a fourteenth-century retable from Barnard that was said to come from Pau, France (BMFA 24.149).[13] J. Templeman Coolidge, Jr., was consulted about the display of the retable and responded:

> Thank you for writing me about the Barnard altar & inviting me to join you in finding a place for it. I saw it in New York on the 27th March, & was glad to hear from Mr. Barnard that we had secured it. He still has some very beautiful things—much finer than I had ever suspected.

In 1925, Barnard again approached the Boston Museum of Fine Arts, this time proposing the sale of his entire Cloisters. Edwin James Hipkiss, keeper in the Department of Western Art, preferred his evaluation and considered the prices high.[15] He also reportedly felt "that this collection contains a number of good things and a number of not particularly good ones," and for his department did not "want sculpture so much as architectural details, capitals, columns, and window traceries."[16] Before any decision could be made concerning individual objects in the collection, John D. Rockefeller, Jr., secured the Cloisters for the Metropolitan Museum of Art in New York.

Although the acquisition of medieval sculpture seems to have been of primary concern at this time, the museum also made several noteworthy purchases of painting from the Middle Ages in the 1920s. The museum's collection of medieval paintings had previously been dominated by Italian Primitives, although the collection included a fifteenth-century Spanish *Coronation of the Virgin*, given by Denman W. Ross in 1910 (BMFA 10.36). Eleven years later, the museum added another Spanish medieval painting through the purchase of a detached fresco of Christ in Majesty from Santa Maria de Mur in Catalonia (BMFA 21.1285).

Prior to the pioneering work of Spanish art historians, Josep Puig y Cadalfach and José Pijoan, few had known of the Romanesque frescoes adorning the walls of remote Catalan churches, but in 1907, the publication of *Les pintures murales catalans* revealed these previously hidden treasures. The art world, ever watchful for newly uncovered masterpieces, took notice. The dealer I. Pollak bought the apsidal fresco at Santa Maria de Mur and hired a team of Italian experts, under the supervision of Franco Steffanoni, to detach it for transport out of the country.[17] The mural was eventually shipped to New York where it was purchased by the Boston Museum of Fine Arts and installed in a specially built chapel in the Evans wing. The surreptitious removal of the fresco from Santa Maria de Mur created a furor in Spain, and the government took immediate steps to prevent further foreign exploitation of the Romanesque frescoes in Catalonia by instituting a program for their removal to the Museo de la Ciudadela in Barcelona.

Arthur Kingsley Porter, Harvard's expert on Romanesque art, had been consulted on the purchase of the mural from Santa Maria de Mur, but his evaluation was reported to have been less than enthusiastic.[18] The impetus for the purchase seems to have come rather from Charles Henry Hawes, the museum's assistant director.[19] An Englishman educated at Cambridge University and former professor of anthropology at Dartmouth College, Hawes wrote a scholarly article on the Spanish mural in which he proudly described it as "the only fresco of its kind in the country."[20]

Six years later, the Museum of Fine Arts acquired two twelfth-century Castilian frescoes from San Baudelio de Berlanga which were installed in the Chapel with the Catalan mural. The Fogg Art Museum had also been interested in these detached frescoes for its already formidable collection of Romanesque art, but the cost of the entire series proved prohibitive. The Museum of Fine Arts was able to secure only two of the frescoes for its collection after the dealer agreed to sell the murals individually.[21]

Just as the construction of the Evans wing had stimulated interest in the acquisition of medieval painting, the addition of the wing for the decorative arts also had affected the purchases of monumental art from the Middle Ages. In 1925 and 1926, the museum bought a number of examples of medieval stained glass, including twenty-eight panels of fragments as well as a fifteenth-century Apostles' Window from Herefordshire (BMFA 25.13). When the Decorative Arts wing opened in 1928, the three lancets of the Apostles Window were installed in "a small gallery suggesting a private chapel" and set "in stonework made from measured drawings of the original tracery."[22]

The museum also acquired a twelfth-century sculpted portal from San Miguel de Uncastillo which came highly recommended by both A. Kingsley Porter and Paul J. Sachs, associate director of the Fogg Art Museum (Fig. 2). The director of the Museum of Fine Arts was also supportive and considered the opportunity unique: "My own feeling is that here is a good example of Romanesque, complete and imposing, and that the chance of getting such either from France or Spain will most probably not occur after November 1st."[23] His words proved prophetic. While the Boston Museum of Fine Arts was successful in securing its Spanish portal, the Fogg Art Museum's own negotiations for a sculpted doorway from Carraceda were disrupted by the Paris dealer, Georges Demotte.[24]

The Museum of Fine Arts also explored the possibility of purchasing a French Romanesque portal as evidenced by a letter from Edwin Hipkiss to the director:

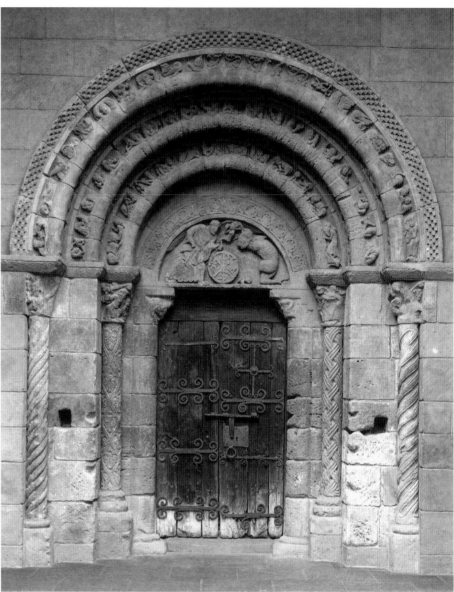

We drove 25 or 30 kms. to a small village near Melle on the road to Poitiers. There I saw a most sorry ruin with four capitals, a badly damaged, small doorway and a simple rose window. The political gentleman who spoke a little English was most involved in his ideas of business but summed up, we were to make an offer for purchasing the entire ruin, removing it from the site and there he would treat with the village people who owned it.

There is nothing in it that we need especially. I went to Saintes in a rented Ford car and so I had an opportunity to see all the Romanesque churches en route. I gained much by way of comparison and details and felt all the more sure of both our installation and the excellence of our own portal.[25]

The recently purchased and newly arranged medieval objects in the Decorative Arts wing, which opened in 1928, seems to have inspired donations from private collectors as well (Fig. 3). Walter Gay wrote to the director that "since seeing the beautiful Gothic room in the Museum, I would like to make a contribution to it from my own collection" and proceeded to donate three sculpted reliefs, including two late Gothic English alabasters from Nottingham (BMFA 29.1024–1025).[26] Gay's reliefs joined another fifteenth-century alabaster of the Holy Trinity (BMFA 27.852),

192

which had been purchased from the collection of Frank Gair Macomber, a local collector of medieval armor and former honorary curator of the Department of Western Art (Other Collections).

While the Museum of Fine Arts made strides in the acquisition of monumental art from the Middle Ages, the minor arts had been almost completely ignored since the initial reception of several gifts in the nineteenth century. The museum directed its attention to the minor arts, however, when the Rütschi Collection was offered for sale in 1931. The evaluation by Hipkiss was most positive:

> The Alfred Rütschi Collection of ecclesiastical objects of the Romanesque, Gothic and Renaissance periods is to be sold at auction in Lucerne on September 5, 1931.
>
> This in my opinion is the most important collection, within its scope, that has appeared on sale within my knowledge.
>
> It contains many fine objects much needed to strengthen our small collection of the arts of the Middle Ages. At the Metropolitan the Morgan Collection is world famous, and we unfortunately have about half a dozen objects of no great merit.[27]

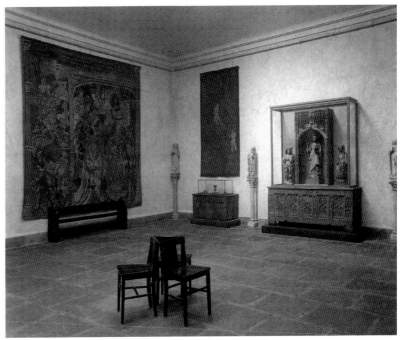

Fig. 3. Gothic Room, 1928. (Courtesy, Museum of Fine Art, Boston)

Opinion was divided, though, and Denman Ross considered the objects offered for sale "very expensive things, I should let them pass. Some very poor in proportion. I regard them as luxuries."[28]

Hipkiss garnered additional support from Frank G. Macomber who:

> admires the collection and asks me to quote him as saying that while we shall not find perhaps the 'supreme examples of the world' there, they are very fine in style and workmanship, judging from the illustrations, and he believes that purchases would be wise and helpful toward improving our Gothic and Romanesque collections. He points out many items that one might expect to see in a great museum like the M. F. A. and they are not here and not easily acquired.[29]

Inquiries were made regarding the collection and particular interest was shown in several medieval ivory book panels and pieces of Limoges enamelwork. The museum ultimately declined to bid, however, because there was no suitable representative to corroborate Germain Seligman's assessment of the objects, and "we were taking too much risk at so great a distance."[30]

Less uncertainty surrounded two medieval ivories that were acquired by the museum a few years later, both of which possessed established credentials. The Italian plaque of the Crucifixion, purchased in 1934, had been part of the world-famous Trivulzio collection in Milan and was also

published in the corpus of Byzantine ivories written by Adolph Goldschmidt and Kurt Weitzmann (BMFA 34.1462).[31] The other panel from the Spanish Romanesque reliquary of San Millán de la Cogolla was the missing half of a plaque in the National Museum of Florence, and it was undoubtedly purchased with the knowledge that Porter had tried to secure it for the Fogg Art Museum (BMFA 36.626).[32]

For years, the Museum of Fine Arts had relied on advice from the local art and academic communities, as well as the consensus of the trustees, when purchasing art from the Middle Ages and had built a respectable, if not outstanding, collection. It became increasingly apparent, however, that a specialist was needed if the medieval collection were ever to develop a first-class reputation.

In 1939, the museum appointed Georg Swarzenski (1876–1957) as Fellow for Research in Sculpture and Mediaeval Art and almost immediately, he began to purchase works with the full financial support and backing of the administration. The following year, Swarzenski mounted a comprehensive exhibition of medieval art entitled "Arts of the Middle Ages 1000–1400" that featured not only the works of private collectors and public institutions, but also objects available from the leading dealers.[33] Acquisitions continued apace, and in 1948, Swarzenski was

joined in his efforts by his son, Hanns. Together they built the medieval collection at the Museum of Fine Arts into the third largest in the United States with particularly outstanding representations of enamel- and metalwork. With the arrival of the Swarzenskis, the medieval collection at Boston finally assumed it rightful place among the leading American public institutions of art.

1. The early years of the Museum of Fine Arts are discussed in J. de Wolfe Addison, *The Boston Museum of Fine Arts* (Boston, 1910); B. I. Gilman, *Museum of Fine Arts Boston 1870–1920* (Boston, 1920); "The Museum of Fine Arts and the Boston Ethos," *Apollo* 90 (Dec. 1969): 457–65; and N. Burt, *Palaces for the People: A Social History of the American Art Museum* (Boston, 1977). The most complete history remains W. M. Whitehill, *Museum of Fine Arts Boston: A Centennial History*, 2 vols. (Cambridge, Mass., 1970). For the Metropolitan Museum of Art, see A. H. Mayor, "The Gifts that Made the Museum," *Bulletin of the Metropolitan Museum of Art* 16 (Nov. 1957): 85–107; and C. Tomkins, *Merchants and Masterpieces: The Story of the Metropolitan Museum of Art*, rev. ed. (New York, 1970; New York, 1989).

2. "While I believe the Museum has reason to be proud of its Staff, at several points it is still inadequate. We have no Curator, or Keeper who is an authority on mediaeval or renaissance art. . . ." A. Fairbanks, "Report of the Director," *Boston Museum of Fine Arts Annual Report* 44 (1919): 76. Quoted in Whitehill, *Museum of Fine Arts Boston*, vol. 1, 387.

3. The influence of Denman W. Ross (1853–1935) at the Boston Museum of Fine Arts is difficult to overestimate. As an undergraduate at Harvard, he had heard Charles Eliot Norton's lectures on the fine arts and studied medieval history under Henry Adams, receiving his Ph.D. in 1880. A skilled artist, Ross taught courses on the theory of design at Harvard and wrote a number of books on the subject. He was also a masterful collector of Near Eastern and Asian art, though few fields escaped his keen eye. Both the Museum of Fine Arts and the Fogg Art Museum received thousands of objects of various media from him over the years. In addition to his early gifts of textiles, Ross also donated a significant amount of Venetian Gothic ironwork to the Museum of Fine Arts between 1887 and 1896 and until his death in 1935, was a pivotal figure in the museum's acquisitions. On his extensive donations, see A. W. Karnaghan, "The Ross Collection," *Boston Museum of Fine Arts Bulletin* 30 (Feb. 1932): 8–21.

4. Formerly Athenaeum 46. The panel had been bought by Charles Folsom in 1846 from the Boston auction house of Howe and Leonard for $1.25 before being given to the Boston Athenaeum. It was sold in 1977 and is now in the Thyssen-Bornemisza Collection. I wish to thank Michael Wentworth, Curator of the Boston Athenaeum, for information regarding this panel. See also O. Sirén, "Trecento Pictures in American Collections," *Burlington Magazine* 14 (Nov. 1908): 125, pl. 2; and L. B. Kanter, *Italian Paintings in the Museum of Fine Arts Boston*, vol. 1 (Boston, 1994), fig. 1.

5. BMFA 83.175a,b&c. The triptych is now attributed to Niccoló de Ser Sozzo and Francesco Neri da Volterra. See Kanter, *Italian Paintings in the Museum of Fine Arts Boston*, 101-3, no. 19.

6. Denman W. Ross files, Denman W. Ross to the editor of the [*Boston*] *Transcript*, [1914], Archives, Museum of Fine Arts, Boston.

7. For a contemporary discussion of the museum's collection of Italian panel paintings, see O. Sirén, "Some Early Italian Paintings in the Museum Collection," *Boston Museum of Fine Arts Bulletin* 14 (Feb. 1916): 11–15.

8. J. R. Coolidge, Jr., "Report of the Committee on the Museum," *Boston Museum of Fine Arts Annual Report* 31 (1906): 47.

9. F. V. Paull, "Division of Western Art Other Collections," *Boston Museum of Fine Arts Annual Report* 37 (1912): 117, 135. The following year, the Visiting Committee also purchased a spurious "fifteenth-century French" tomb slab (BMFA 13.585).

10. BMFA 19.68. The Museum of Fine Arts also received a similar capital from the estate of Hervey Wetzel which had been on loan at the museum since 1917 (BMFA 19.645). Both were purchased from the dealer Dikran Kelekian. See W. Cahn and L. Seidel, *Romanesque Sculpture in American Collections*, vol. 1 (New York, 1979), 102-4, figs. 101-2.

11. A. Fairbanks, "Report of the Director," *Boston Museum of Fine Arts Annual Report* 46 (1921): 99–100. Quoted in Whitehill, *Museum of Fine Arts Boston*, vol. 1, 400.

12. George G. Barnard file, George G. Barnard to the Museum of Fine Arts, Boston, Dec. 5, 1918, Archives, Museum of Fine Arts, Boston.

13. C. H. H[awes], "French Gothic Altarpiece," *Boston Museum of Fine Arts Bulletin* 22 (June 1924): 21. It has subsequently been reattributed to Anglesola, Spain, where a fragment still existed in 1926. See D. Gillerman, *Gothic Sculpture in America I. The New England Museums* (New York, 1989), 107–8, no. 77. The misidentification of Spanish work as French was not uncommon in this period because French Gothic sculpture commanded higher prices. The museum had previously purchased three early sixteenth-century alabaster statuettes of saints said to be from Amiens, that have since been reattributed to Burgos (BMFA 18.316–318).

14. J. Templeman Coolidge file, J. Templeman Coolidge to Arthur Fairbanks, Apr. 9, 1924, Archives, Museum of Fine Arts, Boston.

15. Hipkiss, an architect with a special interest in American colonial art, had been hired as keeper in the Department of Western Art in 1919. Seven years later, the Department of Western Art became the Department of Decorative Arts of Europe and America and Hipkiss was named curator.

16. George G. Barnard file, memo, Mar. 31, 1925, Archives, Museum of Fine Arts, Boston.

17. X. Barral i Altet et al., *Prefiguración del Museu Nacional d'Art de Catalunya* (Barcelona, 1992), 50.

18. Denman W. Ross files, [Edward J. Holmes] to Denman W. Ross, Oct. 5, 1927, Archives, Museum of Fine Arts, Boston.

19. Whitehill, *Museum of Fine Arts Boston*, vol. 1, 416.

20. C. H. H[awes], "A Catalonian Fresco of the Twelfth Century," *Boston Museum of Fine Arts Bulletin* 21 (June 1923): 32–40.

21. BMFA 27.785ab–786. The frescoes of the Last Supper and the Three Marys at the Sepulchre from San Baudelio are now exhibited in the museum's Romanesque Room, which opened in 1995. See C. H. H[awes], "Two Twelfth Century Frescoes from the Hermitage Church of San Baudelio de Berlargo, Spain," *Boston Museum of Fine Arts Bulletin* 26 (Feb. 1928): 6-11, figs. 7-8; and *The Art of Medieval Spain A.D. 500–1200* (New York, 1993), 223-28, nos. 103d&e.

22. A. W. K[arnagnan], "The New Wing for Decorative Arts of Europe and America," *Boston Museum of Fine Arts Bulletin* 26 (Dec. 1928): 96.

23. Denman W. Ross files, [Edward J. Holmes] to Denman W. Ross, Oct. 5, 1927, Archives, Museum of Fine Arts, Boston.

24. See K. McClintock, "Academic Collecting at Harvard," above.

25. Department of Decorative Arts files, Edwin J. Hipkiss to Charles H. Hawes, May 16, 1930, Archives, Museum of Fine Arts, Boston.

26. Walter Gay file, Walter Gay to Edward J. Holmes, June 2, 1929, Archives, Museum of Fine Arts, Boston.

27. Department of Decorative Arts files, Edwin J. Hipkiss to Edward J. Holmes, July 24, 1931, Archives, Museum of Fine Arts, Boston.

28. Department of Decorative Arts files, memo from Denman W. Ross, July 28, 1931, Archives, Museum of Fine Arts, Boston.

29. Department of Decorative Arts files, Edwin J. Hipkiss to Edward J. Holmes, Aug. 3, 1931, Archives, Museum of Fine Arts, Boston.

30. Department of the Decorative Arts files, note from Edwin J. Hipkiss to Charles H. Hawes, [n.d.], Archives, Museum of Fine Arts, Boston.

31. A. Goldschmidt and K. Weitzmann, *Die Byzantinischen Elfenbeinskulpturen des X.-XII. Jahrhunderts* (Berlin, 1934), abb. 220. See also E. J. Hipkiss, "A Carved Ivory Plaque," *Boston Museum of Fine Arts Bulletin* 33 (Apr. 1935): 20–21.

32. E. J. Hipkiss, "A Spanish Romanesque Ivory," *Boston Museum of Fine Arts Bulletin* 35 (Feb. 1937): 10–11; and *The Art of Medieval Spain*, 264-65, no. 125f.

33. See K. McClintock, "'Arts of the Middle Ages' and the Swarzenskis," below.

William M. Millken and Medieval Art

Heather McCune Bruhn

*W*illiam Mathewson Milliken, who served as director of the Cleveland Museum of Art from 1930 to 1958, played an important role in the transition of medieval art collecting from private enthusiasts to public institutions.[1] His purchases of medieval works—particularly objects from the Guelph Treasure—helped to raise the Cleveland Museum of Art to international importance and bring medieval art to the attention of American museums and museum goers alike (Fig. 1).

William M. Milliken was born in 1889 and grew up in Stamford, Connecticut. He entered Princeton University in the class of 1911, but his graduation was postponed until the following March due to illness.[2] Milliken spent his summer vacations from the university traveling throughout Europe, and particularly England, visiting great cathedrals and museums.[3] He also began to study the history of art and architecture in his last two years at Princeton. Upon his graduation, Milliken attempted to follow in his father's footsteps and pursued a career as a textile merchant. In 1914, he discontinued his unsuccessful business and accepted an unpaid position in the cataloguing department at the Metropolitan Museum of Art in New York, a post he had declined two years earlier at his graduation. This assignment lasted six months, at which point he was made an assistant in the Department of Decorative Arts under its curator Dr. Valentiner, who was absent from the museum, having returned to Germany at the outbreak of the war. William Milliken was finally promoted to Assistant Curator of Decorative Arts in 1916.

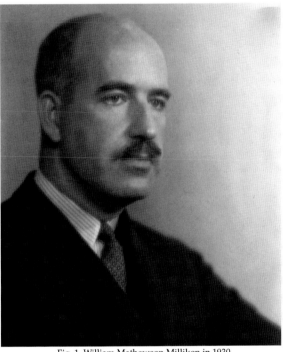

Fig. 1. William Mathewson Milliken in 1930.
(The Cleveland Museum of Art)

Milliken's work at the Metropolitan, particularly his work with objects acquired by the great collector J. Pierpont Morgan, had enormous impact upon his tastes in art. In 1914, while Milliken was working in the Department of Decorative Arts, the Morgan Loan Show opened at the Metropolitan and stayed on exhibit until 1916. The Loan Show contained all of Morgan's minor arts collection, which included hundreds of examples of medieval metalwork. In 1916, J.P. Morgan, Jr., presented these objects to the Metropolitan. The Morgan loan show put Milliken into contact with an unequalled collection of medieval and Renaissance objects. Sherman E. Lee, in an article celebrating Milliken's eighty-fifth birthday, stated that this contact with Morgan's collection had an "ineradicable and profound impression on the young and dedicated connoisseur." Lee also compared Morgan's and Milliken's love of precious materials and objects "whose workmanship surpassed the material," with that of Abbot Suger of St.-Denis.[4]

When the United States entered World War I in 1917, Milliken enlisted. He was commissioned a second lieutenant in the Air Service as a ground officer, and served in England and the United States. When he was discharged at the end of the war on Christmas Eve, 1918, Milliken was unable to resume work at the Metropolitan because his former position was no longer available. He applied for and was awarded the job of Curator of Decorative Arts at the Cleveland Museum of Art and began work there on February 1, 1919.

Milliken's first article for Cleveland, "French Gothic Sculpture in the Museum," appeared in the January-February 1919 *Bulletin of the Cleveland Museum of Art*. Several of the pieces illustrated were purchased in 1919, possibly with the involvement of Milliken, because they represent a new type of acquisition for the museum. Therefore, it seems likely that he worked with his new department at the Cleveland Museum of Art before he officially assumed the curatorship on February 1, 1919.

During his first few years as Curator of Decorative Arts, Milliken's medieval purchases for the Cleveland Museum of Art were relatively minor. Then, in 1922, he purchased the small German ivory plaques from a portable altar (CMA 22.307-309) from New York dealer Emile Rey. Milliken later described his first view of the ivories:

Mr. Rey showed a series of four reliefs in morse ivory—ivory from the tusk of a walrus—the material as such, [was] unfamiliar. The pieces were immensely intriguing. Monumental in scale, even if tiny in size, the Christ in the Mandorla could have been enlarged and would have graced the tympanum of a great cathedral. What was the basis on which to judge them? Was there a criterion?

Many years before, with not the faintest idea that life would ever be passed in museums, my family and I were crossing the ocean. A conversation of my mother and two older brothers with the then Director of the Metropolitan Museum of Art, Sir Casper Purdon Clark, turned on the joys and trials of collecting. Sir Casper said something which supplied that criterion. "There are three kinds of objects to buy; those of which you are sure at first sight; those about which you have a moment of doubt; and those which seem possibly wrong. Buy only in the first category and then check with every means in your power to be sure that you are right. . . ."

These morse ivories had overwhelmed me. I had a veritable Überraschung, a word which expresses perfectly the emotion when a work of art sweeps you off your feet. The ivories did that in no uncertain fashion. Somehow they must come to Cleveland[5]

While Milliken negotiated the sale, Jeptha Homer Wade II, who became president of the museum in 1920, traveled to New York to ascertain the worth of the ivories in question.[6] Wade compared the pieces Milliken was buying to similar ones in the Metropolitan Museum of Art and was so impressed that he purchased them and presented the ivories to the Cleveland Museum as a gift.

When J.H. Wade purchased the German ivories for the museum, he used money from his newly created trust fund. The fund, established in 1920, was to be used by the Cleveland Museum of Art to acquire "European and American paintings, rugs, embroideries, brocades, laces, jewelry, and artistic objects in gold, silver and enamel." Purchases from the fund were subject to Wade's approval. He added to this fund during his life and at his death in 1926 its value was close to $1.3 million. He also gave $200,000 as a challenge to encourage others to support the museum.[7]

Wade was involved with the Cleveland Museum of Art long before his presidency and the establishment of his trust fund. In 1892, Wade gave land for the museum to the city of Cleveland for Christmas. He gave many of his own treasures to the museum—even before the museum was incorporated—and with his wife gave thirty-four of their best paintings to fill gallery space for the Cleveland Museum of Art's inaugural exhibition in 1916.

Milliken and Wade teamed up on several medieval acquisitions with Milliken supplying the inspiration for purchases and Wade providing the capital. (It was not unusual for Wade to support the acquisition of medieval works of art; he was particularly interested in fine metalwork and precious objects, as demonstrated by the terms of his trust fund.) In 1923, Milliken and Wade collaborated on the acquisition of the spectacular Spitzer Cross (CMA 23.1051), a Limoges enamel from around 1190. The silver-gilt and enamel table fountain (CMA 24.859), found in the gardens of a palace in Constantinople, followed in 1924. It had been rejected by the Louvre because the Paris dealer who offered it for sale had not removed it from "the remains of the ball of earth which had so miraculously preserved it," causing questions about how the piece would look when cleaned. Milliken, however, took the risk and arranged the purchase of this unique piece, which is considered one of the most remarkable in the Cleveland collection.[8] In 1925, Cleveland's acquisition of the world famous Strogonoff ivory plaque (CMA 25.1293) prompted Paul J. Sachs, director of the Fogg Art Museum at Harvard to write: "it is a triumph for all concerned. Every serious student and every lover of truly great things must now visit The Cleveland Museum of Art if only to see this one object."[9]

In 1923, Milliken wrote to Wade about scholarly reactions to Cleveland's medieval purchases:

Mr. Demotte . . . said that the quality of our little case of ivories and enamels was such that if we continued to develop that with small things of this type we would have a vitrine of remarkable quality. . . .

I have just come back from New York and was interested while there to have the people at the Metropolitan Museum, Prof. Allan Marquand, Prof. Frank Jewett Mather, Jr., and Mr. Morey at Princeton say "I hear you are acquiring some wonderful ivories at The Cleveland Museum of Art."[10]

J.H. Wade, for his part, clearly appreciated his collaboration with Milliken, as demonstrated by this letter from December 11, 1925:

It is very difficult to judge the real quality of many antiquities from a photo, however good it may be. Some of the purchases you have advocated in the past have seemed unduly expensive judged from their photos, but when received, I think in every case they have more than justified your judgment, and I want to take this opportunity to tell you how much I appreciate the opportunities you have furnished to provide so many rare and precious objects for the museum.[11]

Jeptha Homer Wade II passed away in 1926, but this did not put an end to Milliken's medieval purchases. In fact, Cleveland's greatest medieval acquisition was made during the Great Depression. The nine Guelph Treasure objects purchased by Milliken required "a very considerable sum . . . far larger than had ever been appropriated for purchase before," to be taken from the John Huntington Art and Polytechnic Trust.[12] So much money came out of the

Huntington Trust (the largest of the three bequests that developed into the Cleveland Museum of Art) that it was not used again for acquisitions until 1946, and thereafter was used only sparingly.[13]

In 1930, the Duke of Brunswick put the Guelph Treasure up for sale.[14] The treasure was the greatest heirloom of the House of Brunswick-Lüneburg, and by 1930 comprised eighty-five precious ecclesiastical objects, including ecclesiastical plate, reliquaries, and crucifixes. Milliken made the first major purchase from the treasure for Cleveland. Milliken persuaded museum trustees to give him moneys from the Huntington Trust and other funds, despite the fact that several of the trustees felt the treasures to be too good for Cleveland. In his autobiography, *Born Under the Sign of Libra*, Milliken writes, "It was argued that [the treasure was] beyond the appreciation and understanding of the general public for whom the Museum had been built." Milliken's solution to this problem, "I did the only thing I could do. I went back to them and cried."[15] Soon after this purchase, Milliken was appointed director of the museum.

The six Guelph Treasure pieces that Milliken bought are magnificent examples of medieval art and craftsmanship. Stephen N. Fliegel, curator of Early Western Art at Cleveland, counts them "among the finest pieces in the treasure."[16] They range from the tiny eighth-century Cumberland Medallion (CMA 30.504), which depicts Christ in cloisonné enamel and gold on copper, to the fourteenth-century Monstrance with the Paten of St. Bernward (CMA 30.505), which contains a fragment of the True Cross. The director of the Städelsche Kunstinstitut in Frankfurt finalized the deal with Milliken, "Weeping with one eye, laughing with the other."[17] Milliken immediately capitalized on the publicity the Cleveland Museum of Art would receive from his purchase:

> I have told Swarzenski, Stocklet and several others so news may begin to leak out. I think that it should when all Europe is coming to see these things; one Sunday they had to stop selling tickets because of the crowd. The name of our Museum and the importance of its collections would thus get a chance of being known widely. We are the first purchasers. That in itself is a news item of greatest importance.[18]

During the Guelph Treasure's visit to the United States in 1930-31, Milliken acquired more pieces for the Cleveland Museum of Art: the Gertrudis Altar (CMA 31.462), two ceremonial crosses (CMA 31.461 and CMA 31.55), and a fifteenth-century architectural monstrance (CMA 31.65). The acquisition of the expensive Gertrudis Altar necessitated the exchange of one of Cleveland's earlier Guelph purchases—a thirteenth-century German portable altar bearing a twelfth-century Byzantine framed plaque.[19] Mrs. E.B. Greene of Cleveland, who with her family traveled with Milliken on the same steamer to Europe when Milliken first went to see the treasure, contributed towards the purchase of the Ceremonial Cross of Countess Gertrude.[20] According to Milliken, the newly purchased Guelph Treasure pieces meant "a tremendous increase in prestige."[21] Eric Maclagan, director of the Victoria & Albert Museum wrote to Milliken regarding the quality of his purchase, saying: ". . . I have often said to people on this side, that I regard your Museum as our most dangerous rival. . . . I must congratulate you most heartily on the purchases from the Guelph Treasure"[22]

Milliken's visionary purchases of medieval art for the Cleveland Museum of Art during the 1920s and early 1930s, culminating with the purchase of the Guelph Treasure objects, helped not only to increase the status of his museum, but also to give medieval art more prominence in American museums. At Cleveland, he established a collection of unquestionable quality, in keeping with his decision to favor quality over quantity. Although Milliken's experience with J. Pierpont Morgan's collection undoubtedly influenced his taste for small, intricately worked precious objects, Milliken's own unique instinct and insight led him to identify and acquire some of the finest medieval pieces available. Milliken relied upon experience from his travels, his classes, conversations with scholars and collectors, and above all, upon his own emotional response to objects when he evaluated possible acquisitions for the museum. His ability to successfully communicate this emotional response to museum trustees gave Milliken access to museum funds for his purchases. Stephen Fliegel's statement regarding the Guelph Treasure objects can easily be used to characterize all of Milliken's collecting: "[The selection] testifies to the connoisseurship and erudition of William Milliken that he would have recognized instantaneously the importance of these objects; and to be able to identify among the finest pieces in the treasure is certainly good fortune for Cleveland."[23]

1. S. E. Lee and W. D. Wixom, "In Memoriam, William Mathewson Milliken 1889-1978," *Bulletin of the Cleveland Museum of Art* 65 (Apr. 1978): 110.
2. H. Hawley, "Directorship of William M. Milliken," *Object Lessons: Cleveland Creates an Art Museum*, ed. E. H. Turner (Cleveland, 1991), 101–2.
3. W. M. Milliken, *Born Under the Sign of Libra: An Autobiography* (Cleveland, 1977); and W. M. Milliken, *A Time Remembered: A Cleveland Memoir* (Cleveland, 1975).
4. S. E. Lee, "William Mathewson Milliken on his 85th Year," *Bulletin of the Cleveland Museum of Art* 61 (Dec. 1974): 319–20.
5. Quoted in Hawley, "Directorship of Milliken," 121. Hawley does not reveal the source of Milliken's comments.
6. E. H. Turner, "Overview: 1917-30," *Object Lessons: Cleveland Creates an Art*

Museum (Cleveland, 1991), 19.

7. Ibid., 60.

8. Hawley, "Directorship of Milliken," 103.

9. Quoted in Turner, "Overview 1917–30," 21.

10. W. M. Milliken to J. H. Wade II, Jan. 24, 1923, F. A. W. I. papers folder 134, Archives of the Cleveland Museum of Art.

11. J. H. Wade II to W. M. Milliken, Dec. 11, 1925, F. A. W. I. papers folder 134, Archives of the Cleveland Museum of Art.

12. E. H. Turner, "Overview: 1930-45," *Object Lessons: Cleveland Creates an Art Museum* (Cleveland, 1991), 89.

13. Ibid., 83.

14. G. V. Kelly, "Ancient Guelph Treasure is Won by Art Museum: Religious Objects Collected by German Kings, Part of $10,000,000 Coming Here," *Cleveland Plain Dealer*, Aug. 26, 1930, Clipping file, Archives of the Cleveland Museum of Art.

15. Quoted in J. B. Wilder, "Führer Outflanked for Guelph Gold," *Northern Ohio Live* (Dec. 1994): 16.

16. Quoted in Wilder, "Führer Outflanked," 16.

17. German proverb, *Weinend mit einem Auge, lachend mit den andern*. Quoted in Wilder, "Führer Outflanked," 16.

18. W. M. Milliken to Rossiter Howard, Aug. 8, 1930, Exhibition files: 1931 Guelph Treasure, Archives of the Cleveland Museum of Art.

19. W. Milliken, "The Acquisition of Six Objects from the Guelph Treasure for the Cleveland Museum of Art," *Bulletin of the Cleveland Museum of Art*, 17 (Nov. 1930): 169; and Registrar's files 31.462 and 2222.30, Cleveland Museum of Art.

20. Registrar's file 31.55, Cleveland Museum of Art.

21. Milliken to Rossiter Howard, Aug. 8, 1930, William M. Milliken papers, Archives of the Cleveland Museum of Art. Quoted in Hawley, "Directorship of Milliken," 109.

22. William M. Milliken to John D. Rockefeller, Jr., Nov. 21, 1930, in which he quotes a letter from Eric Maclagan, Exhibition files: 1931 Guelph Treasure, Archives of the Cleveland Museum of Art.

23. Quoted in Wilder, "Führer Outflanked," 16.

The Guelph Treasure: The Traveling Exhibition and Purchases by Major American Museums

Heather McCune Bruhn

At the end of the first World War, Ernst August II of the House of Brunswick-Lüneburg, Duke of Hanover, found himself with many impoverished relatives, servants, and retainers on his hands.[1] In 1923, he tried to secure the Guelph Fund, money owed to the House of Hanover by the Prussian government as compensation for the annexation of Saxony in 1867. At the same time, the duke indicated that he intended to sell his family's greatest heirloom, the Guelph Treasure.[2] He was "reported to have said that he must raise money by the sale of the treasure or dismiss some of the former court officials and stop the pensions of others."[3] During the negotiations, the duke agreed not to sell the Guelph Treasure if the Guelph Fund was indeed made available to him. The government, unable to raise the money, offered to give the nearby Castle of Marienburg to the duke. Ernst August II continued to negotiate the sale of at least part of the treasure. In January 1930, the provincial administrator of Hanover arranged for the duke to sell the treasure at a special price—equivalent at that time to $2.5 million—in an attempt to keep the treasure in Germany. The municipal council of Hanover, the Prussian Diet, and the German government were supposed to purchase the treasure, but the poor economic climate of the depression prevented this sale.[4] Therefore, eighty-two of the eighty-five Guelph Treasure objects were placed into the hands of dealers in 1930. Julius F. Goldschmidt headed the consortium of dealers, which also included Z.M. Hackenbrock, J. Rosenbaum, and Rosenbaum's nephew, Saemy Rosenburg.

Details of the Guelph sale were kept secret, but this did not prevent the press from printing speculations. The duke, they said, attempted to have the treasure sold in its entirety for $10 million, but "no one agency could be found to pay this price."[5] A price cut, authorized by the duke (who still exercised control over the Guelph Treasure), may have brought the price down to $5 million.[6] According to William M. Milliken, "Rumor has it that the duke invested the proceeds in cinema stocks and lost it all." He continues, "I have no documentary proof of this."[7]

The pieces that form the original nucleus of the Guelph Treasure were dedicated between 1030 and 1038 by Countess Gertrude I and her husband, Count Bruno Liudolf, ruler of the earldom of Brunswick, to a collegiate church that they had founded not far from their castle. Most of these pieces were dedicated in 1038 when Liudolf was entombed at the church. (Countess Gertrude was later buried here.)[8] Several generations later, Gertrude III of the Brunons married Henry the Proud of the Guelphs in the early twelfth century, uniting the two families. In 1172,

their son, Duke Henry the Lion of Brunswick, returned from the Crusades with relics and devotional objects to add to his family's rich collection.[9] Several new reliquaries were made to house relics that the duke brought back from the Holy Land.[10] According to popular belief, one of these was a fragment of the True Cross, which is now contained in the paten of St. Bernward. Henry the Lion is also named as donor on two arm reliquaries and was probably the donor of the cupola reliquary, which contained the head of St. Gregory of Nazianzus, a relic that the duke brought back from Constantinople.[11] At his death in 1195, Duke Henry the Lion left the treasure to his son, Emperor Otto IV of Germany.[12] By this time, the treasure included reliquaries, portable altars, ecclesiastical plate, and other sacred vessels. The earliest piece in the Guelph Treasure is the Cumberland Medallion, a late eighth-century work in gold and cloisonné enamel, but the provenance of this piece is unknown.

At the death of Otto IV in 1218, the Guelph Treasure was moved from the old Basilica of St. Blasius to the new Cathedral of St. Blasius in Brunswick, which had been built by Duke Henry the Lion. It remained there for five hundred years. During the thirteenth, fourteenth, and fifteenth centuries, objects were added that surpassed the "nucleus" of the Guelph Treasure in number but rarely overshadowed its artistic importance. The Dukes of Brunswick took the treasure into their own castles after the Reformation, when the Cathedral of Brunswick became Protestant but the family remained Catholic. In 1671, Duke John Frederick of Hanover came to the rescue of his cousin, the Duke of Brunswick, during a citizens' revolt and demanded the Guelph Treasure as compensation. Duke John Frederick then presented the treasure to the Cathedral of the Castle of Hanover.[13] In 1803, the Guelph Treasure was moved temporarily to England because of the threat of a French invasion, but was returned to Hanover in 1867 when it became the private possession of the king. There was a brief exhibition of the Guelph Treasure at this time in Vienna. It was then moved back and forth between several locations before being placed into Swiss bank vaults by the Duke of Brunswick and Cumberland, son of the King of Hanover, in 1918. This move was made in expectation of the sale of the Guelph Treasure. At this time, after thefts and other losses that may have occurred over the centuries, the Guelph Treasure contained eighty-five pieces.

Four art dealers, headed by Julius F. Goldschmidt, purchased the Guelph Treasure from the Duke of Brunswick in 1929. It is possible the dealers did not actually purchase the treasure but merely acted as agents for the duke.

Goldschmidt and his associates, Saemy Rosenberg, J. Rosenbaum, and Z.M. Hackenbroch, put the treasure up for auction, first exhibiting it at the Städelsche Kunstinstitut in Frankfurt and later in Berlin. The Berlin sale was held at a private club, the Deutsche Gesellschaft, and was a much quieter affair than the Frankfurt sale—the German government demanded that the treasure be shown in relative secrecy in order "not to facilitate action that might be conducive to the loss of the treasure for Germany."[14] When it became clear that the expensive treasure could not be sold as a whole, the contents of the Guelph Treasure were sold individually.

Despite Germany's obvious interest in keeping the Guelph Treasure in the country, there were no major offers from German buyers (just a few minor pieces were sold to private collectors). William M. Milliken, soon to become the new director of the Cleveland Museum of Art, made the first major purchase while traveling with his mother on their annual trip to Europe.[15] On July 7, 1930, Milliken wrote to Julius Goldschmidt in Frankfurt relaying his travel plans, asking to be allowed to see the treasure and requesting that Goldschmidt send him a copy of Otto von Falke's book on the Guelph Treasure.[16] Milliken wrote acting director Rossiter Howard at the Cleveland Museum of Art a month later, exulting: ". . . we were able to make a killing and had the first pick and made the first purchase . . . It is incredible and if I only had two million dollars instead of 200,000 we could have made the Cleveland Museum immediately world renowned. As it is this will mean a tremendous increase in prestige. Six pieces from the Guelph Treasure!!! . . . We are the first purchasers. That in itself is a news item of greatest importance."[17]

Milliken's purchase hit the press in the United States like a storm, with reporters vying with one another to obtain exclusive and accurate stories. The cost of the Guelph pieces was kept confidential, but this did not stop the press from speculating. *Cleveland Press* reporter Robert Bordner wrote, "My private guess is that the figure is somewhere about $150,000, knowing that about $100,000 was paid a few years ago for the big tapestry of St. George and the dragon."[18] In addition to the price, the religious significance of the Guelph pieces drew a lot of attention. Cleveland's Guelph pieces were displayed in the museum just a month after their purchase in Germany.

That fall, Julius Goldschmidt and his syndicate brought the Guelph Treasure to the United States. The art dealers probably hoped Milliken's enthusiasm would be typical of prospective American purchasers. The newly created Goldschmidt and Reinhardt Galleries in New York were the first to show the treasure, from November 30, 1930, through the end of the year. Four trustees from the Cleveland Museum of Art, John L. Severance, Francis F. Prentiss, William G. Mather, and Leonard C. Hanna, Jr., took Cleveland's Guelph objects by train to New York after they had "only been shown for six weeks in Cleveland."[19] J.P. Morgan, Randolph Hearst, Clarence H. MacKay, Michael Friedman, Philip Lehman, and Jules S. Bache, along with the four Cleveland Trustees, made up the honorary committee for the New York exhibition. Milliken, now director of the Cleveland Museum of Art, delivered the opening day address at the exhibit.

Between January 10 and February 1, 1931, the Guelph Treasure was shown as a whole in Cleveland at the Museum of Art (Fig. 1). Attendance at the show broke all previous records for the museum. Over 2,500 people came to the opening reception, which required invitations, and the following day's attendance was between 8,000 and 11,000 people.[20] In less than a month, the Cleveland Museum of Art recorded 74,894 visitors, with Milliken delivering a total of 21 lectures to more than 6,500 people.[21] During the Cleveland exhibition, Milliken convinced museum trustees to make another Guelph Treasure purchase. Milliken wrote Frederick A. Whiting, his predecessor as director, "I may tell you in confidence that the Museum has made a further purchase from the Guelph Treasure . . . It is the great golden Portable Altar and the two Crosses given by the Countess Gertrude to the Cathedral of St. Blasius about the year 1040. This group ranks, in my mind, as the greatest of the collection."[22] The purchase of the expensive Gertrudis Altar necessitated the exchange of one of Cleveland's earlier Guelph purchases— a thirteenth-century German portable altar bearing a twelfth-century Byzantine framed plaque.[23] Julius Goldschmidt and his associates donated the fifteenth-century gilt silver and crystal architectural monstrance with a relic of St. Sebastian as a gesture of appreciation for Cleveland's patronage and "in memory of the Exhibition . . . held in the Cleveland Museum of Art . . .," which brought the number of Guelph pieces in Cleveland up to nine.[24] At this point, the Cleveland Museum of Art decided not to allow its treasury pieces to travel to the other exhibition venues because ". . . the Trustees feel that they have no right at the present moment to deprive the public of the view of the pieces," which had been shown in Cleveland only for a short time and in the face of great public interest.[25] Only the Pennsylvania Museum of Art was allowed to exhibit the three Gertrudis pieces.[26]

Fig. 1 Clevelanders lining up to view the Guelph Treasure exhibition on Jan. 11, 1931, at the Cleveland Museum of Art. At right are the dealers who brought the treasure to the United States, from l. to r.: Sammy Rosenberg (hands in pockets), Julius F. Goldschmidt (bald), and Z.M. Hackenbroch (left hand in pocket). (The Cleveland Museum of Art)

The Guelph Treasure Exhibition then traveled to the Detroit Institute of Arts, where it was exhibited without the nine Cleveland pieces, from February 10–25, 1931. Next it traveled to the Pennsylvania Museum of Art (March 16–23), the Art Institute of Chicago (March 31 to April 20) and finally to the M.H. de Young Memorial Museum in San Francisco, where the forty-two pieces remaining in the Guelph Treasure were exhibited from December 1 to 31, 1931.

Several American museums, in addition to the Cleveland Museum of Art, acquired pieces from the Guelph Treasure when it was exhibited in the United States. None of these purchases emulated Milliken's acquisition of early Guelph pieces for Cleveland. Except for the Fogg Art Museum's twelfth-century ivory, the pieces purchased by other American institutions are all from the fourteenth and fifteenth centuries. The Art Institute of Chicago ended up with eight pieces: the Antiquarian Society of the Art Institute of Chicago (under the direction of Mrs. Chauncey McCormick) purchased a fourteenth-century Altar Cross (Cat. 70); Kate S. Buckingham bought three monstrances; and Chauncey McCormick acquired four reliquaries.[27] All of these pieces were eventually given to the Chicago museum. Harvard University's Fogg Art Museum purchased the Casket in Tower Form, a Siculo-Arabic ivory. The Pennsylvania Museum of Art, now the Philadelphia Museum of Art, acquired two pieces, while the Nelson-Atkins Museum of Art in Kansas City purchased the Monstrance with a Finger of St. John the Baptist (Cat. 71)

and a Reliquary Cross.

The Guelph Treasure sale and exhibition had a tremendous impact upon medieval art collections in the United States. According to Milliken, the Guelph Treasure purchase made by his institution in 1930 brought the Cleveland Museum of Art instant international respect.[28] The fact that "among the objects comprising the eighty-two items which form the treasure are individual pieces which rank as the foundation stones for all study of Mediaeval and German art . . ." doubtless prompted museums and individuals who normally collected other types of objects to acquire Guelph Treasure pieces.[29] For example, the Nelson-Atkins Museum of Art did not have a substantial medieval collection at the time that it acquired its two pieces from the treasure. Mr. and Mrs. Chauncey McCormick of Chicago, whose art collection seems to have consisted mainly of mid-nineteenth-century silhouettes and some sixteenth- to eighteenth -century decorative arts, purchased five Guelph pieces (one of these for the Antiquarian Society).[30] The McCormicks, no doubt, recognized the great artistic importance of the treasure despite their tendency to purchase much later pieces. Kate Buckingham, who purchased three monstrances from the treasure, collected a wide variety of objects, including Chinese pottery and bronzes, Japanese prints, Italian silver, and English lusterware.[31]

The events surrounding the sale of the Guelph Treasure also attracted a great deal of attention, which meant that the museums that exhibited the treasure experienced, in

some cases, record crowds. According to *Cleveland Plain Dealer* reporter Grace V. Kelly, it was not just the high price or the richness of the treasures that attracted attention. Many came to the exhibition to pay homage to the relics of the saints and of the True Cross. "There were those who leaned above the objects so that one could fairly feel the prayer within their thoughts."[32] Milliken, who can be credited with bringing the treasure to the United States, best defined the impact of the Guelph Treasure: "[It] has caught the imagination of America. No single art event has ever attracted such universal attention. It is as if the cathedrals of Hildesheim or Bamberg, Mainz or Limburg had been transported to our shore."[33]

1. The titles "Duke of Hanover" and "Duke of Brunswick" are used interchangeably in literature concerning the Duke, because he is the son of the King of Hanover and Duke of Brunswick and Cumberland. F. H. Taylor, "Notes on the Guelph Treasure," *Parnassus* 2 (Dec. 1930): 24. See also W. M. Milliken, letter of Jan. 20, 1960, Registrar's file 30.504, Cleveland Museum of Art.

2. P. M. De Winter, *The Sacral Treasure of the Guelphs* (Cleveland and Bloomington, Ind., 1985), 132.

3. G. V. Kelly, "Ancient Guelph Treasure is Won by Art Museum: Religious Objects Collected by German Kings, Part of $10,000,000 Coming Here," *Cleveland Plain Dealer*, Aug. 26, 1930, Clipping file, Archives of the Cleveland Museum of Art.

4. De Winter, *Sacral Treasure*, 132-33. Also see R. Bordner, "Germany's Loss is Cleveland's Gain", *Cleveland Press*, Oct. 11, 1930; and "Guelph Relics Shipped For Exhibition Here: German Collection To Be Resold After Display Next Month," *New York Herald Tribune*, Oct. 18, 1930, Clipping file, Archives of the Cleveland Museum of Art.

5. "Art Treasures for Museum," *Celina, Ohio Standard*, Aug. 26, 1930, Clipping file, Archives of the Cleveland Museum of Art.

6. J. B. Wilder, "Führer Outflanked for Guelph Gold," *Northern Ohio Live* (Dec. 1994): 16. "Guelph Art Gems Go on Exhibition Here Tomorrow: 82 Works by Craftsmen of the 8th to 15th Centuries Valued at $5,000,000: Pieces Bought in Germany: Show Will Aid Catholic, Jewish, Protestant Big Sisters," *New York Herald Tribune*, Nov. 29, 1930, Clipping file, Archives of the Cleveland Museum of Art.

7. W. M. Milliken, letter of Jan. 20, 1960, Registrar's file 30.504, Cleveland Museum of Art.

8. "Exhibition of the Guelph Treasure," *Bulletin of the Art Institute of Chicago* 25 (Apr. 1931): 50; W. M. Milliken, "The Guelph Treasure in Cleveland," *American-German Review* (Dec. 1955-Jan. 1956): 5, 6; and De Winter, *Sacral Treasure*, 28. The identity of Gertrude is clarified in W. M. Milliken, "The Acquisition of Six Objects from the Guelph Treasure for the Cleveland Museum of Art," *Bulletin of the Cleveland Museum of Art* 17 (Nov. 1930): 164; and D. W. Warner, "The Guelph Treasure," *Cleveland Club Woman* (Jan. 1931): 5.

9. "Cleveland to have some of the Famous Guelph Treasure Pieces," *Cleveland News*, Jan. 11, 1931; and "Guelph Treasures, 82 in Number, Seen Here," *Art Digest* (Nov. 1, 1930): 13. Duke Henry the Lion's lineage is discussed in H. Welshimer, "America's Four Relics of the Cross," *Cleveland Plain Dealer*, Apr. 5, 1931, 13.

10. The Duke received most of the relics from the Eastern Emperor in Constantinople who, "feeling himself rather shaky on his throne, wished to conciliate Henry. . . ." (Warner, "Guelph Treasure," 5). According to De Winter, Duke Henry the Lion was "presented with fourteen mules loaded with gold and silver and silken vestments by the Byzantine Emperor Manuel Comnenus" as Henry returned from Palestine. Although he expressed his "immense thanks," the Duke indicated that he preferred to receive holy relics of certain saints. The Emperor complied, and Duke Henry triumphantly returned to Brunswick the following year bearing relics and precious objects. De Winter, *Sacral Treasure*, 55-56; and W. M. Milliken, "The Guelph Treasure," *American Magazine of Art* 22 (Mar. 1931): 165.

11. Cleveland Museum of Art, *The Guelph Treasure: Catalogue of the Exhibit* (Cleveland, 1931), 3.

12. "Guelph Art Pieces Coming to America: Cleveland Museum Buys Six Articles of Famous Medieval Treasure in Germany; 'St. Blaise's Horn' Included; Elaborate Paten of St. Bernward and Portraitive Altar Also Are Among 11th Century Relics," *New York Times*, Aug. 27, 1930, Clipping file, Archives of the Cleveland Museum of Art.

13. "Guelph Treasure Sold by Duke of Brunswick: J. and S. Goldschmidt and Associates Buy Unique Collection of XIth to XIVth Century Art," *Art News* (Jan. 18, 1930): 3, 13.

14. Quoted in Wilder, "Führer Outflanked," 16; and De Winter, *Sacral Treasure*, 133. Neither gives a specific reference for this quote.

15. "Imports Costly Art For Museum: Milliken Arrives in New York with Goldsmith's Work of 8th Century," *Cleveland Plain Dealer*, Oct. 8, 1930. Milliken's trip to Europe with his mother was an annual occurrence, according to a conversation with Virginia Krumholtz, director of the Archives of the Cleveland Museum of Art, July 23, 1995.

16. W. M. Milliken to Julius Goldschmidt, July 7, 1930, Exhibition file [no. 200]: 1931 Guelph Treasure, Archives of the Cleveland Museum of Art.

17. W. M. Milliken to Rossiter Howard, Aug. 8, 1930, Exhibition files: 1931 Guelph Treasure, Archives of the Cleveland Museum of Art. The price is discussed in H. Hawley, "Directorship of William M. Milliken," *Object Lessons: Cleveland Builds an Art Museum*, ed. E. H. Turner (Cleveland, 1991), 109.

18. R. Bordner, "Art World Gets Ready for Season: New Treasures to be Shipped Soon from Europe; Other News," *Cleveland Press*, Aug. 6, 1930.

19. W. M. Milliken to William R. Valentiner, Jan. 22, 1931, Exhibition files: 1931 Guelph Treasure, Archives of the Cleveland Museum of Art.

20. W. M. Milliken to Edwin D. Barry, Jan. 7, 1931, and I. T. Frary to Paul M. Rea, Feb. 2, 1931, Exhibition files: 1931 Guelph Treasure, Archives of the Cleveland Museum of Art.

21. W. M. Milliken to F. A. Whiting, [n.d.], Acquisition files: 1931 Guelph Treasure, Archives of the Cleveland Museum of Art.

22. W. M. Milliken to Frederick A. Whiting, Jan. 21, 1931, Exhibition files: 1931 Guelph Treasure, Archives of the Cleveland Museum of Art.

23. Milliken, "Acquisition of Six Objects," 169; and Registrar's files 31.462 and 2222.30, Cleveland Museum of Art.

24. Registrar's file 31.65, Cleveland Museum of Art.

25. W. M. Milliken to William R. Valentiner, Jan. 22, 1931, Exhibition files: 1931 Guelph Treasure, Archives of the Cleveland Museum of Art.

26. W. M. Milliken to Mrs. Chauncey McCormick, Mar. 5, 1931, Exhibition files: 1931 Guelph Treasure, Archives of the Cleveland Museum of Art.

27. Julius F. Goldschmidt to Bessie Bennett, Apr. 13, 1931, and Apr. 17, 1931, Guelph Treasure, Archives of the Art Institute of Chicago.

28. W. M. Milliken to John D. Rockefeller, Jr., New York, Nov. 21, 1930; and Milliken to Mrs. Chauncey McCormick, Mar. 5, 1931, Exhibition files: 1931 Guelph Treasure, Archives of the Cleveland Museum of Art.

29. W. M. Milliken, "The Guelph Treasure," *American Magazine of Art* 22 (Mar. 1931): 163.

30. File: Mrs. Chauncey McCormick, Department of European Decorative Arts and Sculpture and Classical Art, The Art Institute of Chicago.

31. "Miss Buckingham, Patron of Arts: Member of an Early Chicago Family Gave City Fountain Costing $1,000,000: Made Gifts to Institute: Planned Memorial Statue to Alexander Hamilton—Dies at Age of 79," *New York Times*, Dec. 15, 1937.

32. Quoted in Wilder, "Führer Outflanked," 17.

33. W. M. Milliken, "The Guelph Treasure," *American Magazine of Art* 22 (Mar. 1931): 163.

"Arts of the Middle Ages" and the Swarzenskis

Kathryn McClintock

The Guelph Treasure Travel Exhibition of 1930–1931 brought the heirlooms of a European aristocratic family to the United States. Nine years later, "Arts of the Middle Ages 1000–1400" at the Boston Museum of Fine Arts presented the medieval treasures acquired by American collectors to their fellow citizens. The Guelph Treasure had been limited almost exclusively to ecclesiastical metalwork, but "Arts of the Middle Ages" provided a comprehensive survey of objects of various materials from the Romanesque and High Gothic periods. Byzantine works were also on exhibit, but were included primarily for their influence on artistic developments in Western European art; an exhibition at the Worcester Museum in 1937, "The Dark Ages," had already dealt extensively with Byzantine and early medieval art.

Panel paintings and sculpture were displayed with enamelwork and textiles, and secular items took their places alongside liturgical objects (Fig. 1). But unlike the loan

exhibition at the Philadelphia Museum of Art in 1931, organized to set off the period rooms in the newly installed medieval wing, "Arts of the Middle Ages" emphasized the craftsmanship reflected in individual works. The skills of the stonemason, leather worker, bronze caster, and tapestry weaver were there for all to see for "the effect in [medieval] art was to produce objects of superb craftsmanship, of the highest functional value, of absolute, unquestioning honesty in conception."[1] The show lacked only the jewel-like creations of the stained-glass makers, deemed too difficult to exhibit in proper fashion.[2] But more than merely paying homage to medieval craftsmanship, "Arts of the Middle Ages" was also a testament to the taste of several generations of American collectors.

The exhibition was organized by Georg Swarzenski (1876–1957), a leading medieval scholar and museum administrator of international repute. His extensive publications included monographs on German Romanesque manuscript illumination, Nicola Pisano, and fifteenth-cen-

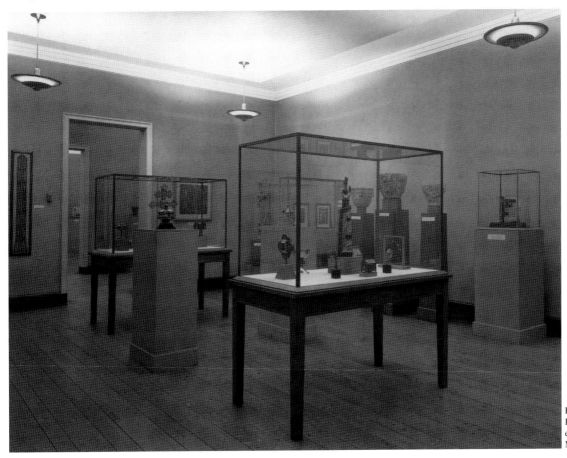

Fig. 1. One of the Romanesque rooms in the exhibition. (Courtesy, Museum of Fine Arts, Boston)

tury German alabaster sculpture as well as co-editorship of the catalogue of the Guelph Treasure.[3] He had also written catalogues for several private collections of medieval and Renaissance art in Europe, which made him eminently suited to the task of organizing a comprehensive show devoted exclusively to medieval art.

Former director-general of the municipal museums in Frankfurt, Swarzenski had been forced to resign in 1937 during the Nazi purge of Germany's intellectual community. He then moved to America where he joined his son, Hanns, at Princeton University. He remained at the Institute for Advanced Studies at Princeton until 1939 when he was offered the position of Fellow for Research in Sculpture and Mediaeval Art at the Boston Museum of Fine Arts through the foresight of Paul J. Sachs.[4]

Swarzenski was hired to build up the collection of medieval art at the museum, and one of his first official acts was to mount a comprehensive loan exhibition. As initially conceived, the exhibition was to include medieval objects from European as well as American sources. The outbreak of World War II, however, prohibited the transportation of objects from the Continent. Fortunately, the works of art available in the United States proved sufficient for an entire show, and "Arts of the Middle Ages 1000–1400" opened to the public on February 17, 1940.

Swarzenski requested works from the leading collectors, public museums, and dealers of medieval art in America and was met with remarkable cooperation from all quarters.[5] Less than a handful of private collectors failed to lend any works, among them, Philip and Robert Lehman of New York City, Raymond Pitcairn of Bryn Athyn, Pennsylvania, and Arthur Sachs of New York and Paris.[6] The list of individuals who contributed to the exhibition was formidable, indeed, and included several of America's leading businessmen-collectors. Samuel Kress lent two panel paintings from his extensive collection of Italian art, now in the National Gallery in Washington, D.C.; George Blumenthal provided three ivories, two enamels, and a bronze candlestick destined for the Metropolitan Museum of Art in New York.

Collectors within the academic community as well as museum personnel were also well represented. A marble angel from Florence Cathedral (FAM 1957.57) came from Arthur Kingsley Porter's collection of sculpture through his widow, and Professor A.M. Friend, Jr., of Princeton University contributed two works in metal, including a corpus from a crucifix (Cat. 58). Swarzenski, a noted collec-

tor himself, also lent a number of works anonymously, including a small Limoges enamel plaque (BMFA 74.535) and a fifteenth-century alabaster bust of the Virgin (Cat. 72).[7] Edward Jackson Holmes (and his wife), former director and president of the Boston Museum of Fine Arts, also loaned objects.

Private collectors formed the largest group of lenders , and all were from the Northeast (half living in New York City). In most cases, these thirty-one individuals loaned only one or two objects, illustrating that collecting medieval art was neither the primary focus of their acquisitions nor restricted to a limited circle of connoisseurs. In addition to works of sculpture, paintings, and the minor arts, private collectors provided examples of medieval leather work, ironwork, and ceramic ware that were not available from public sources. Three women also lent works in fabric, reflecting the traditional purview of female art collectors.[8] In all, private contributions to the exhibition represented the largest range of media and technique on display.

Institutional support was equally enthusiastic, although the New York Hispanic Society and the Detroit Institute of Art declined to participate. Both the Walters Art Gallery and the Morgan Library freely lent treasures from their collections, and together were responsible for sixty percent of the illuminated manuscripts on display. Dumbarton Oaks was the major contributor of Byzantine works of art, reflecting its preeminence in that field. The Yale University Gallery of Art lent seven early Italian panel paintings from the James Jackson Jarves Collection, and the Fogg Art Museum provided four examples of Romanesque sculpture in both wood and stone as well as a thirteenth-century Spanish tomb monument. In addition, thirteen textiles from the Boston Museum of Fine Arts made up over a third of the works of fabric on display. In each case mentioned, the objects requested and lent accurately illustrated the strengths of the individual institutions.

The Metropolitan Museum of Art, however, was underrepresented in relation to its significance as the largest collection of Western medieval art in America. Only nine of the thirty-seven objects requested were loaned, and none of the Metropolitan's ivories were allowed to travel to Boston.[9] The Cleveland Museum of Art also did not permit any of its ivories to be part of the exhibition, and even the Walters Art Gallery, so generous with its manuscripts, sent only four ivories. It is likely that these museums, on the advice of their curators, were reluctant to expose their fragile and valuable ivories to possible damage. Swarzenski, however, did have greater success in securing ivories from

private collectors, and the host institution also placed three of its four medieval ivories on display.

The substantial holdings of architectural sculpture in American institutions, such as the Cloisters, the Philadelphia Museum of Art, and the Toledo Art Museum, were also unavailable for loan because they were permanently installed in period rooms. Fortunately, some sense of medieval monumental art could be experienced at the Boston Museum of Fine Arts by visiting the Romanesque portal from San Miguel de Uncastillo (BMFA 28.32), although it was not officially part of the exhibition.

As one might expect, the art dealers of New York welcomed the opportunity to showcase their wares in such a prestigious venue, and among those participating were Duveen Brothers, Inc., Dikran G. Kelekian, Raphael Stora, and Arnold Seligmann, Rey & Company, Inc. Art dealers provided a wide range of objects, including seven panel paintings, three ivories, and three wooden caskets. The single largest contributor was also the leading dealer of medieval art in America, Joseph Brummer. Swarzenski asked him for seventy-five objects and received fifty-two, primarily sculptures and metalwork. Not only did the exhibition reflect past patterns of collecting, but it also presented the best examples of medieval art currently available for purchase in the United States.

Swarzenski must have been very pleased with the support he received from the American art community. Three hundred thirty-two objects of various media and technique were made available to the viewing public and were listed in the catalogue accompanying the exhibition. Swarzenski, however, had one great personal disappointment in relation to the exhibition. He had been unable to secure the twelfth-century German gradual from the Abbey of Ottobeuren, owned by the John Carter Brown Library in Providence, Rhode Island. Swarzenski had a special scholarly interest in this work as he had written two books on medieval manuscript illumination.[10] In addition, the Brown Library gradual was the only item on the loan requests marked "***Very Important." But in spite of this and other gaps in the exhibition, the result can be deemed nothing less than a triumph for medieval art in America.

The works were displayed in five different rooms, one room given over to Byzantine artifacts, two rooms to Romanesque and two to Gothic. There was no attempt to create period rooms as had been done for the opening of the medieval wing at the Philadelphia Museum of Art in 1931, however, for the emphasis was placed on "individual works designed or executed by prominent artists."[11] Among the objects receiving special mention was the Ste.-Chapelle angel de lude from the Morgan Collection, described as "the most beautiful Gothic statue in America."[12] It was given the place of honor in the center of the main gallery (Fig. 2).

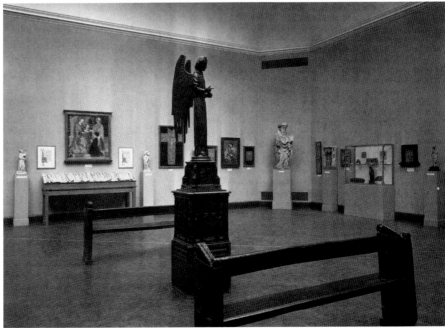

Fig. 2. The main gallery of the exhibition.
(Courtesy, Museum of Fine Arts, Boston)

"Arts of the Middle Ages" received extensive coverage in both art journals and the popular press and was considered the most important loan exhibition to be held at the Boston Museum of Fine Arts. The media spoke of the exhibition in superlative terms, and one newspaper article described it as "a voyage of genuine discovery, or re-discovery, depending on one's point of view."[13] The same article went on to say:

> Much as we are still today in the penumbra of the Renaissance it is difficult to assess this hieratic, expressionistic, volatile, and cogniscent [sic] art of the Middle Ages. Yet the impact of the easily discernible things is immediate. The richness of the imagination, the prolific use of rare materials, the exquisite choice of significant form, the obvious alliance with much of the latest developments in contemporary art, all these can be observed by the casual informed spectator.[14]

Visitors from throughout the United States came to Boston to see "Arts of the Middle Ages," and only the traveling exhibition of Miniature Period Rooms, which had been on view in Chicago and at the World Fairs of San Francisco and New York, had a larger audience.[15] As a showcase for medieval art in America, the exhibition enjoyed unparalleled success and would continue to have a profound effect long after its closing on March 24, 1940.

"Arts of the Middle Ages 1000–1400" provided a unique opportunity not only to assess the strength of other collections, but also to examine the best works then available from the art dealers in New York. It is no coincidence that almost a quarter of the objects on view were lent by dealers or that the largest single contributor was the Brummer Gallery, Inc. In organizing the exhibition, Swarzenski was not only aware of the past, but was also concerned with the future of the medieval collection at his museum.

When Swarzenski was offered the position at the Museum of Fine Arts, he had been informed that "we are especially weak in the mediaeval field and in the whole matter of European sculpture."[16] He began to rectify this situation almost immediately by purchasing a twelfth-century marble relief with Romulus and Remus (BMFA 39.747) and a limestone statue of a prophet (BMFA 39.760). These newly acquired works were exhibited in "Arts of the Middle Ages" as was a recently purchased bronze statuette of a lion (BMFA 39.608). The following year, Swarzenski bought two additional sculptures that were included in the exhibition: a stone lion from Raphael Stora (BMFA 40.784) and a marble bust of a woman from Jacob M. Heimann (BMFA 40.71). Several years later, Eugene Garbáty would donate a marble torso (BMFA 46.843) from the show to the museum, perhaps in recognition of the efforts undertaken to build the medieval collection at Boston.

The Museum of Fine Arts acquired other objects featured in "Arts of the Middle Ages," including one of the jewels of its collection, the aquamanile of Samson and the Lion (Fig. 3).[17] Almost a third of the objects at the exhibition had been enamels or metalwork, and nearly forty percent of them were currently in the possession of art dealers. Swarzenski made the acquisition of the minor arts an additional focus for the medieval collection at the Museum of Fine Arts, and ultimately bought seven examples of metalwork or enamel and an ivory arm reliquary (BMFA 49.488) from the objects Joseph Brummer supplied for "Arts of the Middle Ages."

Hanns Swarzenski joined his father at the Museum of Fine Arts in 1948 and brought a special expertise in the field of medieval metalwork, one of his classic works being *Monuments of Romanesque Art: The Art of Church Treasures in North–Western Europe* (published in 1954). No attempt was made to create a systematically complete collection, however, for the emphasis was on rare and unusual objects of exceptional quality. Hanns Swarzenski did not limit himself to the art market in America, and also visited dealers in Europe to secure the best works with relatively limited funds.

Between 1939 and 1971, the Swarzenskis were able to elevate the medieval collection of the Boston Museum of Fine Arts to the third largest in the United States with many fine examples of sculpture and metalwork (Fig. 4). As Francis Henry Taylor had written about the exhibition, "Boston has at last discovered the Middle Ages and, as Boston so often has done in the past, having finally accepted medieval art as an object worthy of its interest, it has gone about exploiting this interest with eminent, even superlative success."[18]

"Arts of the Middle Ages" was a prestigious showcase for medieval art in America and highlighted the individual work rather than the "ensemble" or period room. By 1940, the display of medieval art in a picturesque environment evocative of George Grey Barnard's Cloisters was becoming passé because the objects of the Middle Ages were seen increasingly as objects worthy of the treatment afforded masterpieces from other periods. The sale of the Joseph Brummer's collection (first to the Metropolitan Museum of Art in 1947 and then to the general public in 1949) would further intensify this concept by the sheer quantity and quality of the works available.

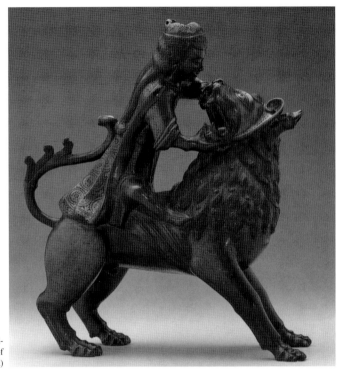

Fig. 3. Aquamanile, Germany, Hildesheim(?), mid-13th–early 14th century, leaded latten. (Museum of Fine Arts, Boston, Benjamin Shelton Fund)

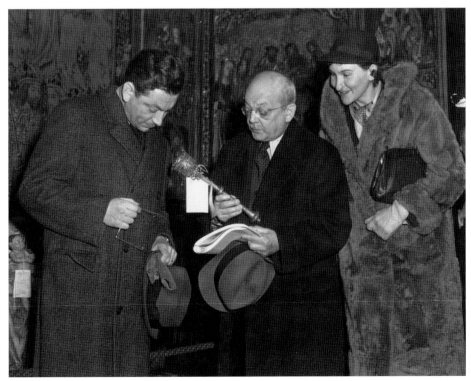

Fig. 4. Hanns and Georg Swarzenski at the Hearst Sale, 1941. (Courtesy, Musuem of Fine Arts, Boston)

1. "Boston Museum Opens Magnificent Exhibition of Mediaeval Art," *Art Digest* 14 (Feb. 15, 1940): 6.

2. G. Swarzenski, "Arts of the Middle Ages," *Boston Museum of Fine Arts Bulletin* 38 (Feb. 1940): 5. Visitors to the exhibition, however, could see a fif-teenth-century stained-glass window from Herefordshire (BMFA 25.213) in the Decorative Arts wing of the museum.

3. *The Guelph Treasure: the Sacred Relics of Brunswick Cathedral formerly in the Possession of the Ducal House of Brunswick–Luneburg*, eds. O. von Falke, R. Schmidt, and G. Swarzenski, trans. S. M. Welsh (Frankfurt-am-Main, 1930).

4. Sachs was not only the assistant director of the Fogg Art Museum, but was also a trustee of the Museum of Fine Arts and had arranged for Swarzenski to meet the museum's director, George H. Edgell, in Jan. 1939. Swarzenski joined the staff a month later.

5. These conclusions are based on a comparison of the catalogue "Arts of the Middle Ages" with the list of loan requests kept in the exhibition files of the Department of European Decorative Arts, Museum of Fine Arts, Boston. This list does not include paintings or textiles which were handled by other departments. Unfortunately, it appears that the documentation for the requests of textile and paintings has not been preserved.

6. Sachs did not lend his Byzantine ivory plaque because it was in Europe at the time. All but one of the objects requested from the Pitcairn Collection were currently on display at the Philadelphia Museum of Art, which did participate by loaning three pieces from its own collection.

7. Swarzenski contributed at least five other works in addition to those just mentioned: three églomisé plaques (BMFA 74.481–3) and bronze statuettes of a lion and a bridled horse. The statuettes are now in a private collection in New York as is the alabaster bust of the Virgin. Swarzenski wrote that "the exhibition is built up exclusively of works from American collections," clearly identifying himself with his adopted homeland. See G. Swarzenski, "The Arts of the Middle Ages," *Art News* 38 (Feb. 17, 1940): 8.

8. K. D. McCarthy, *Women's Culture: American Philanthropy and Art, 1830–1930* (Chicago, 1991).

9. These numbers reflect only the requests made for sculpture, metalwork, and ivories. The Metropolitan Museum of Art also lent a linen panel and a tapestry, bringing the total number of items to eleven.

10. G. Swarzenski, *Die Regensburger Buchmalerei des X. und XI. Jahrhunderts* (Leipzig, 1900); and *Die Salzburger Malerei von der ersten Afgangen bis zur Blutezeit des Stils* (Leipzig, 1908–1913).

11. G. Swarzenski, "The Arts of the Middle Ages," *Art News* 38 (Feb. 17, 1940): 12.

12. Ibid. This free–standing bronze sculpture was sold to the Frick Collection in New York in 1943. See *The Frick Collection: An Illustrated Catalog*, vol. 4 (New York, 1970), 49–61.

13. W. G. Dooley, "Middle Ages: Spiritual, Craftsmanlike Quality of Its Great Art," *Boston Evening Transcript*, Feb. 17, 1940, 6:1.

14. For a further discussion of the association of medieval art with modern art theory, see M. Caviness, "Broadening the Definitions of Art: The Reception of Medieval Works in the Context of Post-Impressionist Movements," *Hermeneutics and Medieval Culture*, eds. P. J. Gallacher and H. Damico (Albany, N.Y., 1989): 259–82.

15. *Boston Museum of Fine Arts Annual Report* 65 (1940): 15.

16. Georg Swarzenski file, G. H. Edgell to Georg Swarzenski, Feb. 10, 1939, Archives, Museum of Fine Arts, Boston.

17. BMFA 40.233. See G. Swarzenski, "Samson Killing the Lion: A Medieval Bronze Group," *Boston Museum of Fine Arts Bulletin* 38 (Oct. 1940): 67–74. Although most of the works were purchased, two were received as gifts: a gilt wood reliquary from Stora (BMFA 40.211) and a bronze aquamanile from Garbáty (BMFA 69.1097).

18. F. H. Taylor, "The Middle Ages in Boston," *Parnassus* 12 (Mar. 1940): 5.

3

Catalogue Entries

50. Double Capital, the Feeding of the 4000; the Sacrifice of the Blood(?)

France, Hérault, St.-Pons-de-Thomières,
late 12th century
Marble, 39.3 x 50.8 x 33 cm
Fogg Art Museum, Harvard University
Art Museums,
Gift of Arthur Kingsley Porter
1922.64
Purchased by Porter from
Demotte, Paris
Ex. coll. Marty, St.-Pons

This Romanesque double capital comes from the cloister of the Benedictine abbey of St.-Pons-de-Thomières, founded by Raymond Pons, Count of Toulouse, in 936. The cloister sustained significant damage at the hands of the Huguenots in 1567 and was in complete ruin by the beginning of the nineteenth century. Local residents removed a number of capitals from the site prior to 1840, and attempts by the government to recover the sculpture then in private hands proved unsuccessful. Much of the sculpture, including this capital, was eventually acquired by art dealers who, in turn, sold it to museums in France and abroad. In addition to the significant body of sculpture from St.-Pons now in American museums, there are capitals in the Louvre and the Victoria & Albert Museum.

The surviving claustral sculpture is heterogeneous in style, iconography, material, and execution, and has been attributed to four distinct groups: the Roussillon Group (c. 1140–1155), the Languedoc Group (c. 1135–1150), the Provence Group (end of twelfth century), and the Northern France Group (c. 1230–1250). This capital has been classified with the Provence Group and is related to work at St.-Gilles-du-Gard and the chapterhouse of St.-Etienne, Toulouse. The sculptures of the Provence Group (both single and double capitals) are marked by dense compositions arranged as rows of static figures with little variation in gesture or pose and were all executed in gray or pinkish gray marble.

The subject represented on this capital has proved to be controversial. It has been identified variously as the Sacrifice of the Old Testament, the Sacrifice of the Old and New Laws, and the Sacrifice of the Blood/Feeding of the 4000 (also known as the Multiplication of the Loaves and Fishes). Most recently, an alternate interpretation has been offered: St. Pons bringing the Gospels and sacraments to the pagans.

The Fogg Art Museum received three other capitals from the same site (FAM 1922.65–67) through the generosity of Arthur Kingsley Porter. In the same year, the museum also acquired twelve capitals from Moutier-St.-Jean in Burgundy (FAM 1922.16–27). Both sets of capitals were purchased from Georges Demotte, the Parisian art dealer, who had offered them for sale as part of a larger collection in 1920. Initially, the Fogg Art Museum was interested in acquiring the complete collection, but as concerns over Demotte's trustworthiness grew, Porter only fought for the acquisition of those works (the capitals from St.-Pons and Moutier-St.-Jean) that had impeccable provenances. The purchase of these two sets of capitals marked the beginning of one of the finest public collections of Romanesque sculpture in the United States.

Arthur Kingsley Porter began his career as research professor in Harvard's Department of Fine Arts in 1920, the same year that the Fogg Art Museum purchased its first medieval

50

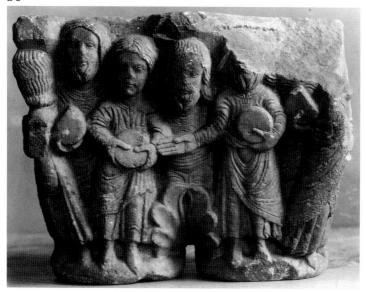

50

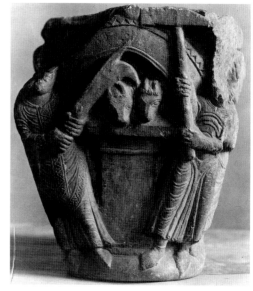

sculpture. Porter (Yale, Class of 1904) had studied architecture at Columbia University, and by the time he began to teach art history at Yale University in 1915, had already written three classic works on medieval architecture. Porter was the only American asked to survey war damage with the Service des Oeuvres d'Art dans Zones des Armeés by the French government, and was the first American scholar of medieval art to receive international recognition.

Until Porter's arrival at Harvard, the medieval collection at the Fogg had been dominated by early Italian paintings, but his scholarly interests in French and Spanish Romanesque art led to the acquisitions not only of the St.-Pons and Moutier-St.-Jean capitals, but also to a variety of twelfth-century Spanish sculpture. Although earlier American collectors, such as Isabella Stewart Gardner and George Grey Barnard, had acquired Romanesque sculpture, Porter's presence at Harvard marked the true rise of Romanesque in the United States. The creation of the Fogg's collection of Romanesque sculpture went hand in hand with developing scholarship and shaped taste as well as reflecting it. Porter's influence was not restricted to the collection at the Fogg, however, and other institutions also benefited from his expertise and advice in acquiring Romanesque art, particularly sculpture from St.-Pons. The Boston Museum of Fine Arts bought one capital, representing the Life of St.

John (BMFA 22.53), while the Fogg Art Museum presented the Dream of the Magi capital (MMA 1922.37.2) to the Metropolitan Museum of Art in New York through Felix Warburg. Several years later, more capitals from St.-Pons were offered for sale. They were purchased by the Toledo Museum of Art on Porter's recommendation, although in this instance, the capitals were sold with modern shafts and bases and presented as an ensemble (TMA 1929.203–208). The St.-Pons "arcade" was installed at the Toledo Museum of Art as part of its medieval cloisters (opened in 1933), one of the last museums to follow the pattern established by George Grey Barnard for the display of medieval art.

K McC

Literature: J. Sahuc, *L'art roman à Saint–Pons–de–Thomières*, Montpellier, 1908; A. K. Porter, "Romanesque Capitals," *Fogg Art Museum Notes* 2 (1922): 30–36; "America Acquires Romanesque Art," *International Studio* 76 (Oct. 1922): 37–39; A. K. Porter, *Romanesque Sculpture of the Pilgrimage Roads*, vol. 8, Boston, 1923, fig. 1271; R. Rey, *L'art des cloîtres romans, étude iconographique*, Toulouse, 1955, 120–23, no. 85; W. Cahn and L. Seidel, *Romanesque Sculpture in American Collections*, vol. 1, New York, 1979, 157–59, no. 17b, figs. 151, 152; R. Bergman, "Varieties of Romanesque Sculpture," *Apollo* 107 (May 1978): 18; L. A. Bussis, "Sculpture from the Church and Cloister of Saint–Pons–de Thomières," Ph.D. diss., Columbia University, 1990, 259–60, figs. 59a–d.

50

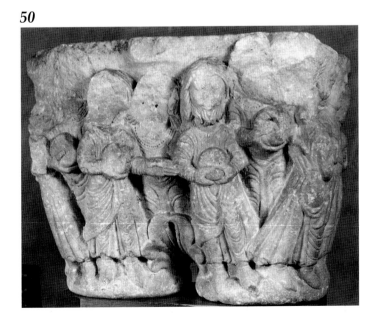

50

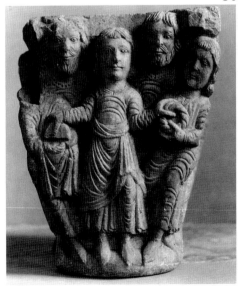

51. Capital, Scenes from the Life of Samson

France, Avignon, Notre-Dame-des-Doms, c. 1150–1175
Marble, 31.8 x 26.7 x 26.7 cm
Fogg Art Museum, Harvard University Art Museums,
Gift of Meta and Paul J. Sachs
1922.132
Ex. coll. B. d'Hendecourt, Paris; Garcin, Apt

This historiated capital has been convincingly attributed to the cloister of Notre-Dame-des-Doms, the cathedral of Avignon. On each of its four faces there is an episode from the life of Samson, the Old Testament hero: Samson wrestling the lion, Samson carrying off the Gates of Gaza, Samson and Delilah, and Samson destroying the temple of the Philistines. The figures are deeply undercut, and the drill has been used effectively to accentuate the architectural frames on three sides. The setting on the fourth face (Samson carrying off the Gates of Gaza) is not articulated and seems to have been left uncompleted. The Fogg Art Museum received a foliate capital from Notre-Dame-des-Doms (FAM 1934.15) twelve years later from Grenville L. Winthrop (Harvard, Class of 1886), a prominent art collector from New York. A third capital from the cathedral of Avignon is now in the collection of the Cloisters (MMA 47.101.24).

This capital was purchased by Paul J. Sachs (Harvard, Class of 1900), assistant director of the Fogg Art Museum (1915–1944) and a professor of fine arts at Harvard. Working in tandem with director Edward Waldo Forbes for almost thirty years, Sachs was responsible for the development of the museum into one of the country's foremost university collections of medieval art. He also initiated the America's first course on museum administration in 1921 and stressed the importance of firsthand experience with original works of art. Although primarily a collector of Old Master drawings and prints himself (he had founded the print club at Harvard as an undergraduate), Sachs also owned a number of medieval pieces which he periodically lent to the Fogg Art Museum. At the time of his death in 1965, his collection was given to the museum.

This capital as well as a twelfth-century foliate capital (FAM 1925.9.1) and a water spout (FAM 1925.9.2) from Moutier-St.-Jean seem to have been bought expressly in support of the efforts of Arthur Kingsley Porter to build the museum's holdings of Romanesque sculpture. Porter acknowledged Sachs's contributions to the Fogg's collection of medieval sculpture when he wrote for permission to photograph the capital, possibly for publication: "If you will allow me to reproduce this [Samson capital], it will be with the Moutier-Saint-Jean and the St.-Pons capitals the only Romanesque sculpture in America which I am admitting. All three lots have been bought by you."[1]

The capital with the Life of Samson was included in the exhibition, "Arts of the Middle Ages 1000–1400," organized in 1940. As one of the six Romanesque objects lent by the Fogg, it represents the preeminent role of the Fogg Art Museum in promoting Romanesque sculpture in America.

K McC

Literature: H. L. Labande, "La cathédrale de Notre Dame des Doms," *Congrès archéologique de France* 76, no. 1 (Avignon, 1909): 7–16; *Exposition des objets d'art organisée par la Marquis de Ganay*, 1913, 7, no. 10; A. K. Porter, "The Avignon Capital," *Fogg Art Museum Notes* (1923): 2–10; *Arts of the Middle Ages, a Loan Exhibition*, Boston, 1940, no. 165; *Memorial Exhibition: Works of Art from the Collection of Paul J. Sachs*, Cambridge, Mass., 1965, no. 84; S. Scher, *The Renaissance of the Twelfth Century*, Providence, R.I., 1969, 127–30, 132, no. 45; J. Thirion, "Le décor sculpté du cloître de la cathédrale d'Avignon," *Fondation Piot-Monuments et Mémoires* 61 (1977): 87–164, figs. 28–31; W. Cahn and L. Seidel, *Romanesque Sculpture in American Collections*, vol. 1, New York, 1979, 160–163, no. 18, fig. 155; R. Bergman, "Varieties of Romanesque Sculpture," *Apollo* 107 (May 1978): 20; A. Borg, "Romanesque Sculpture from the Rhône Valley to the Jordan Valley," *Crusader Art in the Twelfth Century* (BAR International Series, 152), Oxford, 1982, 97–119; N. Netzer and V. Reinburg, *Memory and the Middle Ages*, Chestnut Hill, Mass., 1995, 12, no. 8.

1. Paul J. Sachs files, Arthur Kingsley Porter to Paul J. Sachs, June 20, 1922, Harvard University Art Museums Archives.

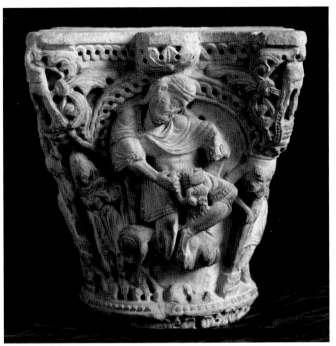

Samson and the lion.

51

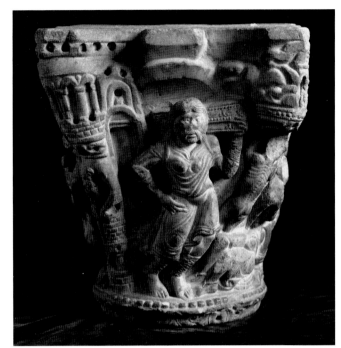

Samson carrying off the gates of Gaza.

51

Samson and Delilah.

51

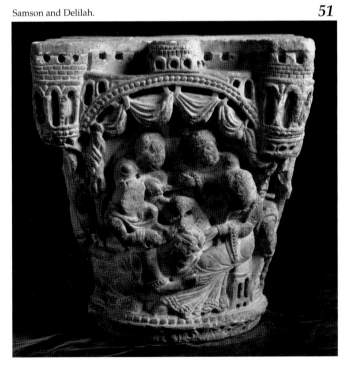

Samson destroying the house of the Philistines.

51

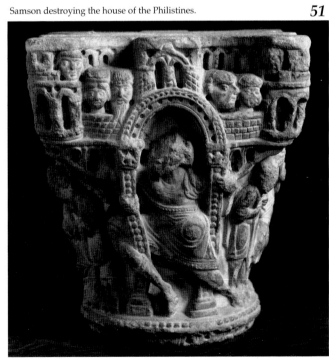

52. Cassone Panel with Beasts in Roundels

Central Italy, 13th century
Wood, 41.3 x 125.1 cm
Fogg Art Museum, Harvard University
Art Museums, Alpheus Hyatt Fund
1936.129
Purchased from L. and A. Grassi,
Florence

Color plate (p. 15)

This wooden panel is decorated with eight medallions arranged in two rows. The upper row contains two roundels with affronted birds and two with pairs of human figures. The lower row consists of four roundels with lions and griffins. The spaces between the medallions are filled with stylized leaves. This type of ornament was common on medieval textiles from the eastern Mediterranean. The use of inhabited roundels was also a popular sculptural motif taken from the classical repertory and is found on the archivolts and door frames of buildings in cosmopolitan areas, such as Venice and the coastal cities of southern Italy. The panel is said to have come from a house near Perugia, but may have been produced in any area with strong connections to the eastern Mediterranean.

There are significant losses along the upper and lower left edges of the panel. The wood is also extensively cracked and worm-eaten. The panel's surface luster is the result of a wax treatment applied to prevent further damage from insects. This conservation effort was undertaken after the panel was acquired by the museum.

A rare survival of Italian Romanesque wood carving, the panel might have been one side of a *cassone*, a chest used to store linen or other household goods. A series of holes on the upper right may have been drilled to secure a lock. Although such chests became increasingly popular in the later Middle Ages, only one other contemporary example exists, the so-called "Terracina cassone" (Palazzo Venezia, Rome). Another possibility might be that the panel is a fragment from an architectural setting like the wooden doors at Arsoli or the choir screen at Santa Maria in Valle Porclaneta, although the placement of the carved border and relative thinness of the panel would argue against it. It has also been suggested that the

panel came from a royal or ecclesiastical throne, such as the one at Montevergine, but the extreme length of the panel does not correspond to the dimensions of any existing throne.

The panel had been on display for a number of years at the Florentine gallery of dealer Luigi Grassi before Edward W. Forbes, the director of the Fogg Art Museum, offered to buy it at a reduced rate. Although Forbes liked the piece very much and wanted it for the museum, he considered other unspecified objects "more needed in our institution."[1] Apparently an accommodation was reached because the panel was acquired the following year and became part of the museum's extensive Romanesque collection.

The Fogg Art Museum lent this panel to the Boston Museum of Fine Arts for the exhibition, "Arts of the Middle Ages." Accepted at the time as an almost unique survival of Italian Romanesque secular art, the panel conformed to Swarzenski's interest in presenting rare and unusual examples of medieval art to the American public. It is also one of the few medieval objects still displayed in its original case, complete with red velvet lining. The use of such cases was a common practice in the 1920s.

K McC

Literature: P. Toesca, *Storia dell'arte italiana*, vol. 1, pt. 2, Rome, 1927, 1143; *Arts of the Middle Ages, a Loan Exhibition*, Boston, 1940, no. 308; W. R. Tyler, "An Early Italian Wooden Panel," *Bulletin of the Fogg Art Museum* 9 (Nov. 1940): 49–55, fig. 2; W. Cahn and L. Seidel, *Romanesque Sculpture in American Collections*, vol. 1, New York, 1979, 191, no. 42, fig. 200; C. V. Bornstein and P. P. Soucek, *The Meeting of Two Worlds: The Crusades and the Mediterranean Context*, Ann Arbor, Mich., 1981, 72–73, no. 47.

1. E. W. Forbes files, E. W. Forbes to Luigi Grassi, May 1, 1935, Harvard University Art Museums Archives.

52

This alabaster relief of the Coronation of the Virgin is a type of object produced in large quantities in England, especially Nottingham, in the fifteenth century for export throughout Europe. They were used in groups as panels of altarpieces and screens and individually as devotional images for private use. English alabaster is actually gypsum, a very soft medium, making it easy to carve but also easily damaged, especially by fire, which breaks it down into plaster of Paris. These reliefs were almost exclusively New Testament subjects, and the Coronation/Assumption of the Virgin was one of the most popular of these. Because of their industrialized manufacture, many alabasters have very similar compositions, although no two are ever exactly alike. It is assumed that the outlines for these compositions were drawn onto parchment or canvas and used repeatedly as a pattern.[1]

The composition of this work is almost perfectly symmetrical along a central vertical axis, the only notable exceptions being the attributes of the figures of Christ and God the Father. Christ, bare chested, blesses with his right hand, while placing the middle crown on the head of the Virgin. God the Father places the lowest crown on her head, holding the orb of the world with his left hand. There are traces of polychromy, most of which are discolored, but red is distinguishable in the drapery of all three figures, as well as a dark color, which may once have been gold, in the hair and crowns of all three figures. A very similar relief exists in the Victoria & Albert Museum, in which the composition is nearly identical, although the style is somewhat different, with more graceful, elongated figures.[2] The symmetry of the cascading folds of the Virgin's robe, as well as the general placement of the figures, are comparable in both works.

This Nottingham alabaster is also of a type popularly collected in the late nineteenth and early twentieth centuries. Allan Marquand, the earliest full professor of art history at Princeton, first published it in 1914, likening the crown to the three-tiered papal tiara and citing other occurrences of the triple-crowned alabaster coronation. These alabasters have been dated to around 1420–1460, about one hundred years after the first appearance of the three-tiered papal tiara. Marquand postulates a connection between the fact that all three members of the Trinity crown the Virgin in this type of alabaster and that the similar papal tiara may symbolically represent the pope as being sanctioned by the Trinity. The historical approach Marquand took to the study of this object is typical of the emphasis placed at Princeton on the relationship of an art object to the historical context in which it was produced.

According to Marquand's day book, now in the museum's archives, he first acquired this work in 1887. Because his day book dealt solely with university business, that would mean that this object may have been used or displayed by the department as early as that date. The piece is mentioned by Augusta Tavender, who wrote, "When the first alabaster work arrived in America it is impossible to state; but as early as 1906 the Metropolitan Museum in New York made a purchase from the Rogers Fund and many pieces have been imported in the succeeding years, so that few large museums in this country are without examples today."[3] Even with the degree of uncertainty expressed in the article, it is safe to assume that the Princeton alabaster, acquired nearly twenty years before the earliest acquisition noted by Tavender, is one of the first pieces of its type to enter an American collection.

S A

Literature: A. Marquand, "The Papal Tiara and a Relief in the Princeton Museum," *Art in America* 2 (Feb. 1914): 153-58, fig. 1; C. R. Morey, "Mediaeval and Renaissance Sculpture," *Art and Archaeology* 20 (Sept. 1925): 138; A. Tavender, "Medieval English Alabasters in American Museums," *Speculum* 30 (1955): 66, no. 20.

1. F. Cheetham, *English Medieval Alabasters* (Oxford, 1984), 17–19.
2. Ibid., 213.
3. A. Tavender, "Medieval English Alabasters in American Museums," *Speculum* 30 (Jan. 1955): 64.

53. Relief, the Coronation of the Virgin

England, Nottingham,
early 15th century
Alabaster, 39.5 x 29.5 x 5.5 cm
The Art Museum, Princeton University,
Gift of Allan Marquand
48
Ex. coll. A. Marquand, Princeton

53

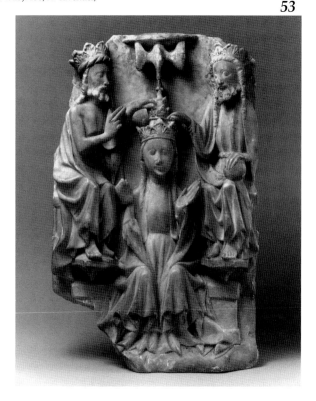

54. Capital, Angels Battling a Dragon

France, Carcassonne, c. 1140
Sandstone, 26.7 x 24.8 x 24.8 cm
The Art Museum, Princeton University,
Museum purchase
86
Purchased from A. Sarraute,
Carcassonne, 1924

This capital is carved to represent two angels in combat with a dragon, and its three-sided decoration indicates that it was probably once one half of a double capital. The emphasis is on the more playful and decorative aspects of the subject, such as the angels' twisting movement and patterned dress, seen most noticeably in the chevron-like pattern cascading below both of the angels' garters. The dragon itself is camouflaged within an S-curve that broadens from the curled tip of the tail near the top of the capital to the area of the head near the bottom.

The subject matter is typical of a group of capitals produced in the French region of Narbonne during the twelfth century. Some of the sculptures still remain in museums in that region, while others are scattered among various French and American museums. The capitals in this group, though smaller and of less consistent quality, are carved in a style that may have derived from the workshop producing the more notable capitals at the Benedictine abbey of St.-Pons-de-Thomières (Cat. 51). Seidel notes a connection with the style and motifs of seals, used primarily by the nobility, of the same time period. She also draws a connection to the feudal concerns of the nobility, such as Christianity's growing conflict with Islam, through the subjects depicted on the capitals. Some depict the process of pilgrimage (the Entombment, Supper at Emmaus), others, the concept or realities of battle (foot soldiers and mounted horsemen, St. George, angels versus the dragon), or courtly activities (riding to the hunt, dancing, music making).[1] Although none of the capitals in the group relate stylistically to pieces that remain in the church and cloister of St.-Paul-de-Narbonne, a similar group of capitals, one of which also depicts a dragon being fought, can be found at the city hall at St.-Antonin, and the Narbonne group may also have originated at a similar civic structure.[2]

This Romanesque capital was purchased by the Art Museum at Princeton University in 1924, while Frank Jewett Mather, Jr., was director, from Antoine Sarraute of Carcassone, though it had previously been owned by a gentleman in Narbonne. It was placed on display immediately, appearing in a 1925 photograph of the recently renovated museum galleries published in the *Princeton Alumni Weekly*.[3] Probably coincidentally, Arthur Kingsley Porter had donated capitals of the St.-Pons-de-Thomières group to the Fogg Museum at Harvard two years earlier. Both institutions probably recognized the value of possessing at least one example of this type of architectural sculpture, and their placement in academic museums ensured their availability for future study.

S A

Literature: A. Borg, "A Capital from Carcassonne," *Record of the Art Museum, Princeton University* 30, no. 1 (1971): 3–6; W. Cahn, "Romanesque Sculpture in American Collections. VII. New York and New Jersey," *Gesta* 10, no. 1 (1971): 48, no. 2; L. Seidel, "Romanesque Capitals from the Vicinity of Narbonne," *Gesta* 11, no. 1 (1972): 41, fig. 17.

1. L. Seidel, "Romanesque Capitals from the Vicinity of Narbonne," *Gesta* 11, no. 1 (1972): 43.
2. Ibid., 44.
3. F. J. Mather, Jr., "An Art Museum at Princeton; The University's Growing Collection," *Princeton Alumni Weekly* 25, no. 18 (1925): 418.

54

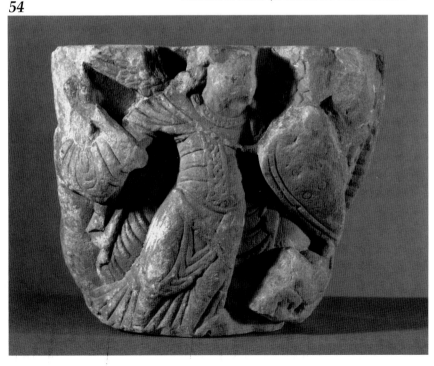

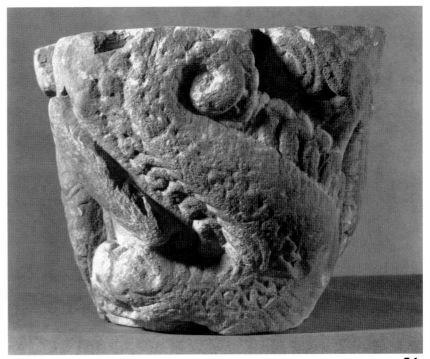

54

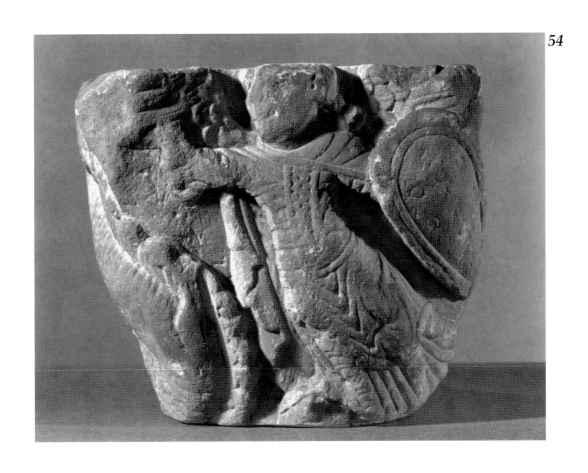

54

217

56. Plaque, the Crucifixion

Northern? France, c. 1340–1360
Ivory, framed in brass,
8.8 x 5.3 x 1.58 cm
The Art Museum, Princeton University,
Gift of Frank Jewett Mather, Jr.
29-36

This extremely tiny ivory plaque was originally used as a writing-tablet cover, then converted to a pax by placing it in a frame. A pax was used during the Eucharist and was kissed first by the priest and then by the congregation before the sacrament. The dark patina on the surface would have been caused by the constant touching and kissing, which came with its use as a pax. Richard Randall notes that the use of the rounded arch appears almost Romanesque and contrasts with the more advanced carving of the drapery. In the catalogue entry for *The Carver's Art*, a 1989 exhibition at Rutgers University, its maker is referred to as "a carver of limited gifts." Because of the relatively simple nature of the carving and the small size of the work, we can conclude that it was probably used in a small, provincial church.

Although the final product may appear somewhat crude and rudimentary, the carver did attempt a detailed rendering of the main figure of Christ. The figure of Christ, slouched over with a strong, twisting contrapposto, is of a type common to most ivory representations of the Crucifixion from this period. Works of this type vary widely in quality—some provide an anatomically convincing representation of Christ's awkward pose, but most simply resort to making the impossible angle of the crossed legs into a decorative motif or, as in this example, concealing anatomical ambiguities underneath heavy folds of drapery. The craftsman who created this piece must have used another Crucifixion, probably more advanced in technique, as his model. There is a stark contrast between the high relief of the front leg of the figure and the back leg, rendered in low relief. Although the artist attempts a somewhat naturalistic depiction of the different spatial planes occupied by Christ's legs, he fails to accurately show how they relate to and are attached to the body.

This crucifixion plaque was a gift to the Art Museum at Princeton from Frank Jewett Mather, Jr., who became a professor at Princeton in 1910 and director of the museum in 1923. Although his teaching specialty was primarily within the Renaissance, he may have acquired this medieval ivory with an eye for its eventual donation to the museum, especially in light of his directorship of the museum and Princeton's philosophy of the museum as a resource for hands-on study.

S A

Literature: *The Carver's Art: Medieval Sculpture in Ivory, Bone, and Horn*, eds. A. St. Clair and E. P. McLachlan, New Brunswick, N.J., 1989, no. 51; R. H. Randall, Jr., *The Golden Age of Ivory: Gothic Carvings in North American Collections*, New York, 1993, 83, no. 91.

56

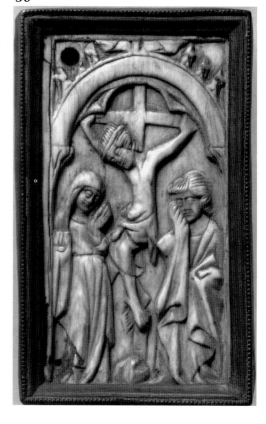

nlike the majority of other works in this exhibition, this ivory cycle of the Legend of St. Catherine is of interest almost solely for the circumstances surrounding its creation and subsequent collection history, rather than its value as an original work of art. It was once thought to be of early fifteenth-century Lombard or Italian origin, but was identified by Richard Randall in 1985 as an early nineteenth-century French forgery.[1] Randall placed the Princeton example among a group of forgeries by the "Master of the Agrafe Forgeries," brought to light in 1969 by Jaap Leeuwenberg. Leeuwenberg identified these forgeries through several recurring and distinguishing features: strangely flat, plank-like hands; a male tunic that is tight at the waist, scalloped at the bottom, and has round, closely spaced buttons running down the length of it; deeply carved hair and beards that stand away from the head; women wearing too-tight barbettes; and, most notably, a cloak held together with an *agrafe* (clasp), often diamond-shaped or a flower with petals. Although other features mentioned by Leeuwenberg, such as "self-assured, essentially modern facial expressions," are somewhat more difficult to define objectively, the stylistic characteristics are coherent and convincing on their own.[2]

The closest stylistic parallels among Leeuwen-

berg's group to the Princeton St. Catherine include a cycle of the Life of Christ from the Victoria & Albert Museum in London, and the carved panels of a casket from the Louvre.[3] In the Victoria & Albert cycle of Christ, a twisting figure in the Flagellation panel, wearing the typical short buttoned tunic, bears a close resemblance to the figure wielding a sword in the scene of St. Catherine beheaded. Each wears the characteristic tunic, and in both, the row of buttons twists exaggeratedly with the twisting of the figure. Another parallel occurs in the similarity of the praying hands of St. Catherine in the same panel to the hands of the woman in the lower left panel of the Life of Christ. Both have the same mitten-like treatment, with each finger defined by an incision onto the flat surface and with the fingertips rounded as a group, not individually. Both also display an awkward angle at the wrist with the praying hands bent impossibly toward the body.

The Louvre casket is the only one of Leeuwenberg's group with panels framed by the same ogee style arch as the Princeton forgery. In addition, the treatment of facial features in this example is very similar to the Princeton St. Catherine. Figures in both examples exhibit mouths consisting of taut lines, pinched at the corners, full cheeks, and slit eyes.

57. Set of Plaques, the Legend of St. Catherine

Paris, early 19th century (in style of Italy, Lombardy, early 15th-century)
Ivory with traces of gold,
5.1 x 3.6 x .32 cm each
The Art Museum, Princeton University,
Museum purchase,
Carl Otto von Kienbusch, Jr.,
Memorial Collection, 1929
29-160 a–h

57

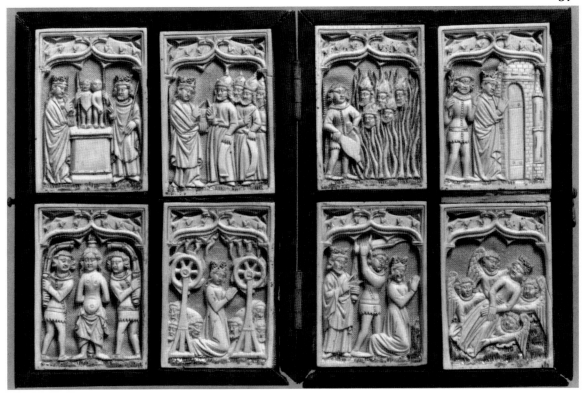

Although the cycle of St. Catherine is presently arranged within a wooden frame as a diptych and was described as such in its sole public exhibition before its identification as a forgery, the nineteenth-century forger may have been looking at a diptych, or he may have used the top of an ivory casket as his compositional model. Quite a few caskets exist in which the cover is composed of eight scenes arranged in two rows of four, one above the other. This is the format on a Flemish casket of the mid-fifteenth century from the Walters Art Gallery depicting the Life and Passion of Christ.[4] Although the quality of carving is higher in the Walters casket, the arrangement is the same: eight small panels set out in two rows of four, and the same framing ogee arch within each panel.

The inclusion of a forgery in any exhibition raises a number of questions about the nature of forgeries and how they relate to the purpose of the exhibit. First, why was the forgery produced? Leeuwenberg notes that the first known occurrence of an ivory from this group can be traced to 1806, when a casket entered the Louvre collection as spoils from Napoleonic conquests, and from this information, he estimates that the forger and his workshop were active during the last quarter of the eighteenth century and the first half of the nineteenth century.[5] Mark Jones, in the exhibition catalogue, *Fake? The Art of Deception*, suggests that the importance of fakes should be reconsidered because, as he puts it, "each society, each generation, fakes the thing it covets most."[6] The St. Catherine plaques, therefore, indicate what was in demand, beginning with the time and place they were produced, that is, early nineteenth-century France, and lasting until they were identified as a forgery a decade ago. As a surge of interest in objects of the Middle Ages occurred, the Master of the Agrafe Forgeries produced what was in high demand: "Gothic" ivories. Just as Gothic ivories were highly coveted luxury items during the period in which they were originally crafted, so they were prized once again in the nineteenth century by those wealthy enough to indulge in the growing mania for the Gothic heritage.

This ivory was acquired in 1929 as a gift from Carl Otto von Kienbusch (Princeton, Class of 1906), best known for his collection of arms and armor now in the Philadelphia Museum of Art. One might assume because his main interest did not lie in ivories, and because he was not a scholar of art history but merely an enthusiast, Kienbusch was taken in by an inferior work of art, a forgery. The Louvre and the Victoria & Albert Museum, however, cannot claim ignorance, and one must look elsewhere for explanations of the success of these forgeries. One factor may be the somewhat slower development of the study of medieval art within art history in general. It simply took some time for the scrutiny of art historians to catch up with the large numbers of medieval objects available.

Another possible explanation may be that the steady rise in popularity of collecting medieval objects throughout the nineteenth century in Europe and the early twentieth century in the United States made these precious ivories look attractive to their owners, who may not have scrutinized them closely. A similar issue is raised in the catalogue for an early exhibition in Minneapolis of fakes and forgeries which asks why an object loses value when it is detected as a forgery.[7] The answer given by the author is that every fake contains something of its own time, and therefore cannot be as timeless as a great work of art. At some point after its creation, the forgery will be discovered to have characteristics related to the time in which it was made, which then override the qualities the craftsman tried to evoke based on what he had seen in earlier works. The atmosphere of enthusiastic collecting of medieval art in the United States in the early twentieth century seems to have been similar to that in Europe in the nineteenth century, when the ivory forgeries were made. Perhaps the same enthusiasm that allowed the forged ivories to enter the market in nineteenth-century Europe caused them still to be accepted as the genuine article a century later in the United States.

S A

Literature: *The Carl Otto von Kienbusch, Jr., Memorial Collection*, Princeton, N.J., 1956, no. 66.

1. Richard Randall to Robert Guy, June 18, 1985, file for the ivory Legends of St. Catherine, The Art Museum, Princeton University, Princeton, N.J.
2. J. Leeuwenberg, "Early Nineteenth-Century Gothic Ivories," *Aachener Kunstblätter des Museums-Vereins* 39 (1969): 113.
3. Leeuwenberg, figs. 25 and 28.
4. See R. H. Randall, Jr., *Masterpieces of Ivory from the Walters Art Gallery* (New York, 1985), no. 359.
5. Leeuwenberg, 142.
6. M. Jones, *Fake? The Art of Deception* (London, 1990), 13.
7. The Minneapolis Institute of Arts, *Fakes and Forgeries* (Minneapolis, Minn., 1973).

his twelfth-century Mosan corpus from a crucifix, which at first seems somewhat rigid and symmetrical, reveals certain subtle variations in its bronze form upon closer consideration. Christ's right arm is raised slightly higher than his left, creating an obtuse angle between his right arm and the vertical line of his torso, in contrast with his left arm, which is perpendicular to the body. The folds of his loincloth fall asymmetrically, hanging lower on his left than his right. This naturalistic detail sets off the geometric, chevron-like pattern seen in the middle of the front and sides of his garment and the stylized knotting of the loincloth, centered over the abdomen. This sort of contrast is seen again in the thoughtful, rounded modeling of the head and hair versus the sharply incised, stylized ribs. When viewed from the side, the front of the body reveals a softly undulating line, with the most interest focused on the head, sagging forward from the arms, which are drawn tautly back.

This piece is unusual in that the span from fingertip to fingertip is slightly wider than the length from head to toe. Its most distinctive features are the ribs, drawn as stylized parallel lines on the torso, and the circular motif of the loincloth, tied in the center rather than at the side. The corpus shows a few traces of gilding, most noticeably in the hair, beard, and folds of the drapery. The figure has two sets of holes in its hands, but only one at its feet, suggesting that it was removed from its original cross and attached again either to the same or a different one before it was finally removed permanently.

This corpus was given to the Art Museum at Princeton as a bequest of Albert M. Friend Jr., in 1956, although it was used in teaching much earlier. It was "long a feature of the Manuscript Seminar Room in McCormick Hall," home of the Department of Art and Archaeology at Princeton, and presumably was available there for study by students and faculty.[1] Its only public exhibition before it joined the collection of the museum was at the Boston Loan Exhibition of 1940. Calkins stresses its German heritage and associates it in style with a corpus in Cleveland and another in Hildesheim attributed to Roger of Helmarshausen. The Cleveland corpus reveals some similarities in the treatment of the hair and the incisions of the ribs, and while the facial type is related to our example, it is not as deeply carved nor as sensitively revealed. The Princeton corpus can also be placed with-

in the classification system developed by Peter Bloch, in which he groups corpuses according to the arrangement of the loincloth.[2] Of the two major groupings, loincloths with horizontal closings versus those arranged diagonally, this example falls into the former category. Among the subcategories of that grouping, it possesses the type of loincloth, *Tütenfalten über den Schenkeln*, with the front center folds of the loincloth recessed and tubular drapery over the thighs. Of the corpuses Bloch assigns to that classification, the Princeton work is most closely related to two corpuses, one in Frankfurt (Liebieghaus 914) and the other in Brussels (Musées Royaux 6569), both of which exhibit a similar chevron pattern in the center folds of drapery and a schematized pattern of incised ribs. The Brussels example, in particular, also shares with the Princeton work a restrained downturn of the head and controlled emotion, along with an armspan that approximately equals the height from head to toe. The similarities of these two pieces reinforce their common Mosan origin.

S A

58. Corpus

Meuse Valley, early 12th century
Brass with gilt, 19 x 17.8 x 2.54 cm
The Art Museum, Princeton University,
Bequest of
Professor Albert Matthias Friend, Jr.
56-107
Ex. coll. A. M. Friend, Jr., Princeton

Color plate (p. 15)

58

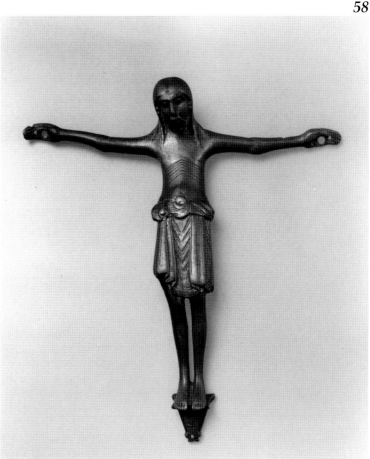

Literature: *Arts of the Middle Ages, a Loan Exhibition*, Boston, 1940, no. 264; R. B. Green, "A Romanesque Bronze Corpus," *Record of the Art Museum, Princeton University* 19, no. 1 (1960): 21-25; R. G. Calkins, *A Medieval Treasury*, Ithaca, N.Y., 1968, 131-32, no. 45; University of California Art Galleries, *A Medieval Miscellany, Romanesque and Early Gothic Metalwork*, Santa Barbara, Calif., 1974, no. 1; E. J. Hürkey, *Das Bild des Gekreuzigten im Mittelalter: Untersuchungen zu Gruppierung, Entwicklung und Verbreitung anhand der Gewandmotive*, Worms, 1983, 211, no. 227; L. R. Stewart, "Five Medieval Crucifixes in The Art Museum, Princeton University," senior thesis, Princeton University, 1983; *Selections from The Art Museum, Princeton University*, Princeton, N.J., 1986, 55; P. Bloch, *Romanische Bronzekruzifixe* (*Bronzegeräte des Mittelalters*, 5), Berlin, 1992, 166, III A 13.

1. R. B. Green, "A Romanesque Bronze Corpus," *Record of the Art Museum, Princeton University* 19, no. 1 (1960): 21.
2. P. Bloch, "Staufische Bronzen: die Bronzekruzifixe," *Der Zeit der Staufer: Geschichte, Kunst, Kultur: Katalog der Ausstellung*, vol. 5 (Stuttgart, 1977).

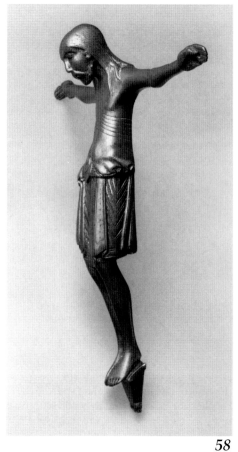

58

Chis plaster model after the "Capital with Winged Lions" (Cat. 42) is an excellent illustration of the design and building processes practiced at Bryn Athyn under Raymond Pitcairn's able guidance. This particular piece was carved after the original Romanesque capital, and then used as a mason's model for a capital of identical design now installed in the south porch of Glencairn. The use of models at Bryn Athyn encompassed two spheres of practice, the use of actual medieval pieces as inspirational tools and learning devices, and the use of full scale plaster models which incorporated aspects of the original ancient pieces. The construction of the cathedral was carried out by the use of full scale plaster models of the various architectural areas of the church, which served as guides to constructing, carving, and refining the various structural and decorative elements of the cathedral. These plaster models often incorporated medieval motifs and structural devices that the craftsmen at Bryn Athyn would have seen in the medieval artifacts that Pitcairn collected.

This piece is also representative of the taste of Raymond Pitcairn. Over the years, he amassed a collection of approximately 408 sculptural pieces; of these, 125 are capitals. A substantial number of these capitals depict strange or fanciful beasts, such as the winged lions seen in this piece. Pitcairn not only admired these beast capitals enough to purchase a large number of them, he also had many capitals made by the Bryn Athyn artists depicting fanciful beasts which were inspired by the medieval prototypes. Many of these fanciful beast capitals created by Pitcairn's artists were then incorporated into the structure of Glencairn, to decorate the bell tower, cloister, porches, and even the Great Hall of his magnificent Romanesque home. The capital that this cast served as a model for, however, represents the only instance of an exact copy being installed within the walls of Glencairn. The remainder of the capitals and other architectural decoration of Glencairn are interpretations of the medieval monuments; they are pieces inspired by the spirit and perfection the artists and Pitcairn himself saw in the sculpture of the Middle Ages, not direct copies.

B L

Literature: Unpublished

59. Mason's Model, Capital with Winged Lions

American, Bryn Athyn, c.1921–1940
Plaster of Paris, 37 x 50 x 33 cm
(After marble original, France, Roussillon, 1125–1150, in Glencairn Museum, inv. 09.SP.168)
Glencairn Museum, Academy of the New Church, Bryn Athyn
08.MD.67

59

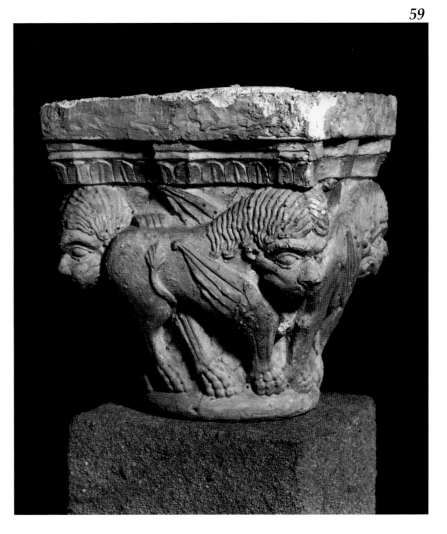

60. Capital with Seated Figures

Northern France, c. 1150–1170
Limestone, 35.1 x 27.3 x 27.3 cm
Glencairn Museum,
Academy of the New Church,
Bryn Athyn
09.SP.63

Color plate (p. 17)

This limestone capital is decorated on each of its four sides with seated figures flanked by two beasts and two foliate volutes that contain heads. The faces of the beasts have been obliterated, as have the faces of three of the four seated figures. Five of the eight heads contained within the volutes retain most of their facial features. The seated figures' hand gestures vary from figure to figure; two have hands clasped in prayer (sides A and B); one has hands folded, one over the other, in his lap (side D); and the fourth figure, which only retains portions of the upper arms, seems to be raising them up and out to his sides (side C). While regular, angled folds articulate the drapery on each of the seated figures, the actual depiction of the garments varies slightly on each.

The only head of the seated figures that retains distinguishable features is markedly classicizing (side A). The figure has short hair and a round face. This, along with the relatively well-proportioned bodies of all of the figures, perhaps points to the influence of models from Roman antiquity. The heads within the volutes, with their heavy cheeks and large almond-shaped eyes, also reveal classical influence. This motif of including tiny heads within the volutes of capitals also seems to have classical origins. For example, several Ionic capitals in Sta. Maria in Trastevere, which are spolia from the Baths of Caracalla, show heads protruding from the leafy vines of their volutes.[1] This motif is also found on a capital from the Abbey Church of St.-Remi in Reims, now in the Philadelphia Museum of Art (PMA 45-25-40). There are, indeed, many artifacts from the period of Roman occupation

in Reims, such as the Porte de Mars, which dates from the third century.

While the style of the heads relies heavily on Roman precedents, the drapery seems to be inspired by an altogether different source. All of the figures are clothed in garments with stylized, repetitive folds. These folds are boldly articulated, and their great depth is possible evidence of the use of the drill, which was also used on the pupils. The deep folds give way to smooth areas of stone, where the legs of the figures are articulated from beneath the drapery. This type of drapery is seen in several pieces of sculpture from Noyon Cathedral dated c. 1170. The figure of Moses (MMA 65.268), which Pitcairn donated to the Metropolitan in 1965, also shares the deeply cut drapery and articulation of the knees. The folds of his drapery, while more naturalistic than the Pitcairn capital, fall in the same repetitive cascades that most closely approach the drapery of the figure on side C of the capital. Although a definite provenance for this piece has not yet been established, evidence strongly points to an origin in northern France, somewhere near the artistic centers of Noyon or Reims.

The iconography of this piece is perhaps just as much a mystery as its provenance. The beasts that surround the seated figures are more than likely lions. Their bodies and paws are rather crudely and inaccurately portrayed, but they are not without precedent in portrayals of lions in Romanesque France. The inclusion of lions points to the possibility that the scene depicted on this capital may be Daniel in the Lions' Den. During the Romanesque period, the depiction of the story of Daniel in the

60

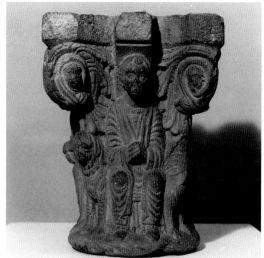

Side A.

60

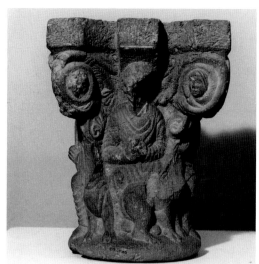

Side B.

Lions' Den was quite prevalent, both in stained-glass programs and in sculpted form, although the version of the story emphasizing Habbakuk's role was more often portrayed.[2]

The Old Testament recounts that Daniel was an administrator to the Persian King Darius, who favored him above the others because of his honesty and strength of spirit. The other administrators working for the king were jealous of Daniel, and knowing of Daniel's steadfast devotion to his God, they convinced Darius to pass an edict forbidding prayer to none but himself for the next thirty days. When Daniel was caught praying to his God, he was sent to the den of the lions as punishment. King Darius sent him there regretfully, still believing Daniel to be wise and noble. After a rock was placed at the mouth of the lions' den to seal Daniel's fate, King Darius told his much esteemed friend that he hoped Daniel's God would rescue him from the lions. The next morning, Darius ran to the lions' den and called to Daniel. Daniel replied that his God had sent angels (perhaps represented by the heads in the volutes on the Pitcairn capital) to shut the mouths of each of the seven lions, because God believed Daniel to be innocent. He also said that his trust and faith in God had saved him.

Most medieval depictions of Daniel in the Lions' Den did not portray all seven lions, but rather, they reduced the scene to its simplest expression: a pair of lions flanking Daniel, the compositional device used on each face of this capital.[3] There is a second Romanesque capital depicting Daniel in the Lions' Den in the Pitcairn Collection (Glencairn 09.SP.22), also of limestone and dated to the twelfth century,

which also does not show the requisite seven lions. Instead there are only two sculpted on each of the sides of the capital that flank Daniel. The device of two beasts flanking a seated figure points to the possibility that the subject portrayed on this capital is Daniel in the Lions' Den, but the depiction of Daniel in four varying poses is unusual, rendering the iconographical identification of this piece inconclusive. Although there are no known modern capitals decorating Bryn Athyn Cathedral or Glencairn that portray Daniel in the Lions' Den, the story is depicted in the glass of the south transept lancet windows. This subject must have had a certain relevance for Pitcairn to be represented twice within his collection and to have been included in his glazing program for the cathedral.

This piece is representative of Pitcairn's particular taste for French Romanesque limestone capitals. Approximately sixty-two percent of the sculpture collection amassed by Pitcairn was made of limestone. A majority of these limestone pieces were also figural, and as we have seen, Pitcairn also preferred capitals with sculpted beasts. Although Pitcairn did not know the original provenance of this piece, its style, like that of the Noyon Moses figure he purchased, certainly appealed to him.

B L

Literature: Unpublished.

1. D. Kinney, "Spolia from the Baths of Caracalla in Sta. Maria in Trastevere," *Art Bulletin* 68 (Sept. 1986): 379–97, figs. 3, 5–10.
2. W. Cahn, "Romanesque Sculpture in American Collections. XVI. The Academy of the New Church, Bryn Athyn, Pa.," *Gesta* 16, no. 2 (1977): 77.
3. L. Réau, *Iconographie de l'art chrétien*, vol. 2, pt. 1 (Paris, 1956), 403.

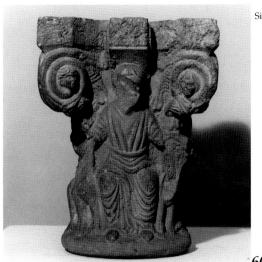

Side C.

60

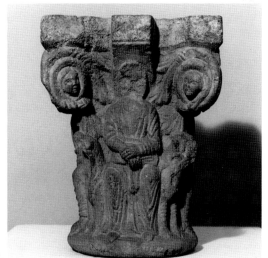

Side D.

61. Impost Block with Acanthus Decoration

France, Abbey of St.-Denis?,
 mid-12th century
Limestone, 36.8 x 81.2 x 34.3 cm
Glencairn Museum,
Academy of the New Church,
Bryn Athyn
09.SP.271
Purchased from L. Demotte,
Paris, 1923

Color plate (p. 17)

In 1144, Abbot Suger consecrated the choir of the abbey church of St.-Denis, considered by most scholars to be the first truly Gothic structure ever created because of its rib vaulted ceiling, pointed arches, open ambulatory, and large areas of stained glass. Suger had brought together some of the finest and most creative craftsmen from many areas in Europe to realize his ideas for what his church should be in much the same way Raymond Pitcairn (in the 1920s and 1930s) assembled some of the brightest artisans of the time to help him realize his dream of constructing a cathedral in the Gothic tradition for the members of the Swedenborgian religion in Bryn Athyn, Pennsylvania.

This particular impost block is unique among Pitcairn's collection of medieval artifacts because it is the only piece within the entire sculptural program of the cathedral that the artists at Bryn Athyn copied directly.[1] The design of the twelfth-century block directly inspired the impost blocks in the Council Chamber of the cathedral. The borders of the stained-glass windows decorating the Council Chamber are also based on border panels from St.-Denis within the collection. It is perhaps no coincidence that this important room, which was used as a meeting place for the church's priests and as an annual gathering place for the international Council of the Clergy of the General Church of the New Jerusalem, would include sculptural and decorative elements modeled after pieces believed to be from one of the most preeminent medieval Christian monuments in France.[2]

This impost block was purchased by Pitcairn in 1923 from the Parisian art dealer Lucien Demotte. Pitcairn purchased several pieces in his collection from Demotte, including a stained-glass border panel from St.-Remi at Reims (Cat. 67). This sculpture is indicative of Pitcairn's taste for French Romanesque sculpture from the twelfth century; over three-quarters of his collection of stone sculpture dates from this period. The purchase of this piece also shows his informed approach to collecting medieval sculpture; he believed the impost block was from a medieval structure known for the perfection and innovation of its design under the guidance of Abbot Suger. In his writings, Suger stated, "All thy walls are precious stones," in reference to the importance of each detail in his new abbey church.[3] Pitcairn shared this same concern for the perfection of every detail and stone in his new cathedral; thus he chose his pieces carefully and

knowledgeably, so his craftsmen would have nothing less than perfection to inspire them.

The St.-Denis provenance of this impost block or "pilaster capital" has never been documented, yet there is a growing body of compelling evidence that points to just such an origin. Originally, the block was believed to be from St.-Denis because of the decoration that covers three sides of the piece. Similar acanthus leaf patterns decorate sculpture throughout St.-Denis, as well as the stained-glass windows found in the abbey church (Cat. 66). In fact, impost blocks with similar acanthus leaves enveloping an acanthus bud and of roughly the same proportions can be found on the piers in the ambulatory of the Romanesque crypt at St.-Denis, which may point to a place of origin there. Although imposts similar to this block are found in the crypt, comparable stones do not exist, so far as can be determined, in any other areas of the twelfth-century monument.

Crosby considered the possibility that this impost was originally designed for Abbot Suger's twelfth-century remodeling of the nave and transept, but was relegated to use as a foundation block after the project came to a halt at Suger's death in 1152. Cahn believes this block may have been unearthed during the nineteenth-century excavations at St.-Denis, but he emphasizes the problems with the attribution to the abbey, because during the 1800s, it served as a repository for architectural and sculptural fragments from various sources in the Ile-de-France region, thus further complicating a firm attribution to St.-Denis.

Several other analogous impost blocks exist in the United States; a second in the collection of the Glencairn Museum (09.SP.12), and two others in the collection of the Metropolitan Museum of Art (13.152.1, and 1983.226, formerly Glencairn 09.SP.13). Although all four share the same carving technique, weathering, and the acanthus leaf decoration so common throughout St.-Denis, their dimensions vary when compared to each other and to impost blocks still in place within the crypt of St.-Denis.[4]

Recently, the limestone of two of these impost blocks (Glencairn 09.SP.271, and Metropolitan Museum 13.152.1) was sampled to determine its compositional characteristics through neutron activation analysis (NAA), which is carried out at the Brookhaven National

Laboratory.[5] The compositional characteristics were then compared to a reference group of pieces firmly attributed to St.-Denis and with limestone quarried in the Paris basin and surrounding areas. The limestone that composes the Metropolitan impost was found to have affinities with limestone from the Paris quarry reference group, yet not one of the pieces comprising the St.-Denis reference group was found to match limestone from that quarry. These results led Pamela Blum to conclude that one of the impost blocks from the Metropolitan (13.152.1) originated from a church other than St.-Denis.[6]

This impost block is actually included in the St.-Denis twelfth-century reference group, which is made up of "sculpture in situ or from dispersed objects in museums incontestably attributable to the abbey."[7] Although the exact placement of the block within the church can not be ascertained, the affinities of the limestone of this piece with others quarried for St.-Denis make it highly probable that this impost block did, indeed, originally come from the abbey church.

B L

Literature: S. McK. Crosby, *L'Abbaye Royale de Saint-Denis*, Paris, 1953, 48; W. Cahn, "Romanesque Sculpture in American Collections. XVI. The Academy of the New Church, Bryn Athyn, Pa.," *Gesta* 16, no. 2 (1977): 69–78, fig. 12; S. McK. Crosby et. al., *The Royal Abbey of Saint-Denis in the Time of Abbot Suger (1122–1151)*, New York, 1981, figs. 8a-d; J. Hayward and W. Cahn, *Radiance and Reflection: Medieval Art from the Raymond Pitcairn Collection,* New York, 1982, fig. 30; W. W. Clark, "New Light on Old Stones: Quarries, Monuments, and Sculpture in Medieval France. An Introduction," *Gesta* 23, no. 1 (1994): note 31.

1. File on Glencairn 09.SP.271, Glencairn Archives, The Glencairn Museum, Bryn Athyn, Pa.
2. B. E. Glenn, *Bryn Athyn Cathedral: The Building of a Church* (Bryn Athyn, Pa., 1971), 176.
3. *Abbot Suger on the Abbey Church of Saint-Denis and Its Art Treasures*, ed. and trans. E. Panofsky, 2nd ed. (Princeton, 1946; Princeton, 1979), 122- 37.
4. S. McK. Crosby et al., *The Royal Abbey of Saint-Denis in the Time of Abbot Suger (1122- 1151)* (New York, 1981), 55.
5. L. L. Holmes, G. Harbottle, and A. Blanc, "Compositional Fingerprinting: New Directions in the Study of Provenance of Limestone," *Gesta* 33, no. 1 (1994): 10.
6. P. Z. Blum, "Fingerprinting the Stone at Saint-Denis: A Pilot Study," *Gesta* 33, no. 1 (1994): 20, n. 6.
7. Ibid., 19.

61

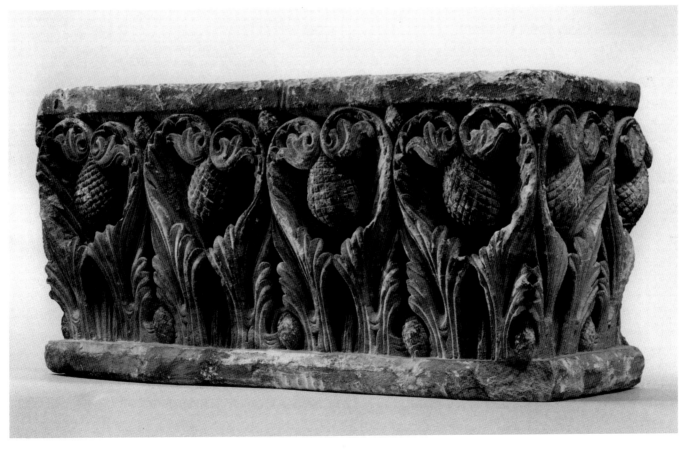

62. Panel, Old Testament Prophet

France, Normandy, Jumièges?,
c.1325–1350
Pot metal glass and silver stain,
59.9 x 34.6 x .64 cm
Glencairn Museum,
Academy of the New Church,
Bryn Athyn
03.SG.24
Ex. coll. H. Lawrence, New York

Color plate (p. 17)

This panel, along with its pendant (Glencairn 03.SG.23) was purchased at the sale of the collection of Henry Lawrence in 1921. Both are pastiche panels, made up of fragments of medieval glass from two entirely different locations and time periods. They also contain pieces of modern glass used to fill the gaps left between the ancient fragments. Often pastiche panels such as these were composed by dealers who realized that a complete composition would have greater value in the eyes of prospective buyers than a series of fragments.

The figure in this panel dates from the fourteenth century, and fragments of the original damascene background still surround him. The pointed arch shape that forms the top of the lancet is composed of glass from the thirteenth century. The scroll that the figure holds is also medieval glass, but it is from another window, while the inscription "Sanctus Jacobus" is a modern addition. This inscription is, in fact, erroneous; the cap the figure wears identifies him not as St. James, but as an Old Testament Prophet. Caviness has pointed out that this type of cap was usually reserved for Old Testament figures in the region where the figure is believed to have originated.

62

The technical virtuosity and refinement of this piece point to an origin in Normandy (the delicate modeling seen in the face and hair attest to the degrees of subtle shading that the use of silver stain allowed). There, between 1310–1340, possibly in Rouen, a shop of artists worked in a style very similar to that seen in this panel. The furrowed brow, the undulating curls of the beard and hair, and the more naive rendering of the drapery and hands compared to the complex modulation of the face and hair are all characteristics of this Norman workshop that can be seen in this piece. Caviness believes this figure was probably originally part of a large cycle of standing figures known as a "credo prophétique" that decorated the Abbey Church of Jumièges. This would have included twenty-four figures representing Apostles and Old Testament Prophets, each holding a scroll similar to the ones seen in both Glencairn panels, with either Christian creeds or prophecies from the Old Testament written on them. The scroll containing the inscription "Sanctus Jacobus" could have simply replaced the original prophetic scroll.

These pieces are important not only because they possibly represent some of the few remaining fragments of stained glass from the glazing program of the Abbey of Jumièges, which is now in ruins, but they are also important to this exhibition because they were purchased by Pitcairn at the Lawrence sale of 1921, the occasion of the largest single purchase of stained glass made by Pitcairn. The Lawrence sale was one of the most important auctions of medieval art ever held in the United States because it contained approximately seventy-seven panels or fragments of stained glass from some of the most important medieval monuments in Europe. At the sale of Henry Lawrence's vast collection of art, which also included rare tapestries and furniture, Pitcairn purchased twenty-three panels of medieval glass to add to his collection at Bryn Athyn. For these panels, he paid $153,850, an astonishing amount in the auction houses of 1921.[1] Lawrence had been a friend to Pitcairn; he had invited him and his artists into his home to draw and study the magnificent stained-glass panels he kept there. When Lawrence passed away in late 1920, Pitcairn mourned the loss of a great friend and supporter. When Lawrence's collection was put up for sale, Pitcairn realized it would be an excellent opportunity to obtain some of the panels he had admired so dearly over the years.

B L

Literature: *Collection of a Well Known Connoisseur, A Noteworthy Gathering of Gothic and Other Ancient Art Collected by the Late Mr. Henry C. Lawrence of New York*, New York, 1921, no. 360; J. Hayward and W. Cahn, *Radiance and Reflection: Medieval Art from the Raymond Pitcairn Collection*, New York, 1982, 231–34; *Corpus Vitrearum Checklist: Stained Glass before 1700 in American Collections*, vol. 2, Washington, D.C., 1987, 139.

1. T. E. Norton, *100 Years of Collecting in North America: The Story of Sotheby Parke Bernet*, (New York, 1984), 91.

In 1916 Raymond Pitcairn began his collection of medieval art with the purchase of a grisaille panel much like this piece, from the chapter house of Salisbury Cathedral.[1] After spending years sending his artists to Europe to draw and study the windows of the great cathedrals, Pitcairn decided that it would be much more useful to have actual pieces of medieval stained glass on site at Bryn Athyn, so the artists there would have direct access to the subtleties of authentic stained glass. Pitcairn was a notorious perfectionist, and he wanted the cathedral he was constructing for the Church of the New Jerusalem to be as grand and inspiring as any of the cathedrals he had seen on his many voyages to Europe. For this reason, Pitcairn began amassing an enormous collection of medieval artifacts from some of the most famous Romanesque and Gothic structures in Europe so that the artists he had gathered at Bryn Athyn could approximate as closely as possible the perfection and organic unity of the most grand medieval structures.

Pitcairn planned to glaze the aisle windows of his new cathedral with grisaille glass, which inspired him to purchase over fifty medieval grisaille panels (approximately twenty-nine percent of his stained glass collection) for his artists to study. These fifty panels make up one of the largest existing collections of grisaille anywhere, and range in date from the first half of the thirteenth century, to the first half of the fourteenth century. This was a period of great development within the grisaille genre, and Pitcairn's choice of panels dating from this time shows his intricate knowledge of and feel for grisaille and for medieval art in general. The group of grisailles Pitcairn collected consisted mostly of glass from thirteenth-century France.[2] During the period that Pitcairn was collecting, these grisaille panels, along with the numerous ornamental borders he bought, were not very popular with other collectors of medieval stained glass, who generally preferred more colorful and elaborate figural panels.

This particular panel is an excellent representative of the grisaille from the Pitcairn Collection. It dates from the thirteenth century with a provenance that has been traced to the cathedral at Sées in lower Normandy. Sées Cathedral is an important monument in the history of medieval stained glass, because its glazing program represents the first known instance of the use of band windows, where sections of colored glass are surrounded above and below by bands of grisaille. The attribution to Sées is based on affinities of this panel with the nineteenth-century glass now installed there. This nineteenth-century glass was copied from the original medieval grisailles by the restorers Leprevost and Steinheil from 1879 to 1895, and installed in the cathedral to replace the old glass. The panel was recorded by Baron Guilhermy in 1860 to have come from the St. Nicholas Chapel, the first radiating chapel on the north side of the choir at Sées, and in fact, panels similar in design that date from the nineteenth-century restoration are in place there today.

This panel is in excellent condition, with only a few minor restorations to the grisaille area, but with extensive restorations to the outer fillets.[3] From the 1860 description by Guilhermy, we know that the golden yellow castles depicted along these fillets represent "les châteaux de Castille," a reference to Blanche of Castille, mother of King Louis IX. Borders containing castles such as these were common during the 1250s and remained popular for a decade after the death of Louis in 1270. The yellow fleur-de-lys (lily) of France surrounded by a blue boss in the middle of the central quatrefoil adds an additional area of brilliant, shimmering color to the surrounding colorless glass. The grisaille portion of this panel

63. Grisaille Panel with Fleur-de-lis and Castle Border

France, Normandy, Sées,
Cathedral of St.-Gervais-et-St.-Protais,
1270–1280
Pot-metal glass, 57.5 x 61.9 x .64 cm
Glencairn Museum,
Academy of the New Church,
Bryn Athyn
03.SG.53
Purchased from J. Brummer,
Paris, 1921

Color plate (p. 18)

63

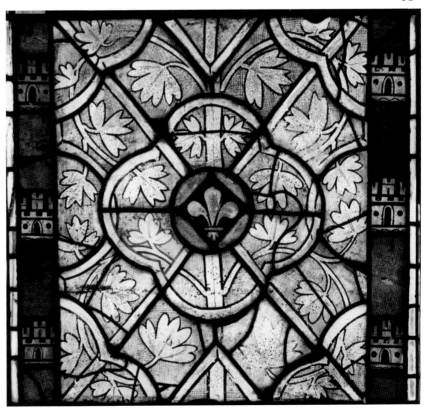

is decorated with columbine branches that sprout upwards; both the depiction of growth in a single direction, and the accurate, specific depiction of the columbine leaves point to what Meredith Parsons Lillich has identified as a "transitional" approach to grisaille design.[4] The only retardataire element seen in this panel is the crosshatching of the background.

Pitcairn purchased five panels from the cathedral at Sées, four of which were grisailles (Glencairn 03.SG.54, 03.SG.48, and 03.SG.78). All of them were purchased from Joseph Brummer, one of Pitcairn's most trusted dealers. This panel was purchased in 1921 from Brummer, along with a second grisaille (03.SG.54), also from the St. Nicholas Chapel at Sées. These two panels are nearly identical; only the columbine leaves that decorate the background of this piece have been replaced with ivy leaves in the second panel from the chapel of St. Nicholas. All of the Sées grisailles contain small areas of brilliant color surrounded by colorless glass. Raymond Pitcairn must have realized, as the glass designers of Sées Cathedral had before him, that these areas of colorless glass would allow more light to enter the interior of the church, and, therefore, make it even more luminous than structures decorated with panels containing deeply saturated areas of color.

B L

Literature: J. Hayward and W. Cahn, *Radiance and Reflection: Medieval Art from the Raymond Pitcairn Collection*, New York, 1982, 225–27, fig. 88; M. P. Lillich, "Stained Glass from Western France (1250–1325) in American Collections," *Journal of Glass Studies* 25 (1983): 125–26; L. Grodecki and C. Brisac, *Le Vitrail gothique au XIIIe siècle*, Fribourg, 1984, 259–60, fig. 142; M. P. Lillich, "Monastic Stained Glass: Patronage and Style," *Monasticism and the Arts,* ed. T. G. Verdon, Syracuse, 1984, 259; H. J. Zakin, "Grisailles in the Pitcairn Collection," *Studies on Medieval Stained Glass: Selected Papers from the XIth International Colloquium of the Corpus Vitrearum*, New York, 1985, 91, note 16; *Corpus Vitrearum Checklist: Stained Glass Before 1700 in American Collections*, vol. 2, Washington, D.C., 1987, 135; M. P. Lillich, "Les Vitraux de la Cathedrale de Sées à Los Angeles et dans d'autres musées americains," *Annales de Normandie* 40, nos. 3-4 (July–Oct. 1990): 153–54, fig. 3.

1. J. Hayward and W. Cahn, *Radiance and Reflection: Medieval Art from the Raymond Pitcairn Collection* (New York, 1982), 229.
2. H. J. Zakin, "Grisailles in the Pitcairn," *Studies in Medieval Stained Glass: Selected Papers from the XIth International Colloquium of the Corpus Vitrearum* (New York, 1985), 84.
3. File on Glencairn 03.SG.53, Glencairn Archives, The Glencairn Museum, Bryn Athyn, Pa.
4. M. P. Lillich, "Three Essays on French Thirteenth Century Grisaille Glass," *Journal of Glass Studies* 15 (1973): 69–78.

The upward curve of the lower portion of this piece shows that at one time it bordered a circular area of glass; either a rosette from a double lancet window or the central medallion of a rose window would contain such circular forms with peripheral lobes. When Raymond Pitcairn purchased this piece from Bacri Frères in 1923, its provenance was unknown. Recently, Jane Hayward attributed it on stylistic grounds to a specific region, and from there to a specific church. Using the unique foliage depicted on this piece, she was able to trace its region of origin to the glazing style of the Aisne River valley, which includes the churches at Laon, Soissons, and Braine. The intricately curling white leaves that spiral backwards to form trefoil-like buds at the tips, which contrast with the rigid fronds they both envelop and are surrounded by, along with the blue background surrounded by red edging, can all be seen in the rosettes of varying designs in the lateral windows of the clerestory of Soissons.

This is one of only three lobate sections in the entire Pitcairn collection. The "Bust of Jacob with Foliate Lobes," from the related church of St.-Yved in Braine (Glencairn 03.SG.230) includes two lobes above the figure of Jacob.[1] Their presence within the collection shows that although Pitcairn's tastes and purchases were specialized—both by type and by provenance or style—he realized his artists needed access to a wide variety of different forms (figural panels, ornamental borders, roundels, lobes) and media (grisaille, pot-metal, silver stain) to design and glaze a cathedral in the medieval tradition. In fact, lobate sections designed by Pitcairn's artists were used in the east window of Bryn Athyn Cathedral to surround a circular rosette depicting an image of Christ, and around the rosettes above the double lancet windows in the chapel of the cathedral.

Pitcairn most often purchased stained glass originally from the churches of St.-Remi at Reims, St.-Yved at Braine, and the Cathedral of St.-Gervais-et-St.-Protais in Soissons, the probable place of origin for this lobe. The Soissons provenance of this piece then, places it within this closely related group, whose style had quite an appeal to Pitcairn, as he

purchased approximately thirty-six pieces of stained glass from these three churches, most notably the "King from the Tree of Jesse Window" from Soissons (Glencairn 03.SG.229).

B L

Literature: L. Grodecki, "Nouvelles découvertes sur les vitraux de la cathédrale de Troyes," *Intuition und Kunstwissenschaft: Festschrift für Hanns Swarzenski*, Berlin, 1975, 199; J. Hayward, and W. Cahn, *Radiance and Reflection: Medieval Art from the Raymond Pitcairn Collection*, New York, 1982, 145–47; *Corpus Vitrearum Checklist: Stained Glass Before 1700 in American Collections*, vol. 2 Washington, D.C., 1987, 114.

1. *Corpus Vitrearum Checklist: Stained Glass Before 1700 in American Collections*, vol. 2 (Washington, D.C., 1987), 109.

64. Lobate Section

France, Ile-de-France, Soissons,
Cathedral of St.-Gervais-et-St.-Protais,
c. 1210–1215
Pot-metal glass, 31.8 x 37.5 x .64 cm
Glencairn Museum,
Academy of the New Church,
Bryn Athyn
03.SG.71
Purchased from Bacri Frères, Paris, 1923

Color plate (p. 18)

64

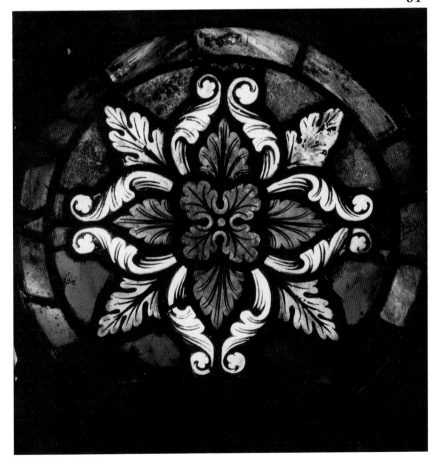

65. Roundel, Martyrdom of Two Saints

France, Ile-de-France or Burgundy,
c. 1210–1215
Pot metal glass, 54 x .64 cm
Glencairn Museum,
Academy of the New Church,
Bryn Athyn
03.SG.112
Purchased from M. Acézat,
Paris, 1927

Color plate (p. 18)

This figural panel depicts a scene of three soldiers beheading two martyrs. Because of the reconstructed condition of the piece, however, it is difficult to identify the original subject with any certainty. Jane Hayward has suggested that it may depict the martyrdom of Sts. Gervasius and Protasius, who were beheaded together, and were most often venerated in northeastern France, the area where this panel is believed to have originated. She also discusses the possibility that a third martyr was originally included, because of the large number of fragments in the piece. If there was indeed a third martyr being beheaded here, the martyrdom of St. Denis with his companions Rusticus and Eleutherius could have been the subject.

Like the pastiche Prophet panel that Pitcairn purchased from the Lawrence sale (Cat. 62), this roundel has evidence of areas of replacement glass. Several areas of the background and fillet have been replaced with either new or medieval glass portions. For example, a section of the red fillet just above the group of soldiers has been filled in with a portion of bloodstained hair very similar to the hair seen on the martyr on the right. The martyr to the right is also missing his right arm; the stopgaps used to replace it follow the original lead line of the arm (which extends outward from the right shoulder), and show its original upraised and bent position. A section of chain mail that was probably part of an arm was inserted beneath the martyr to the left. A second section of chain mail was also inserted at the tip of the raised sword of the leftmost soldier. None of the figures have retained their legs and seem to be floating in the midst of the background.

When Raymond Pitcairn purchased this piece in 1927, the dealer Michel Acézat assured him that it had been purchased from a private collection in Le Mans. Pitcairn could have then assumed that the piece was once originally from the prominent cathedral that was located in Le Mans. This panel, however, does not share any stylistic affinities with glass produced for the cathdral there. In fact, it had been purchased only three years earlier at an auction of the Heilbronner collection in Paris.

It has been suggested by Hayward that the motif of showing the figures' heads in profile could reflect the influence of the atelier at Sens Cathedral. The Glencairn panel also shares the gently folding drapery and angular jawlines of figures decorating windows at Sens, such as those in the Good Samaritan window.[1] While the Pitcairn panel is probably not a product of the workshop associated with Sens, the similarities between this piece and stained glass produced by the Sens atelier are striking enough to point to the direct influence of that important artistic center.

Pitcairn most often purchased decorative panels for his artists to study, but his collection is not without some fine examples of figural pieces as well. This piece is representative of the collection's figural panels because its place of origin is believed to be somewhere in the Ile-de-France, the area from which many of the stained-glass panels purchased by Pitcairn originally came. The circular, or roundel form was used in several areas of glass in the Bryn Athyn Cathedral, such as the eastern window of the chapel. The Martyrdom panel, with its border fillets surrounding delicately modelled figures set against a colorful, generalized background could have served as inspiration for the figural medallions in the eastern window of the chapel.

B L

Literature: *Catalogue des sculptures et vitraux: Collections de M. Raoul Heilbronner*, Paris, 1924, no. 98; C. Gómez-Moreno, *Medieval Art from Private Collections*, New York, 1968, no. 188; J. Hayward and W. Cahn, *Radiance and Reflection: Medieval Art from the Raymond Pitcairn Collection*, New York, 1982, 168–71, no. 63; *Corpus Vitrearum Checklist: Stained Glass Before 1700 in American Collections*, vol. 2, Washington, D.C., 1987, 118.

1. The Good Samaritan window at Sens dates to approximately 1210–1215.

65

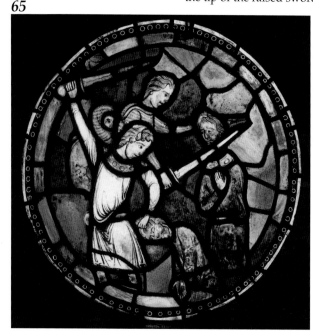

The Abbey Church of St.-Remi, located in northeastern France, was virtually destroyed by severe bombardment during the First World War, so only a very few examples of authentic stained glass remain from the once majestic Benedictine abbey. Several fragments that did survive World War I were installed in chapel windows in the south transept and were used to identify the origin of this particular border section. The motif of white arches encircling delicately curving palmette leaves of green, yellow, and purple that sprout rhythmically from a white stem resembles the border sections found within St.-Remi, two other ornamental panels within the Pitcairn collection from the abbey (Glencairn 03.SG.34, and 03.SG.129), and several other related borders within the collection at Glencairn.

Pitcairn seems to have been rather taken with the motif depicted on this border, since he purchased several panels depicting it or stylistically similar designs, such as those seen in the decorative panels from the cathedrals of Reims (Glencairn 03.SG.244) and Soissons (Glencairn 03.SG.134). The motif of the palmette enclosed within an arch, similar to that seen in the St.-Remi borders, can in fact be found in the ornamental passages surrounding the figural scenes of the central lights decorating Bryn Athyn Cathedral's north wall chancel clerestory. The similarities and differences between the medieval models and the twentieth-century glass show that while the Bryn Athyn artists utilized these artifacts as models, they did not merely produce direct, uninspired copies; instead these medieval examples inspired them to create truly original designs that retained a medieval character because of their affinities with the ancient glass.

The large number of ornamental stained-glass borders, such as this piece in the Pitcairn Collection, is one of the main reasons this collection is unique. Pitcairn was very particular about the pieces he added to his collection, because these panels were to be used by the highly talented artists at Bryn Athyn to inspire their designs for the stained glass that would eventually decorate the new cathedral. This piece is not only representative of this large portion of borders within the stained-glass collection (approximately fifty-six percent), it also shows the specialization within this group of glass borders, because it is a rare example of a horizontally oriented border. Pitcairn's purchase of this section must have been a function of the need for his artists to view and learn from all types of borders, not merely vertical ones. This piece also reflects his taste in stained glass; the most commonly represented style of medieval glass within the collection dates from 1190–1230 and comes from the churches of St.-Remi in Reims (seven panels), St.-Yved in Braine, and the Cathedral of St.-Gervais-et-St.-Protais in Soissons (twenty-nine panels from both), whose glazing styles are all closely related.

B L

Literature: J. Hayward and W. Cahn, *Radiance and Reflection: Medieval Art from the Raymond Pitcairn Collection*, New York, 1982, 110–12, fig. 38b; *Corpus Vitrearum Checklist: Stained Glass Before 1700 in American Collections*, vol. 2, Washington, D.C., 1987, 107; M. Caviness, *Sumptuous Arts at the Royal Abbeys in Reims and Braine*, Princeton, N.J., 1990, 373, no. R.b.19.

66. Border Section with Foliage Pattern

France, Reims, Abbey Church of St.-Remi, c. 1190–1200
Pot-metal glass, 17.7 x 13.9 x .64 cm
Glencairn Museum,
Academy of the New Church,
Bryn Athyn
03.SG.216
Purchased from M. Acézat,
Paris, 1928

Color plate (p. 18)

66

67. Border Section from a Life of St. Benedict Window

France, Ile-de-France, Abbey of
St.-Denis, c. 1144
Pot metal glass, 14 x 14.5 x .64 cm
Glencairn Museum,
Academy of the New Church,
Bryn Athyn
03.SG.190
Purchased from Bacri Frères,
Paris, 1923

Color plate (p. 18)

Stained glass was an integral part of Abbot Suger's remodeling of his abbey church of St.-Denis. Suger believed that light from the stained-glass windows in his abbey could be a powerful source of faith and inspiration for those who experienced the magic of its dazzling jewel-like colors. This same reverence and respect, however, was not paid to the windows by Alexander Lenoir, who, in 1799, removed approximately 140 panels of the original twelfth-century stained glass from the abbey to be put on display in his Musée des Monuments Français.[1] Of these 140 panels, only about thirty-one were ever returned to St.-Denis; the rest were either destroyed in transit or sold by Lenoir to other collectors.

In 1794, before the panels were removed by Lenoir, the architect Charles Percier sketched the details of many of the windows. These sketches are the only record of what the windows originally looked like and were used by Viollet-le-Duc to guide his restoration project begun in 1847. Perhaps as a further guide to Viollet-le-Duc's restoration efforts, the young architect Just Lisch made tracings of several panels of glass in 1849. Among these tracings are a border section from the Life of St. Benedict window (Glencairn 03.SG.33) and a figural scene from the window depicting the *Death of St. Benedict Witnessed by Two Monks*, now in the Musée de Cluny.

It is clear, when comparisons are made between this border, the sketches of Percier, the tracings of Lisch, and the other remaining fragments from the Life of St. Benedict window, that our border shares the same origin. All of the extant border fragments from the Life of St. Benedict window contain the same motif of palmettes enclosed by a white vine stem that sprouts curving leaves. Abbot Suger stated in his writings that the stained glass for St.-Denis was "made from the exquisite hands of many masters of different regions."[2] Scholars have named the artist responsible for these panels the Saint Benedict Master, whose style was characterized by flat elongated figures and rich ornamental passages.[3] The figures of the two monks are extremely drawn out; their drapery folds are extremely linear and flat. This same flattening of forms can be seen in the ornamental borders of the scene, with the planar pearl-like dots painted on the undersides of the palmettes diminishing the illusion of depth in the curling fronds.[4]

Abbot Suger does not specifically mention a Life of St. Benedict cycle in the iconographic scheme of his new stained-glass program, so the exact location of this window at St.-Denis cannot be conclusively ascertained. Most scholars, such as Carmen Gómez-Moreno and Jane Hayward, believe that the St. Benedict window from which this border originated was located in the St. Benedict chapel, which was the first chapel on the north side of the crypt.[5] This border fragment, along with the others from the St. Benedict window, are all in excellent condition. Hayward attributes the exceptional condition of the glass to the fact that the crypt was protected from the elements and, therefore, the glass was sheltered to a greater degree than the glass in the choir above.[6]

The excellent state of the two St. Benedict fragments may have been what prompted Raymond Pitcairn to purchase them. Certainly the availability of decorative borders with such a prestigious provenance was also a compelling factor. Unlike most collectors of medieval stained glass during the 1920s, Pitcairn purchased ornamental borders. Other collectors really had no use for them; they were much more interested in obtaining narrative and figural pieces to display in their collections. Throughout the 1920s and 1930s, Pitcairn amassed a substantial collection of border fragments from some of the most important medieval monuments in France, such as the Cathedral of Notre Dame at Chartres and the Abbey Church of St.-Remi at Reims. Border panels make up no less than sixty percent of all of the stained glass in Pitcairn's collection; this large proportion of ornamental borders makes the Glencairn Museum unique among other medieval collections. An overwhelming number of the decorative panels Pitcairn obtained were from France, specifically the Ile-de-France, which would include this particular piece.

Pitcairn's reasons for collecting these borders are intrinsically tied to the building of the new cathedral at Bryn Athyn. For Pitcairn, these were not merely pieces to be admired in a museum; their primary purpose was to serve as models for the borders of the windows that would decorate the cathedral. The artists Pitcairn brought together at Bryn Athyn needed border panels as well as figural pieces to study so they could approximate as closely as possible the styles and techniques of the medieval masters, in order to create entire windows in the tradition of the Gothic craftsmen. This particular border section, along

with Glencairn 03.SG.33, was used to inspire the ornamental borders surrounding the figural stained-glass scenes in the council chamber of the cathedral.

B L

Literature: C. Gómez-Moreno, *Medieval Art from Private Collections*, New York, 1968, no. 177; *Corpus Vitrearum Checklist: Stained Glass Before 1700 in American Collections*, vol. 2, Washington, D.C., 1987, 103.

1. S. McK. Crosby et al., *The Royal Abbey of Saint-Denis in the Time of Abbot Suger (1122- 1151)* (New York, 1981), 61.
2. *Abbot Suger on the Abbey Church of Saint-Denis and Its Art Treasures*, ed. and trans. E. Panofsky, 2nd ed. (Princeton, 1946; Princeton, 1979), 72.
3. L. Grodecki, *Le Vitrail roman* (Fribourg, 1977), 96.
4. S. McK. Crosby et al., 88, 90, fig. 17.
5. Ibid., 65.
6. J. Hayward and W. Cahn, *Radiance and Reflection: Medieval Art From the Raymond Pitcairn Collection* (New York, 1982), 89.

67

68. Statue Group, Coronation of the Virgin

Germany, Westphalia, mid-14th century
Oak, 38.1 cm high
The Metropolitan Museum of Art,
Gift of George and Florence
Blumenthal, 1941
41.100.150
Ex. coll. G. Blumenthal, New York

This very fine high relief statuary group in oak represents the Coronation of the Virgin. Originally endowed with polychrome decoration, it would doubtless once have been part of an altarpiece, where it most likely formed the central section. The Virgin and Christ sit next to each other on a bench, Mary turning slightly toward Christ with her arms in a position of prayer. Christ is seated frontally, his left hand holding an orb which rests on his knee, while his right hand (now missing) would have been in the act of placing a crown on the Virgin's head. The crown (also missing) would probably have been made of metal.

As the cult of the Virgin grew in popularity in the Gothic era, the Coronation of the Virgin, apparently first introduced in the twelfth century, became increasingly popular as a subject for Christian art, often appearing in monumental portal and apse decorations. In the fourteenth century, carved wooden altarpieces became a preferred location for this subject.

The Blumenthal group has been compared to a slightly larger oak Coronation now divided between London and Amsterdam, attributed to Liège, c. 1330–1360.[1] The type and position of the figures in the two groups is similar, but the drapery of the Blumenthal group is less fussy and more fluid, and the shape of the heads in the Blumenthal Coronation is different as well, with broader, more rounded foreheads. A closer comparison can be made with the statues, also in oak, of John the Baptist and two female saints in the Victoria & Albert Museum (132–, 133–, 134–1869), attributed to the Mosan or Lower Rhenish region c. 1340–1360. These figures share with the Blumenthal group similar proportions, drapery style and facial type, yet they, too, bear some relation to the London/Amsterdam Coronation. None of these works has been definitely localized, and it has been suggested that they may, in fact, be the product of itinerant artists, perhaps even part of a single workshop, who moved from one place to another, depending on the commissions they received.[2]

Like J.P. Morgan, George Blumenthal was a New York banker who became president of the Board of Trustees of the Metropolitan Museum of Art (1934-1941), but he represents a very different sort of collector. Morgan had seemingly collected almost everything, and he ruled the Metropolitan as he ruled his financial empire. Blumenthal was a more modest collector, in both senses of the word. His collecting was largely limited to western European art of the Gothic and Renaissance periods. His collection also included much eighteenth century French art, but this may represent the interests of his first wife, Florence, who took up art collecting after the death of a child. His second wife may have shared Florence's interests, for at his death in 1941 Blumenthal left his post-1700 art to her. The pre-1700 objects were given to the Metropolitan without any stipulations at all. This was an unusually modest provision; many previous donors, such as Benjamin Altman and Michael Friedsam (who died in 1914 and 1931, respectively) had specified that their collections be kept together physically to perpetuate their memory. After Morgan, Blumenthal was the largest contributor of objects to the medieval collection.[3] His interest in medieval art was most conspicuous at his Paris home. A substantial addition to his residence, the music salon, was built in the form of a Gothic chapel. It incorporated numerous original medieval architectural elements. Blumenthal was president of the Metropolitan when the new Cloisters was being built in the mid-thirties. His interest in the success of the project was such that he allowed his salon to be demolished so that the medieval portions could be incorporated into the new structure. The Froville arcade and the windows from Sens are the most visible parts of his gift to the new museum building.

Blumenthal's interest in Gothic and Renaissance art was also reflected in the architectural details of his New York residence. His living room was constructed from the courtyard of a Spanish Renaissance palace. (Along with the contents of his house it was given to the Metropolitan and was eventually built into the museum as the Blumenthal patio.) His library was decorated in a Gothic style with groin vaulting, stained-glass windows, and linenfold doors. Blumenthal's collection was much more personal than Morgan's. His Gothic and Renaissance art objects were intermingled throughout his house, forming an integral part of his home; they were not used to fill museum galleries or storage rooms. This Coronation of the Virgin at one point resided in the library. Blumenthal transferred most of his major art objects to the Metropolitan in 1940. This was one of the pieces that was given, along with the household furnishings, after his death the following year.

A R

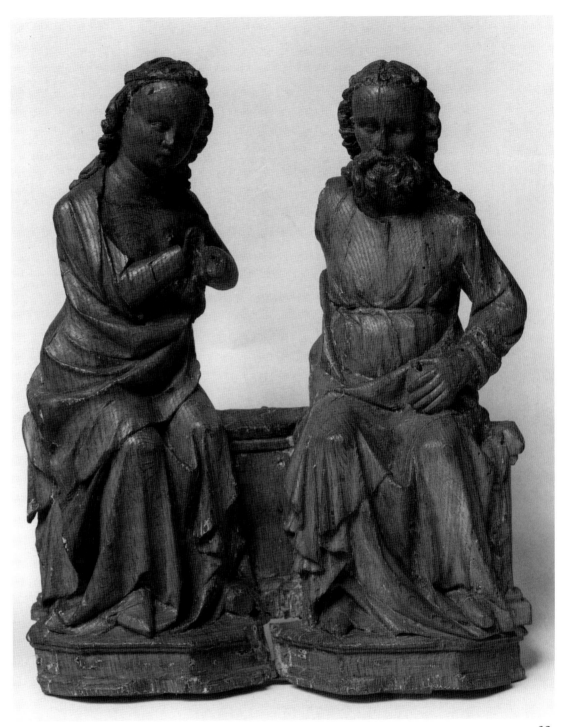

68

Literature: Unpublished.

1. The Virgin is in the Victoria & Albert Museum, London, (A4-1929) and the Christ is in the Rijksmuseum, Amsterdam (1978-40). This comparison was suggested by Dr. Willy Halsema-Kuba of the Rijksmuseum, as noted in the files of the Metropolitan Museum of Art.
2. P. Williamson, *Northern Gothic Sculpture 1200-1450* (London, 1988), 99.
3. J. D. Rockefeller, Jr.'s donations of funds to the Metropolitan's Cloisters may exceed the value of the Blumenthal medieval collection.

69. Statue Fragment, Head and Torso of the Virgin

France, 14th century
Oak, 35.5 x 24.4 x 15.2 cm
The Metropolitan Museum of Art,
Gift of George and Florence Blumenthal,
1941
41.100.222
Ex. coll. G. Blumenthal, New York

69

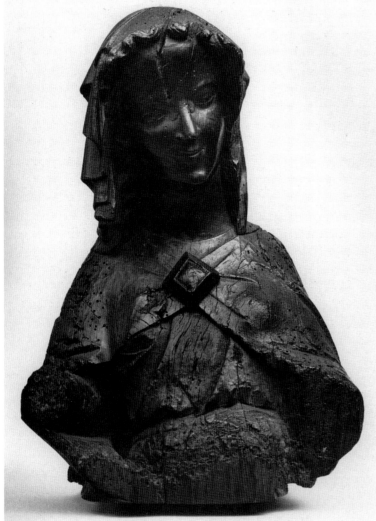

The positioning of the arms and the turned, tilted head suggest that this fragmentary sculpture is probably the upper part of what was originally a Madonna and Child. The small holes in the surface indicate that it suffered severely from woodworm, which may account for the loss of the lower portion of the Virgin and of the Child. All traces of the original polychromy have been lost, and the surface today has a polished appearance. The Virgin would have once worn a crown, the placement for which is still visible on her veil.

In spite of the extreme disfigurement of this statue, it retains its original gracefulness of pose. It is usually assigned a date in the fourteenth century, but the Virgin does not possess the flat, broad face common to figures produced at that time. Rather, her almond-shaped eyes, contained smile, and pointed chin place her within the lineage of the so-called Joseph Master of the western portals of Reims Cathedral, carved towards the middle of the thirteenth century. Not only does she share the facial features of the Joseph Master's figures, but the lozenge-shaped clasp which fastens her mantle and the flat, straight folds radiating from it bear a distinct resemblance to the arrangement of these elements on the angel, also attributed to the Joseph Master, on the left jamb of the left portal of the western façade at Reims. Consequently, a dating in the latter half of the thirteenth century seems more appropriate for the Blumenthal Virgin.

Virtually all American collectors of medieval art before 1940 had significant contacts with Europe. George Blumenthal was no exception; in fact he was an American only by adoption. Born in Frankfurt-am-Main of German-Jewish parents, he moved to America when he was twenty-four (1882). Like most of these same American collectors, he seems to have been well educated. Although he did not attend college, he spoke French and Latin, as well as English and his native German. New York City became his primary residence, but he maintained strong ties to the continent. He kept a large house in Paris and another near Cannes, and actively supported a variety of French cultural endeavors, including the American Foundation for French Art and Thought, which he founded. His French philanthropic activities were so considerable that he was inducted into the Legion of Honor. Blumenthal became a trustee of the Metropolitan Museum of Art in 1909. After his partial retirement from banking in 1925, he devoted much of his time to art collecting and the Metropolitan. The following year he had a large catalogue of his collection privately printed.[1] This piece was not included in the catalogue, and so was presumably acquired after that date. In 1928 Blumenthal gave $1 million to the Metropolitan, and six years later became President of the Board of Trustees of that institution, serving actively until his death, and presiding over the creation of the new Cloisters museum of medieval art in the late 1930s.

A R

Literature: J. Seligmann & Co., *Loan Exhibition of Religious Art for the Benefit of the Basilique of the Sacré-Coeur of Paris*, New York, 1927, pl. 16.

1. S. Rubinstein-Bloch, *Catalogue of the Collection of George and Florence Blumenthal* (New York, 1926).

uke Otto the Mild, who added the south aisle to Brunswick Cathedral and restored, enhanced, and commissioned many objects for the Guelph Treasury in the fourteenth century, probably commissioned this cross. The front is faced with silver-gilt foil and depicts the crucified Christ in the center with round medallions at the end of each arm of the cross. The figure of Christ is worked in chased relief and is shown with his feet placed side by side, though other crucifixes of this period normally place Christ's feet one over the other. Each medallion contains a stamped Evangelist symbol holding an empty text band. The sides of the cross are faced with silver-gilt foil and decorated with wavy tendrils and five-petaled flowers. The back of the cross is only partially gilded. It is decorated with five chased gilt disks—one at the end of each arm of the cross and one in the center—which are set with small pearls. Each of the disks at the arms of the cross is decorated with six connected palmettes around a central boss embellished with pearls; the central disk bears an eight-pointed star with pearl rosettes at the tips. The cross is mounted on a six-sided copper base, which was added in the fifteenth century. This base may have prompted Abbot Gerhard Molanus to describe the cross in 1697 as: "A gilded copper Crucifix without relics."[1]

The stamped symbols of the Evangelists and the decorative tendrils on the sides of the cross are identical to those on the silver binding of the Plenar for Sundays from the Guelph Treasure, now in the Staatlichen Museen Preussischer Kulturbesitz, Kunstgewerbermuseum, Berlin. An inscription on this tenth-century book of masses and prayers tells us that it was rebound in 1326. This inscription also provides us with a fairly accurate date for the cross. We can also assume that the crucifix and silver binding for the Plenar for Sundays were produced in the same Brunswick workshop, since the Evangelist symbols on both objects come from the same molds and the decorative tendrils were made with the same metal punch.

A statement issued at the time of the purchase of this cross for the Art Institute states that it "fills a need in the antiquarian collection of early medieval objects of importance."[2]

H B

Literature: G. W. Molanus, *Lipsanographia sive Thesaurus sanctarum Reliquiarum Electoralis Brunsvico-Luneburgicus*, Hanover, 1697, 23, no. 30; W. A. Neumann, *Der Reliquienschatz des Hauses Braunschweig-Lüneburg*, Vienna, 1891, 109–11, no. 6; *The Guelph Treasure: The Sacred Relics of Brunswick Cathedral Formerly in the Possession of the Ducal*

House of Brunswick-Lüneburg, eds. O. von Falke, R. Schmidt, and G. Swarzenski, Frankfurt-am-Main, 1930, 183, 80, no. 50, pl. 89; B. Bennett, "Exhibition of the Guelph Treasure," *Bulletin of the Art Institute of Chicago* 25 (Apr. 1931): 49, 51; B. Bennett, "Some Ecclesiastical Objects," *Bulletin of the Art Institute of Chicago* 25 (Sept. 1931): 79; *The Antiquarian Society of the Art Institute of Chicago: The First One Hundred Years*, ed. V. Tvrdik, Chicago, 1977, 250–51, no. 319; P. M. De Winter, *The Sacral Treasure of the Guelphs*, Cleveland, 1985, 118, no. 44, fig. 148.

1. "Ein Kupffern vergüldetes Crucifix ohne Reliquien."
2. "Chicago," *Art News* 29 (Apr. 18, 1931), Department of European Decorative Arts file 31.263, Art Institute of Chicago.

70. Altar Crucifix

Germany, Brunswick, c. 1326, with 15th century foot
Silver with gilding on wood core,
19.3 cm high (27.8 cm with foot)
The Art Institute of Chicago,
Gift of the Antiquarian Society,
1931.263
Purchased from Goldschmidt Galleries,
New York, 1931
Ex. coll. Ducal House of
Braunschweig-Lüneburg;
Brunswick Cathedral

Color plate (p. 19)

70

Back.

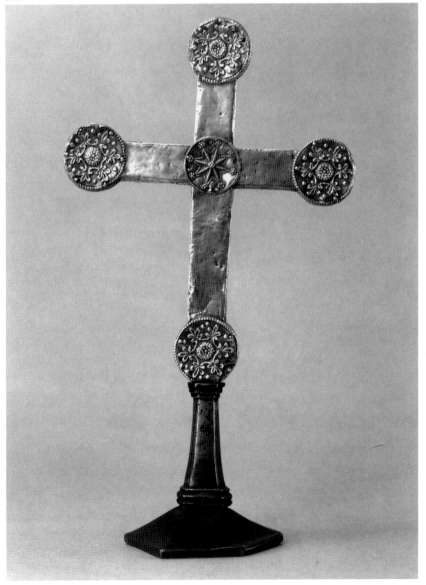

71. Monstrance with Relic of St. John the Baptist

Germany, Lower Saxony, c. 1400
Silver gilt and glass,
57.8 x 20.3 x 20.3 cm
The Nelson-Atkins Museum of Art,
Kansas City, Missouri,
Purchase: Nelson Trust
31-71
Purchased from Goldschmidt Galleries,
New York, 1931
Ex. coll. Ducal House of
Braunschweig-Lüneburg;
Brunswick Cathedral

Color plate (p. 20)

This large reliquary is known as a monstrance because its relic, a bone from the finger of St. John the Baptist, is visible. The unifying theme in this work is late Gothic architecture in miniature. A six-sided chapel-like structure with buttresses and tracery windows sits atop the six-lobed base. Above this, the simple hexagonal shaft is interrupted by a hexagonal roofed building, whose projecting corner pieces are topped by stepped gables. The shaft continues upward to a broad band decorated with rosettes and a pearl border before widening into a lobed chalice that echoes the base. This chalice, which is decorated with tiny hanging gilded bells, provides a pedestal for the central reliquary cylinder and its flanking architectural structures, which resemble the aisles of a Gothic cathedral, as seen from the exterior. These flanking structures feature open-work windows, decorated gables, and high, delicate pinnacles. A piece of the finger of St. John the Baptist, held in gold settings and topped with a tiny figure of a lamb holding a cross banner, is contained in the central glass cylinder. The bone would originally have been displayed within a rock crystal cylinder wide enough to fill the space between the flanking architectural ornaments. Broad bands embellished with rosettes would have held the original cylinder in place. Above the cylinder rises an hexagonal, open-towered chapel. It stands upon a base of six small buildings with high underpinned "masonry" and stepped gables. This base supports six pillars, upon which cast figures of saints are displayed beneath elaborate canopies (Sts. Blasius, James the Less, Peter, Paul, Thomas of Canterbury, and John the Evangelist). Ogee arches stretch between the pillars of the chapel. Inside the chapel, standing on a hexagonal pedestal, is a cast figure of St. John the Baptist holding a lamb. The chapel is topped by a steep, six-sided roof, ornamented with crockets on the ridges. The tiny six-sided structure at the apex of the roof may have supported a figure of Christ, as indicated by a seventeenth-century description of the piece.

This monstrance was purchased in January 1931 by H.W. Parsons, who had been hired by the trustees of the William Rockhill Nelson Trust to acquire objects for the nascent Nelson-Atkins Museum of Art.[1] Julius F. Goldschmidt, who sold the piece to Parsons, indicated that the glass cylinder containing the finger bone was broken when the monstrance was in the posession of the Duke of Brunswick.[2] The current glass cylinder was added by S.N. Hlophoff, probably in 1963.[3] An examination of the monstrance by the Conservation Department at the Cleveland Museum of Art revealed traces of mercury in the gilt surfaces, indicating that the monstrance was fire gilded.[4]

According to William M. Milliken, who was the first to make a major purchase from the Guelph Treasure, this object is one of the finest examples of a monstrance from the Guelph Treasure. This opinion echoes those of earlier scholars, including Abbot Gerhard W. Molanus, who described the piece in an inventory of the treasure from 1697:

> A large, excellent device in the form of a monstrance of gilded silver and [a] very artful (ingenious) old Gothic work. Christ is situated on the top [the figure of Christ is now missing]; underneath, St. John the Baptist shows with his fingers the lamb which he is carrying on his arm. Round about the monstrance hang silver bells. In the middle, in a chamber, can be seen a fragment of a blackish-colored bone contained in gold with the inscription: Os de Ossibus Sancti Johannis Baptiste. (A bone of St. John the Baptist).[5]

An earlier inventory from 1482 calls the monstrance: "a beautiful, large monstrance with the finger of St. John the Baptist."[6]

Several other large monstrances, also in the form of miniature architecture with crystal containers for the relics, entered the Guelph Treasure at about the same time, in the late fourteenth and early fifteenth centuries. Like the Kansas City monstrance, some of them reside today in American collections. Comparable pieces can be found in Cleveland (CMA 31.61) and Chicago (A.I. 62.91).

H B

Literature: G. W. Molanus, *Lipsanographia sive Thesaurus sanctarum Reliquiarum Electoralis Brunsvico-Luneburgicus*, Hanover, 1697, 27, no. 44; W. A. Neumann, *Der Reliquienschatz des Hauses Braunschweig-Lüneburg*, Vienna, 1891, 281–83, no. 56; *The Guelph Treasure: The Sacred Relics of Brunswick Cathedral Formerly in the Possession of the Ducal House of Brunswick-Lüneburg*, eds. O. von Falke, R. Schmidt, and G. Swarzenski, Frankfurt-am-Main, 1930, 198–99, 91, no. 64, pl. 99; W. M. Milliken, "The Guelph Treasure," *American Magazine of Art* 22 (Mar. 1931): 168; *Nelson Gallery-Atkins Museum Handbook I*, 5th ed., Kansas City, Mo., 1973, 69; *Songs of Glory: Medieval Art from 900-1500*, Oklahoma City, Okla., 1985, 197, no. 64.

1. Julius F. Goldschmidt to the Trustees of The William Rockhill Nelson Trust, Jan. 23, 1931, Nelson-Atkins Museum of Art, Kansas City, Mo.
2. Julius F. Goldschmidt to Bessie Bennett, Apr. 13, 1931, File: Guelph Treasure, Art Institute of Chicago Archives.
3. Examination summary, 1989, Department of Conservation, Nelson-Atkins Museum of Art, Kansas City, Mo.
4. Analytical Report, Mar. 12, 1991, Conservation Department, The Cleveland Museum of Art.
5. "Eine grosse vortreffliche *Machine* in *Figur* einer *Monstrantz* von verguldetem Silber und sehr künstlicher alter Gotischer Arbeit. Auff de Spitze stehet Christus / darunter *S. Johannes* der Täuffer mit Fingern ziegend das lamm so er auff den Armen träget. Rund umb die *Monstrantz* hengen silberne Glocken. Mitten ist in Gold gefasset zu sehen ein zimlich Stück vom Knochen schwärtzlicher Farbe mit der *Inscription: Os de Ossibus Sancti Johannis Baptiste.* (Ein Knoche *S. Johannis* des Teuffers)."
6. ". . . eyn schone grote monstrancie cum digito sancti Johannis baptiste."

his crowned head of the Virgin is associated with the *Schönen Madonnen* (Beautiful or Fair Virgins), expressions of the International Gothic style arising in the major centers of central and northern Europe around 1400. Developed under the artistic influence of the Parisian court, the style of the Schönen Madonnen reflects the same emotional expressiveness and elegant refinement found in this sculpture. The youthful beauty of the Virgin is also emphasized and corresponds to contemporary hymns extolling the physical grace of Mary as a visible manifestation of her spiritual beauty.

This type of elaborate crown is commonly seen on statues from France and Germany, but the Virgin's veil does not fall in the usual manner. Rather than hanging freely, the veil turns up on her right shoulder and continues to fold up along the back. Although very uncommon, the treatment seen here is repeated on a mid-fifteenth century, limestone statue of the Virgin and Child from Weissenburg (National Museum, Munich).[1]

Although most of the Schönen Madonnen are carved from limestone, northern European sculptors increasingly used alabaster and marble after 1300. Alabaster statues were often accented with touches of polychromy and imitated the precious quality of similarly painted ivories. Substantial traces of red are visible on the Virgin's crown, and recent cleaning has also revealed extensive gilding of the hair. In addition, the scalloped edge of the veil is covered with orange paint, possibly a ground for the application of gilt. Minute traces of orange paint have also been found just under the drapery in front.

Works in alabaster are often of modest dimensions, due to the softness of the material, but taller statues, consisting of multiple blocks, also exist. The slight extension of the Virgin's drapery in front may indicate that this fragment originally came from a statue made up of three or four blocks in the manner of the standing Virgin and Child in the Kerner-Haus, Weinsberg.[2] If this head were originally part of a freestanding figure, the height of the entire statue would have been approximately three to four feet, a common range for fourteenth- and fifteenth-century cult statues of the Virgin.

There are also other reasons to believe that this exquisite head originally belonged to a figure of a standing Virgin. While reliquary busts in wood and precious medals, often encasing a saint's skull, are common in the Middle Ages, in these instances, the head is always strictly frontal. A series of sculpted busts adorns the fourteenth-century triforium of St. Vitus in Prague, and there is a portrait bust on the socle of one of the

Schönen Madonnen (City Museum, Torun), but these works were either carved in relief or were part of a larger architectural setting, and again, the heads tend to be frontal.[3] The independent nature of this sculpture and the turning and tilt of the Virgin's head further support the contention that this bust was originally part of a standing figure, possibly holding the Christ Child.

Other sculpted medieval busts, such as the portrait of a young woman (BMFA 40.71) have proved to be forgeries, or were cut down from full-length statues such as the effigy of Marie de France (MMA 1941.100.132) or the fifteenth-century crowned head of the Virgin in the National Museum, Nuremburg.[4] This suggests that a market for medieval "busts" existed and was perhaps conditioned by the ubiquity of half-length Renaissance portraits as well as the presence of partial reproductions of medieval sculpture in the cast collections of museums. Moreover, the fabrication of busts (either through forgery or removal from full-length statues) may have also enhanced their desirability as mantle ornaments for both European and American private collectors.

Georg Swarzenski lent this work anonymously to the "Arts of the Middle Ages," and it is one of four alabaster sculptures included in the exhibition. Swarzenski had a special appreciation for medieval alabasters and had written a monograph on fifteenth-century German examples. One of the goals of the show had been to illustrate the variety of technique and media employed by medieval craftsmen, and this crowned head of the Virgin provided the American public with a rare opportunity to see an outstanding example of late Gothic alabaster carving from the Continent. It also reflects the sophisticated and highly refined taste of Swarzenski as a European collector recently emigrated to the United States.

K McC

72. Statue Fragment, Crowned Head of the Virgin

Central Europe, Austro-Bohemian, early 15th century
Alabaster with polychromy, 26 x 23.5 x 15.2 cm
Private Collection of Michael and Stark Ward
Ex. coll. H. Swarzenski; G. Swarzenski, Boston

Color plate (p. 19)

Literature: *Arts of the Middle Ages, a Loan Exhibition*, Boston, 1940, no. 196, pl. 59; C. Gómez-Moreno, *Medieval Art from Private Collections*, New York, 1968, no. 42.

1. *Gothic and Renaissance Art in Nuremberg 1300-1550* (New York, 1986), fig. 79.
2. J. Steyaert et al., *Late Gothic Sculpture: The Burgundian Renaissance* (Ghent, 1994), 332, fig. 101a.
3. For a discussion of the base of the Torun Madonna, see M. S. Frinta, "A Portrait Bust by the Master of Beautiful Madonnas," *Art Quarterly* 23 (1960): 36–51, esp. 39–41, and figs. 1 and 2.
4. *Die Bildwerke in Stein, Holz, Ton und Elfenbein bis um 1450* (*Die mittelalterlichen Bildwerke*, 1), ed. H. Stafski (Nuremberg, 1965), 130–31, no. 121.